Abandoned New England

Revisiting New England: The New Regionalism

SERIES EDITORS

Lisa MacFarlane, University of New Hampshire
Dona Brown, University of Vermont
Stephen Nissenbaum, University of Massachusetts at Amherst
David H. Watters, University of New Hampshire

This series presents fresh discussions of the distinctiveness of New England culture. The editors seek manuscripts examining the history of New England regionalism; the way its culture came to represent American national culture as a whole; the interatction between that "official" New England culture and the people who lived in the region; and local, subregional, or even biographical subjects as microcosms that explicitly open up and consider larger issues. The series welcomes new theoretical and historical perspectives and is designed to cross disciplinary boundaries and appeal to a wide audience.

Richard Archer, *Fissures in the Rock: New England in the Seventeenth Century*

Nancy L. Gallagher, *Breeding Better Vermonters: The Eugenics Project in Vermont*

Sidney V. James, *The Colonial Metamorphoses in Rhode Island: A Study of Institutions in Change*

Christopher J. Lenney, *Sightseeking: Clues to the Landscape History of New England*

Diana Muir, *Reflections in Bullough's Pond: Economy and Ecosystem in New England*

James C. O'Connell, *Becoming Cape Cod: Creating a Seaside Resort*

Priscilla Paton, *Abandoned New England: Landscape in the Works of Homer, Frost, Hopper, Wyeth, and Bishop*

Adam Sweeting, *Beneath the Second Sun: A Cultural History of Indian Summer*

Abandoned New England

*Landscape in the Works of Homer,
Frost, Hopper, Wyeth, and Bishop*

Priscilla Paton

University of New Hampshire

Published by University Press of New England Hanover and London

University of New Hampshire

Published by University Press of New England, 37 Lafayette St., Lebanon, NH 03766

© 2003 by University of New Hampshire

Printed in the United States of America

5 4 3 2 1

Library of Congress Cataloging-in-Publication Data

Paton, Priscilla.
 Abandoned New England : landscape in the works of Homer, Frost, Hopper, Wyeth, and Bishop / Priscilla Paton.
 p. cm. — (Revisiting New England)
 Includes bibliographical references (p.) and index.
 ISBN 1–58465–313–2 (cloth : alk. paper)
 1. New England—In art. 2. Arts, American—20th century. 3. Landscape in art. 4. Landscape in literature. I. Title. II. Series.
 NX653.N48P37 2003
 700'.92'274—dc21 2002156136

The author gratefully acknowledges permission to reprint the following material:

Excerpts from poems by Robert Frost POETRY OF ROBERT FROST edited by Edward Connery Lathem. Copyright 1930, 1939, 1947, 1969 by Henry Holt and Co., copyright 1936, 1944, 1958 by Robert Frost, © 1964, 1967, 1975 by Leslie Frost Ballantine. Reprinted by permission of Henry Holt & Co., LLC.

"The Figure a Poem Makes" from SELECTED PROSE OF ROBERT FROST edited by Hyde Cox and Edward Connery Lathem. Copyright 1939, © 1967 by Henry Holt and Co. Reprinted by permission of Henry Holt & Co., LLC.

Reprinted by permission of Farrar, Straus and Giroux, LLC:

Excerpts from "In the Village" from THE COLLECTED PROSE by Elizabeth Bishop. Copyright © 1984 by Alice Helen Methfessel.

Excerpts from "Arrival at Santos," "At the Fishhouses," "Brazil, January 1, 1502," "Cape Breton," "Crusoe in England," "End of March," "The Moose," and "Song for the Rainy Season" from THE COMPLETE POEMS 1927–1979 by Elizabeth Bishop. Copyright © 1979, 1983 by Alice Helen Methfessel.

Excerpts from Letter "To Isle and Kit Barker October 12, 1952," Letter "To Loren MacIver July 3, 1949," Letters "To Robert Lowell—November 26, 1951 and December 14, 1957," Letters "To Dr. Anny Baumann—January 8, 1952 and July 28, 1952" from ONE ART: LETTERS by Elizabeth Bishop, selected and edited by Robert Giroux. Copyright © 1994 by Alice Methfessel.

For David, who always believes in me

Contents

Illustrations

Preface

When my mother received a diploma in 1941 from Massachusetts State College (now the University of Massachusetts at Stockbridge) where she had studied horticulture, Josie and Mae Sullivan—the landlady and her daughter—gave my mother a new edition of Robert Frost's poetry:

> To Marian,
>> In Memory of two very happy
>> years with you
>>> Josie and Mae Sullivan

My mother had liked to read the autographed Frost collection in the house, obtained when the Sullivans had attended one of Frost's readings. No doubt the *Collected Poems of Robert Frost* seemed an appropriate graduation gift.

I don't believe that my mother had much time to read New England's popular poet. She soon married a man bent on being a farmer. As a boy he had been set on becoming a White Mountains guide, but his practical, self-made lawyer father (who had taken his son hiking) discouraged that route and allowed farming as a more acceptable outdoor career. After the marriage, three boys, a succession of farms and farm animals, and somewhat later, two girls followed. My mother may have walked by cellar holes closing up like dough to a pasture spring and brought in a small calf and its mother, although she probably didn't have much time or energy to read about such things.

So the Frost volume stayed on the white bookshelf at my parents' Maine farm, next to books from my mother's childhood (spent on another dairy farm) and several left by a previous owner, a schoolteacher: collections of Longfellow and Whittier, the *My Book House* series, a miniature 1860s edition of Shakespeare plays with fragile yellowed pages, thin blue books of Victorian morality tales in which children, if I remember rightly, were very naughty and very good and got sick and then died. In with all these nineteenth-century ghosts was the teacher's illustrated anthology, *This Generation*, which began with selections from E. A. Robinson, Robert Frost, Van Wyck Brooks, and then went to William Butler Yeats, and

a section titled "The War and the Waste Landers." So T. S. Eliot, Picasso, and Faulkner made it into a New England farmhouse.

However, their names did not come up at the supper table. (With seven sitting down, the main concern was who could eat fast enough to reach for seconds before everything disappeared.) I do remember my mother talking of Frost and reading him again after his televised appearance at President Kennedy's inauguration. Anyway, with all those books in the house someone seemed destined to be an English major. But my interests in college followed, or were directed to, the traditional canon (Chaucer, Shakespeare, Milton) and the avant-garde types I had read in *This Generation* (Eliot, Yeats, Faulkner, Woolf). I don't think I read a Frost poem my entire undergraduate career (though it is amazing, then and now, how few poems an undergraduate may read). I had the sense he was looked down upon, that he was quaint and popular, a source of gift books for mild-mannered women like my mother. Occasionally I'd hear a student or professor remark that there actually might be something to Frost. When I was in graduate school, however, Frost, like Wordsworth, was significant and innovative. And, somehow, Frost was modern and to be read seriously.

In the farmhouse living room, near the L-shaped white bookcase, hung a color copy of Millet's *The Gleaners*. In the upstairs hallway next to a window looking out on an ancient apple tree in the pasture, was a print of dogs lapping milk in a shed. I liked this one very much because it reminded me of the many puppies that our dog Wags whelped; although my mother had fixed a cozy box, the first litter was born in the adjacent room on a brother's bed. I didn't consider the Millet any reflection of our life, except the greens might have harmonized with the view outdoors. The puppies reminded me how of much puppies loved to eat. And that was my introduction to art. Somewhere in grade school I became vaguely aware of Winslow Homer. I remember that in fourth or fifth grade we did a study project on Maine life (as if we weren't living it already) that culminated in a Maine dinner with haddock. We weren't coastal, and many of us, depending on the kind of farm, had eaten too much tough chicken or too much stewed beef, so fish seemed like a treat. Lobster would have been out of the question, and most of us probably wouldn't have dared tackle it. The local (very local) newspaper did a story, and may have included a picture of a fisherman in a sou'wester—a classic Homer image. I probably saw notices in Sunday newspaper supplements of regional Homer exhibitions, but I didn't go. Somehow, I was vaguely aware of Homer and associated him with tourism: artists painted pictures of the sea and

fisherman, copying Homer, and tourists visiting the coast would buy them, just as they did the lobster traps that they tied to the roofs of their cars to take back to Massachusetts, New York, or New Jersey.

I did my senior high school research paper on Picasso (neatly divided in rose, blue, and cubist periods) because I wanted to be sophisticated and know about the world out there, know about art, and pronounce the *r*s in "park" and "car." I heard of Andrew Wyeth, too, though ignorant of his questionable status in the abstract expressionist artworld. A high school friend, whose parents weren't farmers and who had a few connections outside the county, got a coveted summer job as a waitress on Monhegan, famous for cliffs and artists' colonies. There she once poured coffee for Wyeth's son, Jamie. I took Wyeth, Homer, and Frost for granted, part of the local landscape I inhabited but did not closely examine, part of the New England tourists wanted to see. At Bowdoin College, I considered taking art courses, but became more involved in music. I did attend exhibitions, mostly imported and contemporary, and only had slight awareness that the college had great pride in its Homer collection. An original Homer could have stared me in the face at one time, like the Longfellow and Hawthorne portraits, the Scylla and Charybdis one passed through to enter the library, but it was somehow too familiar to penetrate.

Since youth, I've lived in vastly different places: Minnesota, Kansas, Texas, England, Italy, Florida, Iowa, and now Ohio. And of course I've read many books and seen many works of art. But I keep returning to versions of a pastoral that is welcoming but raw on the edges—the scene of dwindling pastures, firs, and granite. The landscape of my childhood still holds me. I don't know what kind of romantic "child of nature" I might be (I was jokingly called "dirt baby" in college because of my background), but the power of landscape has sustained this study. Rooted as it is in my family history, it moves beyond the immediately personal to offer a scholarly exploration of the values of landscape. Not surprisingly, the focus is on poets and artists bound to a New England that seemed provincial and quite out of date even as they lived in it. This book aims to provide fresh angles on their revisionings of landscape and to probe the human need to feel connected and defined, paradoxically bound and freed, by a sense of place.

Acknowledgments

There are many I must thank. Larry Reynolds encouraged this project when it was barely a conception and saw it through its immature phases, always providing insight and support. Richard Wendorf, in an NEH summer seminar, helped me develop my thinking about interarts issues. George Monteiro's sympathetic, careful reading of the manuscript aided me in the final revisions. I am also deeply grateful for the insights and encouragement offered by Oliver Buckton, Andrew Furman, David Hamilton, Robert Kern, Karen Kilcup, Krishna Lewis, Kristen Renzi, Matthew Roudané, Robert Schultz, Joy Sperling, David Tatham, Marlene Tromp, Steven Vogel, and the Robert Frost Society.

I gratefully acknowledge the support provided by a Schmidt College Summer Fellowship, Florida Atlantic University. Additional funding from the Denison University Research Foundation helped finance the illustrations that are essential to this book. Parts of chapters appeared in altered form in the *South Atlantic Review, Mosaic: A Journal for the Interdisciplinary Study of Literature,* and the *Iowa Review.* I thank the editors for permission to reprint the selections here. I also express gratitude to Phyllis Deutsch and Ellen Wicklum at the University of New England Press for their faith in this work.

My children, James and Elizabeth, deserve my gratitude: they spent their vacations visiting the landscapes depicted in this study and tolerated many a museum tour. My parents, brothers, and sister hosted me and indulged my interests during trips to Homer's Prout's Neck, Hopper's Cape Cod, and Wyeth's Cushing, Maine. I do not have the words for irrepressible, inexpressible David, who saw me through this with humor and love.

A Note on Texts

Excerpts from Robert Frost's poetry and prose are quoted from *Frost: Collected Poems, Prose, & Plays*, edited by Richard Poirier and Mark Richardson (New York: Library of America, 1995), referred to in the notes as *FCP*. Excerpts from the poetry of Elizabeth Bishop are quoted from Elizabeth Bishop, *The Complete Poems, 1927–1979* (New York: Farrar, Straus and Giroux, 1983), referred to in the notes as *Poems*. Other citations are from *Elizabeth Bishop: The Collected Prose*, edited by Robert Giroux (New York: Farrar, Straus, and Giroux 1984), referred to as *Prose*, and from *One Art: Elizabeth Bishop Letters*, edited by Robert Giroux (New York: Farrar, Straus, and Giroux 1994), referred to as *One Art*.

Abandoned New England

Introduction: Lost Prospects

Whatever the landscape had of meaning appears to have been
abandoned . . . —ELIZABETH BISHOP, "Cape Breton" (1955)[1]

Perhaps in some half-imagined American past, it was common to
strike out for a prospect, with notebook and sketchbook in hand, and
record a scene that impressed itself upon body and spirit. Such an atten-
tive ramble might now seem an extinct avocation that could have little to
do with expressing contemporary life. Why—when the word "nature" has
become bankrupt—should anyone still seek out prospects, vistas, foot-
paths, and rural roads, hoping to be led to an inspiration point? What
individual or communal needs could be served by contemplating and even
replicating the view? Probably such practices seem backward, fostering a
delusion that there is a profound nature and that people can be in accord
with it to shape a physically and spiritually sustaining habitat. A scenic
postcard on the refrigerator door or a gorgeous nature calendar at the
office are the typical remnants of literary and artistic traditions. In the
highly technological and wired culture of the new millennium, how can
landscape matter?

Landscapes—as real sites and as representations—certainly had enor-
mous importance and resonated with an immense history of idealization,
adoration, alteration, practical use, and exploitation. When the land-
scape—as imagined utopia, real property, and promotional image—is that
of the "New World," it leads into the vast subject of the colonization of
the Americas and the ideologies that guided exploration, settlement, and
expansion. Prior to the modern era, American landscape was saturated
with aesthetic and ideological value: representing the covenant with God
or the dangers of the heathen wilderness, promoting an agrarian ideal as
moral and economic base for a democratic society, exemplifying faith in

the corresponding divinity of the human and the natural, fostering the settlement along new frontiers and the rush for gold, justifying a survivalist business ethos, supporting or challenging manifest destiny. The land was inextricable from the creation and thwarting of national and individual destinies, from the issues of power, race, class, and gender that still obsess American thought.

Now past resonances seem abandoned and irretrievable. The terrain itself remains in ancient and remade forms to elicit questions about the values—whether admirable and nurturing, sentimental and nostalgic, corrupt and moribund—that reside in its visual and verbal representations in literature, the arts, film, or advertisement. The term *landscape* is immediately familiar, but its evolution introduces a complex heritage in which human actions persistently shape what is later deemed "natural." "Land" derived from agricultural practices and the division of plowed lots; even as the word became applied to greater and more diverse tracts, it remained linked to communal definitions of property as "a space defined by people" that "could be described in legal terms."[2] While "landscape" in common usage loosely refers to an outdoors scene, for landscape architects and historians the word emphatically points to appropriation, interpretation, and manipulation of place for human ends. It is, as John Stilgoe explains, "shaped land, land modified for permanent human occupation, for dwelling, agriculture, manufacturing, government, worship, and for pleasure."[3] This definition includes cities, suburbs—indeed, any areas where "nature" has been "improved" by conscious and haphazard design. Most of what we observe, then, whether in city or country, has behind it a history of human resourcefulness and folly.

The design and vision behind past and present sites are inseparable from representations of place. "Landscape" refers not just to the material world but to its depiction, with the result that "natural beauty is so riddled with conceptions derived from painting and poetry that landscape refers ambiguously to parts of nature *and* representations of nature in paintings, photographs, and film."[4] A scene may illustrate a Platonic or classical ideal, exemplified by the Roman campagna under golden light in the seventeenth-century works of Claude Lorraine. In contrast to that mythical realm, it may seem a detailed mimesis by a Dutch "landskip" artist, a topography of a country squire's prosperous holdings, or a sublime romantic fantasy by J. M. W. Turner. For Georgia O'Keeffe, the American Southwest—a skull against red hills—yields icons through which modernist abstraction revives primitivism. Yosemite's Half Dome rising out of the

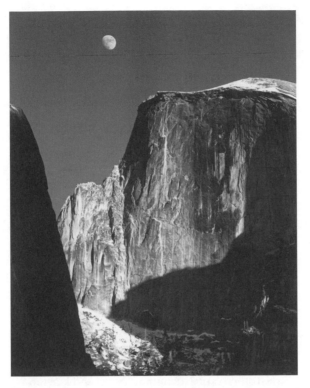

Fig. 1. Ansel Adams, *Moon and Half Dome, Yosemite National Park*, 1960. © Ansel Adams Publishing Rights Trust/Co.

Merced Valley becomes through Ansel Adams's technical skill an "objective" view offered by straight photography and a highly formalized—and invented—version of earth's pristine grandeur (fig. 1). Contemporary Americans believe themselves less mannered than eighteenth-century tourists who looked into a "Claude glass," which framed and reflected scenery in miniature so that life would imitate art. But artists, photographers, writers, and architects still think in terms of spatial, temporal arrangements: Adams had students hold up a frame to the great outdoors in order to select a subject and focal range. Less deliberate observers witness scenes boxed by the windows of vehicles, by travel posters, by their own video cameras, by the television and cinema screen. The transformation of a yard into a pleasing lawn has behind it traditions of European landscape design, in which place symbolizes the moral outlook and social aspirations of the owner, something updated in Martha Stewart's advice to do a good

thing by tending one's domain with a perfectionism that spares no expense.

So when many of us think of "landscape," some hybrid comes to mind, born of personal memories entangled with inherited images. It may be the scene of a specific place or a composite with grass, hills, plains, and water, although sand and snow may replace the dominant green. There are typical variations: a pretty glade, a meandering river, a fertile valley, a serene lake, undulant pastures, or the wild vista of a mountain prospect. A conventional image has even been statistically (if also ironically) confirmed as everybody's favorite painting in the 1997 *Painting by Numbers: Komar and Melamid's Scientific Guide to Art:* surveys directed by two artists led them to paint an "American" scene that cannot be specifically placed, with a green foreground, water, a mountain, blue sky, deer, and people—including George Washington.[5] Statistics may not result in stunning beauty, but they can suggest that we have ingrained in us an image of familiar people in a familiar place. Although contemporary artists and photographers can feature construction equipment, roadkill, or two women seated near an intersection (fig. 2), the dominant image suggested by the mention of landscape remains a harmonized version of the wild and pastoral.

Even if we do not pay conscious and constant attention to the terrain around us, we act, think, and speak in terms of placement and movement. "Landscape" and other terms denoting place and position have gone a long way toward metaphor, seemingly disconnected from physical reference: the landscapes of the mind, the landscape of political change, or in postmodern patois, the "contested sites" and "mapping" of cultural discourses. We may continue to ask "who" and "where" we are as if the pairing of pronouns were necessary for self-awareness. This figurative trend nonetheless underscores the importance of space and place to conceptualization and imagination, as verbal clichés carry ghostly imprints of physical existence. Landscape and environmental scholars delineate perceptions of place, often beginning with the classical idea from Cicero that "first nature," *natura, naturans,* describes the unmanipulated earth, while "second nature," *natura, naturata,* refers to "natural" materials altered by human effort—the garden and the domesticated animal.[6] Landscape evolves from this "second nature." Despite these distinctions, for contemporary viewers "ordinary" landscape includes "nature" (even if reworked) and is in opposition to the urban and to "progress." It is the pleasant prospect recalling the mythic promise of creation.

As in the Joni Mitchell song that has become that oxymoron, a modern

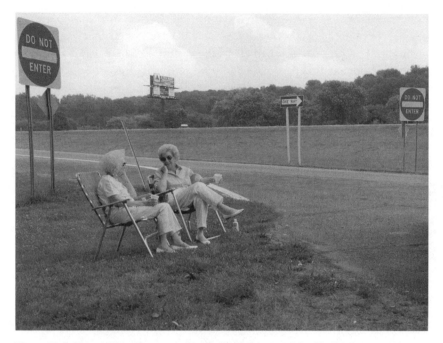

Fig. 2. Mark Haven, "Rest Stop near Campbell, August 1997." *Double Take* 5, no. 3 (Summer 1999). Copyright Mark Haven.

classic: "They've paved paradise and put up a parking lot." That parking lot—favorite unbiodegradable emblem of dependence on cars, fossil fuels, and pavement—is a threat in its convenient ubiquity. The general sense of things is that Americans are dwellers of cities and suburbs whose vision in the course of a day encompasses highways, streets, shopping malls, offices, apartments, houses—sometimes nicely set off by appropriate "land-scaping." The "new world" is the World Wide Web, accessed through the terminal whose screen receives our gaze and whose icons and "windows" offer exciting prospects to explore—or to become hopelessly lost within. Landscapes and seascapes are for summer outings and ski vacations, for children at camp. Though everyone eats, few work the earth for a living: farmers make up about two percent of the population. The commonplace image of the pleasing countryside results more from sentiment and calendar imagery than from experience with agriculture; even so, "pastoral themes constitute a popular, powerful, and pervasive mindset in contemporary American culture."[7] Environmentalism may be a significant movement, with recycling as part of the suburban repertoire; it has hardly,

however, altered corporate and consumer habits that make this a high-production, high-consumption, high-waste nation. "Deep ecology," usually symbolized as an unwashed tree hugger in the way of the evil machine, is considered the practice of cranky extremists. Our routine emotional, political, and professional lives do not seem overtly governed by the ideologies that once tied American destiny and its arts to a promised land of deliverance, an agrarian republic, or the robust frontier of the wilderness.

It often takes a threat, a disaster, or scandal, blown up by active media coverage, to turn attention to location and nature. Real-life tales of human vulnerability in freakish conditions (more immediately tangible than the long-term greenhouse effect) become best-sellers and spawn similar accounts: Sebastian Junger's *The Perfect Storm: A True Story of Men Against the Sea* about the death of six fishermen in a 1991 gale in the Grand Banks; Linda Greenlaw's *The Hungry Ocean* about her experiences as captain of a swordfish boat (she was also a source for Junger); Jon Krakauer's *Into the Wild,* tracing the survivalist and eventually fatal quest of Chris McCandless in Alaska; and Krakauer's *Into Thin Air: A Personal Account of the Mount Everest Disaster* about the 1996 deaths of five climbers on the mountain.[8] These tales of entrance "into" nature's realm dramatize the contest of the heroic, even tragic, adventurer against the odds. The first incident illustrated that contemporary fishermen, even those who spent much of their onshore time in bars, lead lives as risky as those of men in earlier centuries, the fisherman as isolated as a Winslow Homer figure. It showed too that meteorological history could outdo itself: the " 'Halloween Gale,' as that storm has come to be known, retains the record for most powerful nor'easter of the century."[9] The McCandless story follows an idealistic young man who wished to forsake his parents' tainted suburban life for the "genuine" experiences of Jack London's fiction. The Everest disaster, partly caused by another rogue storm, epitomizes the complication, as well as the corruption, of myths of heroic survival and loss. Krakauer's original subject was the commercialization of climbing, as professional guides help wealthy amateurs experience thrills. One lesson of the event was that paying a large fee could not guarantee survival above twenty-six thousand feet: one cannot yet purchase control of life, altitude, stamina, and weather.

The weather closer to home, that ballast of daily conversations, continually asserts a power beyond human technologies with intensified hurricanes, floods, and ice storms. The "El Niño" phenomenon of 1997–98

necessitated government aid to specific regions because storms do not follow a policy of equal treatment for all. Even if weather is now influenced by carbon emissions and other forms of human input, it remains under the mysterious category, "acts of God." The impact of rain, wind, snow, and ice reveals again that climate and place, whatever else they are worth, affect not only the physical and emotional experience of habitat but also micro- and macroeconomics: national, corporate, and individual spending power.

In a lighter vein than Death and Destruction by Force of Nature, Bill Bryson's *A Walk in the Woods: Rediscovering America on the Appalachian Trail* made the best-seller list with its parody of the virile outdoorsy man. If the author could complete "the grandaddy of all hikes," he would prove himself: "I would no longer have to feel like such a cupcake. I wanted a little of that swagger that comes with being able to gaze at a far horizon through eyes of chipped granite and say with a slow, manly sniff, 'Yeah, I've shit in the woods.' "[10] Much of this account is a satiric look at human "nature," which asserts its pettiness even when surrounded by what should be awe-inspiring scenery. Bryson admits that during the hike he often desired civilization's comforts, just as his whining out-of-shape companion dreamed of returning to the world of cream soda and the *X-Files.* Yet the humor carried the message that the eastern forest "is in trouble," and that the trail holds travelers "strangely in its thrall." If Krakauer found the prospect of the world from atop Everest an anticlimax to the intensity of his exhaustion, Bryson finds during a late fall hike in Vermont nature redeemed, as he looks at New England peaks in fall colors: "It was so beautiful I cannot tell you. . . . I don't recall a moment in my life when I was more acutely aware of how providence has favored the land to which I was born."[11] When that "favored" land was attacked by terrorists on 11 September 2001 (an absolutely gorgeous day in Manhattan), one of the many responses to the deaths and destruction of the World Trade Towers was a return to Nature. Posttrauma visits to national and state parks increased, prompting Secretary of the Interior Gale Norton to reconnect American destiny with its landscape: "What better places to begin that healing process than in our parks, where Americans can draw strength from national icons of freedom and peace from [the] splendors of nature."[12]

Despite this general awareness of the potential for natural disaster and for reassuring peace and beauty, those loaded terms *landscape* and *nature* apparently belong to the past, as do the literary and artistic responses

they inspired: pastoralism, romanticism, transcendentalism, luminism, and naturalism. In *Landscape and Power*, W. J. T. Mitchell proposes that landscape in its various renderings such as gardening, poetry, and painting has become in the twentieth century an "exhausted medium, no longer viable as a mode of artistic expression."[13] This is a provocative declaration that despite its immense history landscape has little to do with contemporary thought and ways. A corollary is Fredric Jameson's statement that in the late capitalist era "nature is gone for good."[14] Indeed, one defining point of postmodern thought is the disappearance of "nature" and the debunking of anything once termed inherent or natural. What "nature" and "natural" refer to in various traditions and common parlance is frequently debated, and the list becomes increasingly long and conflicted: a divine creation and nurturing spirit; essential traits; whatever is born; the organic as opposed to the manufactured; the innocent, the right and the moral; the vicious, the lawless and the instinctive; and the socially constructed passing for ideological purposes as innate. Yet "nature" and "natural" with all their connotations remain in steady use, despite scholarly anxiety and despite the sense that landscape in painting and nature in literature have lost value. This does not mean, however, that one can purchase for a bargain a commanding view of the mountains near Aspen, the Pacific coastline at Santa Monica, the islands and ocean surrounding Mount Desert Island.[15] One must have a million at least to possess those particularly fine prospects.

It is easy to say that nature has died to be resurrected as commodity. This is evident in a trip to the mall, which has its own landscape of familiar chain stores, food courts, fountains, and dusty greenery. Jennifer Price, in *Flight Maps: Adventures with Nature in Modern America*, details the shopper's quest to find "Nature as a nonhuman Place Apart" in that most human of constructions. The irony is that through consumerism at Nature Company stores people attempt to escape the inauthenticity of a material society.[16] In other stores, T-shirts, one of the most popular forms of current representation, are adorned with botanical illustrations and endangered species. Megabookstores sell updated versions of Idealized Nature in richly colored calendars and coffee-table books. An absurdly frail and emotionally restless species, we generally require tools and toys to leave the comfortable safety of familiar buildings. We no longer fashion our own implements as indigenous people do, but turn to outfitters Patagonia, REI, Northern Mountain Supply, Pasmore Outdoor, Gander Mountain, Cabela's, or OutdoorDepot.com. With a credit card, generous

spending limit, and Internet access, one can order from L. L. Bean of Freeport, Maine, all the right clothing, gear, tents, fishing equipment, canoes, bikes, and campfire espresso makers, complete with speckled-blue enameled demitasse cups.

However, all this commodification of real estate, ornamental artifact, and outdoor paraphernalia circles back to moral and aesthetic realms, to physical and emotional needs and desires. Why do people still want to live by, look at, and be part of "nature"? To approach that enormous issue, I turn to the not-so-distant past, to the works of writers and artists for whom nature was not yet a remote "place apart," who inhabited and represented wild and rural landscapes as home. In attending to Winslow Homer, Robert Frost, Edward Hopper, Andrew Wyeth, Elizabeth Bishop, and others in passing, this study explores the persistence of poetic and painterly representations of landscape just as that "medium" was losing dominance. These figures had to bridge the chasm between the places that defined them and the dominant trends of the era in which they lived.

In the antebellum age, Emerson could call for a "genius" of "tyrannous eye" to celebrate the poem of America whose "ample geography dazzles the imagination."[17] By the end of the nineteenth century the dominant gaze upon the New World had shifted to a backward glance. How quaint and quiet seem the seascapes of Winslow Homer, the deserted Cape Cod scenes of Edward Hopper, the dry fields of Andrew Wyeth, and the plain-spoken accounts of remote places by Robert Frost and Elizabeth Bishop. While that quaintness colored their reception, these figures were lauded and popularized to varying degrees for the continuance of a New England heritage closely linked to the myth of America's national beginnings, to a political, religious, and personal independence bound to life in a beautiful but harsh setting. The comfort of that heritage is disturbed, though, by their revisions of landscape traditions: the imperial, sublime prospect of nineteenth-century representations often seems emptied in their works. As the once grand landscape is diminished, so is the human figure who would contemplate and claim it. Yet these artists and writers, in understated, ironic, and elusive ways, continue to observe and reimagine abandoned scenes. Their paintings and poetry indirectly ask, what does a landscape represent? How can it persist, when the forces of modernism seem to make nature vanish?

It has become commonplace to think that the pantheistic faith of Wordsworth and Emerson, of Thomas Cole and Frederic Church, fails for later generations because the correspondences between the natural and

human no longer seem part of a divine scheme but only the workings of a fallible imagination. Nonetheless, there is more to the accomplishment of belated pastoralists than a postromantic label. The adherence of Homer, Frost, Hopper, Wyeth, and Bishop to abandoned landscapes demonstrates that for them—and to an extent the culture they express—the garden, the pasture, the shore, and the woods remain the location of knowledge, doubt, fulfillment, frustration, security, fear, alienation and authenticity. Landscape remains entangled in ontological, epistemological, and metaphysical inquiries, in relationships of power, in physical deprivations and pleasures. The ready sense of a pleasing countryside may result from sentimental habit, but significance lingers behind the nostalgic haze. The paradox of twentieth-century "views" is that landscape, pastoral, and nature have lost meaning yet still exert a hold on the imagination.[18] This paradox is tested in the following essays for the cultural and private meanings of these artists' descriptive conventions, conventions outworn in an era largely defined by the urban, the industrial, the technological, by the avant-garde, the modern, and the postmodern.

A related paradox surfaces in the reputations of Homer, Frost, Hopper, Wyeth, and Bishop, who have occupied prominent, yet qualified, places in the development of American art and literature. They are defended, their limitations explained, misunderstandings about them corrected. Their reputations were marred to various degrees by the biases of avant-garde and formalist polemics, and by reductive concepts of "Americanness," "manliness," "womanly" reticence, and the "native tradition." Their status, as will be further explored, reflects the seemingly diminished worth of landscape.

Homer and Frost particularly appeared the opposite of the cosmopolitan aesthete; indeed, in popular reception they have been embraced as quintessential Yankees. Bishop, even with her wide travels, stayed closed to domestic circumstances and plain speech in poems of Nova Scotia and Worcester, Massachusetts. Hopper with his urban icons was not linked with rusticity, but his American scenes of city buildings and country roads were those that could be seen by an ordinary (albeit isolated and voyeuristic) middle-class viewer. Wyeth is more likely to be linked with the popular art of Norman Rockwell than with either sublime or confrontational trends. Unlike the expatriate avant-garde, these figures were homey, familiar, and clung to the value of the vernacular and the local. Homer, though, was not born a fisherman, California-born Frost acquired a dialect, Hopper frequently viewed the landscape in transit from a train or car

window, Wyeth was born to a self-consciously artistic and highly theatrical family, and Bishop became for practical purposes an orphan shuffled between relatives. They were not so blandly native as first appears. Being native and at home is not simply an inherited state but one created, often with difficulty. It takes effort to stay in place and claim one's inheritance.

The essays that follow overlap in discussing the rural, the natural and the nativist, the use of reticence and realism, and the depiction of the Northeast. The paintings and poems concern themselves with residual and emergent values in landscape.[19] However, as befits the distinctiveness of these artists and poets, each essay addresses a topic specific to the individual's outlook, career, and cultural context. The essay on Homer and Frost outlines shifting aesthetic and cultural values at the turn of the century, the limitations of the men's portrayal as self-made Yankees, and the price of their popular success. The next on Homer explores further the transition from the nineteenth to twentieth century in connection with the painter's recurring subjects, especially survival in nature. His paintings have long been associated with primal power: the resolute fishermen, the Adirondack guides and hunters, and the crashing waves of Prout's Neck, Maine, appealed to urbanized businessmen longing for images of outdoor manliness. However, the inverse of this potency is also a significant element of his vision—the images of powerlessness. The depictions of black figures and prey in pastoral and sublime settings fuse social inequality with "natural" threats: these representations imply such figures were surrogates for the fears of the mainstream audience.

Building on the preceding discussions of the native tradition, "The Hick on the Hillside, The Woman at the Window" returns to Frost's "poet-farmer" image, source of his general popularity and of disrespect in highbrow circles. Agrarian ideology provides a context of ambivalent attitudes toward the rustic-clown and suggests that Frost could both tap nostalgia and portray rural desolation when the farm no longer functioned as the dominant and much idealized emblem of American goodness. Readings of poems expose stereotypes of the rural and the meaning of the land for characters other than the poet: Frost's early works illustrate a New England, quietly aware of class and gender tensions, that can offer the pastoral idyll and sublime prospect, but repress it with drudgery and social strictures.

The essay on Hopper and Wyeth pairs artists held in very different regard, but both drawn toward the bleak and the lost. Hopper, who bridges warring modern aesthetics by combining realism and formalism,

rural and urban subjects, elicits questions of reading and seeing. Should his landscapes be read as thematic responses to nineteenth-century traditions or as primarily formal arrangements? The likely answer is both: his views from the road offer vestigial icons presented as reductive geometry, while the former use-value of the landscape haunts the scene. Wyeth, too, has a more complicated relation to nostalgia than is often credited. Like some of Frost's poems, his paintings stir latent and contradictory responses toward the rural, often mingling admiration for a spartan life with hints of degeneracy.

Elizabeth Bishop is set apart by her gender and her quieter, more solely academic status; for decades she was lauded by the knowing as the "poet's poet." The "popular" woman poet of nature remains Emily Dickinson, typifying a profound, if not completely comprehensible, response to the world outside her window: her eccentricity, like that of Thoreau, provided a memorable type. If Bishop in the surrealism of her early poetry and in the breadth of her travels breaks away from the Victorian image of a cloistered intellectual spinster, she nonetheless inherits a disposition that inclines toward enigma and alternates between revealing and veiling a reclusive self. Bishop inherits as well a poetic interest closely identified with masculine endeavor. Despite the seeming modesty of her descriptions, she continues landscape traditions in a loaded way. As it was for colonists, explorers, and romantics, the land for Bishop is an image of her own desire, both the alien other and the projection of self. Her poetry adapts the traditional feminization of landscape, turning the trope on itself to celebrate a womanly desire and voice.

"The Ghost of Self-Reliance" brings these and other artists together in a consideration of the portent and curious popularity of abandoned scenes. Urban worldliness is left behind for images of cut forests, empty cellar holes, derelict houses, and empty roads; such retreat is either a moral touchstone to be recovered or a delusion to be rejected. The essay asks if nostalgia and elegy prevail, accompanied at times by a hypocritical longing for the "simple life," or if synthesis and renewal are latent in the icons of desertion that occupy the modern rural prospect. An epilogue carries such issues further, testing them against some contemporary trends to raise again the question: what potential remains for landscape?

My approach is broadly informed by landscape aesthetics and iconology, the overlapping interests of "green cultural studies" and nature writing, and interpretations of place by cultural geographers. "Landscape" has al-

ready been introduced as problematic and almost infinitely stretched. The use of the word here is intended to be open-ended and inclusive (I include, for example, seascapes). "Landscape" is more capacious than "pastoral" alone, which could theoretically be restricted to the literary depiction of the life of shepherds.[20] It is less capacious than "nature," though it seems "Nature" will not be left out of the discussion—it may be a myth, but an insistent and intrusive one. "Landscape" is flexible enough to allow for analogies between textual and visual images. The connotations of "landscape" direct attention to the element of human perception and creation, and to how that seeing and making blurs division between an objective "out there" and a subjective "view," between physical place and representation. Also blurred (or interactive) is the boundary between human construction and the nonhuman world of process and form. We construct meaning, but as Anne Whiston Spirn reminds us, "Humans are not the sole authors of landscape. . . . All living things share the same space, all make landscape, and all landscapes, wild or domesticated, have coauthors, all are phenomena of nature and culture."[21]

Landscape aesthetics, according to W. J. T. Mitchell, constitutes "a field that goes well beyond the history of painting to include poetry, fiction, travel literature, and landscape gardening."[22] Influenced by Mitchell's work on iconology, or "the study of both 'what images say' and 'what to say about images,' " David C. Miller supports discussion of "American iconology" as arising "from the premise that the visual and the verbal are deeply implicated in each other." The traditional study of the "sister arts" of poetry and painting has been revamped as interarts explorations of "the high degree of visual-verbal interaction throughout the American literary and artistic tradition."[23] Also involved in iconology are controversial issues of perception and interpretation: how do or should we "read" the visual and "see" the verbal? The interplay of the visual and verbal nonetheless calls for careful distinctions between the media. This study enters into the debate of the formal versus iconic and narrative values in paintings; of how, in Michael Ann Holly's phrase, "the fundamental incommensurability of structure between image and word" should, or should not, be transposed in visual poetry and telling pictures.[24]

As stressed above, landscape (and its derivative, "landscaping") direct attention to the continual human adaptation of the environment. The shaping of the world is ancient and ongoing: images of abandoned New England depend on patterns of settlement and migration.[25] While "landscape" and "nature" may belong to the past, that complex past has formed the present. In real and imagined landscapes, the past can become man-

ifest, a geographical and symbolic continuation of the eons. Or it can seem invisible, necessitating archaeological quests that may expose, destroy, and misinterpret the layers. The impulse to excavate the strata has led to a recent proliferation of interdisciplinary studies, particularly on eighteenth- and nineteenth-century representations of nature and landscape.[26] Through their various methodologies and emphases, scholars of landscape concur that human response and the physical world have inevitably and reciprocally marked each other.

That reciprocity can appear benign and at its most ideal expressive of a mythic bond between the hermit and the wilderness, the gardener and the garden, the patriot and fatherland, the architect and the rational community. John Brinckerhoff Jackson, whose books and lectures helped make landscape study a legitimate academic inquiry, writes of the best to be witnessed in physical landscapes: "The beauty that we see in the vernacular landscape is the image of our common humanity: hard work, stubborn hope, and mutual forbearance striving to be love."[27] He then connects landscape to culture with a telling simile: "Like a language, a landscape will have obscure and undecipherable origins, like a language it is the slow creation of all elements in society. . . . A landscape, like a language, is the field of perpetual conflict and compromise between what is established by authority and what the vernacular insists upon preferring."[28] Through Jackson's conception, landscape embodies a very "American" development as the "common"; and the "vernacular"—the scene not of aristocratic arcadias but of George Caleb Bingham's jolly boatman, fur traders, and frontiersman—asserts a "stubborn hope" (fig. 3).

Although such optimism seems outdated when set against awareness of the power struggles, ugliness, and waste that also shape the American scene, the concept of landscape as language remains compelling and contributes to the synthesis of the verbal and visual. Landscape architect and scholar Anne Whiston Spirn extensively develops the idea in *The Language of Landscape* to recover what she believes are important and pragmatic aspects of place and daily life. While J. B. Jackson depended upon "if" and a simile, Spirn boldly uses "to be" verbs in equating landscape and language to find a primal text:

The language of landscape is our native language. Landscape was the original dwelling; humans evolved among plants and animals, under the sky, upon the earth, near water. Everyone carries that legacy in body and mind. . . . Landscapes were the first human texts, read before the invention of other signs and symbols. . . . Speaking and reading landscape are by-products of living—of moving, mating,

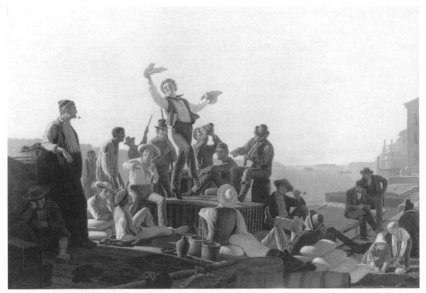

Fig. 3. George Caleb Bingham, *The Jolly Flatboatmen in Port*, 1857, oil on canvas, 119.5 cm × 176.8 cm (47⅟₁₆ in × 69 ⅝ in.). The Saint Louis Art Museum.

eating—and strategies of survival—creating refuge, providing prospect, growing food. To read and write landscape is to learn and teach: to know the world, to express ideas and to influence others.

Metaphors grounded in landscape guide how humans think and act.

Verbal and mathematical languages, the word and the formula, merely describe and interpret the world for they are not the things they describe, but always one or more steps removed. In landscape, representation and reality fuse when a tree, path, or gate is invested with larger significance.[29]

Spirn's argument demonstrates landscape's centrality and reminds us that we are not so distant from our ancestors as we mold and interpret place in the acts "of moving, mating, eating . . . creating refuge, providing prospect, growing food." If we become more self-conscious of creating this language, then we can become more responsible about how we "think and act" toward each other and our surroundings.

Throughout her defense of landscape, Spirn illustrates convincingly that landscape is a text with its own rhetorical and grammatical rules. It is a postmodern tactic to "read" all elements of daily life as encoded text (often a text to be subverted). However, Spirn's ardent passages recall

devotion to the Book of Nature and romantic notions of pure language and Symbol as Reality uniting the material and spiritual. Spirn, in her critical sophistication, may be distanced from the celestial vagueness of American transcendentalism, but belief in the "speaking" character of objects and place echoes Emerson in "Nature" and "The Poet":

It is not words only that are emblematic; it is things which are emblematic. Every natural fact is a symbol of some spiritual fact. Every appearance in nature corresponds to some state of mind, and that state of mind can only be described by presenting that natural appearance as its picture. . . . Light and darkness are our familiar expression for knowledge and ignorance; and heat for love. Visible distance behind and before us, is respectively our image of memory and hope.

Things admit of being used as symbols, because nature is a symbol, in the whole, and in every part. Every line we can draw in the sand, has expression; and there is no body without its spirit or genius. All form is an effect of character; all condition, of the quality of life; all harmony, of health; (and, for this reason, a perception of beauty should be sympathetic, or proper only to the good.) The beautiful rests on the foundations of the necessary.[30]

Although Emerson's use of the "proper," "good," and "beautiful" sounds archaic, there still is a hunger, if not exactly for absolutes, at least for a connection between word and experience that "feels" much closer. Spirn, while acknowledging human invention, seeks the universal in landscape: "The closer invented meanings are to significant, inherent qualities the more they draw from embodied knowledge rather than disembodied, abstract ideas, and the more likely those meanings are to be shared broadly."[31] Knowledge should be embodied in the Real and the Necessary: this formula sounds antiquated, yet those devoted to landscape attempt to "ground" abstractions in the interchange of the human mind and physical existence. Such grounding must be cautiously done; "inherent" values of the material world (if they exist) can still be easily distorted by our imagining—and thus inventing—what they are. On one hand, we can admire and emulate that desire. On the other, we must beware of anthropomorphic tendencies; we always rely on human language, even as we are aware that our languages respond to a world-out-there. If the language of landscape, whether with romantic or postmodern undertones, becomes too heady, there is always Thoreau to offer a parable. At Walden, he "taught" a language to his crops through modest agriculture: "making the

yellow soil express its summer thought in bean leaves and blossoms . . . making the earth say beans instead of grass,—this was my daily work."[32]

Much daily work, however, does not result in an enlightened correspondence between person and place, bean and earth. Spirn, again echoing the transcendentalists, sees enormous possibilities endangered by ignorant complacency: she provides cautionary tales of trees that die because of construction and of ignored underground rivers that well up to destroy a community. The loss of "fluency in the language of landscape" entails an intellectual, ethical failing because it "limits" the "partnership between people, place, and other life and further reduces the capacity to understand and imagine possible human relationships with nonhuman nature."[33]

Also turning from optimism and creation to pessimism and disclosure, other scholars lean heavily on the "perpetual conflict and compromise" Jackson saw in landscape's language. For them, the expression of a language of love and forbearance has been shaped by problematic desires and prejudices. Place and language have degenerated into ecological and social disasters. Skeptical readings, not surprisingly, often focus on issues of hegemony. Since *Homo sapiens* appeared, land has been a politicized territory—a claim, a border, a battlefield. Landscape, as it both reveals and obscures the workings of political, social, and economic force, becomes "an instrument of cultural power."[34] Such formulations undercut, for example, the "rightness" of the English country house in paintings and literature: it represents not the moral leadership of the upper class, but the exploitation of soil, tenants, and colonies. Another highly recognizable example is the ideology of manifest destiny, made blatant in an 1868 Currier and Ives print, *Across the Continent: Westward the Course of Empire Takes Its Way* (fig. 4). During that moment in American culture, nothing seemed more right and natural than claiming the Wild West and seeing the rugged settlers as exemplifying a native spirit. (Those now called "Native Americans" played an unwilling vanishing act in this scheme.)

Following conquest and imperialism, capitalism has been for many interpreters the modern era's shaping ideology. Instead of homesteads and trains relentlessly stretching all the way from the East Coast to California, the paradigm (whether consciously chosen or not) seems to be of endless developments of upper-middle-class trophy houses surrounded by shopping malls. Rather than a divine presence or the fruits of local love, the urban and suburban settings where most Americans live display the bit-

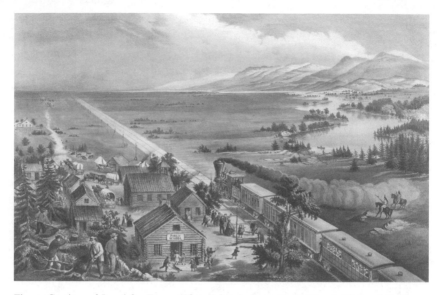

Fig. 4. Currier and Ives (after Frances Flora Palmer), *Across the Continent: Westward the Course of Empire Takes Its Way*, 1868. Denison University Art Gallery.

tersweet produce of development, investment, growth, marketing, and profit. Environmental historian William Cronon summarizes this sweeping trend: "Whether one looks at the destruction of the great herds of bison or flocks of passenger pigeons in the nineteenth century, the extirpation from North America of whole ecosystems like the tallgrass prairie, or the increasing assaults on biodiversity worldwide, the immense power of a political economy based on culturally commodified nature is everywhere apparent, producing an alienation from the natural world—and from the effects human actions have thereon—that is all too characteristic of modernity."[35]

Another critical perspective on landscape challenges the gendering of place that lies behind myth, religion, reverence, appropriation, and abuse. "Nature" and "Earth" have long been called Mother. Women writers and critics have complex responses to this identification: it can seem empowering to be considered part of a nurturing life force, to be attuned to, in Carolyn Merchant's words, "the ancient Earth Mother, rechristened 'Gaia.' "[36] This feminine harmony is implied in a recollection from contemporary naturalist, writer, and environmental advocate, Terry Tempest Williams: "One of the first images I have as a very small child was sitting with my mother and grandmother on the beach in California and feeling

the waves circle around us, even the foam around my legs, my body's impression on the sand. The sand shifts as we shift. Being there with my mother and grandmother on either side was very female, very porous, very tactile."[37] Williams's early experience in "nature" strikes her as "very female," and her description echoes traits often linked with the feminine in Western culture. The experience is fluid, circular, shifting, "porous," and "tactile," rather than firm, linear, stable, autonomous, and cerebral.

Williams—who has written in *Refuge* and *Desert Quartet* of woman's bond with landscape as sustaining, spiritual, and erotic—seems eager to ally herself with an earth mother. However, she also claims that women cannot solely be seen in the "nurturing role" of "caretakers of the earth," which would be "limiting and ultimately unfair to both men and women."[38] In an anthology of women's writings on nature, *Sisters of The Earth*, Lorraine Anderson expresses a similar desire to imagine a "feminine" relationship with the earth while avoiding the entrapment of stereotypes and past dominance: "Although I've concluded that there is no such thing as a woman's view of nature, I do think there is a feminine way of being in relationship to nature. This way is . . . characterized by humility rather than arrogance, by appreciation rather than acquisitiveness. It's available to both men and women, but it hasn't been exercised much in the history of Western civilization."[39] Thus Merchant, Williams, and Anderson exemplify the dilemma of many women writing of nature: they may find significance in the archetypal identification of woman, nature, earth; or they may resist that identification as falsifying the natural world's otherness and as perpetuating stereotypes of women as a "lower order."

As these writers and critics uncomfortably realize, nature-as-female and female-as-nature are social constructs that permit male domination "of women and nature as resources."[40] In the aesthetic traditions of landscaping and painting, natural scenery is often a Galatea re-created in ideal form, to be scrutinized by the male gaze. In the New World, the literature of colonization plays out gender stereotypes. Annette Kolodny in *The Lay of the Land* illustrates how often in the American tradition the land has been viewed as the ideal female body, the virgin that will yield its fruits through exploration and exploitation.[41] Merchant, again, contrasts Native American myths of corn mothers transforming "a desert into a garden" to the Enlightenment collusion of a "male" science and economics: "The extraction of resources from 'nature's bosom,' the penetration of 'her womb' by science and technology, and the 'seduction' of female land by male agriculture reinforced capitalist expansion."[42]

Of course, landscape is not always feminized; instead, it can be opposed to a version of stifling, domesticated, "feminine" civilization—the rugged wilderness versus the hothouse flower. Whether or not the land is woman, it is the setting upon which the human actor establishes that he is all male. Traditionally men, even bookish, arty, sickly, alcoholic, and dapper men (Henry David Thoreau, Stephen Crane, Jack London, Ernest Hemingway, Winslow Homer, Frederic Remington, and Ansel Adams are but a few who come to mind) test their virility in the outdoors. Even when contemplative and pacifistic like Thoreau, they employ active, aggressive verbs as they "live deliberately, to front only the essential facts of life" and "drive life into a corner."[43] When trouble arises, as in Stephen Crane's "Open Boat," they can be stoic in the company of men, so that under duress they recognize "the subtle brotherhood" and know this as "the best experience" of their lives.[44] Alone in the outdoors near Hemingway's "Big Two-Hearted River," a man does not need Virginia Woolf's' Mrs. Ramsay to serve boeuf en daube and orchestrate an aura: epiphany comes with canned beans, ketchup, and spaghetti. All this is quite familiar, but the persistent, if not consistent, gendering of nature and landscape continues to have tremendous impact on representations and real use.

While much postmodern thought has centered on exposing ideologies and power structures, recent work in "green thinking," the contemporary activity of earth artists and nature writers, and the insights of cultural geographers further challenge conceptions of the nonhuman world. They have had to rehabilitate concepts of a text's or artifact's referentiality to "actual" places and rethink terms that remain dear to them, such as "wilderness." Pursuing the guiding insight that reality is socially constructed, scholars have gone far in debunking conceptions of "nature," often arguing convincingly that the "natural" is a social masking created by a cultural hegemony that maintains the status quo. Thus liberation comes with the revelation that it is not inherently "natural" to be heterosexual, "natural" to be submissively female," "natural" to own land and improve it. The problem then becomes how to determine a viable language of landscape when any language is a mediation. Some ecocritics find postmodern theory in its dismissiveness of earth's physicality biased and shortsighted. As Paul Shepard summarizes, "the original configurations to which abstractions refer no longer have currency. Reality has dissolved in a connoisseurship of structural principle." He enlivens his point about the presumptuousness

of "the postmodern rejection of Enlightenment positivism" by adding, "There is an armchair or coffeehouse smell about it. Lyotard and his fellows have about them no glimmer of earth, of leaves or soil."[45]

However, fissures within postmodernisms have given ecocritics ways to begin recovering theoretical, if not exactly absolute, connection to the earth. Intensely self-conscious of the anthropomorphism pervading the history of nature, they probe the tenets impeding imaginative and activist responses to the nonhuman environment. From a strictly linguistic approach "nature" and "landscape" can only be discussed in reference to textuality with its semantics and semiotics, but from the sociopolitical and postcolonial viewpoints, place merits attention as a literal and figurative site for readings of otherness and conquest. To better grasp the relationships between mental constructs and the history that "really" happens because of those constructs, critics are developing the negative capability to accept that "human beings are a fragment of nature, and nature is a figment of humanity."[46]

It is not surprising, then, that ecocriticism finds solipsism and arrogance in postmodernism's inability to account for Nature-Out-There. John Hay, in "The Nature Writer's Dilemma," is put off by a philosopher who boldly claims, "Everyone knows man is a part of nature," when that philosopher offered neither explanation nor sign that he had any awareness of "the lower life forms." Hay retorts, "There is reason to suspect the assumptions of the human brain when it becomes too elevated from the earth that nurtured it."[47] The charge is rephrased by philosophers sympathetic to environmental concerns. In *Landscape, Natural Beauty and the Arts*, Kemal and Gaskell assert that "[philosophers] seem unable to make a space for natural beauty at all."[48] Contradictions within "the tradition of Western Marxism known as Critical Theory" are dismantled by Steven Vogel in *Against Nature*: "The main strands, I am afraid, have been failures; the tradition finds itself in dilemmas that vitiate its most common claims about nature's status." Critical Theory, in its attention to the active social subject, can exclude "nature" by neglecting to confront how the physical world is "*literally* socially constructed as a 'built' environment," in other words, by failing to recognize "nature's own sociality." Or it can label nature as "other," "as an ontological realm beyond the human and finally not graspable by it"; this labeling, however leaves no philosophic avenue for rationally and responsibly exploring interaction of the human and nonhuman.[49]

When "nature" and "landscape" can no longer be read as a manifes-

tation of divinity, when foundational, positivistic, and postmodern systems cannot account for responses to it or assert the power of superior comprehension over it, then it stymies theoretical approaches. Scholars concerned with environmental aesthetics and ethics find themselves caught between debunked idealism and positivism, the irresolution of excessive relativity, and tentative hopes for pragmatism. This tangle results in "despair and futility" at "the attempts of environmental philosophers to justify the value of natural entities," a justification many believe necessary for supportable policies. Eric Katz concludes that "no one, it seems, can give a plausible account and justification of the intrinsic value of nonhuman natural entities," and that there is "*no common ground* for the start of rational negotiation" as human experience of nature widely differs.[50] An impasse exists in according theoretical significance to a world that humanity did not completely spawn, to something beyond its philosophy.

Cultural studies often accord high value to region as bound to issues of ethnicity, gender, and power; again "nature" and "landscape" are manipulated by ideologies to disguise political agendas. The tactics of cultural studies, however, can be turned on themselves to create a place for excluded nature. For example, Jhan Hochman contends current criticism has not sufficiently recognized that characterizations used to subordinate "people of color, women, the lower classes and youth" are "also used to anathematize nature": if nature is "construed as unconscious, as raw material, any entity associated with nature stands to lose rights to ethical culture." Nature has also been the "other" to the dominant human subject. Hochman thus advocates the "greening" of theory:

> These connections make nature's inclusion in cultural studies—in the form of green cultural studies—reciprocally important: since people and nature are made abject in similar terms and by similar practices, attention to the way nature is treated . . . provides insights into overarching theories and strategies of power which impact on persons; conversely, green cultural studies has the potential to rediscover a nature that is still essentialized as mere matter—a continuum from dead to not fully "present"—and reconfigure it as essential, a fifth world that matters.[51]

In redressing the subjugation of various peoples, scholars tend to render "nature," allied with the instinctive, the bodily, the dark, the unconscious, as contrary to expression and selfhood. The natural world, according to Hochman, must be "reconfigured" so that respect for it is seen as integral as respect for other people.

Others take similar stands in seeking a critical basis that allows for rocks and hills and trees. William Cronon insists: "Asserting that 'nature' is an idea is far from saying that it is only an idea, that there is no concrete referent out there in the world for the many human meanings we attach to the word 'nature.' "[52] Like many ecocritics, Cronon seeks ways to integrate social construction with a commonsense awareness of place. While he deconstructs such sacred creeds as "In Wildness is the preservation of the World," he also avoids ending with emphasis on the prison house of language: "In reminding us of the world we did not make, wilderness can teach profound feelings of humility and respect. . . . Feelings like these argue for the importance of self-awareness and self-criticism as we exercise our own ability to transform the world around us, helping us set responsible limits to human mastery—which without such limits too easily becomes human hubris."[53]

To remain humble, environmental critics not only pit themselves against theoretical landscape but against Nature (however constructed) itself. If it is naive to label the outdoors as the primary source, it should at least be included as *a* source. Donald Scheese, in thinking about Thoreau's sublime style in "Ktaadn," not only read "voluminous criticism," but also climbed the mountains that Thoreau hiked. Scheese found it disconcerting, to say the least, that scholars did not consider Thoreau's previous climbing experiences, which were altered or ignored in the final version of "Ktaadn": "I think [this neglect] is symbolic of the academy's, particularly the English profession's, general neglect and ignorance of the nonhuman environment, and its emphasis on nature as a social construct rather than physical reality."[54] It seems ironic that Scheese's hiking led him to realize the extent to which Thoreau's wilderness is a literary construction adapted to a specific audience; however, his point remains that knowledge of the "nonhuman environment" should be synthesized with theoretical approaches.

It can still be tempting to privilege the mountain of granite as a source and, by implication, as a final truth. Nor is this the only temptation for those seeking humility through a clarified connection to the physical planet. There is perhaps a counterarrogance, paralleling the defensiveness of such down-home figures as Frost and Wyeth against avant-garde dandies. Ecocritics may pride themselves for hands-on knowledge, for being "real," even if they avoid that word: they canoe, they hike, they botanize. Critical tensions could be parodied as the flannel-shirt he-men and windblown earth women versus logocentric sedentaries.

However critics may find their pride and humility in the outdoors, their theoretical and ethical goals converge with the aspirations of contemporary nature artists and writers. All want a moral vocabulary that encompasses the overlapping realms of existence. Barry Lopez, like other nature writers, parallels "our relations with wild animals" to "our regard for the other sex, other cultures, other universes," and includes the natural world in the quest to rise "above prejudice to a position of respectful regard toward everything that is different from ourselves."[55] Besides this ethical outlook, writers, artists, and critics want to revive physical sensation in the outdoors. Sensation is not unmediated truth; but if postmodernism can address sexual longings, it can also address the physical and emotional desire to be outside.

Yi-Fu Tuan, whose practice of cultural geography has greatly influenced ecological thinking, coined "topophilia" to describe a pleasurable response to the outside world. Though analytical, measured, and extraordinarily learned in his scholarship, Tuan finds his own experiences in Death Valley pushed him beyond reason into poetry: "When I woke up, the sun had risen high enough to throw its rays on the range of mountains across the valley and presented me with a scene, totally alien to my experience at that time, of such unearthly beauty that I felt transported to a supernal realm and yet, paradoxically, also at home, as though I had returned after a long absence."[56] In the second millennium, we dare not call this either divine revelation or instinct. Yet we do not want to deny it, to let criticism (once again?) kill the pleasure. Even as realization of language's mediation prevents the return of scholars, writers, and artists to a naive oneness with pure nature, even as they can deconstruct Thoreau's faith in "pure Nature" and his awe at her "Powers," they do not want to foreclose on the possibilities of his epiphanies:

Talk of mysteries!—Think of our life in nature,—daily to be shown matter, to come in contact with it,—rocks, trees, wind on our cheeks! the *solid* earth! the *actual* world! the *common sense! Contact! Contact! Who* are we? *where* are we?[57]

The quest for morality and sustaining "contact" in renewed paradigms for nature is threatened not only by critical blinders but also by environmental degradation. Ecocriticism segues from a revaluation of nature writing and landscape iconology to a jeremiad. Lawrence Buell, as he asserts the "most ambitious goal" of his study *The Environmental Imagination,*

urgently connects nature writing to the future quality of life in a developed society:

If, as environmental philosophers contend, western metaphysics and ethics need revision before we can address today's environmental problems, then environmental crisis involves a crisis of the imagination the amelioration of which depends on finding better ways of imaging nature and humanity's relation to it. To that end, it behooves us to look searchingly at the most searching works of environmental reflection that the world's biggest technological power has produced; for in these we may expect to find disclosed . . . both the pathologies that bedevil society at large and some of the alternative paths it might consider.[58]

Buell clearly places his inquiry in the midst of concerns that preoccupy the end of the twentieth century and beginning of the twenty-first. Like Hochman, Cronon, and Merchant, he accepts contemporary theory as he tries to create a place within it for nature. Nonetheless, Buell's debt to nineteenth-century transcendentalists unabashedly exists. Humanity finds itself in a crisis, largely of its own making as it fails to act upon its best self, and "the pathologies that bedevil society at large" originate in a failed imagination's flawed responses to nature. The concept of nature as key to individual and civic health is ancient, classic, romantic, and now postmodern.

The concept of a "crisis," of an ensuing dire state, and a persistent "pollution" (if not an outright apocalypse of escalating cancers, pestilence, earthquakes, and hurricanes) recur throughout contemporary writing of besieged Nature. The dramatic flaw—hubris, sloth, gluttony, avarice, collusion, ignorance—is sought again and again. Nature writer Jack Turner states, "that our ecological crisis is a crisis of character, not a political or social crisis. This said, we falter, for it remains unclear what, exactly, is the crisis of modern character; and since character is partly determined by culture, what, exactly, is the crisis of modern culture."[59] These crises of the imagination and character involve profound uncertainties about "progress" (a concept once so positive), knowledge, and action. Whether one agrees with the direction of Turner's earnest questioning (which recasts environmental issues as a "holocaust"), the crisis rhetoric he and others engage resurrects ancient—and apparently still powerful—myths of nature. The sins of a chosen people bring down a plague of locusts; Titania and Oberon quarrel and contagion falls upon the land; the Fisher

King's impotence blights his cursed domain; benighted agriculture erupts in a dust bowl; scientific arrogance poisons birds; a government studies how to dissolve other countries and in the process radiates its own citizens; natural diseases are enhanced to become biological weapons. Current talk of crisis echoes traditional ideas of harmony and disharmony between the human and the natural worlds. We may have renamed the true and false gods over the millennia; but our original sin as being needy and fallible, unable to see beyond our mortal moment, has always spawned destruction. Throughout the detached critical jargon, myths endure: something is wrong at the heart (and mind) of humanity, and without redemption an apocalypse threatens.

Not surprisingly, then, artistic representations of nature, along with critical and political discussions of those representations and the environment, often envision a recurring recovery narrative, a return to an ideal. As Rebecca Solnit remarks, "Eden, Paradise, Arcadia, and the Promised Land lurk behind most political and environmental arguments, since they are arguments about how to make the world better."[60] Carolyn Merchant outlines this powerful recovery plot in its many guises:

Indeed, the story of Western civilization since the seventeenth century and its advent on the American continent can be conceptualized as a grand narrative of fall and recovery. The concept of recovery . . . entailed restoration of health, reclamation of land, and recovery of property. The recovery plot is the long slow process of returning humans to the Garden of Eden through labor in the earth. Three subplots organize its argument: Christian religion, modern science, and capitalism. The Genesis story of the Fall provides the beginning; science and capitalism, the middle; recovery of the garden, the end.[61]

The fear intensifying since the nuclear age is that development and technology have failed to re-create Eden but instead have set off uncontrollable decline. This plot is inevitably linear, ending in an ecological collapse. In a long history of often devastating alteration of the planet (supposedly for human good), rational mastery and scientific "objectivity" have not been kinder than anthropomorphic myths.[62] A dominant "sense of terminus" or "endism"—new coinings for a postmodern apocalypse—is manifested in titles such as Merchant's *The Death of Nature*, Paul and Anne Erlich's *Extinction*, and Bill McKibben's *The End of Nature*.[63] A narrative of progress achieved through enlightened human intervention is replaced with a narrative of decline caused by the arrogant, fallacious assumptions of

mechanistic science and capitalism. Merchant names this "a grand narrative of environmental endism," but suggests an alternative: "The postmodern critique of modernism is both a deconstruction of Enlightenment thought and a set of reconstructive proposals for the creation of a better world."[64] Like many ecocritics she wishes to rewrite the plot and self-consciously proposes "a postpatriarchal, socially just ecotopia for the post-millennial world of the twenty-first century." Despite her self-awareness, Merchant leaves behind the careful phraseology in describing this ecotopia: "each earthly place would be a home, or community, to be shared with other living and nonliving things."[65]

Landscape—Windemere, Innisfree, Walden Pond, Yosemite, The Land of Little Rain, Tinker Creek, Everest—may still be where one hopes to go in body and soul to transcend the dissatisfactions of contemporary life. Yet this desire remains on an endangered list. Although apocalyptic fears surface throughout history, we worry that "environmental endism" is more than a recurring mindset but an account of genuine changes to the globe. However, even that balance of loss and hope is not peculiar to our time; it is ancient and recalls for me the song of Frost's oven bird: "The question that he frames in all but words / Is what to make of a diminished thing."[66]

That song returns us to the specific figures of this study. They offer entry into the shifting valuation of countryside, and all of them witnessed loss and sought recovery in the landscape around them. Modern and postmodern thought highlight alienation and rootlessness, exile and displacement, colonization and diaspora; I don't wish merely to claim that such attitudes can be found in the stay-at-home figures of this study (that has already been shown). Rather, I wish to see how the places they found themselves in were both safe havens and the source of disturbing searches. Alienation and attachment begin at home. These artists confronted affinity and otherness in their scenes. Their works concern how humanity does and does not belong to the land, questioning a simple identification or an equally simple divide between self and world. Neither "home" nor "belonging" is quite what it seems.

The seascapes of Homer, the farmland and woods of Frost, the roadside views of Hopper, the derelict fields of Wyeth, the Nova Scotia homeyness and the Brazilian exotica of Bishop were created at a time when the myths were forgotten, submerged, or presumed out of fashion—unless something lies fallow and hidden.

Rustic Sophistication: Lionizing Winslow Homer, Defending Robert Frost

They have become icons of Yankee hardiness and character, bound to a New England at once harsh and welcoming. The prophecies from Ralph Waldo Emerson and Walt Whitman, from Thomas Eakins and Robert Henri, that a Poet or Painter should create an American art, free from the taint of Europe and nourished by the new soil of democracy, appear fulfilled in the works of Homer and Frost. The two contributed to the formation of American cultural myths, particularly to the virtue of working the sea and land. Though not without professional connections, they avoided identification with intellectual groups and seemed more at ease with the common folk they depicted. Photographs reflect their authenticity, their idiosyncrasy, and their archetypal presence. In an image taken in 1908 at Prout's Neck, Maine, Winslow Homer is dressed as if sitting for a patriarchal portrait (fig. 5). His cravat and collar are neat, and there seems to be a boutonniere in his dark coat (he had a reputation for being dapper in a Brooks Brothers wardrobe), while his sportier hat is suspended in air. His expression appears formidable, and baldness lends severity to his profile. The dark eyes are pocketed by bags, and deep creases frame a moustache that would obscure any rare attempts at smiling. Homer looks as if he had borne the trials of a financial institution or political office with reserved endurance, except for the hat's suggestion of whimsy and the backdrop. The bush and sky behind him remind us this is the windblown outdoors and imply that long contemplation of the sea has marked this face.

Robert Frost's large face is lined and his expression bemused, as in late pictures he poses dressed in baggy clothes before a pasture or barn.

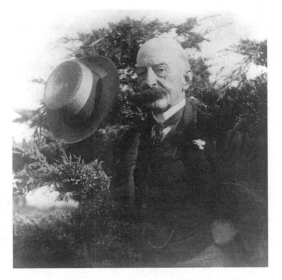

Fig. 5. Peter Juley, *Last Official Portrait of Homer,* 1908.
Bowdoin College Museum of Art, Brunswick, Maine, Gift of the
Homer Family.

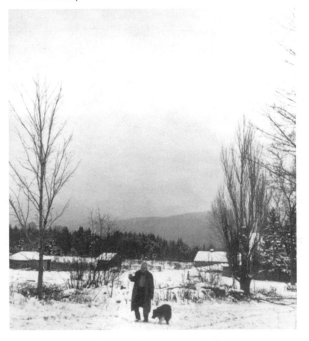

Fig. 6. Frost with his dog Gillie, Vermont, 1961. Dartmouth College
Library.

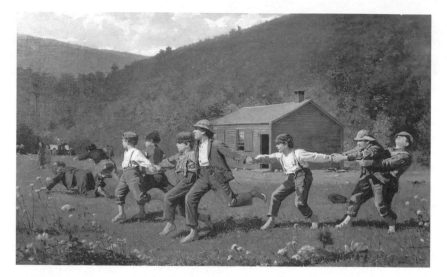

Fig. 7. Winslow Homer, *Snap the Whip*, 1872. Oil on canvas, 22 × 36". Collection of the Butler Institute of American Art, Youngstown, Ohio.

As his popularity increased, Frost was photographed in suits at a variety of venues: auditoriums, offices, airports. He rubbed shoulders with world leaders, meeting Kennedy and Khrushchev, though his off-hand comments about Americans being "too liberal to fight" proved undiplomatic.[1] But the standard image is of the poet dressed for "real" work, against the background of a hill farm (fig. 6). In such depictions, the nativism of Homer and Frost looks undeniably rooted in the locale that has formed their features and work. For both popular and scholarly audiences, they are a variation on the American Exception, the representative original, the one-of-a-kind individual who nonetheless characterizes a type. Painter and poet are idolized icons of realism and regionalism. Homer's images, like those of Ansel Adams and Georgia O'Keeffe, are reproduced frequently in the readily consumed form of museum notecards and memorabilia. A variety of trade books (for adults and children) and scholarly monographs use a Homer image for a striking cover.[2] I have seen reproductions of the tropical fishing scenes available for a time in Target stores and also hanging in a mediocre chain hotel in Charles City, Louisiana. Even people who do not recognize the name may have seen a Homer image like *The Fog Warning*, with a lone fisherman in a dory who looks over his shoulder toward the darkening horizon, or the scene of country childhood in *Snap the Whip* (fig.7).

And Frost's name has for generations come as close as any poet's to being a household word. From the publications of his first books, *A Boy's Will* in 1913 and *North of Boston* in 1914, Frost's rusticity has been played up for audiences. Like very different talents—Walt Whitman, Mark Twain, F. Scott Fitzgerald, Carl Sandburg, Dorothy Parker, Ernest Hemingway—Frost became a Personality. His residences at college campuses and frequent public appearances, driven by his various financial and creative anxieties, established him as America's White-haired Poet.

Homer and Frost (such down-to-earth names!) have gone beyond their individual works to exemplify nativism, but at some cost. The painter who began his career with illustrations of the Civil War and the poet who ended his with an appearance at President Kennedy's inauguration have been commemorated for their outdoorsy, "imperfectly tamed," and "manly" art. Also to various degrees, they have been denigrated for provinciality, roughness, insignificant subject matter, or lack of beauty. Homer is then the hermit-realist retreating from revolutionary art, and Frost the cracker-barrel sage who pshaws modernism.

Exemplifying nativism, Homer and Frost have been honored and marred by ambivalence toward that tradition. If the problem resides within the Yankee image, it is there complexly, involving a host of attitudes about Americanness, modernity, popularity, elite aesthetics, rusticity, and the validity of the "book of nature." The canonization and criticism of the two, from the beginning of the century to the present, have been conditioned by definitions of the masculine American artist, especially in relation to an emerging highbrow and avant-garde culture. The paradoxes that co-exist with a need to proclaim artist and poet "American" (and even "modern" to suit the prevailing aesthetic) stem from the difficulty of reconciling these phases of aesthetic development and critical thinking: the defense of the American at the beginning of the century with the ascendance of the high modern aesthetic; the residual ideal of an American identity being bound to pastoral experience with the increasingly prevalent tropes of alienation in the city; and the nativist emphasis on the artist's or poet's popular image as an ordinary man with the dominance of potentially elitist formalist trends in criticism from roughly the 1930s through the 1960s.

So Homer and Frost were national, virile, real, representative, original—and out of date. They employed conventions that, like God, should be dead. Yet they were of the modernist age as well, and the myths they embodied do not quite explain the shifts, subtleties, and tensions in their works. What follows is an attempt to see through the critical biases, or,

to adapt lines from a Frost poem, to discern "beyond the picture, / Through the picture" a "something" that might better reveal these two icons.[3]

> *Winslow Homer is an important figure in the annals of America art, and the period in which he lived and wrought, the last half of the nineteenth century, produced no American painter so thoroughly national in style and character. He was the most original painter of that time, and at the same time the most representative.*
>
> —William Howe Downes, 1911[4]

Winslow Homer became known as the distinctive American by working in a medium developed within European traditions. American landscape painting is hardly an indigenous form despite references to local topography: the preeminent painter of the Hudson River School, Thomas Cole, modeled himself after Claude Lorraine and translated seventeenth-century classical idealism into American light. With Native American craft relegated to curious artifact, eighteenth- and nineteenth-century American art was (as surely as the nation's literary forms) an import. As Samuel Isham explained in 1910: "The fundamental and mastering fact about American painting is that it is in no way native to America, but is European painting imported, or rather transplanted, to America, and there cultivated and developed; and even that not independently, but with constant reference to the older countries, first one nation or school having a preponderating influence, then another."[5] Homer, as he employed inherited conventions of representation, appeared to break away, replacing schools of art with a different "preponderating influence": his native landscape.

How apt then to proclaim Homer the quintessential Yankee, a "true" American Artist, as did William Howe Downes in his biography published a year after the painter's death. Downes was not alone in celebrating Homer as an American Adam. Commentaries from about 1880 to 1900 distinguish Homer from European (particularly French) and European-trained American artists, who generally enjoyed greater critical approval and success with collectors at the time. Homer's compositions were "eccentric and original": "The freshness, the crudity, and the solid worth of American civilization are well typified in the thoroughly native art of Mr. Homer."[6] What comes to mind with these statements are the mythic paintings of Grand Bank fisherman, Thoreau-like images of a bearded Adirondack guide, and forceful studies of wave and rock done at Prout's Neck,

Maine. Although his independence and "direct" realism may have asserted themselves from the beginnings of his career, it took a while for Homer to create (and be known as) a native archetype—an archetype of the American as the ordinary man whose quiet heroism reveals itself in an elemental landscape.

The outdoors is represented in nearly all of Homer's work. (The telling exceptions are generally women in the domesticated space of their traditional roles: schoolteachers with exasperating students; young ladies discreetly seated against a nondescript interior; or ex-slaves against the blurry darkness of their cabin.)[7] One means of charting Homer's career is to follow shifts in his depictions of place. In works of the 1870s, setting is integrated with social activity. Women hold their finery against the ocean breeze in *Long Branch, New Jersey* of 1869; children "snap the whip," fish in secluded streams, steal birds' eggs or watermelon, pick berries, go boating, and nap in the noon sun. Homer later moved away from social tableaux to an outdoors ever more "realistic" in its roughness and more mythical in its conception. The natural world moves from backdrop to dominant subject, from generic context to proving ground—a "sea change" that assured Homer's status as the great artist of nature's "truth." During his career and in the aftermath of his continuing reputation, the reception of Homer and his painting have been entangled with conflicting cultural attitudes defending the masculine, fearing the feminine, seeking the native, envying the European, discounting the rustic, admiring the mythic, and honoring the pose of art's mysterious isolation.

For the earlier part of his life and career, Homer was exposed to much that was typically "American" for the time. He was born in 1836 to a middle-class Boston family, who moved in a few years to relatively rural Cambridge. Homer's mother, Henrietta Maria Benson Homer, was an amateur watercolorist; it is speculated that in the pious tradition of the day she named this son after Hubbard Winslow, a Boston clergyman. His father, Charles Savage Homer, a hardware merchant, left his business in 1849 and traveled to California during the gold rush, but returned in 1851 without striking it rich. A brother, Charles S. Homer, Jr., graduated from Harvard's Lawrence Scientific School to become a chemist and well-to-do businessman specializing in paints and varnishes during the era of elaborate decoration and heavy furniture. Homer, who apparently had no great love for school, had since childhood displayed artistic talent. Instead

of being packed off to Europe to take the high road to Art, he was apprenticed to the lithography shop of John H. Bufford. Homer designed covers for popular sheet music for his first assignments, and later provided topical illustrations. He went on to document the Civil War and then worked as a New York–based illustrator documenting the American way of life for *Harper's Weekly* and other popular magazines. The latter part of his bachelor life is the source of the popular mythology of Homer as reclusive Yankee: it was spent near his brothers' families in Prout's Neck, Maine, with trips to northern hunting and fishing clubs and to tropical resorts. Despite or because of the mainstream content of his earlier illustrations, Homer presented himself (and this presentation was later seized upon by his admirers) as pursuing more and more independence in living as he pleased and painting what he wished. To Joseph Foxcroft Cole, a painter Homer met at Bufford's (where reproduction of popular images was the name of the game), Homer claimed, "If a man wants to be an artist, he should never look at pictures."[8] When Homer was offered a permanent position with *Harper's,* he declined in echoes of Civil War rhetoric: "I had had a taste of freedom. The slavery at Bufford's was too fresh in my recollection to let me care to bind myself again. From the time I took my nose off that lithographic stone, I have had no master, and never shall have any."[9]

Even given the acclaim for Homer as *the* nativist painter, undercurrents that something is missing run through accounts of the artist. A retrospective exhibition that opened at the National Gallery in Washington, D.C., in 1995, demonstrated Homer's fame—and its volume (more than two hundred paintings plus nearly as many items of miscellanea) provided what William James might dub a "cash-value" definition of prolific. Nicolai Cikovsky, Jr., Homer scholar and curator of American art at the National Gallery, gave the opening lecture on 14 October, in which he stressed that the exhibition arose out of the "absolutely unshakable conviction" of Homer's greatness as a painter. He further remarked that the painter's reputation was "unbroken," that he "never had to be rediscovered," that the monumentality of his painterly conception remains. Cikovsky, perhaps acknowledging that Homer did not set out to make every piece a grand statement, also said that "we take him seriously—but not too seriously."[10] This is certainly canonization. But in such remarks and in other critics' writings a defensive tone creeps in, as if one doth protest too much Homer's greatness.

As will also be seen with Robert Frost (and dramatically with the too

popular Andrew Wyeth), those who lionize Homer do so with some insistence and write as if against the grain. I suspect he remains a very national painter in reputation and value: while a few paintings belong to European collections, he is clearly not in the universal Great Master category (a category that has not vanished despite revisionist apprehensions) of say, Michelangelo, Rembrandt, or Vermeer (whose few enigmatic canvases draw large crowds). If Homer's American reputation has been "unbroken," it has at times been shaken. During his lifetime, his variation on realism with rural subjects did not accord with beaux arts aspirations of the Gilded Age or with the Neoclassic idealism of early twentieth-century critics aiming to shore up cultural unity and high-mindedness with Art. Although Homer died in 1910, before the infamous Armory Show of 1913 introduced such foreign artistic experimentation as Marcel Duchamp's *Nude Descending a Staircase No. 2* (dubbed by a contemporary reviewer "an explosion in a shingle factory"), the assumption remains that then and now turn-of-the-century writers and artists are judged by their "modernism"—equated with the urbane, avant-garde, and bohemian. In the 1930s, a director at the Museum of Modern Art wrote that Homer seems "of considerably more importance than . . . in 1920" and that the "objective world of Homer and Eakins, the imaginative world of Albert Ryder need no apology in 1930."[11] This syntax implies that the "world" of American artists had needed apology in the decades of cubism and abstraction. The intellectual excitement and sensationalism of early modernist "isms"— impressionism, cubism, fauvism, dadaism, surrealism—obscured appreciation of realist art and stoked partisan aesthetics. The archetype of the artist was a social and aesthetic anarchist, or an unstable visionary, as Robert Crunden suggests of Rimbaud: "The first true modernist artist was Arthur Rimbaud, the young French poet who flared briefly during the first half of the 1870s. His religious yearnings, his hallucinations, his breaking down the artificial barriers of both language and form, his development of an implicitly irrational and illogical mode of discourse, all helped to make him the legendary prototype of the modernist artist." Crunden then explains that modernism "had a different feel" in America, "a predominantly Protestant and puritan country, hostile to the arts" and that "Modernists did *not* share those presumably universal Protestant values."[12]

Certainly this modernism, which has become the "center" for artists of the twentieth century, leaves out reserved Homer (and Frost) as worlds away from such madmen/priests as Rimbaud or Van Gogh. Appreciation of realism receded further in the 1950s and 1960s when abstract expres-

sionism made New York the center for innovation.[13] The influential and daunting Clement Greenberg, who promoted such movements, had little sympathy for realism. In 1961, Greenberg dismissed Homer as "small, dapper, reserved, and dull . . . he had no inner life apart from that which he put into his pictures." The critic grudgingly respects Homer's water-colors, but also speculates that naturalism in American art had no future at the end of the nineteenth century, so "both Eakins and Homer more or less withdrew into themselves. Not that they stopped developing, but the further growth of their art took place within more provincial limits."[14]

If Homer did not fit an upper-class image of the refined painter (John LaFarge, Thomas Dewing, John Singer Sargent) or the bohemian one of artist as tortured soul, he occasionally embodied another image that suited his era: the artist as businessman. One side of European-influenced mod-ernism is the image of the radical artist. Another side of modernism is the increased commodification of art and artist: accompanying the develop-ment of American business sense and acquisitiveness, was the heightening of the market through publicity, consumerism, and professionalism—an "encroaching corporate culture."[15] Homer, in his look and his letters, seemed to partake of this capitalistic mode. In the company of other artists, he could be mistaken as a businessman, and was overheard to remark, "[Painting is] just like any other business. . . . It is spend one dollar and get back 33⅓ cents."[16] One scholar finds in his letters "a keen if cynical awareness of the importance of supply and demand in the art market," while another still believes him more "Yankee trader" than "mod-ern corporate boardsman."[17] To straddle the issue, Homer was attuned enough to the economic climate and his own success that he kept in mind the market for his paintings; he also remained distanced in physical and psychological ways. Talking of sales goes against the starving artist ste-reotype, but using practical terms to cover up artistic aspirations and frustrated emotions—as when Homer complained, "the fact that good pic-ture High Cliff is unsold has been most discouraging to me"—also suits an image of the repressed New Englander.[18] Practicality, passion, and re-pression merge to form a visionary crank and an aesthetic curmudgeon: the Thoreau who in "Economy" rails against his neighbor's failings; the Homer who complains that his "best" work does not sell.

That image of the Yankee—frugal with money, words, and emotional display—connects with the problem of Homer's nativism and provinciality. The painter's admirers strain against the "limits" of criticism's own pro-vinciality in selective definitions of artistic achievement as social refinement

or as avant-garde modernism. Bruce Roberston begins his 1990 study, *Reckoning with Winslow Homer,* "Winslow Homer is as much an artist to reckon with today as he was one hundred years ago," and explains that Homer still "evades our understanding."[19] Cikovsky again, in a biography of the artist, insists that "Homer's undertaking has not been seen, as I think it should be, in the larger context of modernism," and offers a reading of his artistic endeavor and temperament that parallels those of "Edouard Manet, Edgar Degas, and Claude Monet, and the American expatriate James Whistler": "his obliqueness of vision and meaning, his problematic relation to artistic tradition, his deliberate originality of style, his detachment, his irony, his anxiety . . . , his impersonality and social aloofness, are properties of Homer's modernism."[20] The assumed conventionality and transparency of realism have impeded subtle readings of his too familiar paintings. However, that modernist cliques misread and discounted realist artists is not the sole issue. When a revolution is brewing, as it seemed to be at the beginning of the twentieth century, it is difficult not to take sides. From the 1870s through the 1970s, critics and defenders of nativism have, out of national insecurities about taste, forced artists into aesthetic camps. In using Homer to define American, they find fault where a postmodern perspective might find revealing ambiguity, and discover merit in what now might be considered pernicious.

The reception of Homer (and in ensuing decades that of Frost) was caught in a contradictory trend: a desire for American culture that nonetheless disparaged the local and looked with resentment, envy, and longing to European culture. Attitudes toward "high" and "serious" art versus "low" and "popular" entertainments, formed at the end of the nineteenth century and beginning of the twentieth, still influence judgments of taste and status.[21] Antipathy toward provincial realism reaches an apex in the wonderfully condescending criticism of Henry James on Homer paintings in an 1875 exhibition. James found the early rustic pieces such as *Milking Time* "honest," "vivid," "manly," but "damnably ugly" (fig. 8). While blasting the painter's subjects, James concedes the Pyrrhic victory of individuality to Homer:

The most striking pictures in the [National Academy] exhibition were perhaps those of Mr. Homer. . . . Before Mr. Homer's little barefoot urchins and little girls in calico sunbonnets, straddling beneath a cloudless sky upon the national rail fence, the whole effort of the critic is instinctively to contract himself, to double himself up, as it were, so that he can creep into the problem and examine it

Fig. 8. Winslow Homer, *Milking Time,* 1875, oil on canvas, 61 × 97.2 (24 × 38¼). Gift of the Friends of Art and other donors, Delaware Art Museum.

humbly and patiently, if a trifle wonderingly. . . . He is a genuine painter; that is, to see, and to reproduce what he sees, is his only care; to think, to imagine, to select, to refine, to compose, to drop into any of the intellectual tricks with which other people try to eke out the dull pictorial vision—all this Mr. Homer triumphantly avoids. He not only has no imagination, but he contrives to elevate this rather blighting negative into a blooming and honorable positive. He is almost barbarously simple, and to our eye, he is horribly ugly; but nevertheless there is something one likes about him. What is it? For ourselves, it is not his subjects. We frankly confess that we detest his subjects . . . his freckled, straight-haired Yankee urchins, his flat-breasted maidens, suggestive of a dish of rural doughnuts and pie. . . . He has resolutely treated them as if they *were* pictorial, as if they were every inch as good as Capri or Tangiers; and, to award his audacity, he has incontestably succeeded. . . . The want of grace, of intellectual detail, of reflected light, could hardly go further; but the picture is the author's best contribution, and a very honest, and vivid, and manly piece of work. Our only complaint with it is that it is damnably ugly![22]

It is hardly surprising that James would not be enamored of rustic bluntness. He falls on the other side of the "national fence," the side preferring all things European. The year of the Homer review also saw the serial publication of James's *Roderick Hudson.* In that novel, a patron of the arts

wishes to prove himself a "good citizen" through the purchase of "certain valuable specimens of the Dutch and Italian schools . . . and then present his treasures out of hand to an American city."[23] The novel's imaging of art and artist bear no resemblance to either Homer's rough-and-ready scenes of childhood or his reticent, businesslike manner. The main character, Roderick Hudson, is an impassioned artist who impresses the patron with a painting of a "figure [that] might have been some beautiful youth of ancient fable—Hylas or Narcissus." Hudson himself appears as "some beautiful, supple, restless, bright-eyed animal."[24] Whatever irony may be present in James's characterizations, they are nonetheless a backward look, over the Atlantic, toward classic and romantic traditions.

Another later American critic espousing Neoclassic values was Kenyon Cox; the figures of Cox's own art—carefully modeled nude women—probably strike current viewers as cloying kitsch. Despite the admiration for Homer expressed in a 1914 essay, Cox failed to predict the grounds of Homer's popularity in passing judgment on *Snap the Whip*: "It is painted in a dry and rather timid manner, with hot, brown undertones, and possesses very little beauty; but it makes such an impression of truth that it is quite unforgettable. . . . It is difficult to imagine anyone's loving the picture very much, but no one can help respecting it."[25] Cox could acknowledge the success of *Snap the Whip* at exhibitions, but could not "imagine" how others could love it. Yet this frequently reproduced painting has achieved an iconic status similar to that of a literary work initially disparaged for roughness and now admired for it: Mark Twain's *Adventures of Huckleberry Finn*. In these representations of an "all-American" rough-and-tumble boyhood, the crude and ordinary trump the genteel.

Boyhood may be ever popular; the same cannot be said of Homer's other rustic subjects. His farm scenes, which earned James's picturesque detestation, again disappointed Kenyon Cox:

If any one could have painted [American farm life], and have got out of it something equivalent to what Millet got out of the life of the French peasant, Homer was surely the man. The fact that he failed, as others have done, and has left nothing important in that field, is one more proof that the American farmer is unpaintable. His costume and his tools are too sophisticated to suggest the real simplicity and dignity of his occupation.[26]

The problem is not only Homer's execution but the subject itself. The "unpaintable" American farmer is both too crude and too advanced for

art: he lacks, to borrow James's terms, "grace" or "intellectual detail," and his improved agricultural technique fails to express the "dignity" of sowing and reaping. Of course, the French peasant seems more "real" to Cox because more idealized by art. The image of the rustic is generally at its most appealing when removed in time and place, when the pastoral is fictive.

It seems Homer's 1870s farm paintings were too honest in their directness. They offered neither a refinement that could compete with European accomplishment nor a pastoral serenity that could evoke Claude and Virgil. Although Homer did a series of shepherdesses, those figures seem awkward and out-of-place rather than picturesque. His farm scenes may be peaceful or anecdotal, but they did not strike viewers as either cozy or inspiring. Homer's observation was too blunt, as American art scholar Sarah Burns notes:

His vision of the New England agricultural scene—unpicturesque, unembellished with humor, sentiment, or moral message—seemed mystifyingly blank. His sunburned youths and strapping maidens, naturalized versions of Millet's monumental peasants, were the inhabitants of a new American pastoral too close to the truth to exert a strong appeal. Undistorted reflections of the American farmer's real status and the true tenor of rural existence, Homer's paintings . . . confronted an audience that still demanded rustic fancy dress.[27]

Farming has often been admired in American history, but depictions of the ideal were preferred to images of plainness or drudgery. Most non-farmers preferred to imagine a simple yet noble calling rather than a struggling economic endeavor of crops, cattle, and underpaid help. (As the nation became less rural, attitudes toward farming became more negative, as will be traced in discussion of Frost's poetry.) The end of the nineteenth century witnessed a growing desire to return to nature but not, apparently, to milking. In the 1880s and 1890s, many assumed that "man was not made for urban life," yet they did not expect their children to become farmers (who seemed unenlightened about the natural splendor about them). Instead, contact with the outdoors was a necessary physical and spiritual respite before return to the fray of high finance.[28]

The circumstances of Homer's life and career after 1880 satisfied this desire in providing images of understated resilience and dignity outdoors. His art underwent an almost literal seachange when he took a second trip to Europe. (The first in 1867 did not seem to have a significant impact.)

For 1881 and 1882, he stayed at English fishing villages in the Cullercoats and Tynemouth region—a site that attracted such Barbizon-influenced artists as Jules Breton, who sought elemental types at elemental labors.[29] During the course of Homer's stay, his scenes became more somber as he painted fisherwives anxiously awaiting their husbands' return from sea or women working on mundane tasks made dignified by their patient pose, as in *Mending the Nets* (fig.9). The monumentality of these figures suggests the influence, unacknowledged on Homer's part, of classical sculpture and idealized peasants; the representation of English mists conveys a poetry that does not obscure danger and drudgery.[30] The reasoning behind Homer's stay at Cullercoats and its effect remain mysterious. One biographer proposes that Homer's sustained attention to the struggles of fishing families jarred him from a comfortable middle-class outlook as he observed their dependence upon the life-threatening sea (though Homer had already strayed from bourgeois delights in painting ex-slaves). Others speculate he was undergoing some sort of breakdown or midlife crisis.[31] In any event, his painting now broached mythic themes through a slightly idealized realism.

In serendipity, Homer's brothers and father had now moved to Prout's Neck, Maine, where Homer could live near them in some comfort and observe "regular" fishing folk and the drama of the ocean. At Prout's Neck, more resort than wilderness, the artist was not exactly the hermit of legend; neither did he live extravagantly, take on students, attend salons, or join other groups of artists. His paintings of rock and shore evoke isolation, feeding the image of solitary meditation. As one critic explains, Homer "left behind the society and bustle of the city, the world of art, and the hope of love, for a life stripped down to its essentials. He became as monolithic as his subjects."[32] In depicting New England fisherman, he provided the sort of images that merged outdoor labor with heroic myths of survival and endurance. Ambiguous and remote expressions on the figures, rather than conveying rural dullness, seemed stoic reserve against the backdrop of threatening waves. Homer did not verbalize these changes: if he did speak, it was with his customary ironic reticence, as when he advised a young painter, "Do figures, my boy. Leave rocks to your old age. They're easy."[33] Others provided grander formulations: Mrs. Van Rensselaer, a contemporary of Homer who had previously found his work crude, admired these paintings for "strong sincerity," "originality of mood," "vigor of conception," and a "stern poetry of feeling . . . [Homer] had never reached before."[34] Homer was now, in Kenyon Cox's words,

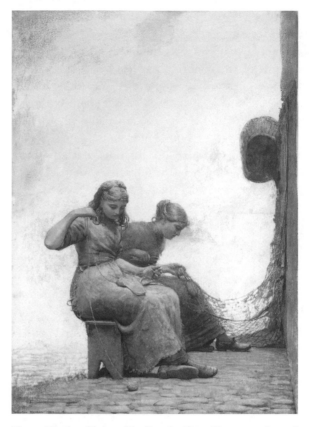

Fig. 9. Winslow Homer, *Mending the Nets*, 1882, watercolor and gouache over graphite, 69.5 × 48.9 (27⅜ × 19¼). Bequest of Julia B. Engel, Photograph © 2002 Board of Trustees, National Gallery of Art, Washington.

"a great figure painter and interpreter of humanity." Where Homer's farms had apparently failed to intrigue a range of viewers, his sea could be perceived as evoking romance, heroism, mystery; for the rising business classes it could be the stage for Darwinian struggles for survival and dominance. In painting the fishing fleets of the Grand Banks, the guides of the Adirondack Mountains, or forceful waves and obscure mists a stone's throw from his studio, Homer offered nearby wildness for urbanized viewers, a desired antidote to the "unnatural" confinement of city life.

This wildness for some viewers enacted the masculinity of the American character. Virility—perceived as a healthy outdoor manliness more abstinent than not—redeemed the nation's strength from the vitiating femininity

of genteel beaux art culture (and later, as will be seen with Frost, from the effeminacy of expatriates). An 1898 Harper's editorial complained, "It is a period of refinement and decoration, in which the *how* is more important than the *what*. . . . It is a day of little masters, of the art that seeks effect but feels nothing, of small and exquisite things . . . of the dainty representation of our own small ideas."[35] The dainty, refined, and decorated are associated with the feminine parlor and preening dandies—Whistler drawing out his moustache. Homer's route to greatness lay not only in his increasing independence but in what also seemed an increasingly rugged art. From croquet-playing ladies, whose bell-skirts dominate the social landscape, Homer turned to rough-dressed hunters and no-nonsense fisherman. From the 1880s on, the adulation of Homer equated masculinity with an ideal individual, free from social machinations and possessing an unmediated bond with the earth. Instead of the infinitely subtle insights that burden the consciousness and arrest the actions of a sensitive "hero" in a Henry James tale (or, later, of an antihero in a T. S. Eliot poem), there is the wordless certainty of a man who knows what he is and where he is; that is, outdoors.

Commentators found such certainty in Homer's images. William A. Coffin wrote in 1899 for *Century Magazine* of the hailing sailor of *All's Well:* "The poetry of a humble but free and manly calling is put before us with simplicity, directness, and a sincerity that is as convincing in its expression as it is beautiful in pictorial aspect. There is a breath of great art in this picture, and if the artist had produced nothing but 'The Lookout' and 'Eight Bells,' these two great works would be sufficient to give him a place in the first rank of the world's painters of the poetry of toil on sea and land."[36] For Coffin, manly poetry also pervaded the landscapes without a human figure; he said of the seascape *Maine Coast,* "It is virile and broad." In such readings the paintings confirm an ideal that man, in close contact with nature, will inevitably be ennobled by the challenge of daily tasks and lead a life of simplicity, simplicity, simplicity.

This message is repeated in 1905 by Homer Saint-Gaudens, son of the sculptor Augustus Saint-Gaudens: "Winslow Homer personifies the clearest type of fresh American virility. . . . Sober, earnest, and full of movement, his pictures go direct to the point with originality of vision, and with that strange power of the big man who does the thing that subconsciously we have often felt though never expressed. . . . He never becomes pretty, but ever remains direct."[37] The emphasis on, and pride in, Homer's masculinity persisted through the first half of the twentieth century, par-

ticularly with critics who rejected the assault of modernism and "arose like knights of old to protect the sacred honor of art."[38] For many, that masculinity outweighed possible formal limitations: as Frank Jewett Mather, Jr., remarked in 1927, Homer's "art is mostly bones," "but it is direct, virile and masterly. . . . It is a male art and often a raw art."[39] Even in midcentury, Lloyd Goodrich, another champion of artistic nativism, would find in Homer's "male art" maturation and progress: "The strain of feminine refinement in some earlier pictures was replaced by masculine power."[40]

This gendered power also seemed a trait of a prominent contemporary collector of Homer, businessman Thomas B. Clarke. In eschewing the much favored European art for works by Americans such as George Inness and Homer, Clarke exemplifies the intersection of virility, business savvy, and support of nativism He could be a leader in aesthetics and in the market—a Renaissance man with an eye on the bottom line, as Barbara Weinberg describes him: "The impressive scale of Clarke's collecting activities in American art is consistent with the robust and enthusiastic manner in which he approached many other cultural, social, civic, and political activities discussed below. It is also in accord with his almost obsessive acquisitiveness in other areas."[41] "Robust," "enthusiastic," "obsessive" Clarke sounds like a captain of industry, the new American man. After fostering a taste for American art, he eventually reaped a profit from the sale of his collection. Just as it is difficult to determine the balance of profit motivation and aesthetic pursuit with Homer, it is a debate whether Clarke was an ardent devotee, a shrewd speculator in art, or both.

Women as well bought Homer's varied art, and not everything in his work appeared inevitably masculine. It seems now that many of Homer's late watercolors could be labeled "pretty," even "feminine," if we fell into a stereotypical gendering of depictions of flora and fauna.[42] His tumultuous waves and formidable rocks can be read as opposing sexual forces, as the feminine ground for masculine survival, or as the alien and inhuman. One could also argue that Homer's conception and technique are complex matters that render an illusion of "raw" directness. The countervailing criticism of the 1880s through the 1930s did not, however, make these points. Rather, it marked a divide between crude nativism and beaux art sophistication, between manly roughness and womanly gentility, between low and high taste.

Part of Homer's image that did satisfy conflicting preconceptions about artists was his isolation. As the American artworld became more intercon-

nected and professional at the end of the nineteenth century, awareness of those circumstances was set off by the atavistic faith that the "true artist . . . was the unincorporated individual, who produced himself."[43] Known as a recluse, Homer could be the individual, the nonconformist, and the meditative artist—to stand well with a variety of audiences. Elusive, mysterious solitude is enhanced in *The Artist's Studio in an Afternoon Fog* of 1894, which Homer gave to the architect who helped convert a carriage house near the family dwelling to a live-in studio (fig. 10). This eerie landscape, with the vague shapes hardly recognizable except for the studio's balcony and its setting on the coastline, is one of the few paintings that approach a self-portrait in its depiction of the artist's situation.[44] The perspective places the viewer out on the rocks, nearly in the water—difficult to re-create at Prout's Neck unless one is a seagull. The shapes on the horizon merge in tonality with the land, so that the atmosphere metamorphoses the human into the natural.[45] If this painting is self-projection, it enhances the image of the artist not as bohemian or businessman, but as unknowable force of nature.

Perhaps the sea resolved several levels of difficulties, whether acknowledged or not, for Homer. It offered an escape from an increasingly commercial society and nearby family tensions: Homer wrote above a sketch of his studio, "Where the women cease from troubling & the wicked are at rest—Prout's Neck."[46] It provided a subject that could be rendered as mythic narrative, delightful watercolors, or profound oils: paintings that could find different markets to support the artist. It may have been a form of constant change and timelessness, providing a technical challenge and a sexual and metaphysical other. As a painter of the sea, Homer exemplified nativism in a dedication to the American scene and national virility, and their assumed source in nature's power. When he dropped narrative and human figures from the scene, the blank subject of the sea allowed for ambiguity in mood and nearly abstract form. For all his normality as a man who followed sales, corresponded with galleries, bought tailored suits, and remained attached to family, the sea gave Homer (or, rather, allowed him to create) an identity and place apart.

A Boy's Will was published in 1913 during Frost's two-year stay in England, when the poet was already a long way from the youthful daring of the title: he was thirty-eight years old, married, father of four children, with a history of teaching and farming behind him. *North of Boston* with

Fig. 10. Winslow Homer, *The Artist's Studio in An Afternoon Fog*, 1894, oil on canvas, 61 × 76.8 (24 × 30¼). Memorial Art Gallery of the University of Rochester, R. T. Miller Fund

its dramatic monologues in hill-country dialect followed in 1914. Although the early promoters of these books included the literary elite of London, especially Ezra Pound, Frost did not become associated in the public's eye with such a group but was cast in the role of an ironical country farmer. This was not seen as a sophisticated modern "persona" of the sort Pound would create, or a Yeatsian mask. Rather, the image of the Authentic Yankee (which Frost fostered) became the source of the popularity that sustained his career as it thwarted academic recognition of his poetic sophistication.

Frost was not, like Robert Burns, born to the plow: his country ways seemed both inevitable and a fluke. He was born in 1874 in San Francisco to Isabelle Moodie and Will Frost. His parents had eastern roots, but the energetic and volatile Will had been drawn to the West; as his son later said, "The excitement of the place appealed to my father. . . . He was part of it. There was gold dust in his eyes, you might say."[47] The marriage between the religious Belle and drinking Will became strained during the

childhood of Frost and his younger sister Jeanie. Will was not the success he had hoped to be in journalism or politics; then his health began to fail, and he died of tuberculosis in 1885. Belle took the children back to her husband's family in Lawrence, Massachusetts. Finding his grandparents less than welcoming, Frost did not immediately feel at home: "At first I disliked the Yankees. They were cold. They seemed narrow to me. I could not get used to them."[48] As he attended local schools, moved about New England, took over his mother's rougher classes to ensure discipline, attended and left Dartmouth and Harvard, dramatically pursued and then married his elusive high school sweetheart, Elinor White, witnessed the death of their firstborn son, settled for a time on a farm in Derry, New Hampshire, Frost became an insider and outsider—a New Englander with "a mood apart."

Like Homer, Frost was confined by charges of provincialism, by narrow definitions of manliness and Americanness, and by a critical climate still insecure about the native achievement it desired. Unlike Homer, Frost, whose publications belong to the twentieth century, was judged more harshly by the dictates of high modernism. His "barding around" the country and media appearances made his personality more problematic. He played too well a type; and then the authenticity of that type gave way under Lawrance Thompson's biographical portrait of Frost as a monster to his family and a bitter rival to other poets. His well-known character became a liability obscuring the poetry. Years after Lionel Trilling and Randall Jarrell asserted that Frost was more than a popular country bumpkin and revealed the poet as a challenging modern master, a defensiveness remains among those who claim the poet's significance. Reacting to the assumption that Frost does not "fit" progressive twentieth-century trends, critics play devil's advocate as they insist that old-fashioned Frost can and should be read as "modern" or "postmodern," or, for those who discount such labels, that Frost should be considered as worthy and intriguing as T. S. Eliot or Wallace Stevens. For several decades those scholars who value Frost have argued that his work is misunderstood and that he is not sufficiently acknowledged as "one of the great American poets of this century."[49] As Seamus Heaney bluntly explains, "Among major poets of the English language in this century, Robert Frost is the one who takes the most punishment."[50]

If that punishment seems most severe in Thompson's massive biography (volumes appeared in 1966, 1970, 1976), exclusive focus on Frost's personality obscures critical assumptions underlying vindictive and defen-

sive responses to the poet.[51] Neither revisions of his character nor so-
phisticated readings of his best work (and there are many) have sufficed
to secure his worth. The poet's antiquated pastoral conventions and his
association with New England, which enhanced his "Yankee" authenticity
but tarnished him with the image of its quaint decline, make it easy to
think Frost outdated; this dismissal, however, glosses over the persistence
of the pastoral mode in the twentieth century and more subtle ways in
which the region's faded gentility created a ripe moment for Frost. Also,
while Frost's desire to be both a profound and a popular poet led to
unevenness in his writing and to self-contradictory literary poses, not all
fault lies with him: reactions to his popularity reveal scholarly ambivalence
about the ideal of a democratic writer capable of reaching many.

In readers' minds there are several Frosts. Often the most readily de-
fined and closest to caricature is the genial, chatty American institution—to
some, refreshingly middlebrow and "antimodern." This image, which still
has a strong hold, is summed up by Joseph Brodsky in a 1994 *New Yorker*
article: "[Frost] is generally regarded as the poet of the countryside, of
rural settings—as a folksy, crusty, wisecracking old gentleman farmer, gen-
erally of positive disposition. In short, as American as apple pie."[52] Derek
Walcott, in his review of the 1995 Library of America edition of the poet's
works, also evokes that image: "Frost: the icon of Yankee values, the smell
of wood smoke, . . . the reality of farmhouse dung."[53] However, the
"other" Frost suits the modern canon.[54] In that infamous moment of
reputation-making, Lionel Trilling, during a tribute on the poet's eighty-
fifth birthday, brought Frost into the modernist camp by declaring him a
"terrifying poet" who would disturb one's sleep.[55] Never mind for the
moment that some of Frost's poems might be soothing; he had been
declared sufficiently disturbed and disturbing to be considered with the
"high" moderns.

Despite Trilling's 1959 unveiling of the dark Frost, the suspicion re-
mains that there is not a broad awareness of the poet's complexities.
Complaints about the lack of respect for Frost echo through decades of
scholarship. In his 1975 study, *Robert Frost: Modern Poetics and the Land-
scapes of Self,* Frank Lentricchia attacks "a widespread and casual as-
sumption among the *cognoscenti* of literary theory that Frost cannot bear
sustained theoretical contemplation" and urges "that the difficulty in
Frost's poetics is not absence of depth and modernist sophistication, but
too much subtlety." Almost twenty years later in *Modernist Quartet,* Len-
tricchia continues to defend Frost and lament his status: "Frost wanted

to be a poet for all kinds, but mainly he failed. He is the least respected of the moderns." Robert Kern notes that "there is still a stumbling block . . . in granting to Frost the full status of a modern writer." John Hollander, in the foreword to the 1990 reprint of Richard Poirier's *Robert Frost: The Work of Knowing,* talks of "the rescue of one of our greatest poets from his own clouds of misdirection" and of how "Frost's peculiar greatness as a poet had confused a whole critical generation." Poirier in his 1992 book, *Poetry and Pragmatism,* defends American writers, including Frost, against the "loud mouth of contemporary criticism"—the loud mouth voicing the dominance of European or expatriate intellectual movements over native ones. William Pritchard, in a preface to the 1993 edition of his critical biography, *Frost: A Literary Life Reconsidered,* regrets that the reviews of the 1984 edition neglected what Pritchard "cared most about: the fact that, along with T. S. Eliot and Wallace Stevens, Frost was one of the great American poets of this century."[56] Where is Frost's (or his audience's) "failure," where is the "stumbling block" to understanding and accepting the poet's achievement?

Much of the answer lies in conflicted and partisan cultural attitudes. As was the case with Homer, literary nationalism buttresses many early portrayals that emphasize Frost as both ordinary and American. In the 1929 tribute, *Robert Frost: Original "Ordinary Man"* (later reprinted as *Swinger of Birches*), Sidney Cox quotes his friend Frost as claiming, "I guess I must be just an ordinary man," and then Cox, presumably paraphrasing a professor, declares him "the best poet America has ever had."[57] What Cox treasures in Frost is a variation on American Exceptionalism, the paradox that an American artist can be "ordinary" in his roots and experience and—because of that very ordinariness—extraordinary in his achievement. (Frost played with his own sense of distinctiveness in the phrase "the exception I like to think I am in everything.") Louis Untermeyer, well known as Frost's confidant and an influential anthologist and critic, sought in the 1920s a democratic poetics that he believed Frost exemplified: "Poetry has swung back to actuality, to heartiness and lustihood. Latterly the most aristocratic of the arts, appreciated and fostered only by little salons and erudite groups, poetry has suddenly torn away from its self-imposed strictures and is expressing itself once more in terms of democracy."[58]

This nebulous ideal of a lusty, democratic art is repeated by those who defended nativist art. Frost was not aspiring to be dominantly elitist: as Mark Richardson explains, he believed that "the role of the artist . . .

should remain as much conciliatory as oppositional; and that the artist should work to *establish* fellowship with the larger patterns of culture rather than work . . . to escape the consequences of that fellowship."[59] To return for a moment to Winslow Homer, Royal Cortissoz praised him in 1925 with a polemical patriotism; like Untermeyer with Frost, the art critic sought a national ideal: "[Homer's] art was born in him; it grew as he grew; it was nurtured from his youth on the racy elements of the American character. . . . In being true to his nation Homer was true to himself."[60] Cortissoz feared that artistic movements like cubism would not act as "a unifying cultural ideal especially important in the diffuse, materialistic American democracy" and that the "new modernism seemed divisive, threatening to separate artist from public."[61] But these attitudes toward American aesthetics were not universal in the era of jazz and the lost generation. Certainly, the cultural relation of artists to audience was variable and uncertain during the decades of the modern experiment. Against that trend, Cortissoz and Untermeyer in different spheres advocated figures who might move beyond "art for art's sake" to provide social unity. Untermeyer's anthology featuring Frost, *Modern American Poetry*, was directed toward a general rather than elite readership not only for the sales potential but for ideological motives.[62] It suited the social agendas of Cortissoz and Untermeyer to view Homer and Frost as ordinary rather than elite, as representative of an art based on local "actuality" and therefore worthiest of the title "American."

And the "American" Frost was also applauded for "virility." My concern here lies not with defining what is or is not "masculine" about Frost, but with the poet's own and his admirers' insistence on virility as an essential trait in American culture; that label both promoted him and inhibited awareness of the range of his creativity and perception.[63] In a parallel to Homer criticism, Sidney Cox pairs Frost's roughness with manliness: "There was something earthy and imperfectly tamed about him"; "The axis of his character is unspoiled manliness and humanity."[64] Frost, who began his poetic career with a butterfly, praises one of his son's poems as "no sissy poem such as I get from poetic boys generally. It is written with a man's vigor and goes down in to a man's depth." Like his supporters, Frost seems defensive of verse's manhood and eager to create a "muscular poetics" that defines him as all male.[65]

Masculinity in American literary and visual arts during the modernist transition was linked with nativism and self-reliance. Early commentators on Frost emphasize his "native" character, self-educated independence,

and, in the words of imagist Amy Lowell, his "direct contact with the world—the little world of hill and upland, of farmhouse and country town."[66] However, masculine roughness and "truthfulness" to a little world require apology. Cox again, reading the poetry as a transcript of observed life, points to a vulnerability: Frost's readers "wondered if the language was not *too* much like speech to be great poetry, and if the people and their stories were not too exactly drawn from everyday New England."[67] His poetry's "masculine" attention to stern facts seemed not so much imaginative art as blunt realism and narrow regionalism. Lowell as she praises Frost adds, "but his canvas is exceedingly small."[68]

Amy Lowell's account of Frost's world is mildly genteel compared with Ezra Pound's infamous review of *North of Boston*. Although Pound was keener on Frost than Henry James was on Homer, condescension dominates: "A book about a dull, stupid, hemmed-in sort of life, by a person who has lived it, will never be as interesting as the work of some author who has comprehended many men's manners and seen many grades and conditions of existence."[69] Frost is to Pound as Homer is to Whistler. While Pound's oft-quoted words fed the legend of Frost's and Pound's souring relationship, they also evoke stereotypes that have damaged respect for the native tradition. (Granted, as seen with Homer, the native tradition often downplayed or denied its intellectuality and craft in favor of its commonality with a region and its "naturalness.") Very alive in contemporary views of Frost is the rustic, with his homey and "artless" platitudes, versus the sophisticate with his slick worldly knowledge and urbane expression. Frost as neurotic often commands more respect than Frost as farmer.

The prevalence of masculine, nativist, and rustic stereotypes clarifies the context that has hampered Frost. In the world of "modernist poetic history," he appears "anomalous" in his character and his punishment.[70] Seen in the broader context of American aesthetics, nativism, and pastoralism, he has company. Like Homer, and as will be seen like later realist artists, Frost found that being American with "an old-fashioned way to be new" did not fit well with being High and Modern. While Frost had consorted with literary elites during his England stay, that influence was downplayed as he became the Poet of New England.[71] The formalism of the visual and literary arts that developed out of early modernism devalued "provincial" Frost. From the 1950s on, however, some formalist approaches "redeemed" Frost by reading him as subtle and "modern"—the necessary term for approbation—and they downplayed his Americanness

in favor of illuminating his debt to the classical and English traditions. (A similar process happened with Winslow Homer in the mid-twentieth century, when his nativism was downplayed in favor of similarities with Continental artistic trends, including the plein-air movement associated with impressionism.) The shift in Frost criticism caused other problems for the poet's reputation, as it led to ignoring or apologizing for Frost's "sugary" poems (Jarrell's word for "Birches"), and to continued condescension toward his regionalism, his pastoral conventions, and his general popularity.

So if Frost, and Homer as well, have been considered Yankees, the true Americans, what has that meant? A mixed message in terms of cultural values and achievement. Commentary through the 1930s on the paintings and poetry confirms stereotypes that powerfully existed then and that persisted through later decades to haunt American studies. The American is self-educated, crude, hardworking, and honest. Rarely is he linked with the beautiful, a subjective sensibility, or the refined in art—areas dangerously "feminine." His authenticity runs counter to trained mastery but arises from local character and scenery. However, there is doubt, even among defenders, about the American's ability to compete technically, aesthetically, and philosophically with Europeans (or worse, with effete expatriate intellectuals). To be "American" is to be representative, manly, popular, and inferior.

Of course, not all is negative. In the largely urbanized twentieth century, it has been simple to see Frost and his New England as a quaint Currier and Ives print. Because of the charm of his poetic and performing voice, Frost was far more successful than Homer with images of the small farm. Shifting attitudes toward the American farm at the beginning of the century allow the poet to be at once a comforting throwback and a modern skeptic. In other words, his poetry can be both popular (bordering on the nostalgic) and modern (with unnerving perceptions) when the farm no longer serves as the dominant emblem of virtuous livelihood and goodness for American culture. The urbanization of culture included the centrality of the city in literature and art. This change, while it fostered the demeaning views of rusticity, may have left Frost "free" to debunk and reimagine nineteenth-century images of pastoral life.

Also important, Frost renews the Northeast as the site of significant literature-making: his own. Again, there is a parallel with Winslow Homer. Sarah Burns argues that Homer displaced the feminine and "stunted" New England of local-color writers, such as Sarah Orne Jewett and Mary E. Wilkins Freeman, with paintings of hunters, fisherman, and ocean force.

Instead of offering faded gentility and understated persistence, Homer depicts "Maine—and the wild North in general—as the pure source of renewal for masculine strength and energy."[72] Frost, too, offers a refreshed spirit in a familiar landscape. His first books, even as they include many grim scenes, often rejuvenate the landscapes with a "boy's will." Gender biases again enter into issues of literary achievement and popularity: the youthful virility, hope, and pleasure in many Frost poems supplanted E. A. Robinson's impotent and claustrophobic despair, or the depression of Wharton's *Ethan Frome*. Despite the frequent emphasis on Frost's "virility," Karen Kilcup finds that his poetry has much in common with women "local colorists" of the preceding generations; she notes his empathy for poor rural women and the early books' experimentation with female speakers. However, Frost was generally applauded for rising above the supposed restricted regionalism of women writers to attain "universality." Readers and critics through the 1970s often overlooked the poetry's complex sexuality and multiple perspectives in praise of the lyric voice—the voice of the "universal" masculine tradition.[73] In such views active masculinity again dominates New England aesthetics: the youth looks forward to the past, as he becomes the "authentic" man, the poet-farmer imagined by Thoreau.

Approaching Frost's rural settings from a related angle, we can view his status as a subset of the status of the pastoral, both as a genre and a mode reflective of a culture's attitudes toward life in nature. Defenders of the pastoral argue that in the modern era it has often been misunderstood or trivialized; it is not merely a fanciful literary escape or a nostalgic return to an agrarian past. Paul Alpers writes against the diminishing and sentimentalizing notion "that pastoral is motivated by naive idyllicism" and in discussing Frost stresses that "pastoral is founded on irony": this may be an overstatement for all pastoral poems, but it does imply that human limitation underlies the desire for and failure of the idyllic world.[74] Leo Marx, in his 1986 essay "Pastoralism in America," writes against the belief that "pastoralism," as cultural ideology, has become "anachronistic." He speculates that pastoral's mediation between "the realm of the collective, the organized, and the worldly on the one hand, and the personal, the spontaneous, and the inward on the other" and its attention to nature may still speak to individual and cultural needs in an era of "heightened ecological awareness."[75] Although Frost seemed old-fashioned for his time, both his traditional technique and interest in rural life as a "real" and a poetic experience have had amazing persistence. Nature will not quite go

away. It may seem overwhelmed by urbanization and suburbanization and, in the critical arena, by linguistically based theories and the crucial issues of multiculturalism; however, as ecocriticism demonstrates, concern with the imaging of the natural world continues, with important literary and political implications.

As for Frost's versification, what once seemed too literal descriptions of a parochial region becomes for later critics radical approaches to subject matter and execution. His diction and rhythm are not simply echoes of a regional accent, but experiments with a fresh American idiom. As critical criteria evolve, the "simplicities" do not seem examples of direct transcription or appeals to a broad audience (whose appreciation is profitable but dangerous), but rather linguistic playfulness and elusive forms of troping. Further, Frost's craft has found admirers in a triumvirate of Nobel Prize–winning poets, none of them Yankee: Seamus Heaney, Derek Walcott, and Joseph Brodsky, whose essays (quoted above) have been collected in *Homage to Robert Frost*.[76] That "homage" from poets who have themselves renewed traditional verse practices emphasizes Frost's intense craft and profound complexity as man and poet.

Not quite offset by a clique of poet-admirers, the broad audience remains a problem. The "good," "sophisticated," "deep" Frost is not easily reconciled with the "bad," "popular, "light" Frost." While Frost defined himself in opposition to elite trends, he fumed over the "split between popular and highbrow responses to him" and felt that he displeased what he labeled the "Pound-Eliot-Richards gang."[77] Apparently not sharing Untermeyer's optimistic hopes for a democratic aesthetic, John Hollander believes that Frost must be rescued from his popularity: "The "boughten friendship" of middle America celebrated him as a defender against the assaults of modernism. . . . It is by now well known how heavy a payment this exacted, for Frost had doomed himself to a constituency to whom he had to read . . . down."[78]

Frost was and sometimes still is the example of "The Poet," the Longfellow of his day, in popular publications from comic strips to travel magazines; thus the perception remains among Frost admirers that this fame diminishes him in the academic world.[79] Like many Frost scholars, I often lean toward this view, assuming the better Frost is the challenging skeptic who reaches a small audience. But then I remember that I first learned of Frost from my mother, a farmer's daughter and later a farmer's wife, who had received from her landlady a volume of Frost's poetry when she completed a horticulture program. It may be wise to question the sweeping

characterizations of Frost's audience. Frost said of himself, "I am imperfectly academic and no amount of association with the academic will make me perfect."[80] Does the word "academic" here connote a narrow view of poetry's possibilities? Did "middle America" always prefer the sugarcoated, never seeing or admiring the disturbing Frost? If "nonprofessional" audiences in the twentieth century only liked reassuring "nice" pieces, how do we account for the popularity of Ernest Hemingway or Edward Hopper? Frost gained a following through campus talks and readings—were the eager attendants of such events at Michigan or Amherst or Dartmouth misguidedly exhibiting a lowbrow response? Is accessibility (some poems are republished for children) a sign of selling out? Is the cult of difficulty and pain the only avenue by which a modern writer creates a memorable poem?

These questions expose assumptions about audience and achievement that cannot be fully answered here, but they may provoke further consideration of the not so simple relation between "serious" literature and the common reader. Most of Frost's rehabilitation for scholarly readers, from Jarrell and Trilling to Brodsky, lies in the recovery of his skepticism and gloom; these traits, not innately modern, are compatible with the anxiety and doubt pervading twentieth-century literature. Certain poems, such as "The Subverted Flower" or "The Most of It," became accepted in the modern canon because they featured neuroses, fear, and isolation. Of course "pleasant" poems ("The Pasture," "Mowing," "After Apple-Picking," "The Silken Tent," to name a scant few) have been much praised and explicated, though generally with attention to Frost's pastoralism or his craft and without concern for how they fit a "modern" paradigm. What continues to disturb is Frost's own sense of his artistic and financial possibilities with an audience and his subsequent self-promotion. Apparently, early in his poetic career, Frost experienced a conflict between his desire to write an "inconsequential poem" and to write profitable prose, "having resolved it was the thing for a man with a family to do."[81] His perception of a potential audience supports the view that poetry does not generally succeed with a mass market. With aesthetic and economic needs in conflict, Frost evolved a poetry that would work on different levels for different audiences, a compromise that, as compromises often do, involved some loss of artistic integrity and was not consistently successful. Frost scholars always have a list of poems (not always identical) that prove him great, and they have another (again, not always identical) that represent for them his pact with the devil, popularity.[82]

Since the publication of Lawrance Thompson's biography, the spotlight has often fallen on Frost's personality: was he a charming, white-haired Dorian Gray, whose Yankee aphorisms disguised paranoia and rapacious ambition? This characterization spills over into response to the poems: was Frost more concerned with retaliating against enemies than, to borrow Eliot's high-minded phrase, making the modern world possible for art? The reading of the poet's character I shall largely leave to others; revised portraits have been many.[83] However, the issue is not just how bad or difficult Frost was as a person; after all, niceness is rarely required of modern writers. Something else disturbed critics. Perhaps they felt their authority undermined and sensed a cheat—that the poet whose public performance reeked of unfashionable authenticity should be conniving. Worse, the engaging persona gained the poet a large following: he was an antiliterary, hypocritical trickster with Pulitzers in his pocket. This suspicion of being duped, of not getting around Frost as he got around them, may form the subtext behind many criticisms of Frost's character.

The generations of readers, common and scholarly, who may have sat at Frost's feet in a small college room, who had him autograph a volume of poetry, or who at least saw him on television at Kennedy's inauguration, have passed or are passing. The new readers who sit now in classrooms have no personal memory of the "modern" poets, who seem distantly historical. How they respond to any poetry, we like to believe, depends heavily on how the instructor presents it. So how Frost survives the twenty-first century, whether he is forgotten or still punished, depends on that classroom presentation.

Because Frost did not seem to impose the metaphors or provide the paradigm shifts that ushered in the High Modern, his reputation may never be on the same grounds as Eliot's or Pound's. In a 1936 letter to Untermeyer, Frost provides an angle on the critical climate in which he sought to assert himself as different:

. . . isn't it a poetical strangeness that while the world was going full blast on the Darwinian metaphors of evolution . . . a polemical Jew in exile was working up the metaphor of the State's being like a family to displace them from mind and give us a new figure to live by? Marx had the strength not to be overawed by the metaphor in vogue. . . . We are all toadies to the fashionable metaphor of the hour. Great is he who imposes the metaphor.[84]

Frost's emphasis on "fashionable" (and possibly frivolous?) is likely a jab at the dominance of Eliot. Poetic rivalries aside for the moment, Frost,

who "had the strength not to be overawed," realized that one is judged by the "metaphor of the hour" in criticism. But even as we imagine that critical thinking has rejected obeisance to one dominant mode, formalist and avant-garde criteria are the palimpsest beneath apologies for Frost. Responses to Frost indicate that twentieth-century poetry is still generally conceived of as European-based modernism, with elitist and exclusive tendencies, rather than as a range of literary experiments, which include variations on the pastoral. Many of his supporters continue to resent a faulty comparison with Eliot: like Frost in his competitive mood, do they dream that Eliot admirers will cry "uncle"? This resentment is unnerving, because it suggests the longevity of critical habits. (This longevity may make us wonder, if well-known Frost is still insecure, what will be the continuing status of writers, often women and minorities, who have only recently gained a place in the canon?) The case of Frost raises the recurring issue of combining literary standards with open-mindedness.

Frost's poetry, to the discomfort of scholars still influenced, admittedly or not, by the elitism of modernist formalism, crosses the "high," the "middle," and the "low" to remain an example of that ever-emerging and problematic ideal, a democratic art. The tension among the various Frosts—the farmer, the popular icon, the resentful rival, the modern poet— suggests the difficulty we have securing a place for poetry in the marketplace of American culture and the difficulty we have connecting "untrained" responses to those of the "informed" self-conscious critics. Perhaps the Frost most admired (again there is a parallel with Homer) is the one whose work at times resolves the conflict between market and aesthetic values, between the strong, often anti-intellectual American bent toward practicality and common sense, and the powerful impulse that pulls toward the mysterious play of shape, language, and meaning.

The undeniable presence of Winslow Homer and Robert Frost in American arts and letters attests to the continuing imaginative influence of their vernacular figures and scenes. In a nation bent on modernization, both offer a retreat—a New England version of the Forest of Arden—yet through that escape a possible return to something "authentic." The appeal of their work reflects their creative gifts and the persistent cultural desire to measure Man (and less often woman) against Nature. As the following chapters explore, that measure is often neither predictable nor reassuring.

Power and Impotence: The Black Figure and the Prey in Winslow Homer's Outdoors

The land may vary more;
But wherever the truth may be—
The water comes ashore,
And the people look at the sea.

They cannot look out far.
They cannot look in deep.
But when was that ever a bar
To any watch they keep?

—ROBERT FROST, "Neither Out Far Nor In Deep"[1]

 It is Winslow Homer's genius that throughout his prolific career and the aftermath of his continuing reputation, he can seem representative in depicting common scenes of Americana and yet impress viewers as completely original and independent. Despite his withdrawal (surrounded by family) to Prout's Neck, Maine, in the latter half of his life, he had been in touch with much that was popular during the nineteenth century: magazine illustrations of postbellum society at play, paintings of women in elaborate finery, country views of straw-hatted children and youthful farm workers, somber depictions of "Negro life" in the South, studies of brilliantly colored fish and deer against autumn hues, dramatic oils of sublime seascapes with patient women and strong men, and luminous watercolors of Caribbean sensuality. To many he was the man who painted just what he saw. While Homer's scenes avoid crude stereotyping and sentimental excess, distinct predilections and undercurrents of portentous

themes saturate the apparently objective report. The figures in the paint-
ings are defined, and their destinies determined, by where they are. In
their familiarity, Homer's places and people illustrate how the symbiosis
of landscape and inhabitant informs national myths of independent forti-
tude. But it should not be taken for granted that faith in native character
and rapport with the natural world are unshakable in the artist's work. As
the ninetheenth century evolves into the twentieth, he depicts near-heroic
men—woodland guides and Atlantic fisherman—whose ways of life are
being abandoned; other figures in his work, minorities and hunted ani-
mals, are endangered in more immediate ways. In representing Virginia
cotton-pickers or black men fishing off Florida and the Caribbean islands,
Homer's revision of sublime and pastoral traditions broaches the social
inequalities of these roles and destinies. The renderings of African Amer-
icans and also of animals strain against identification, empathy, and oth-
erness in the relationships of the figure to the scene, and of the figure to
the viewer. Homer's scenes, in their attention to distress and powerless-
ness, quietly subvert accepted attitudes so that who is rooted in the land-
scape, who is the prey and who the predator, are not so obvious as first
appears.

Homer was and continues to be most mythologized for the seascapes—
the stoicism of fishermen surviving the force of unrelenting waves against
a broken granite shore. As the closing frontier gave way to the industri-
alized Gilded Age, Homer's outdoorsmen revised dreams from the past.
His subjects and technique were less ennobling than those of earlier New
World artists: Thomas Cole, Martin Johnson Heade, Frederic Church, or
Albert Bierstadt. However, Homer's realism provided a transition from
grand interpretations of landscape as transcendent ideal, luminist tran-
quility, sublime vistas, or edenic manifest destiny, to the patch of wilder-
ness and shore as private retreat. That retreat with its steady attention to
the natural world had about it the air of Thoreau's sojourn at Walden
Pond: the self-sufficiency that arises from honest Nature returns. It also
had the air of a businessman's holiday, as Homer spent time at hunting
clubs that catered to that class, and many of his patrons were both avid
outdoorsmen and men of the financial world.[2]

Within this artistic and social milieu, Homer's contemporaries could
find in his canvases romantic traditions invigorated by Yankee hardiness.
William Howe Downes, art critic for the *Boston Transcript* and, without

much cooperation from his subject, Homer's biographer, struck this chord in 1911. He quotes the archetypal British romantic, William Wordsworth, in hailing the painter's achievement: "The poetry of rhythm is frequently felt in [Homer's] design, which is noble, plastic, and of monumental breadth. But a still more essential poetry is that of "the still, sad music of humanity" which makes itself manifest in his pictures of men in their age-long and unending struggle to bend the forces of nature to their uses."[3]

The "poetry" of Homer's art—which initially struck genteel patrons as harsh—was by no means seen as "feminine" delicacy. Downes was not alone in finding the noble and epic in the painter, though others shift the emphasis from "still, sad music" to volatile power. Another contemporary, Orson Lowell, called Homer one of America's "strongest painters" whose works "show the big, big-hearted man; they are painted, in whatever the medium, with a confident fearlessness and an almost brutal strength."[4] Lowell's words anticipate the title, as well as masculine ethos, of Ernest Hemingway's famous story of 1925, "The Big Two-Hearted River," in which a man traumatized by the past recovers mastery in the rituals of camping and fishing. It appears that identification of the "big-hearted" man with the outdoors—the source of his strength—persists past Homer's moment.

Distrusting idealized male prowess and elemental truths, recent commentators on Homer find force as well, but trace it to ideological and cultural circumstances at the end of the nineteenth century. Notwithstanding his small, dapper appearance, Homer has consistently been associated with "bigness" and "virility"; his scenes engaged businessmen by conveying the edge they wished to feel in a rapidly changing competitive marketplace.[5] Paintings of men surviving the waves, bringing down a deer, and reeling in a trophy reassured urban patrons of their essential manliness. Sarah Burns links the potency of Homer's images to the hopes and fears of his era, and also to an ongoing stereotype of the American male:

> Through the celebration of force Homer fashioned a mythic, irresistible image of an American spirit—masculine, independent, tough, and bold—just at the time when that spirit seemed to waver and fade. . . .
> . . . Ostensibly detached from worldly affairs, Homer achieved a nearly perfect mesh of artistic sensibility and creativity with the masculine, risky, all-American world of big, swash-buckling business enterprise, equally a masquerade in its way, but essential to sustaining an indispensable myth of heroic individualism. Even though the original conditions of viewing have changed, those meanings still seem to buoy and perpetuate Homer's continuing appeal.[6]

These thoughts foreshadow the recent purchase, for more than $30 million, of *Lost on the Grand Banks,* by William H. Gates—familiar to us all as Bill Gates, Microsoft chairman, the self-made man of the computer age whose control unnerves Congress (fig. 11). This purchase further enhances Homer's status, and maybe that of Gates as a man who, caring about something besides dominance of the software market, is not so willing as he once seemed to reduce all culture to pixels. The *New York Times* reported that "Homer's seascapes are considered among the most desirable of the artist's oeuvre, and few ever come on the market," and went on with phrases typically applied to Homer: " 'Lost on the Grand Banks' is not only large—nearly 32 inches tall and 50 inches wide—but considered a powerfully rendered image."[7] In monetary terms at least, Homer and nativist art are elevated, at last achieving parity with Old World traditions: "The purchase catapults American fine art into the same financial stratosphere as European paintings."

While Gates's purchase of the seascape confirms Homer as the virile painter of bigness, it introduces an irony to the paradigm that connects, however plausibly, the man of nature to the man of business. As the title indicates, *Lost on the Grand Banks* depicts two fishermen in a dire situation. They peer over their tipping boat, surrounded by fog and turbulent water, with no sign of their fleet. An 1884 account of fishermen outlines the probable and grandiloquent resolution of their struggle: "Too often are these brave fellows, notwithstanding their most desperate exertions, overwhelmed by the force of nature's elements, and borne down for ever to a billowy grave, their lonely fate witnessed only by the screaming gulls."[8] The control in this painting is exercised by the ocean. Homer's works, if they so often suggest power, must also convey the inverse in moments of peril: impotence and resignation. "Powerful" men appear so because they are surrounded by adverse circumstances, and their dominance rises against the odds that they are weak and will be overwhelmed.

Homer's rendering of power and powerlessness goes beyond waves tossing a fisherman's boat. Nature succumbs to man in depictions of the prey: geese dying on sand dunes as the flock continues to fly into the hunter's range, a wounded doe sliding into a stream, ducks caught in flight, and even a mountain denuded by foresters. While he painted financially secure white men in canoes against the beauty of the Adirondacks, Homer also portrayed the disenfranchised: black figures in the Reconstruction South and the subtropics. Traditionally, the figure in the landscape embodies a range of potential roles—monarch of the scene,

Fig. 11. Winslow Homer, *Lost on the Grand Banks,* 1885, oil on canvas, 80 × 125.4 (31½ × 49⅜). William Gates.

kindred spirit, well-bred tourist—and partakes of the destiny of the place as sacred wilderness, fertile valley, or idyllic escape. These scenes raise the question of how American myths surrounding the figure in the land-scape—be it a moment of empathy or antagonism—translate to those of marginal status. Homer, in paintings such as *The Cotton Pickers, Gulf Stream,* and *Right and Left,* stays with familiar subjects in their expected circumstances. Yet in adapting the types of the fieldworker, the fisherman, and the sportsman's trophy, the artist renders a conventional mode both safe and subversive.

When Yankee Homer painted African Americans during Reconstruction, he again chose a popular subject, albeit one entangled with racial history. Prior to the Civil War, paintings of black figures often sentimentalized the life of presumably happy, simple slaves: one of the best-known examples is Eastman Johnson's *Negro Life at the South* (1859), later renamed after Stephen Foster's song as *Old Kentucky Home* (fig. 12). Such versions of plantation life constituted a picturesque propaganda against incendiary rhetoric and images provided by abolitionists. However, like women, chil-dren, and animals, African Americans could be accepted as the fitting topic of art, but rarely as its creators. The few who aspired to artistic

Fig. 12. Eastman Johnson, *Negro Life at the South / Old Kentucky Home,* 1859, 91.4 × 114.3 (36 × 45). Collection of the New-York Historical Society, accession number S-225, negative number 27225

accomplishment, including sculptor Edmonia Lewis (circa 1843–1911), of mixed Chippewa and African American descent, and Henry Ossawa Tanner (1859–1937), had to prove themselves by starting with established— that is, European and white—subjects and conventions. For example, Lewis copied Michelangelo's Moses, and Tanner often turned to biblical themes, which, while not so common in American art, fit a revered European tradition.[9] As they became recognized both produced images honoring their heritage and thus claimed the artistic right to represent themselves. Lewis's 1867 sculpture *Forever Free* echoes in its title the Emancipation Proclamation and depicts a man and woman, manacles broken, looking upward: the heroic conventions of sculpture become translated to her own history. Tanner is now praised for his early genre paintings of African American life: the most famous, *The Banjo Lesson* of 1893, supplants minstrel-show caricatures with its intimate presentation of the absorbed faces of a man and child. Tanner intended such images to correct the painterly injustices of darky/coon caricatures. In 1894, he criticized the typical representations of African Americans: "many of the artists who

have represented Negro life have only seen the comic, the ludicrous side of it and have lacked sympathy with and affection for the warm big heart within such a rough exterior."[10] Worth noting is that Lewis and Tanner emigrated to Europe to find an atmosphere more conducive to the arts and more tolerant of their race.[11]

It may have been the white painter Homer who could readily challenge stereotypes of blacks and prove their worthiness as subject matter. It is white authority figures, according to contemporary African American scholar Ann Du Cille, who too often provide the "authenticating stamp" on black experience.[12] Although some of his early Civil War works approached caricature—*Our Jolly Cook* features a black man in an exaggerated dance before white soldiers—Homer's paintings of blacks became increasingly distinctive.[13] Thus Homer, like Thomas Eakins, has long been recognized as a sympathetic painter of African Americans: Guy McElroy emphasizes the contribution of these artists in his introduction to *Facing History: The Black Image in American Art, 1710–1940:* "The mature works of Eakins and Homer combine sensitive recording of the uniqueness of individual identity with a rigorous description of all aspects of human activity; in this sense they represent a high water mark in nineteenth century artistic expression of African-American identity, offering an alternative to the penchant for typing that, with a precious few exceptions, marked the development of American art."[14] Popular prints, political cartoons, sheet music covers, and some high art images indicate the prevalence of typing—from grinning, dancing entertainers to napping farm hands—from the 1830s well into the 1900s.

Homer's subtle push against painterly and social conventions in an original rendering of a familiar genre is evident in *The Cotton Pickers* of 1876 (pl. 1). It combines what Alain Locke, promoter of African American arts during the Harlem Renaissance, labeled the "cotton-patch" tradition with another ascendant form of painting at the time, Barbizon landscapes. Popular in Europe and America during the nineteenth century, these paintings could manifest the virtue of common people working the land. The emergence of Barbizon painting also illustrates a fallacy often accompanying pastoral forms: what may begin as a contemporary examination of specific circumstances is transformed into a timeless ideal.

The best-known artist of the French hamlet Barbizon, Jean-François Millet, created imposing visions of country laborers in such works as *The Sower* of 1850, *The Gleaners* of 1857 (fig. 13), and *The Angelus* of 1859. The combination of classical poses, peasant attire, and thick forms with

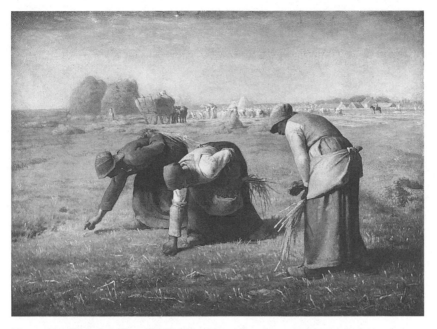

Fig. 13. Jean-François Millet, *The Gleaners*, 1857, oil on canvas, 83 × 111 (32½ × 44). Musée du Louvre. Copyright Alinari/Art Resource, NY

broad faces did not initially elicit praise. In the 1850s critics suspected the politics behind the painter's attention to misery. Depictions of contemporary drudgery were contrary to academic standards that preferred, as Paul de Saint-Victor expressed at the time, "the sacred grove where the fauns make their way, to the forest in which woodcutters are working."[15] The art of Millet and of Gustave Courbet allied itself with a realist identification with the underclasses rather than with aristocratic tastes. Comte de Nieuwerkerke, described as "the head of all official patronage for art during the second Empire," damned Barbizon in a way that reveals these class tensions (though our reading of "democrats" may differ from what he intended): "This is the painting of democrats . . . of those who don't change their linen and who want to put themselves above the men of the world."[16] Contemporary American responses were not necessarily more liberal. William Howe Downes recalled overhearing in a gallery, "How much more interesting Millet's paintings would have been if he had painted a better class of people!"[17] Despite elitist judgments, the Barbizon mode gained favor, practitioners, and collectors. *The Gleaners,* in which poor women collect grains left behind by harvesters, had been "the most

vilified of Barbizon paintings" for depicting lower-class workers as if they were tragic fates, yet it later became a prized icon. This painting and *The Angelus*—portraying a couple, heads bowed in prayer, by their pitchfork, basket, and wheelbarrow—eventually stood as "symbols of longed-for peace and stability"; a World War I French recruitment poster used the gleaners' image to rally the populace about the revered homeland.[18]

Not all Barbizon paintings displayed democratic earnestness. For example, Jules Breton's versions of gleaning, with the presence of children, dogs, and comely maidens, offered a continuation of a benign feudal order.[19] Such polished representations veered away from revolutionary stances to prettify subsistence, confirm class distinctions, and deny the figures a sensibility and worth separate from their physical labors.

Also, when pictures of European peasants crossed the Atlantic they generally lost their immediate social relevance. Either the workers seemed so much at one with the landscape that they became (like the ground they tilled) clods, or the artist's fancy created the "Salon laborer" in "parlor-room pastorals."[20] As noted earlier, American farmers, despite the cozy appearance of rural homesteads in popular prints, did not offer a likely high-art substitute. They lacked a requisite tradition, a statuesque presence, or an ancient earthiness; their pragmatic work was at odds with the divinity of scenery—and an unchanging economic status that might keep them forever poor and picturesque. As much is related by Samuel Isham in his 1901 *History of American Painting:* "He [the American Farmer] was too independent, too sophisticated; his machinery, his reapers and threshers lacked the epic note; they were new like his clothes, his house, all his surroundings." Isham anticipates Kenyon Cox, cited in the last chapter, in finding the American farmer "unpaintable."[21]

However, nineteenth- and twentieth-century audiences did find rustic grace in Homer's black field workers. When the Los Angeles County Museum of Art acquired *The Cotton Pickers* in 1978, curator Michael Quick wrote a commemorative essay admiring "the degree of grace and majesty it gives to its subjects," and praising how the painter's "close observation" yields a paradoxical effect of "awkward but characteristic poses" and "monumentality." Tracing the scene's similarities with Barbizon art, Quick argued that "Homer's *The Cotton Pickers* clearly fits this pattern of distinctly national harvest scenes" with their mythic resonance: "The peasant, rooted in the land, pious and traditional in outlook, seemed to represent the original strengths and beliefs of the people of France, who more and more were becoming city dwellers and factory workers.

Pictures of peasants in regional costume were thus symbolic of the fundamental and enduring character of the nation."[22] Before turning to what insights—and problems—this model introduces to a reading of two black women, I find it illuminating to connect an allegorical reading of the harvest as national emblem to an earlier Homer work, *The Veteran in a New Field* of 1865. In this famous paining, a Civil War veteran has discarded his uniform to reap grain rather than men, re-creating an agrarian image of a republic where swords are beaten into plowshares. The soldier-harvester is anonymous, his back to the viewer while he swings the scythe, so the painting's emphasis rests on the recuperative activity following war.

Homer's *The Cotton Pickers,* on the other hand, resists ready allegory and, while aesthetically pleasing, resists extremes of formal, and social, harmonization with the landscape. How well the women suit the landscape, their meaning within it, are like all questions of interpretation subject to the contingencies of historical perspective. It seems that controversial issues, such as the representations of the disempowered, particularly expose those contingencies. In a 1996 essay, Frances Pohl concludes from her study of African Americans in art that "picture viewing is historically grounded . . . what we see depends upon what we know and the questions we pose."[23] Pohl observes how nineteenth-century viewers stressed the conventional humorous depiction of blacks in such paintings as Homer's *The Bright Side* (1865) of black Civil War teamsters at rest, while recent scholars emphasize the unsmiling gaze of one man.[24] A similar historically grounded bias is evident in William Howe Downes's 1911 reaction to *The Visit from the Old Mistress* in which a former slave owner visits three freed women. Downes found, "In the solemnity of their demeanor, and the humility of their expression, and the evident awe which the presence of the old mistress inspires, there is a blending of pathos and humor"; he did wonder "why the *grande dame* is not human enough to take notice" of the black baby one woman holds.[25] Recent viewers do not find awe in the faces of the ex-slaves, but rather a silent resistance that, in the case of the figure who remains seated while the "mistress" stands, borders on disrespect. Pohl further proposes that a murky figure in Homer's *Prisoners from the Front* (1866), in which Confederate prisoners are turned over to a Union officer (these all clearly painted), is a black soldier. Speculating from physical and circumstantial evidence surrounding the painting, Pohl concludes, "It has taken the civil rights movement, the culture wars, and the increasing presence over the past two decades of art-historical scholarship on and by African Americans for

someone finally to be able to look at *Prisoners from the Front* and ask: 'Is that soldier black?' "[26]

There is no doubt in *The Cotton Pickers* that the figures are "black," though the one to the right may be mulatto or mixed race, which (again depending on viewpoint) may make her conventionally "prettier" as the lighter-skinned or a discomforting example of miscegenation. Whatever that perception, there is agreement that the figures are presented sympathetically and that the scene is pleasing. To me, the young women in browns, reds, and grays stand out against the soft white-green landscape. Another viewer might find them smoothly integrated into the scene, as did Quick: "Wading through the knee-high cotton, and contained within a high horizon line, they seem rooted in the land."[27] With both points of view, the women's physical and emotional presence is central to the painting.

If this scene presents dignity and monumentality, the same cannot be said of a possible companion piece that employs the same models at the same task, *Upland Cotton,* exhibited in 1879 and 1880. This vertically organized landscape presents a hillside of cotton, with the women in similar poses but reduced to small, distant figures. Apparently, nothing inherent in the women's situation solicited either sympathy or respect. This painting received mixed criticism, and either the composition or the criticism dissatisfied Homer enough that at one time he painted over the figures and kept the work in his studio.[28] Contemporary comments slighted the workers and admired the plant: a reviewer for the *Art Journal* in 1879 did acknowledge that the woman stooping to gather cotton "seems to bear the burden of all the toil of her race" and then carefully described the "crispness and delicacy" of the pods, concluding, "The picture is a superb piece of decoration."[29] A *New York Times* reviewer remarked in 1879: "here is a picture that a cotton millionaire or say the Cotton Exchange ought to buy as a graceful tribute to the plant which has made so many fortunes" (which did indeed happen to *The Cotton Pickers*).[30] A year later the newspaper discussed the figures only to denounce them: "Were it possible to give a reason, the ungainliness of the figures might be accepted; but there appears to be nothing in the situation which warrants either the crouching position of the one or the upright pose of the other!"[31] This criticism echoes those of the Barbizon school in depicting the awkward and unwashed, as it is left to the reader to imagine what positions might "exhibit the quintessence of design." Presumably women in the field should evoke the dignity of Wordsworth's 1805 poem, "The

Solitary Reaper." That "Highland Lass," who reaps and sings by herself in an unfamiliar tongue, is distant from the poet, but attuned to the land, the past, and "natural sorrow, loss, or pain." She is not individual, but archetype. In contrast, Homer's women in *Upland Cotton* fail in their "ungainliness" to haunt the romantic heart.

To return to *The Cotton Pickers,* where the figures have been more satisfying, it is worth pursuing how rooted and harmonious they seem. Certainly the grace is not in the adept accomplishment of a task. The woman in the red shirt does not rapidly progress in her work: she appears in somber reverie, her apron caught on a stem. Her thoughtful, wide-eyed gaze is directed off the canvas, so what she sees or thinks remains private and unknown. The sensitivity of her unsmiling face is framed by, and in contrast to, the rough hat that shades her. The other woman bends awkwardly, her aspect disconsolate or surly.[32] Perhaps they are self-consciously posing; but Homer never seemed limited by models' moods in pursuing his painterly intention, so it is likely these expressions and poses are something he meant to capture. In their domination of the foreground and their contrast in form and color to the field, the women may have somber and statuesque dignity, but not contentment, in their labor.

The meaning of the human figure in the landscape depends in part on her response toward the landscape. In this respect, the sidelong gaze of the woman on the right is particularly arresting. Figures in Homer's painting often look down or to the side: his anonymous figures are absorbed in their occupations or look out at a vista that the viewer often sees as well. However, this girl is particularly attractive and striking for the reserved artist. (Her face is now featured on the cover of a children's book, as a likely appeal to adolescents.)[33] As bell hooks argues in *Art on My Mind,* representations of blacks too frequently stress body over mind; this painting is one exception in balancing physicality with a reflective mood.[34] Certainly it is the expression that grants the figure subjectivity and individuality, and enhances the "monumentality" many perceive.

There is another departure from convention in the gaze of this fieldworker. It does not seem an example of classical composure so much as distraction. Again in Barbizon art, Millet presents figures who go about their work or prayers with downcast eyes; Breton portrays women with dreaming eyes as they rest from their labors for a moment. Homer's girl, however, appears self-conscious, separated from her work and the landscape by reverie. Her expression does mirror the anxious sidelong glances of African American figures in other works by Homer. In *Near Anderson-*

ville (1865–66), also known as *At the Cabin Door* and *Captured Liberators,* a woman, probably a slave, stands in the dark entry of a cabin and looks vaguely toward captured Union Soldiers under Confederate guard in the left background. She stands upright, tension expressed in the grasp of her apron, her slightly downturned mouth, and eyes marked by shadows. Again, what she thinks can only be surmised, but the somber hues imply that she finds no joy in Union loss. While restrained distress might be expected of a wartime subject, it also appears in what could be a light genre piece, *The Watermelon Boys* of 1876. Two African American boys and a white boy are eating watermelon, "lifted" from a patch to the right; there is a suspicious gap in the bordering fence. The black boy in the middle, unlike his hungry associates who rest on the ground to eat, stays on his knees and looks warily back toward the fence. An 1878 engraving of the work added a man at the fence waving his arms, the angry farmer. But the oil painting avoids this plausible, contained narrative, so that the boy expresses a generalized anxiety, a fear of being seen and caught in a place where he can never feel at ease.[35]

The anxious gaze of Homer's black figures is contrary to the commanding gaze associated with imperial, patriarchal power. On one hand is the all-knowing gaze, conveying the master's right to survey his possessions with the power of superior vision; on the other is the blindness of the look that cannot "see" the women apart from their labor. In *The Cotton Pickers,* no overseer—ubiquitous during slavery and lingering through Reconstruction—is present to dominate the women socially or visually. Tacitly assumed are the white artist and white viewers who cannot quite confront the workers who look elsewhere. While Homer's models keep their silence, other black women of the era spoke out about disparities in seeing and being seen. Anna Julia Cooper, in *A Voice from the South* of 1892, employs metaphors of sight and speech to convey the neglect of women such as Homer's cotton pickers:

The "other side" has not been represented by one who "lives there." And many can not sensibly realize and more accurately tell the weight and the fret of the "long dull Pain" than the open-eyed but hitherto voiceless Black Woman of America. . . .

. . . Hers is every interest that has lacked an interpreter and a defender. Her cause is linked with that of every agony that has been dumb—every wrong that needs a voice. . . . But in any case [man's] work is only impoverished by her remaining dumb. The world has had to limp along with the wobbling gate and one-sided hesitancy of a man with one eye. Suddenly the bandage is removed from the other eye and the whole body is filled with light. It sees a circle where

before it saw a segment. The darkened eye restored, every member rejoices with it.[36]

Homer's painting by itself may not complete the circle, but Cooper's image of the "open-eyed but hitherto voiceless Black Woman" describes the worker who stares beyond the prejudices of viewers delighting in a pleasant scene.

If the cotton-pickers' rapport with artist and audience is uncertain, so is that with the land. Neither woman seems, in the phrase of Asher Durand's painting, "kindred spirits" with the landscape surrounding them. If they are "rooted in the land," that is not a source of security and happy self-definition. Hindsight could read this painting as one example of the exclusion of blacks from the American agrarian dream, of how social institutions abandoned them. In *Souls of Black Folk* of 1903, W. E. B. Du Bois clarified the brutal, literal way by which enslaved African Americans became part of the soil. He asked a Georgia man to reminisce of the region at the height of cotton market: " 'This land was a little Hell,' said a ragged, brown, and grave-faced man to me. We were seated near a roadside black-smith shop, and behind was the bare ruin of some master's home. 'I've seen niggers drop dead in the furrow, but they were kicked aside, and the plough never stopped.' "[37] The cruelty of slavery, however, did not necessarily lessen the economic and emotional value of the land. The hope of freedmen at the end of the Civil War—many believing they had earned a right to fields they had already worked for so long—was that property, forty acres and a mule, would enable them to support families with self-sufficiency. A plot of tillable ground would assure their prosperity and status as Americans. But the often acrimonious and corrupt path of Reconstruction thwarted that hope, and many found themselves as tenant farmers getting a meager share of the crop or fieldworkers who earned a few dollars per month. As Henry Louis Gates explains, "A Sisyphean sharecropper system quickly emerged as a substitute form of economic slavery." This system and other social and economic injustices created another diaspora: "Between 1870 and 1890, an average of 41,378 people migrated each decade from the South. Between 1890 and 1900, however, more than twice that number migrated—107,796 people."[38]

This displacement has its artistic commemoration in the 1940s *Migration* series by African American artist Jacob Lawrence. Lawrence's text accompanying one of the panels reads, "The Negro, who had been part of the soil for many years, was now going into and living a new life in the urban centers." Other panels make clear that being "part of the soil"

did not necessarily mean ownership or profit, but rather included terrible hardships that drove the move North: floods, boll weevils, widespread poverty. Both the people and the land suffer, as Lawrence illustrates with a wasteland image: "Due to the South's losing so much of its labor, the crops were left to dry and spoil."[39]

However, the gruesome visual and verbal images of DuBois and Lawrence scarcely resemble Homer's mute scene: no violence or abuse there, just blooming puffs of white and stationary women. His painting, conventional in many ways, supposedly did not disturb the sleep of the nineteenth-century "English cotton spinner" who first purchased it.[40] The violence of race relations and war that had invaded the Southern plantation is hidden behind the prosperity of a new crop. The subversiveness of *The Cotton Pickers* remains subdued, latent in an enigmatic gaze that can only be read subjectively.

There is still the question, what does this painting—if read as either an archetypal harvest scene or as a depiction of Reconstruction African Americans—say about the "fundamental and enduring character of the nation"? That it still depends on agriculture, despite war and emancipation, is one possibility; that black workers still ensure Southern prosperity is another. It may exemplify the "picturesqueness" of what Downes called "the African type" and the serenity evoked by a quiet harvest scene. Given that decorative quality, it may nonetheless hint through the women that social injustice and restlessness mar the idyllic pastoral. While paintings of rural workers may exemplify archetypal ties to the land, it does not take a strict Marxist to recognize that the "rootedness" of a peasant or tenant farmer is a sign of caste and class systems—an inheritance difficult to escape. The women in Homer's painting were probably born before the Emancipation Proclamation of 1863, to slave mothers. We can only speculate about what they think, and how freely, when a Yankee painter poses them in the field that seems to be their destiny.

While *The Cotton Pickers* can be pleasingly ornamental despite the gaze, the same cannot be said of a later painting in which tragedy looks inevitable, *The Gulf Stream* (pl. 2). In 1899 at the age of sixty-three, Homer completed the large oil, often considered "his most famous painting" and "one of the best known—and most confounding—paintings in American art."[41] Now more than a century old, this work came out of Homer's trips to Florida and the Bahamas beginning in 1884. It places at the center a

black man in a dismasted ship: "Anne" or "Annie"—"Key West" barely discernible on the stern; in the foreground, sharks; in the background, a waterspout and a ship too distant to provide rescue. Clearly not a complacent genre piece, the painting's renown stems from its potential affinity with grand conventions, sublime nature, and the public significance of history painting. Since the first showings of *The Gulf Stream*, its contents have been repeatedly allegorized, even as its formal composition is found inferior. Also, this "universal" painting is acknowledged as a distinctive historical marker of fin de siècle anxiety, "an emblem of century's end."[42]

So *The Gulf Stream*, with subject and setting alien to the actual experiences of Homer's white upper-class patrons and the Metropolitan Museum Board that eventually approved the painting's purchase, came to be labeled an icon for the age. In addition, this icon appears at odds with Homer's developing aesthetics: during the 1890s his paintings of seascapes without a human presence and of bright tropical forms relied less on narrative, thematic content and more on the refinement of painterly composition. At the turn of the century, Homer apparently regressed to paint a "story-telling piece" laden with allegorical potential.[43] It is as if the artist who became increasingly innovative and modern in balancing "on the knife-edge between realism and abstraction" made in this case an uneasy gesture toward the tradition of history painting.[44] The black man at the painting's center then embodies history, the mood of a decade; he could be Everyman in peril. This figure powerfully reinforces Toni Morrison's premise in *Playing in the Dark: Whiteness and the Literary Imagination* that the "white" world drew on images of blacks as "surrogate selves for mediation of problems of human freedom, its lure and elusiveness." The painting provides an example of "the thunderous, theatrical presence of black surrogacy," as the desolate figure comes to represent an era at drift.[45]

How did a black man and wild ocean come to function as encompassing symbols? Realism is often not so transparent as it seems, and this painting—caught up in race relations and cultural transitions—inspired an entangled history of interpretations. Revealing the codes behind interpretations of *The Gulf Stream* elucidates the continuing power of a "sublime" ocean and how its presence shapes readings of the man and his color. The record of the painting's reception exposes the values by which an American painting, particularly a nativist one during a time when American art was generally held inferior to European, is valorized. In this instance, shifting critical habits involve the volatile issue of one race representing another against a backdrop of strife and subordination.

The sea is universal. Far more ancient than humanity, the ocean is the "fierce old mother," as Walt Whitman declares her, of birth and death. The sea inspires contemplation and conquest; she holds profound secrets and answers but will not reveal them. Thus philosophers, artists, poets, sailors, and quite ordinary shore watchers will look out as they do in Frost's poem, even if "They cannot look out far. / They cannot look in deep." If such perceptions seem swamped in romanticism and myth, suffice it to say that the presence of waves inspires universalizing tendencies in commentary on Homer.

A consensus of opinion, from the painter's contemporaries through much modern scholarship, plots Homer's career as always moving toward greater acclaim and creative freedom; it contends that Homer rose above journalistic illustration and local genre when in 1881–82 he rediscovered the sea in Tynemouth, England, and then left New York, Boston, and Europe behind to contemplate wave and rock at Prout's Neck, Maine. In 1911 Downes wrote with the assurance that his audience would accept the pairing of "Nature" with "Truth" and thrill to their certainty realized in Homer's paintings:

> In Homer's marine pieces there is the consummate expression of the power of the ocean. . . . The tempest's rage is not in his blood; calm in the midst of its violence, his hand and eye are steady, and his work betrays neither agitation nor haste. Nothing but the truth endures. It is sufficient. The art which rests on that lives and will live.
>
> I think we can read between the lines in Homer's works a conviction of the superiority of nature to art. He realized with Emerson, that "the best pictures are rude draughts of a few of the miraculous dots and lines and dyes which make up the everchanging 'landscape with figures' amidst which we dwell." . . .
>
> . . . Nature, broad, spacious, elemental, seems to have sunk into his mind.[46]

Homer's works also inspire later humanistic responses. In a 1990 study, John Wilmerding, a long-established scholar of American and marine art, reached a similar transcendent vista: "in concentrating his vision on a few acres of Maine rock, [Homer] was able to convey a universal sense of nature's forces. From introspection came philosophical breadth, from a finite physical world an expansive cosmos of ideas and feelings."[47]

The blues, greens, reds, and grays on Homer's canvas therefore represent not just an isolated scene in a specific current, but life-and-death matters and a mythic ocean. Reactions to Homer's late marines underscore

the ocean, particularly when the scene is threatening waves rather than a resort beach, as a powerful cultural trope. This is no surprise, considering the heritage of American romanticism and the genuine dangers of fishing and sea travel in the nineteenth century. My emphasis here, though, is on interpretations of the ocean as "natural," "eternal," and "transcendent": it lifts paintings out of a specific context. While Homer's scenes of the Civil War, fashionable women, Adirondack guides, or even Reconstruction cotton-pickers, are usually linked to an historical and local situation, his marine paintings continually elicit the word "timeless." In 1905, Homer Saint-Gaudens wrote,

Local in detail, yet universal in appeal, [Homer's] landscapes and marines seldom lack an element of man, where his figures, ever less prominent, are healthy, vital types rather than individuals. On occasion he has left the important work of his life to do water-colors, paintings of interiors, of sun-bonneted, barefoot girls driving sheep, of Yankee boys playing marbles, of pickaninnies eating watermelon, of New England farmhouses and negro huts. But in the end, he drifts back to the solemn, big expression of the ocean.[48]

Even as watercolors, genre, and representations of "pickaninnies" or "negro huts" are no longer readily dismissed as the unimportant work, the sea remains universal.

There is an exception, but it tends to support rather than supplant archetypal readings. *The Gulf Stream* has been situated within late nineteenth-century determinism and naturalism and specifically associated with Stephen Crane's "The Open Boat," the fictionalized account of the writer's survival of the *Commodore*'s sinking off Florida. In a general introduction to American art first published in 1969, Jules Prown pursued the literary connection: "This man, this anonymous spark of life, is a pawn of forces beyond his control. He is at the mercy of an impersonal nature that does not care about him one way or the other. It may snuff him out, or it may not. The painting, produced one year after Stephen Crane's short story *The Open Boat,* is an exact pictorial counterpart to Crane's Naturalism." However, that context still gives way to allegory: "The Negro in *Gulf Stream* is Everyman. He has no name, like Crane's characters. . . . A man joins the community of men not through peculiarly personal experiences, but through individually encountered common experiences."[49] A door is left open: a critic in 1907 proposed that the painting "assumes the proportion of a great allegory if one chooses."[50] With

such readings, Homer's painting has a strong affinity with a twentieth-century fable of the individual in nature and death, Hemingway's *The Old Man and the Sea* with its relentless sharks that destroy the fisherman's tremendous catch and by implication his masculinity and dignity.

Also finding broad implications in the black man's plight, Wilmerding, writing toward the end of another century, calls the oil a "summary work," bound to a cultural moment: "Bearing the date 1899, [*Gulf Stream*] is . . . an emblem of century's end and, subconsciously as well as intentionally, an embodiment of the fin-de-siècle mood of anxiety, if not despair, felt by many Americans and Europeans in these years. Certainly, it was an age in transition, as Homer's near contemporary Henry Adams was to articulate in *The Education . . .*"[51]

While Homer's paintings of people at sea may be dramatic emblems, the artist was not given to presenting transparently didactic lessons. An air of inscrutability lingers about the reticent Homer and his works. His paintings, while reflecting familiar occupations and landscape, are distinctive. No other artist is quite like him and his works are rarely mistaken for another's, so that some can believe his art "an expression of personal belief, of an individual psyche."[52] Despite the referential realism and "objective" reporting, viewers sense something private and not fully revealed in Homer's choice and rendering of subjects. In a 1990 essay, Nicolai Cikovsky, Jr., declared that *The Gulf Stream* "is clearly about human mortality, about man's lonely confrontation with death," and that the painting is "private because it is the expression of Homer's own thoughts of death and destiny."[53] Later, in the catalogue to the large-scale 1995–96 retrospective Homer exhibition, Cikovsky expressed the difficulty of labeling Homer's paintings as "types," again using this famous example: "Are they narrative (as some of Homer's contemporaries believed, or wanted, *The Gulf Stream* to be) or allegorical? Public or private? Real or imaginary? Visual or visionary?"[54] The implied answer is that the painting bridges categories and contradictions. Yet given this flexibility in interpreting Homer, Cikovsky, like Wilmerding and many others since 1899, considers *The Gulf Stream* "a summary painting" that is allegorical and retrospective.[55]

But how do readings that tend either toward Everyman-allegory or artist's private mood comment upon racial difference? Postmodern and postcolonial critiques have attacked generalizing tendencies in criticism as diminishing the significance of difference and perpetuating stereotypes of the marginalized. Against those charges, is an all-inclusive allegorical ap-

proach to *The Gulf Stream* admirable or lamentable in its colorblindness? Is the man's race a detail of location, less significant than the inhuman force of the sharks and waves? Reactions to Homer's charged scene imply that the sea and the vulnerability of those upon it are universal for twentieth-century eyes—if in a nineteenth-century painting. This is especially true of a painting that references conventions Homer enhanced since the 1880s: the ocean as symbol for eternal mystery and elemental struggles. With Adrift at Sea as a powerful trope for vulnerability and mortality, commentators could readily overlook that belonging to a disadvantaged racial minority and dying by shark attack were not for them "encountered common experiences." Desiring to seek the universal in the particular, viewers over the past hundred years have made a ready leap from the stranded black man of Key West to human fate.

Such readings take for granted the importance of the central figure while rarely articulating the cultural meanings that the late nineteenth or twentieth century attach to "blackness." As I proposed earlier, Toni Morrison's insights on black surrogacy and on how it has been "crucial" to a "sense of Americanness" suit well the painting's reception. Morrison warns against "dehistoricizing allegory" in literature that "produces foreclosure rather than disclosure" in delivering quick interpretation; responses to blackness "can serve as allegorical fodder for the contemplation of Eden, expulsion, and the availability of grace."[56] To apply her insights to *The Gulf Stream*, readings that take the man as a timeless emblem of the "white" viewer's despair turn away from consideration of a specific black figure in historical circumstances.

While reactions over the course of a century allegorize the stranded man as a universal cipher, they paradoxically acknowledge the skin color by placing Homer's painting in an unusual art-historical category, the black man on a boat. In that "genre," racial identity becomes a trope for powerlessness. *The Gulf Stream* has been repeatedly compared with John Singleton Copley's *Watson and the Shark* (fig. 14) of 1778, Théodore Géricault's *Raft of the Medusa* (fig. 15), exhibited in Paris in 1819, and J. M. W. Turner's *Slave Ship* or *Slavers Throwing Overboard the Dead and Dying—Typhoon Coming On* of 1840 (fig. 16, see p. 80).[57] Thus a tradition is established, enabling grand readings of Homer's work and raising his status by association with greatness. The paintings of Copley, Géricault, and Turner depict contemporary events rather than classical or biblical myth. Nonetheless, they draw from the ennobling (or aggrandizing) conventions of history painting in scale, theatricality, and import with

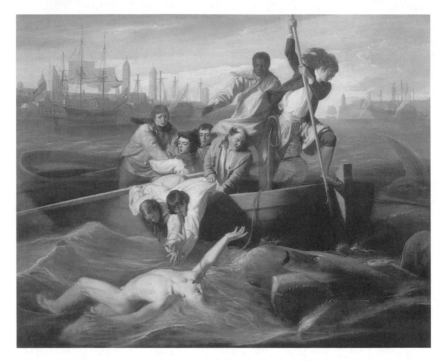

Fig. 14. John Singleton Copley, *Watson and the Shark*, 1778, oil on canvas, 1.821 × 2.297 (71¾ × 90½). Ferdinand Lammot Belin Fund, Photograph © 2002 Board of Trustees, National Gallery of Art, Washington

the result that the "reportage of a current event" is "given an epic quality."[58] The fate of individuals is read as a critique of the culture at large, and in these instances black figures are included in that critique.

In *Watson and the Shark*, based on the rescue of Brook Watson in Havana harbor, a black man forms the pinnacle of the pyramidal composition, but is the least active and attends to the others who perform the rescue. Watson, who lost his leg, prospered later in life, eventually becoming Lord Mayor of London and a baronet. He bequeathed his version of Copley's painting to Christ's Hospital, a London school for poor children, believing the scene held out "a most useful lesson to youth," presumably about providence, heroism, and surviving adversity.[59] In Géricault's *Raft of the Medusa*, black figures appear more imposing: again, one is the apex of a triangle of figures, but vigorously hails the rescue ship as other figures, black and white, collapse in despair and death behind him. The muscular activity of that figure and the ensuing rescue can be read as the return of

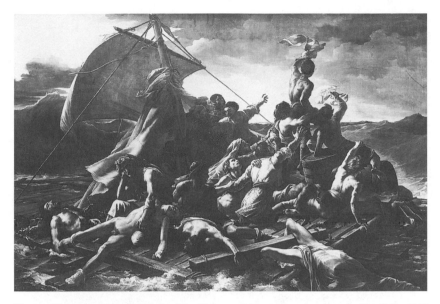

Fig. 15. Théodore Géricault, *Raft of the Medusa,* 1818–19, oil on canvas, 491 × 716 (193⅓ × 282). Musée du Louvre. Copyright Alinari/Art Resource, NY

hope, in contrast to the passivity of Homer's *The Gulf Stream.* However, the incident behind the wreck fosters neither hope nor high regard for humanity. The senior officers abandoned the French frigate *La Meduse* off the coast of Africa, leaving behind about one hundred fifty lower-ranking passengers on a crude raft; after swamping, mutiny, and cannibalism, fifteen survived. The episode was a scandalous lesson of betrayal, neglect, desperation, and misfortune.[60] *Raft of the Medusa* was painted, according to Hugh Honour, when the Atlantic slave trade "was much discussed in France," though "the Restoration government's law against slave trading was notoriously, perhaps even intentionally, ineffective." Given this topicality, it is still difficult to say how much awareness of slavery informed the painting or its viewings. Géricault provides little clue: despite the prominence of blacks in his art, they are "barely mentioned" in his writings, as Honour observes, "and then only as subjects for his art."[61]

The romantic sublimity of these paintings is carried to an extreme in Turner's *Slave Ship.* As in many works of the artist the atmospheric swirls of paint and lurid colors fascinate, while in a painterly synecdoche chained limbs reach desperately out of the waves. This fantastic rendering of slaves thrown overboard in Middle Passage can illustrate the hell of the "insti-

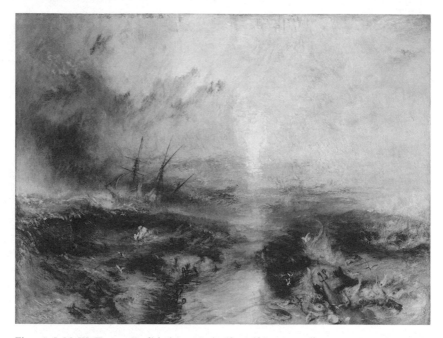

Fig. 16. J. M. W. Turner, English (1775–1851), *Slave Ship*, 1840, oil on canvas, 90.8 × 122.6 cm (35¾ × 48¼ in.). Henry Lillie Pierce Fund. Courtesy, Museum of Fine Arts, Boston. Reproduced with permission. © 2002 Museum of Fine Arts, Boston. All Rights Reserved.

tution." However, such a style, far from the "reporting" of the previous canvases, may also appropriate social events for an introspective, private vision—although idiosyncratic expression, informed by historical circumstance, can become a potent cultural symbol. Turner's temperament and imaginative leap from incident to allegory inspire expansive interpretations of *Slave Ship* as "an expression of Turner's deeply pessimistic cosmic vision in which humanity struggles vainly against elemental forces. In the Middle Passage, the Africans' enforced journey from the land of their birth to death on the other side of the ocean, from freedom to lifelong bondage, from hope to despair, Turner found a metaphor for the human condition."[62] The presence of a black man in a nineteenth-century painting, even when the foe is not Simon Legree but tempestuous waters, calls up slavery. "Natural" and social forces are confused and conflated: is it drowning—cruel Nature—that threatens a black man, or is it subjugation by whites? The suggestion of slavery in a nineteenth-century painting, if it is not explicitly abolitionist, is considered less a summation of black

experience and more a universal theme of bondage, futility, hope, and freedom.

The black figures in the boat paintings then become, as Henry Louis Gates believes blacks often are in art, "ciphers whose semblance to actual historical persons cannot be recognized."[63] One could argue that emblems and ciphers (many of Homer's white subjects are ciphers for stoicism) have immense expressive value, and that it is humanizing to see the black image in these paintings as significant not just for a minority but for the many. To envision the fatal situation in such paintings is to finally acknowledge the plight of a race—the first step toward liberation. Perhaps for this reason Alain Locke praised *The Gulf Stream* in 1936 for beginning "the artistic emancipation of the Negro subject in American art."[64] Then the problem returns that black figures, in so often representing futility or bondage, are not held up as stirring models or particular individuals, but repeatedly become trapped in a downward spiral and reduced to stereotype. Caught up in cultural habits and prejudices, viewers can scan the black man in the painting and automatically assume vulnerability and hopelessness. Insight into racial history and an individual case is again "foreclosed" for the sake of allegory.

If "universal" allegory is set aside, what is the appeal of *The Gulf Stream?* It is not in a formalistic appreciation of the composition. In the 1960s and 1970s, the painting was not much admired, even by those who were and are extremely perceptive critics of Homer and American art. Barbara Novak damned it in 1969 with faint praise, "one of the most famous but least plastically satisfying of Homer's paintings."[65] Roger Stein's 1975 assessment was harsher: "it is not Homer at his best, despite the painting's continuing popular appeal. Poorly painted, harsh in color, melodramatically overstated and terribly derivative in both its symbolism and its structure, *Gulf Stream* is a curious pessimistic mélange of [Copley's] *Watson and the Shark* and [Allston's] *Rising of a Thunderstorm at Sea*."[66] Even as cultural studies has renewed interest in illustration, representation, and historical context, scholars continue to find the work an aberration: "Curiously reactionary in its romantic character and excessive narrative concerns"; "peculiarly romantic and illustrative for so late in Homer's career."[67] When I viewed the painting at the National Gallery exhibition, its vivid color and the busy composition, however remarkable, did not blend well with the other late paintings in the room. *Cannon Rock* (1895) and *Cape Trinity, Saguenay River* (1904–1909)—darkened, myste-

rious evocations of water, rock, and cloud—displayed greater tonal harmony. The prone man of *The Gulf Stream* was not presented so monumentally as the fishermen in Homer's other famous boat pictures, *The Herring Net* (1885) or *Fog Warning* (1885). The figure looked small on the canvas, sharing space with the sharks, and for me the black hole of the hatch drew the eye to the center of the picture.[68] I did overhear a gasped response from one of two viewers, African American, responding to the painting's implied story: "He doesn't have a chance!"

Indeed, the narrative composition—suggesting chronological events involving the sharks, the boat, the storm, and the distant ship—is closer to Homer's illustrations and oils of the 1880s, which feature resilient figures and menace at sea, than to his late enigmatic seascapes or fresh tropical watercolors. Homer repainted the picture after its 1900 exhibition; modifications to the boat and waterline enhanced the sense of a dramatic narrative.[69] As mentioned in the preceding chapter, the paintings of the 1880s from their first viewings have been called mythic and assured for Homer his status as a major, and popular, American artist. While Homer was admired for technique, it was the theme and morality of the subject matter that drew praise. The consideration of narrative and its value in Homer's work is complex. He may appear bound to the reportorial and illustrative conventions of his career's beginnings, yet his paintings frequently avoid a narrowly defined context and strong sense of closure; in the last decades of his life, narrative seems "erased."[70] *The Gulf Stream* significantly lacks the active poses of the 1880s, but it too employs the natural setting for thematic, rather than solely painterly purposes. In making a statement that contradicted his stylistic development in the 1890s, it appears that the artist moved backward.

Attention to the figure's race yields a different perspective on the painting. If "the painting's stylistic achievements are so debatable," according to Peter Wood, "then its persistent power over American audiences must derive from something compelling or resonant in the subject itself"; the painting "can be interpreted as a rich portrayal of both the historical and the contemporary situation of blacks in Homer's America."[71] This point is reinforced in Albert Boime's 1990 book, *The Art of Exclusion: Representing Blacks in the Nineteenth Century*, as he offers this backdrop for *The Gulf Stream:* "the last quarter of the century—and in particular—the last decade—marked the nadir of black people's quest for civil rights."[72] It was, as we know, the era of Jim Crow laws, the Ku Klux Klan, frequent lynchings, and the Supreme Court ruling *Plessy v. Ferguson,* which estab-

lished "separate but equal" as policy. It was the era of the "white man's burden" and chauvinistic imperialism, as American involvement in Cuba, Puerto Rico, and the Philippines confirms. Du Bois, again in *The Souls of Black Folk,* stated that "the problem of the Twentieth Century is the problem of the color line" and portrayed "the Negro of to-day" as "conscious of his impotence, and pessimistic." He even employed an image that recalls Homer's painting, in lamenting the failure of democratic ideals and the terrible state of post-reconstruction race relations: "So dawned the time of *Sturm und Drang:* storm and stress to-day rocks our little boat on the mad waters of the world-sea; there is within and without the sound of conflict, the burning of body and rending of soul; inspiration strives with doubt, and faith with vain questionings."[73] Shipwreck seemed a "natural" metaphor for the foundering of human intention and hope, even if that foundering was social rather than physical. Set against the continued difficulties encountered by African Americans, *The Gulf Stream* becomes "historicized" and then transformed into another allegory, that of a minority's exploitation.

So viewers try out meanings, despite Homer's directions not to "let the public poke its nose into my picture."[74] Avoiding the intentional fallacy is easy with Homer, and his own remarks do not suggest a specific motivation behind the creation of *The Gulf Stream.* He let his paintings speak for him (though it is worth remembering that he spent his childhood in Cambridge, Massachusetts, near Boston's abolitionist furor, and he began his career recording Civil War scenes).[75] While he frequently chose African Americans as subjects for paintings, on the surface Homer's response to racial issues looked quite conventional: he and his brother employed an ex-slave, Lewis Wright, to take care of their father at Prout's Neck.

The Gulf Stream grew out of Homer's visits to Florida and the tropics in 1884 and following years. Engravings from Homer's watercolors illustrate an 1887 *Century Magazine* article by William C. Church on Nassau as a "Midwinter Resort." The resort was not yet booming—"in the height of the season there are only some one hundred and fifty visitors"—and the tropics not yet perceived as conventionally picturesque: "Few Americans can long endure existence in a land without scenery except such as the ocean affords; without a mountain, or a stream of running water."[76] Homer, like his friend, American painter John La Farge, and like Gauguin, participated in an evolving aesthetic that would render the tropics a scenic, painterly subject. Always the Yankee realist, Homer did not produce post-impressionistic tableaux and bold erotic fantasies; nor did he go native,

but was a discreet tourist who returned to his Maine studio. Nonetheless, his interest in depicting muscular, half-nude men in his tropical scenes suggests the pull of a primitive exotic "other."

The *Century* article plays lightly over tropical and racial otherness. Church duly notes the presence of sharks, documented by Homer's *Shark-Fishing—Nassau Bar* which shows two black men hauling in a shark; and the author worries about the safety of bathers. He remarks: "The sharks are not inviting, but there is a tradition that they do not take kindly to black flesh. Indeed, it is hard to find a proof that they meddle with human flesh of any color."[77] Other turn-of-the-century stories in general and sporting magazines re-create the excitement of fishing in Florida, including encounters with sharks and bad weather, all illustrated by drawings of prize tarpons and local fisherman—black *and* white. An 1893 tale of a pleasure cruise caught in high seas, but miraculously making it to shore, ends with this valediction: "Farewell to bars and breakers; good-by to the Gulf Stream and its clear blue sea, to coral reefs and sandy keys; henceforth smooth water and sheltered anchorages!"[78]

Whatever fishing and shark-lore, racist and otherwise, that Homer knew, the creatures apparently fascinated him, and his "great dramatic picture" evolved from sketches and watercolors. Cikovsky says of the work's making, "No other painting by Homer underwent the same development. No other single motif preoccupied him for as long a time, and to no other motif did he return as often."[79] One watercolor study depicts a wrecked boat with sugar cane on the deck; another in 1889 shows the boat, the man, and the shark, although in a simpler, less dramatic composition.

When the painting was at last exhibited, it set off intense reactions. Several women who saw the painting at Knoedler's Gallery forwarded a question about the fate of the man, and Homer provided this crusty reply:

I regret very much that I have painted a picture that requires any description. The subject of this picture is comprised in *its title* & I will refer these inquisitive schoolma'ms to Lieut. Maury [a published oceanographer]. I have crossed the Gulf Stream *ten* times & I should know something about it. The boat & sharks are outside matters of very little consequence. *They have been blown out to sea by a hurricane.* You can tell these ladies that the unfortunate negro who now is so dazed & parboiled, will be rescued & returned to his friends and home, & ever after live happily.[80]

Homer's sarcasm toward these "schoolma'ms" suggests that the painter believed himself beyond the didactic narratives desired by the stereotypical female bluestocking, even as he created one. Homer, despite his reluctance to speak, seemed to value this work finished a year after his father's death. He posed by it, for the only known photograph of the artist by one of his paintings.

Whatever his own emotional response to the painting, Homer knew it was not for intimate and domestic contemplation: "No one would expect to have it in a private house."[81] It seemed destined to be a large statement in a public venue, although the painting did not sell immediately. It was shown at Knoedler's in New York; then in 1901 at an international exhibition in Venice; in 1902 at M. O'Brien & Sons, Chicago; and at the 1906 exhibition of the National Academy of Design. After that exhibition it was purchased for $4,500 by the Metropolitan Museum, which had turned it down a few months earlier (middle-class income around 1900 ranged from approximately $900 to $3,500).[82] The jury of the National Academy of Design had enthusiastically recommended its purchase: reportedly, one painter exclaimed, "Boys, that ought to go to the Metropolitan!" Roger Fry, better known as one of the Bloomsbury set and a champion of European post-impressionism, was then museum director and replied to a jury member about the Homer purchase:

I need not tell you how delighted I am personally. I regard the Gulf Stream as one of the most typical and central creations of American art. It belongs to this country in every way. . . . It is a great masterpiece and counts among the very finest that Winslow Homer has created.[83]

A few grumbled about the grotesque subject, and one reviewer renamed the piece "Smiling Sharks." More, however, praised the painting's power and "artistic interest," and saw its purchase as a sign of Homer's merit—and that of American art.[84] The painting crossed several artistic borders: its realistic specificity and natural environment made it "American," the danger was dramatic rather than merely pictorial, and its content allowed allegorical interpretations that connected the painting to European-dominated high-art traditions.

Despite its differences from Homer's other late works, *The Gulf Stream* reflects tendencies that run throughout the artist's career. It features an isolated figure, more type than individual, with an averted face and en-

igmatic gaze. The figure is represented as private, purposefully absorbed in something other than posing for a painter, and is frequently caught in a moment of suspense with an unknown, probably ominous resolution in the future. Against the backdrop of violent nature, do race and gender matter in variations of this scenario?

The potential for anxiety, along with the dignified stoicism it can inspire, is to an extent "universal" in Homer. The pose of a fisherman can be apprehensive as in *Fog Warning*. Disaster is just beyond the next wave in many of Homer's rescue pictures, as men call for aid and prepare equipment while women look out on a sea that claims the lives of fathers, husbands, and sons. As *The Cotton Pickers* illustrates, the expressions of black figures are also troubled or reflective, though the cause is more likely to be a social disadvantage rather than a natural disaster. Homer painted danger at sea, boats blown away and wrecked, the call to rescue, but the men pictured generally retain their lives, their consciousness, and by implication their manhood. Exceptions are an 1864 Civil War piece, *Skirmish in the Wilderness* with a shadowy falling soldier, and Gates's purchase, *Lost in the Grand Banks,* which is singular in depicting the desperation of white men. In general, the human figures shown as unconscious, inactive, possibly dead, are women and black men—the human prey of natural (and social?) forces. For example, a *Harper's Weekly* illustration from 26 April 1873, *The Wreck of the "Atlantic"—Cast Up by the Sea,* pictures a very upright man over the stiff corpse of a woman washed ashore (her pose seems more appropriate for the boudoir than the rocks); *The Life-Line* (1884) and *Undertow* (1886) dramatize men rescuing unconscious women from the sea. (*The Gulf Stream* still retains some of the virility associated with Homer as it is unlikely that a woman in a boat would be considered emblem of the era.)

A watercolor of the same year as *The Gulf Stream* reflects this pattern of helplessness, provides a possible conclusion to the oil's narrative tension, and suggests why certain paintings are taken as big statements. *After the Hurricane* (fig. 17), also known as *After the Tornado,* was probably painted early in 1899 in the Bahamas. It shows a boat and man washed ashore, but this watercolor has not been called an emblem of the age. Along with the change in medium, the composition appears less illustrative and more spontaneous. While the watercolor can be read as "the final image in a narrative sequence about the power of nature and man's ineffective struggle against it," the play of color, light, and shape has equal, perhaps greater impact.[85] Compared with *The Gulf Stream,* which was

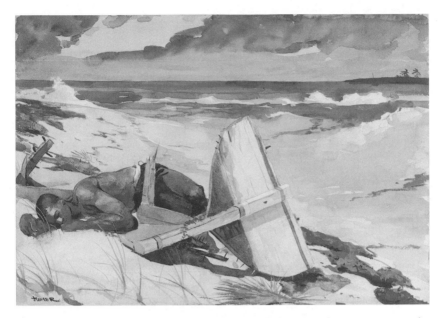

Fig. 17. Winslow Homer, American, 1836–1910 *After the Hurricane, Bahamas,* 1899, watercolor with touches of reddish-brown gouache and with traces of scraping over graphite on off-while wove paper, 38 × 54.3 cm, Mr. and Mrs. Martin A. Ryerson Collection, 1933.1235, reproduction © The Art Institute of Chicago.

probably painted later that year in Homer's Maine studio, this composition strikes me as less dramatic and allegorical. The curious crumple of a man (stunned, dead, near-dead?) appears less a tragedy than a found form. Whiteness, of sand, boat, and water, dominates the foreground: the figure, rather than seeming iconic, becomes part of a contrasting diagonal of tans, yellows, and browns. A reading akin to literary naturalism is possible: the sea and sky are "probably splendid . . . wild with lights of emerald and white and amber" as in Crane's "Open Boat," but they—and the composition itself—are indifferent to the man.[86] Nonetheless, the painting comes closer to twentieth-century coolness and formalism than to nineteenth-century sublimity and narrative. The reception of the two paintings highlights a critical paradox: scholars since the 1960s have generally followed the criteria of formalism and suspected narrative; yet the painting closest to the nineteenth-century genre of history painting is more widely known and acknowledged.

Despite its painterly emphasis, *After the Hurricane* follows the tendency of Homer's narrative works in depicting traditional victims. As will soon

be addressed, the helpless women and black men have an unnerving af-
finity with the stricken animals of Homer's hunting scenes. It is as if the
image of a white man unconscious or passively blank, like the figure in
The Gulf Stream, were too much to bear. An "Africanist persona," in
Morrison's terms, serves the "duties of exorcism and reification and mir-
roring."[87] At century's end fears are displaced onto women's physical
frailty, hunted animals, or onto the vulnerability of blacks—the result of
their social status and, in the tropics, of the physical risks they took to
survive. *The Gulf Stream,* even with its tensions caused by sharks, waves,
tornadoes, remote ships, and unfocused gazes, becomes an acceptable
museum piece because the surrogate is distanced by location and race. A
universal painting, but not too close for comfort.

The Gulf Stream, in its outdated narrative, anticipates modern uneas-
iness about identification, otherness, and the inability to control what is
to come. For what it might gloomily represent about past and future, this
oil (rather than one of the delightful tropical watercolors that Homer also
painted at the time) is taken as a grand statement at the century's conclu-
sion. A statement that looks backward—to established conventions and
history painting, to the "Middle Passage" and slavery, to Homer's own
"serious" depictions of man at sea—is wanted. A statement that can be
labeled timeless and universal, even as it conveys the uncertain mood of
the 1890s and the particular situation of African Americans. A statement
that does not make clear the future but suggests apathy and death. A sense
of social "drifting" becomes the context for Homer's late oils; conversely,
these works become the evidence of a grim sensibility. Even when formalist
concerns have much dominated twentieth-century art history, statements,
and implied narrative retain impact. So viewers of Homer, drawn and
repelled by the sharks that demand an end to the story and their hunger,
have latched onto 1899. They want a statement, a sense of ending, in
representations that give transformative shape to chronology. Given a
prompt, a hint of a story, we endeavor to read the past.

As we experience a millennial transition, we might ask, was Homer
compelled by a date? It is impossible to say with blunt certainty. Discus-
sions of the painting take for granted a reading of the 1890s as a despair-
ing, uncertain decade, "a period of hard, hard times."[88] Allegorical read-
ings of *The Gulf Stream* confirm a sense of belatedness associated with
such turn-of-the-century figures as Henry Adams. If Yankee Homer re-
layed his own fears through a stranded black man, he parallels Boston
Brahmin Adams, who epitomized his displacement by writing of himself in
third person and imagining himself as the alien other: "Had [Adams] been

born in Jerusalem under the shadow of the Temple and circumcised in the Synagogue by his uncle the high priest, under the name of Israel Cohen, he would scarcely have been more distinctly branded, and not much more heavily handicapped in the races of the coming century."[89] The era's anxiety, then, conjures up images of the self as its own "branded," "handicapped" other. This is an identification of the worst kind, seeing what is most despised in the self externalized as a Jew, a black, a woman, or an animal. It confirms that much prejudice is the displacement of self-doubt and self-hatred. It is not the path to a new and just millennium.

But should we consider Homer's—and the viewers'—attention to a black man this harshly? Homer's portrayals of blacks avoid the stereotypes of the pathetic slave in need of the abolitionist's salvation, the grinning minstrel, or the extremes of the sexualized exotic. Yet Homer's possible identification with the figures in *The Gulf Stream* and *After the Hurricane* (the artist's name is positioned close to the collapsed man) remains problematic. The paintings' otherness in featuring a black man is compelling, but so is the solitary man in nature—a paradigm of American myth. The gaze of the artist's black figures protects the subjects' privacy, beyond the purchase of observers. Homer's reticence about his paintings and restraint in conveying tension imply the painter's own privacy. His gestural style in *The Gulf Stream* and choice of an imagined scene also suggest a very subjective involvement; yet his approach in general is based on "realistic" objectivity and attention to "factual" detail.

Like Homer's "schoolma'ams," we are left with questions. Does the painting's reception suggest a color blindness, a breakthrough that does not inevitably take the "architecture of a *new white man*," in Morrison's phrase, as the foundation for American individuality and destiny?[90] Is the painting, as Alain Locke believed, emancipating? Is blackness in opposition to the dream of freedom—the Anglo-Saxon new Adam of the colonies devolves by the end of a century of conflict into the hapless, dark figure? The competing views of the black man in *The Gulf Stream* come together in another important way: they sharply underscore that blackness is not merely marginal.[91] For better and worse, race and color (if too often as negative contrast) are deeply involved not only in political and economic history, but in the history of American self-conception and in imaginative representations of the country's hopes and fears.

As a coda to this interrogation of race in the history of a nation and its art, I turn to Homer's *Right and Left* of 1909 (pl. 3). Considered his last

major painting, the work was completed when Homer was seventy-three. Although Homer's hunting scenes do not have the iconic status of the figures at sea, their representation of animals adds further dimension to the presentation of nature, power, fate, and otherness in his work.

Right and Left may not elicit sweeping cultural allegory, but it does leave behind the genre of sporting art to be taken as a reflection on death and an experiment with disorienting form. Its subject matter looks back to the artist's hunting and fishing scenes in the Adirondacks, often done in watercolor—generally thought a "feminine" medium until handled by Homer. These paintings of fish leaping from the stream and deer caught between hound and hunter were popular with the well-to-do clientele of game clubs, such as the North Woods Club, to which Homer and his brother belonged. As a prelude to *Right and Left*, it is instructive to chart similarities and differences between Homer's paintings and the conventions of sporting art. Homer's works, as always developing the expressive power of watercolor and scenery, are never limited to the narrowest purposes of sporting art: documentation of the hunt, display of the trophy, and commemoration of the social class possessing the vigor and leisure for such pursuits. Contemporary sporting paintings that I frequently see in New England and the Midwest (and never meant for exclusive avant-garde galleries) aim to please with depictions of abundant game on a fine fall day, rendered with great verisimilitude. Such works reaffirm the pleasures of rural living and may motivate environmental concern: potential purchasers likely belong to pro-hunting, pro-habitat groups such as "Ducks Unlimited" and "Pheasants Forever." Usually the scene shows some birds in flight, some on the water or ground, though the focus can shift to faithful Labrador retrievers. In most, Nature does not seem red in tooth and claw, and nothing suggests Darwinian survival. Perhaps this art is complacent, sentimental, easy to mock, though in many ways it respects and seeks to protect its subject.

Homer can approach cozy nature in a scene in which canoeists watch a mother duck and ducklings calmly paddle past, as in the watercolor *Young Ducks* of 1897. More often he offered the action of hunting—the animal's flight, the shot, the retrieval of game—and a distinctive view of the hunter and prey. While current stereotypes of hunters fall somewhere between soulless rednecks and Zen masters of patient skill, more dominant in the nineteenth century was the gentleman in the field. Those who hunted for money and food were looked down upon as lacking sportsmanship: their "pot shots" were acts "of cowardice and ill-breeding."[92]

Homer replaced the sporting gentleman image with the myth of the representative rustic American at home in the wild, shaped by nature, taking only what he needs. The artist chose not to depict hunt club members because, as David Tatham explains, these affluent men "would have appeared as outsiders in the wilderness, which indeed they were." Rather, Homer used local guides in their habitual environs, so that many of his Adirondack paintings "offer an ideal (and impractical) relationship of people to the land, tempting us all to become woodsmen."[93]

If his woodsmen were models of self-reliance in harmony with nature, Homer's animals were something other than the prize and property of a gentry class, or romanticized creatures of wild violence. His depictions of dead geese, falling ducks, and wounded deer seem chance reports, but of course Homer has selected what to report. The moods these scenes elicit for viewers are highly subjective. Those who enjoy hunting could find they re-create thrilling sensations. As one British fan declared of the sporting genre, "That man would be a dull dog indeed whose blood was not fired . . . by such vivid scenes of pleasure."[94] Homer's scenes could also expose a naturalistic undercurrent, with forces of aggression and survival in active tension. The focus on the dying animal or carcass, while not melodramatic, is not exactly triumphant.

Subjective responses are tied to questions of social, psychological, and physical perspective. Homer chooses intriguing visual perspectives in several paintings that may disturb, on several levels, other points of view. In the watercolor, *A Good Shot, Adirondacks*, of 1892 (fig. 18), a young buck, hit while running through a stream, is about to fall onto rocks. The shot, indicated by a white puff in the left background, came from the opposite shore. The animal still seems graceful, eyes large and bright.[95] We may be tempted with the wide-eyed to slip into anthropomorphsim and imagine sensibility and feeling. What is more unusual about the perspective is that we seem to witness the scene from the viewpoint of another animal: according to Tatham, "Homer depicts the successful outcome of a hunter's wait on the Hudson, but he shifts the vantage point from the hunter to that of a companion deer, much as he had done in his paintings of leaping fish in 1889."[96]

A variety of perspectives are at play in *A Good Shot*, then, as the title applauds the hunter's skill and victory, and the viewer's position implies a companion in fear and pain. In this combination, the painting anticipates *Right and Left*. The title again requires the inside knowledge of a hunter. In an anecdote related by Downes, a "sportsman" saw the untitled paint-

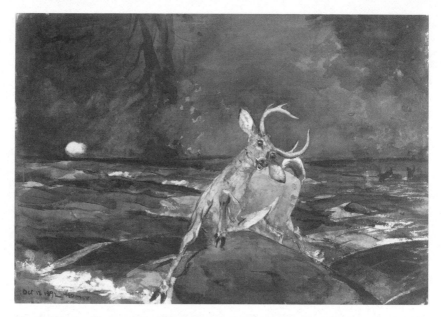

Fig. 18. Winslow Homer, *A Good Shot, Adirondacks,* 1892, watercolor, .382 × .545 (15 × 21⁷⁄₁₆).
Gift of Ruth K. Henschel in memory of her husband, Charles R. Henschel, Photograph © 2002 Board of
Trustees, National Gallery of Art, Washington

ing in a gallery "and at once cried out: 'Right and left!'—admiring, not
so much the picture *per se*, as the skill of the hunter who could bring
down a bird with each barrel of his double-barreled shotgun in quick
succession. So the work was christened.' "[97] While there may be an appeal
to the thrill of blood sport, Homer has again given a familiar genre an
unsettling twist.

Right and Left strikingly departs from simply pleasurable scenes of
outdoor recreation and the trompe l'oeil display of a brace of game. The
undersides of the writhing ducks are almost pushed into our faces. The
confusion of water and sky, the hunter nearly hidden in the distant boat
precariously riding a wave, are akin to the cropping, displacement, and
unexpected perspective of modern art. The hunter is too obscure to be
seen as athletic sportsman or hero: his head is replaced by the red flare
and smoke of the gunshot, as if what matters is the violent action of the
moment. The perspective, like that of *The Gulf Stream*, is an imagined
one, midair over waves, making us ask where we are in relation to the
scene, whether allied with hunter or prey. What relationship do we have

to the obscured, distant hunter, to the jagged waves and sky, and to the ducks at the moment of death with pinpoint eyes?

The eeriness of the painting may be in the duck's eye, which confronts the viewer as human subjects in Homer's paintings do not. That eye's likely artistic source was Audubon's *Golden-Eye Duck.*[98] But whatever their artistic accomplishment, Audubon's works remain in the category of natural history, while Homer's *Right and Left* directly provokes thematic reflection. Like *Fox Hunt* of 1893, in which the predator fox deep in snow becomes prey to ominously oversized crows, *Right and Left* is the work of an aging painter witnessing others', and by implication his own, mortality. These paintings do not suggest the sort of power contested in the marketplace but, more like *The Gulf Stream,* an inevitable doom.

Since ancient days, animals have stood in for human strengths, weaknesses, and fears; Homer's symbolic use of them reveals connections and gaps in such identification. John Berger, in probing why humans look at animals in fascination, posits similarity and difference: animals "are both like and unlike" *Homo sapiens* because they too are "sentient" and "mortal," yet a dumb beast lacks language, which "guarantees its distance, its distinctness, its exclusion, from and of man." Berger continues, "Just because of this distinctness, however, an animal's life, never to be confused with a man's, can be seen to run parallel to his. Only in death do the two parallel lines converge."[99] It is often this moment of death that Homer depicts, attesting to the triumph of the hunter over the hunted and to the harsh brevity of all life.

The parallel dissolves again when consciousness (the blessing and curse of those with thought and language) is taken into consideration. Humanity believes it has the power of the conscious gaze. We observe animals, while as Berger reminds us, "The fact that they can observe us has lost all significance. They are objects of our ever-extending knowledge." Animals, as women and minorities have often been viewed throughout history, are "objects" inferior in consciousness. Yet they also evoke myths—from the primordial to the romantic—of what it means to be natural, belonging to physical existence in direct and "real" ways that self-proclaimed rational and civilized human beings imagine lost to them. The life of instinct becomes an elusive unity of the bodily and the spiritual. To quote Berger again, "the life of a wild animal becomes an ideal, an ideal internalised as a feeling surrounding a repressed desire."[100] This "repressed desire" to recover the nature latent in human existence through immersion in the nonhuman wild surfaces in Homer's outdoors. While the artist employed

working-class inhabitants as models, his urban patrons returned to Nature through his works. Nineteenth-century upper-class pursuers of the outdoors "Strenuous Life" sought respite and recuperation from the demands of Mammon. "To protect themselves against false gods," Peter Schmitt comments, "these sportsmen took to the woods and periodically lived for a time the primitive life they would not dream of making permanent."[101]

The death of the ducks in *Right and Left* is quite permanent, however. But can the look of death convey anything, or is Homer only recording visual fact with the eyes of a deer and duck? We cannot cross the divide between species to imagine what animals see, except to make crude guesses that they see food, safety, and danger. The imaginative possibility exists that in *Right and Left* confrontation and understanding of the other—prey and fellow mortal—are proffered and denied in the stare of the yellow eye.

Identification and otherness, the projection of self and the opposition to self, private and public visions, subjective and objective impressions, are never completely resolved in Homer, so that ambivalence and ambiguity merge with the supposed certainty of his realism. These underlying tensions create in the late paintings, as one art historian explains, "the 'modernist' edge that has ensured his reputation even among the champions of twentieth-century American art for whom typical nineteenth-century illustrative painting holds little charm."[102] Homer's depictions of the marginal and the victim—human and nonhuman—make us confront generalizations about power, impotence, and their connection with "natural" and social forces. At times they confirm stereotypes; their close attention to the subject can also see through the glaze of habit, opening the imagination to nuanced perceptions. As the cotton-pickers, resigned boatman, and staring animals reveal, self and other are not always and forever divided into us and them, but connect in fluctuating give-and-take. The other is different and like us, a paradox that requires constant navigation.

Though the modernist tendency has been to downplay the illustrative and thematic in the artist's career to praise the painterly, I suspect he would not be Homer even to formalist critics if there were not the backdrop of the symbolic ocean. Meaning is both desired and renounced in the late seascapes; the ghost of contemplation permeates the mists of the nearly abstract canvases. Later artists would also turn to the sea, often taking with them the paintbox of modernist composition, as did John

Marin and Marsden Hartley. Some like Rockwell Kent would evoke myths of men made heroic by contact with physical labor and wilderness. But none—because of that mysterious interplay of the particular talent in the particular historical moment—would attain the status of Homer, or as convincingly relay the ethos of individual and place. Perhaps for popular and elitist audiences landscape had to be updated with new location and mediums, with myths and techniques aligned with high modern traits, such as primitivism and technological experimentation; consider Georgia O'Keeffe's Southwest of bone and sand, or Ansel Adams's precisely focused mountains. As Frost would experience, it became increasingly difficult to be a respected Yankee in quaint New England during the twentieth century.

To many, Homer's scenes offer a retreat: half escape from the increasingly urbanized life of America, half confrontation between man (occasionally woman) and nature. While Homer the person stayed in contact with family and dealers and participated in local real estate developments, the artist offered something else. In the solitude of the paintings, he is measured against the vitality, endurance, and mortality of working people and animals; he is pitted against the ocean's turbulent power. It remains for us to decide which is "illusion": the contemporary scene Homer would not depict, or the relationship of the human to the wild. The late paintings, which belong by date to the emergence of modernism, offer neither dominant social realism nor a radical challenge to the conventions of artistic perception. This is not to conclude that Homer was naively old-fashioned, but to emphasize that for him nature remained the essential metaphor for exploration of the human. Though the artist can neither look out far nor in deep, he sees enough to test identity and destiny continually against the waves.

The Hick on the Hillside, The Woman at the Window: Frost's Rustics

> Joe said: "You big boys ought to find a farm,
> And make good farmers, and leave other fellows
> The city work to do. There's not enough
> For everybody as it is in there."
> "God!" one said wildly, and, when no one spoke:
> "Say that to Jimmy here. He needs a farm."
> But Jimmy only made his jaw recede
> Fool-like, and rolled his eyes as if to say
> He saw himself a farmer.
>
> —ROBERT FROST, "In the Home Stretch"[1]

To write of nature alone seemed retardataire enough for the elite circles of early modernism. To present oneself as a farmer was to invite caricature. To experience lyrical transport on a walk appeared above social matters. To attain it picking apples or see it lacking in the lives of country neighbors stirred up unflattering rustic stereotypes. For his first readers and current audience, Frost's real and poetic farming complicates the transcendence of the romantic amble with aesthetic and class issues. Even many positive readings of the poet convey an unacknowledged suspicion toward the program of Wordsworth, Emerson, Thoreau, and Whitman to bind poetic diction to common experience of "ordinary" men and women. (Great faith in the common man and intense suspicion of the masses often run side by side in American culture.) Mocking, apologetic, and defensive responses to Frost—when set against historical attitudes toward the agrarian and New England's "decline"—illustrate how he was marked by wide-

spread condescension toward rural life. As suggested in the second chapter, a deep cultural ambivalence toward the role and character of the farmer hampered Frost and fed his sense of exclusion. Yet this ambivalence curiously enabled him. Rustic sage *and* modern skeptic, he could tap nostalgia for a simple, virtuous country life just as criticism of that life made acceptable depictions of its isolation and dreariness.

From the earliest interviews through late public appearances, Frost has acted, has avoided, and has been coerced into being the poetical farmer. By his own account, he was and was not a farmer. The stances vary in the poetry: sometimes Frost speaks as laborer at one with his work ("After Apple-Picking"); in others he seems a farmer, though a relative newcomer unclear on native habits ("Mending Wall"); and at times he announces himself the poet ("New Hampshire"). Frost worked at farming, played at farming, was lazy about farming, but he aimed foremost to be a poet—albeit a poet who had many farms (fig. 19). In 1913 Frost wrote to friend and former student, John Bartlett, of literary success and farm failure, "But really to arrive where I can stand on my legs as a poet and nothing else I must get outside that circle [of esteem only] to the general reader. . . . Ain't working the land? Easier to write about it? Think I don't understand?" The next year, also in a letter to Bartlett, Frost reversed direction: "I won't make much from poetry. . . . It seems to me as I look at it now I had much rather farm than write for money." Then in a 1915 letter to anthologist William Braithwaite, Frost subordinated farming to the role it played in his first books: "I kept farm, so to speak for nearly ten years, but less as a farmer than as a fugitive from the world that seemed to me to 'disallow' me." In 1960, Frost told Richard Poirier, "I'm not a farmer, that's no pose of mine," but also said, "I haven't led a literary life."[2]

Whatever he called himself, Frost experienced the hard work and near poverty of farming, and his poetry tapped an American ideal both literary and political: the self-reliant farmer whose economic, civic, and imaginative needs converge. In Thoreau's words, this "most poetical farmer . . . does nothing with haste and drudgery, but as if he loved it." Not only should this figure transcend haste and drudgery, he should transcend class issues. As much as Frost participates in this ideal, his work discloses a rift between the poetical and the unpoetical farmer, between the agrarian ideal and the tedium, isolation, and low-class status often linked with rural life.

Frost's audience would have him rumpled, thoughtful, joking, and for

Fig. 19. Frost Children at Derry farm, 1908. Dartmouth College Library.

a moment distracted from poetry with concerns about newly planted fruit trees—and he would play to that audience. A *Boston Post* interviewer in 1916 quotes Frost as saying "I like farming, but I'm not much of a success at it. Some day I'll have a big farm where I can do what I please." The interviewer then fancifully imagines a charmed idyll where the poet will "loaf" as he pleases in a "village forgotten by the whole world." This journalist is later chastised not by Frost, but by a townswoman who objects to the characterization of "our beautiful little village of Franconia" and to her own as "The Old Woman in the Deserted Store."[3] Such mockery and defensiveness of a half-fictionalized country-village poet persists. To cite Joseph Brodsky again, Frost is "a folksy, crusty, wisecracking old gentleman farmer": this typical portrayal of gentleman and hayseed originates in the American variant on the city/country split. Scholarly defenders of Frost emphasize his dark side to save him from his casting as village elder (which, as it turns out, is not far from the country rube).

"Rustic" and "clown" were synonymous in the 1500s: a boorish oaf whose ignorance provides low comedy. Frost himself acknowledges that "rustic" role in a 1937 talk, "What Became of New England?": "All men were created free and equally funny. Before you laugh too much at that,

take another look at it. Four hundred years ago the only people who were funny were yokels. . . . Now, today, even kings are funny. We've come a long way."[4] That equality has not quite seeped into Frost criticism. Foes and friends alike relish coining phrases for the "bad" rustic Frost, as they react with seemingly savvy wit to his popular image: "as American as apple pie," "the reality of farmhouse dung," "a farmer schizophrenic, half Vermont maple-syrup and half raw granite."[5] Critics call up such images presumably to dispel them; yet, half-repelled, half-fascinated, they continue to invoke them and do not always look far behind the stereotypes they play upon. An exception to the mockery is provided by another country poet, Seamus Heaney, who "did love coming upon the inner evidence of Frost's credentials as a farmer poet" and praises Frost's "grim accuracy" in presenting rural life's harsh events.[6] (Apparently it remains more respectable to allow an Irish poet to claim country and folk traditions.) While the clever name-calling intends to puncture a "false" image and redeem Frost, it partakes of the prejudice it is meant to dismiss. While sensing that Frost could not be Frost without provincial New England, scholars employ stereotypes that reflect their absorption of cultural biases and make Frost's attachment to farming suspect. By indulging in rather than questioning the archetype of the rustic as clown, rube, buffoon, bumpkin, they touch on a condescension toward rural life that has run parallel to its idealization throughout American cultural history.

Those stereotypes became especially prominent in the late nineteenth century and the first decades of the twentieth (when Frost was working farms, teaching, seeking to be published, receiving first reviews) and they mark a shift from support of farm life as central to the nation to condescension toward a rusticity that increasingly seemed an aberration on the margin. Caricatures of rural types had long been present, but earlier they had been overridden by faith in the morality and civic purpose of a life in nature and by the potential of the American land. In the late eighteenth and early nineteenth century, figures as various as Thomas Jefferson, J. Hector St. John de Crèvecoeur, and Henry David Thoreau, and movements such as Fourierism promoted an agrarian ideology. Popular illustrations of farming were a form of sentimental propaganda in an economic climate aimed at promoting settlement, a cultural one elevating the virtue of the yeoman-farmer, and an aesthetic one admiring idealized peasants.

As the nineteenth century and industrialization progressed, condescension began to outweigh idealization. Of course, the country mouse could mock the city mouse, too, and rural attitudes toward a rising dominant

urban culture voiced animosity and anxiety. In an 1854 editorial, "Stick to the Farm," a defender of rural life hammered on the demeaning corruption of the city:

You, by birth and education, intended for an upright, independent, manly citizen, to call no man master, and to be no man's servant, would become at first, the errand boy of the shop, to fetch and carry like a spaniel, then the salesman . . . to bow and smile and cringe and flatter—to attend upon the wish of every painted and padded form of humanity . . . and finally, to become a trader, a worshipper of mammon . . . compelled to look anxiously at the prices current of cotton and railroad stocks, in order to learn each morning, whether you are bankrupt or not, and in the end, to fail, and compromise with your creditors and your conscience, and sigh for your native hills.[7]

Apparently, many in the late nineteenth and early twentieth century did not abide by this advice, resulting in the well-known depopulation of New England. During the citified modern era, the "upright, independent, manly" yeoman became the rube requiring the salvation of urban expertise.

This shift in attitude included an association of the rural with the backward and degenerate. After the Civil War rural families were increasingly viewed as sources of "illegitimacy, criminality, insanity, and retardation."[8] If prosperous farming practices already too much resembled agribusiness for traditionalists, the small family operation was ailing. To save the rural population and the country as a whole, urban "experts," supported by President Theodore Roosevelt, sponsored the "Country Life Movement." As agricultural historian David Danbom explains, "To the farmer's urban friends he was the prototypical American, the independent, self-reliant, natural, productive middle-class yeoman, the rock of republican government and the conservator of national morals. . . . But to the farmer's urban detractors he exemplified the worst in American society . . . crudeness, waste, ignorance, and degeneracy." Not much came of the movement, except its powerful influence on the farmer's social status: before the twentieth century, as Danbom writes, the "typical person was a farmer. . . . Now farmers had become peculiar. They were objects of concern."[9]

Rustic stereotypes seem to belong to some distant century, but in nostalgic, comic, and ironic forms they cross over into the twenty-first. The stereotypes resurface during presidential election years when an agricul-

tural state like Iowa becomes newsworthy. The transactions between government and agribusiness become blurred with nostalgia and politicians' desires to appear authentic. In 1999 Vice-President Al Gore "played hayseed" with dialogue like "I hear tell there are gonna be some *caucuses* around here": as columnist Joe Klein observes, "Politicians have forever indulged themselves in misty-eyed Jeffersonian rhapsodies about yeoman farmers."[10] We also live with wholesome images of farm life in promotions of regional tourism—red barns, apple orchards, fall leaves, clear ponds—and advertisements. On television, a healthy-looking farmwoman/actress in the rolling countryside of a Grant Wood landscape advocates the synthetic fat, Olean. At the movies, *Babe* not only made a star out of a robotic pig who wanted to be a collie, but also the laconic, long-faced farmer, who in the triumphant resolution got the last word, "That'll do, pig." On public radio, Garrison Keillor in his blend of high and low art immortalizes the mythical Midwest of "Lake Woebegon," home of Norwegian bachelor farmers. His monologues interweave light satire with rueful longing for a fading rural culture. Perhaps in reaction to the sentimentalization and commercialization of country life (which have gone hand in hand since the days of Currier and Ives), "serious" literature and art have occasionally thrived on the reverse, on farm and backwoods decadence: James Dickey's *Deliverance,* Carolyn Chute's *The Beans of Egypt, Maine,* and Jane Smiley's *A Thousand Acres.* (The clichés of ruin, ballooning from moments of truth, usually stress the city as seducing with glamor, power, and money, while the rural is left to feuding and incest.)

Obviously in comparison with Olean advertisements, *Babe,* and *Deliverance,* Frost's depictions are subtle, but they and his reputation commingle with extreme views of the country. Despite the damage of the farmer-buffoon image, those shifting attitudes permit the "good" and "bad" Frost to come together. The poet can be at once a comforting throwback and a disturbing modern. While his popularity and his farming attempts push Frost beyond self-contained literary pastoral, his poetry does not attain the ideological impact of eighteenth- and nineteenth-century representations of rural life, from Jefferson to popular illustrations. Although many of Frost's poems carry on the rustic myth of virtuous self-reliance, others depict doubt, betrayal, blankness, suffering, and neuroticism. He can write "Mowing," "The Code," or "Two Tramps in Mudtime" to satisfy nostalgia for the Yankee yeoman whose avocation and vocation are one. He can dramatize "illegitimacy, criminality, insanity" in such pieces as "A Servant to Servants," "The Housekeeper," and "The Witch of Coos." The strong

heritage of idealizing the simple life set against urban condescension toward the rustic created a peculiar opportunity for Frost, who found himself a New Englander despite his California childhood. If he wrote endearingly of fetching a calf, an audience was ready to be assured of country goodness. If he wrote bleakly of lonely old men, skittish wives, and dying farmhands, an audience would accept them as confirming the worst of rural isolation.

This bleak portrayal of New England has nineteenth-century precedents. However, as noted above, critical representations of farm life were often overshadowed by complacent images. Much nineteenth-century "art and literature created [rural] stereotypes that masked and blunted social realities even as they exalted values and ideals"; this climate rejected Winslow Homer's rural scenes because the squinting faces of "his farm workers were not often vehicles for statements on heroism, nobility, or rural virtue."[11] Earlier Hawthorne's *The Blithedale Romance* was another exception that punctured the simple-life utopia with schemings of romance and power. However, it centers on city-bred sophisticates while the farm folk are stock characters with no insight into the sufferings of the sensitive and imaginative. Again in that era, a comforting view was more fully embraced. John Greenleaf Whittier, radical in his abolitionist politics, was in another vein the soothing poet of the hearth. "Snow-Bound, a Winter Idyl" counters drear isolation with sympathetic fireside portraits of rustics and guests. Its reception also demonstrates how early such a life seemed a lost past. In 1866, James Russell Lowell praised the poem's "New England interior glorified with . . . inward light" and lamented that "Snow-bound" is of historical interest in describing "scenes and manners which the rapid changes of our national habits will soon have made as remote from us as if they were foreign or ancient. Already, alas! even in farm-houses, backlog and forestick are obsolescent words, and close mouthed stoves chill the spirit while they bake the flesh with their grim and undemonstrative hospitality."[12] There are at least two lessons in Lowell's response to the popular poem. The pastoral ideal for every generation often belongs to a simplified, yet often highly literary or artistic, version of past. As a corollary, it is difficult to honor farm life in a present moment and present place. It is so much more comfortable to dream of past rusticity than to consider it as a current alternative. Lowell does not volunteer himself to return to that life.

To extrapolate from the unpopular bluntness of Homer's farms, the urban bias of Hawthorne, and the popularity of Whittier, the later deval-

uation of rural life led both to condescension toward Frost and to poetic freedom from "rustic fancy dress." The "decline" of New England along with the diminishment of the agrarian model for democracy (not just a high-modernist agenda to explore darkness) made possible less idealized portraits of farm and nature. His bleakness was also anticipated by "local colorists" such as Mary Wilkins Freeman and Sarah Orne Jewett.[13] At times, he was relegated like them to a supposedly dated, sentimental regionalism; at others, he was praised for the sophistication of his skepticism and his connection to a dominant (and male) poetic tradition. Thus the "abandoned" landscape so prevalent in Frost's imagery, while suggesting the economic difficulties of the family farm, permits a return to "highbrow" poetic tropes: to a rustic virtue, untainted by market values, and to the solitary imagination's contemplation of wild nature. Where capitalism fails, transcendence returns.

The backdrop for Frost's pastoralism—the extent of New England's "failure" as a farm region—is a matter of historical debate. There have been and continue to be prosperous farms (though not on the expansive scale of the Midwest and West), alongside derelict ones with ramshackle buildings and pasture reclaimed by wood. In a detailed historical study of a Vermont village at the end of the nineteenth century, Hal Barron counters the notion of "extraordinary decline and decay." He acknowledges the extensive out-migration, especially of young men and women, as he posits that New England communities became more stable and homogeneous, and more stagnant. While poverty and degeneracy may not have been certitudes, hill-country farming seemed distant from the professionalism, efficiency, variety, flux, and "progress" that came to define the urban. Remote in literal and figurative ways, the farm thus became prone to suspicion; as Barron explains, "American culture then, as now, had little tolerance for a situation that did not give at least the illusion of rapid growth and progressive advance."[14] The decline of New England, real enough in some instances, became enlarged as a foil to modernism.

A surface reading of *North of Boston*, Frost's "book of people," could confirm that decline. The poems include deaths of old and young, abandoned cottages, cellar holes, poor children, bad farmers, all set in what "The Generations of Men" describes as a "rock-strewn town where farming has fallen off." Frost, again in "What Became of New England," resisted that dominant impression: "[*North of Boston*] got praise in a way

that cost me some pain. It was described as a book about a decadent and lost society." He rejected a "distinguished" but unnamed critic's comparison of "The Catholic peasantry of Europe [which] renews itself through the ages" with "the Puritan peasantry of New England, [which] has dried up and blown away." Instead of making a direct rebuttal in that speech, Frost implied a significant difference rooted in nationality and the ideal of New England's independence: "The first mistake, of course, was the word peasantry."[15]

While the relation of the poet in the romantic tradition to either "peasantry" or "yeomen" varies, one familiar point is that the poet—as he claims to speak for other men—often allows himself, or is granted by others, a superior sensitivity to landscape. In the Wordsworthian tradition, the poet is inspired by solitary reapers who sing in a strange language and by humble leech-gatherers, as he remains distinguished by his articulate genius. In the rougher American mode, it is a challenge to be first among "equals," to speak as both leader and as one of the many. As Whitman writes in the opening of "Song of Myself," "what I assume you shall assume"—but he assumed it first. So a not uncommon reading of the poet's relationship to landscape and the figures of that landscape applauds the poet's unique perception. For example, David Bromwich writes of Wordsworth's "Resolution and Independence" and Frost's "Two Tramps at Mudtime," the "pleasures of landscape will belong to the poet alone, and be felt at the intervals of his self-questioning; to the figure who confronts the poet, on the other hand, landscape hardly exists."[16] Such a reading may be enhanced by theoretical attention to a poet's self-construction and the fictionality of that construct. Yet it must be kept in mind that the poet is also constructing other characters. Sustained meditation does belong to the solitary poet of many Frost works, but others imagine rural figures who indeed express the trials and pleasures of the landscape.

For *North of Boston,* Frost drew on several acquaintances who are presented as "colorful" characters and as individuals with conflicted responses to their circumstances. These included Carl Burell, who returned to high school (where he met Frost) in his twenties, worked on one of Frost's farms, and was an amateur botanist whose references included Linnaeus and Darwin; John Hall, whom Lawrance Thompson describes as having "little schooling" but a "picturesque vocabulary," "ready wit," and way with animals; and the French Canadian farmer Napoleon Guay. These individuals are known to us largely through Thompson's biography

of Frost, which readily calls them "back-country" people and depends heavily on the poems as evidence of their character. Whatever filter that biographical slant provides, the poems themselves rely upon rural stereotypes and folk ways even as they push to a more inventive awareness.

It is the slow-moving local of "The Mountain" who presents the enticing images of a mountain spring and provides a poetics of sort (more on him later). In "The Black Cottage," a local minister represents a blend of genteel learning with intellectual restlessness: thinking of the Civil War and perhaps Shelley's "Ozymandias," he contemplates faith and idealism. In "The Generations of Men," two "stranger cousins" flirt and speculate about the mystery of "an old cellar hole" that contains the "origin of all the family," their discussion including allusions to Homer's Nausicaä and Shakespeare's Viola, as well as to the "madness" resulting from inbreeding.

"A Hundred Collars" sets up an explicit tension between the native who left to be transformed into a "great" scholar (a "democrat, / If not at heart, at least on principle") and one who stayed, the intimidating half-naked "brute" Lafe. This poem, testing the scholar's "principle," is an extended joke loosely based on the formula that the bumpkin gets the better of the sophisticate. However, its characterizations move beyond simplistic reversal. Lafe, who can easily outtalk "Professor Square-the-circle-till-you're-tired," realizes that his job as collector for a newspaper appeals not because he forces people to pay (he doesn't), but because he enjoys the scenes of rural life: "What I like best's the lay of different farms, / Coming out on them from a stretch of woods, / Or over a hill or round a sudden corner. / I like to find folks getting out in spring, / Raking the dooryard, working near the house." Although Lafe's words (as Frost presents them) may not be strikingly graceful, they convey a conscious appreciation of the rural scene.

"The Self-Seeker," based on a mill accident that happened to Burell, both employs and challenges city/country stereotypes. The poem's speaker, whose injury may leave him crippled, cannot or does not wish to fight the meager settlement offered by the condescending lawyer who represents "stockholders in Boston." The loss for the speaker is not the pragmatic ability to work. More important to him, his friend, the child who visits, though not to the lawyer, is the man's ability to continue his botanical studies and hunt wild orchids. His sensibility—his dedication to flowers, his resignation, his insight into people about him—is more refined and complex than that of the lawyer who is a mere factotum of commerce.

"The Mountain" is a poem that like its landscape is relatively neglected.

It illustrates how New England's "abandonment" creates poetic possibilities for Frost and suggests as well parallels between painterly and poetic landscapes. More important, it highlights the "rustic" as source of lively—not just clichéd—literature. This poem calls to the surface tensions in Frost's poetry: the uneasiness between stranger and native, between the well-off and not-so-well-off, between cultivation and wilderness, between imaginative seeing and practical work. At several different levels, it hints at the difficulties of becoming a poet of New England. The poet seems unsure of his alliances: the poem owes much (too much?) to the English tradition, and within the text the speaker is not sure whether to ally himself with the quester who would climb the mountain or the worker who would keep his place at its base. In this, "The Mountain" touches on a New England that can figure the sublime and lively talk and then repress romantic impulses in the name of practicality and dour habit.

In this poem Frost does not play the poetical farmer, but an outsider. That status alone sets up a significant gap between farmer and speaker. The gap, however, may be different than what occurs in a Wordsworth poem. Along with the superiority of imagination that enables him to partake of the landscape's pleasures, the Wordsworthian observer-poet presumably has a speech, manner, and dress that distinguish him from the rustics. It is difficult to say whether Frost's speaker would present a strikingly different appearance from the man he stops: the circumstantial evidence of photographs from the poet's early years suggests not (fig. 20). Although Frost's poetry may not seem extremely class-conscious, tensions between social (and literary) rankings underlie some of his writings and self-defensive remarks, and feed his claims to be "ordinary" rather than elite. "The Mountain" illustrates the blurred boundary between native and stranger, and between the ordinary man and the poetic "visionary."

The poem offers a colloquial encounter, yet in Frost's mix of the serious and playful it relies upon, and to an extent rewrites, "highbrow" landscape conventions shared by nineteenth-century poetry and painting: the sublime mountain; the middle ground of human cultivation; the human figures that provide scale and access for the viewer/reader; the concept of the prospect that suggests godlike vision, knowledge of nature, and political control. Frost rarely extols the breathtaking vista. Like Robert Burns, who was not always grand enough for Wordsworth, Frost often approaches nature in the small, immediate present, which under scrutiny leads outward, as in "Design." Though "The Mountain" may distantly echo Wordsworth and Shelley, it disavows grandeur:

Fig. 20. Frost in South Shaftesbury, Vermont, 1921. Courtesy of Dartmouth College Library and Blackington Collection, Yankee Publishing Inc.

> The mountain held the town as in a shadow.
> I saw so much before I slept there once:
> I noticed that I missed stars in the west,
> Where its black body cut into the sky.
> Near me it seemed: I felt it like a wall
> Behind which I was sheltered from a wind.[17]

Contemplation of the scene inspires neither the sublimity of inexplicable forces nor expanded human vision. The mountain's power is mostly negative: it "held the town as in a shadow," and cuts out the warmth and

light of sun and stars. It is perhaps a protective wall, but so near that it oppresses. However, this black mass, whose size and inaccessibility hint at the sublime, gives way to a "middle ground" of fertility: "And yet between the town and it I found, / When I walked forth at dawn to see new things, / Were fields, a river, and beyond, more fields."

These lines evoke a peaceful Eden, a fertile vista, like that of Thomas Cole's painting *The Oxbow*, in which one sees "new things" at "dawn." However, the river, "fallen away" since spring and making "a widespread brawl on cobblestones," had left "Good grassland gullied out, and in the grass / Ridges of sand, and driftwood stripped of bark." These images could be read as picturesque, rendering the landscape irregular and wild. But they also present a diminished scene, like the summer in the later and better known poem "The Oven Bird." With either reading, this middle ground suggests New England's agricultural decline and so thwarts Arcadian conventions.

Then another landscape convention is thwarted. If one function of a representation of Nature is to lead to identification, thus giving to the sublime "a local habitation and a name," and another to claim the prospect by naming it, again there are misses. The poet meets a local, a seemingly Wordsworthian figure, "who moved so slow / With white-faced oxen in a heavy cart," and he asks this New England Michael the town's name. Upon hearing "Lunenberg," the poet finds he was "wrong" in his assumption. (The setting is half-invented: Lunenberg, Vermont, is twenty-five miles away from Mount Hor and Pisgah, which border Lake Willoughby, an area where Frost camped.)[18] A tension continues, between the traveling/tourist poet and the local farmer, and between the mountain and a cultivated, prosperous land. Upon being questioned, the farmer claims

> "There is no village—only scattered farms.
> We were but sixty voters last election.
> We can't in nature grow to many more:
> That thing takes all the room!" He moved his goad.
> The mountain stood there to be pointed at.

The farmer strikes an independent figure as small-town democracy struggles against an older romantic tradition. The poetic dialect "naturalizes" the conventions of the sublime, making the limits on human population appear the inevitable result of Nature's force: "We can't in nature grow to many more." Meanwhile the scene is hardly aggrandized by the vernacular complaint, "That thing takes all the room!" The following line, "The

mountain stood there to be pointed at," both naturalizes and exposes the act of seeing a place as a landscape, bound to elicit response from the human spectator. The mountain seems created "to be pointed at," yet that "fact" raises questions about why we look at such a scene and what we look for. More specific to this situation, what do a native and a traveler, who are not romantic tourists or bards, make of a mountain that seems to invite response and attention even as its inhuman mass frustrates them?

The mountain becomes a barrier against the encroachments of cultivation: "Pasture ran up the side a little way" to be met by a "wall of trees with trunks." It is finally named, "Hor," which lacks the European finesse of "Mont Blanc" but has its source in a student writing on "Petra and Its Surroundings" done by seventeen-year-old Frost. That youthful exercise illustrates Frost's absorption of sublime conventions:

From Mt. Hor the view is one of magnificent sameness; but not until the cliffs have towered above, not until the storm has crowded its overwhelming torrents down the ravines, can the grand sublimity of the situation be felt. . . .

But the centre of all, once the busy capital of a thriving nation, now the "City of Tombs," the capital of ruin and decay, is in the sublimest situation of the wilderness.

What a place for romance where everything is as vague as a rainbow half faded in mid-air. In our society novels the imagination displayed is as it were a flying squirrel's flight from a tree-top downward; here it might take its flight as a bird from a fountain of youth.[19]

The mature Frost would turn away from florid admiration of lost civilizations in the wilderness, testifying to the uneasy fit between New and Old World traditions, and between the grand style and the play of the human voice that fascinated him. However, the ravines, a suggestion of past torrents and ruins, and a fountain remain in the poem. "Hor," while belonging to the land of understated farmers, nonetheless suggests a totem of some mysterious divinity that pushes back human progress.

The unknown invites exploration, even from such "ordinary" folk as the two men of the poem. The traveler inquires about climbing the mountain, imagining a godlike prospect of possession and knowledge, followed quickly by practical doubts:

> "There ought to be a view around the world
> From such a mountain—if it isn't wooded
> Clear to the top."

This hope recalls transcendentalist statements that the poet's eye, more so than the deeded farmer's, possesses the landscape. As Thoreau writes in *Walden,* "I have frequently seen a poet withdraw, having enjoyed the most valuable part of a farm, while the crusty farmer supposed that he had got a few wild apples only."[20] Frost denies this attitude in several ways. No one here becomes "monarch" of all he surveys. And yet, while neither figure "owns" the mountain, this "crusty" farmer seems quite able to imagine the view:

> "I've been on the sides,
> Deer-hunting and trout-fishing. There's a brook
> That starts up on it somewhere—I've heard say
> Right on the top, tip-top—a curious thing.
> But what would interest you about the brook,
> It's always cold in summer, warm in winter.
> One of the great sights going is to see
> It steam in winter like an ox's breath,
> Until the bushes all along its banks
> Are inch-deep with the frosty spines and bristles—
> You know the kind. Then let the sun shine on it!"

That the farmer never climbed the mountain convinced early readers that he is a clod who represents "the whole terrible inertia which has settled upon these people dwelling among the unyielding hills" and shows the "utilitarian attitude of the Yankee rustic": in a 1971 essay, Laurence Perrine upsets these interpretations by emphasizing the "poetry" of the farmer's expressions.[21] The tendency to misread the farmer, though, results from more than sloppy criticism: it again reflects long-standing attitudes about rural doltishness and latent tensions in the relationships of the high and the low.

The poet's questions lead to the local man's admission that he does not know the view from the top, but he does know the "fact" of the spring: " 'Right on the summit, almost like a fountain / That ought to be worth seeing.' " And why would it be worth seeing? Again, the farmer's "common" diction skates over the complexity of the sensual, aesthetic, or spiritual delight of seeing. Why is a scene worth viewing? Why do we seek out "one of the great sights going"—for fun, for a challenge, for enlightenment or a moral? How do social roles affect that seeing? Without providing a concrete answer, the poem's spring suggests a myth of origins,

and the brook it engenders "transcends" the natural order to become a wonder and aesthetic pleasure, as the guide's colloquial manner crosses over into the marvelous with lines that anticipate the "casual" talk of the ice storm in "Birches": "inch-deep with the frosty spines and bristles— / You know the kind. Then let the sun shine on it!"

The farmer also shows himself capable of a simile: the mountain sends a "dry ravine" into the pasture and makes the few houses near it appear "Like boulders broken off the upper cliff, / Rolled out a little farther than the rest." His image reinforces the superior strength of the mountain; it also, however, blurs the distinction between the two men by making evident his own companionably poetic powers.

While the farmer remains secure in his faith that the spring is "Right on the summit, almost like a fountain," he is less secure about his right to climb the mountain. He tells of a hiker who "never got up high enough to see" and in a self-mocking or regretful tone explains the oddity of attempting the hike himself:

> "It doesn't seem so much to climb a mountain
> You've worked around the foot of all your life.
> What would I do? Go in my overalls,
> With a big stick, the same as when the cows
> Haven't come down to the bars at milking time?
> Or with a shotgun for a stray black bear?
> 'Twouldn't seem real to climb for climbing it."

Nature as mystic emblem of poetic or imperial power seems contrary to the rural work of the character who, despite his vivid rendering, cannot imagine or accept himself climbing without a purposeful tool or weapon. Though the rustic seems privileged with a "natural" understanding of the mountain and could be a trickster leading on the ignorant traveler, the passage also suggests class differences more readily accepted in British art. The moral and aesthetic landscape is for upper classes who have the leisure, money, and acquired sensibility for proper appreciation. The farmer cannot forget his chores to repossess the land as the Poet. He cannot change the meaning of the landscape he will continue to work upon; he cannot leave the middle-ground to reach wilderness. His language offers only a figurative passage between rural labor and visionary possession. Like the neighbor in "Mending Wall," this farmer will take his freedom and self-awareness only so far; he will not upset accustomed ways.

The traveler, however, is reluctant to assert himself either as superior in class or inferior in practicality, and so becomes caught between his quest for experience and his wish to blur the difference between himself and the local. "I shouldn't climb it if I didn't want to— / Not for the sake of climbing," he says. Though he may have thought to possess the mountain in a Thoreauvian sense, he discovers he cannot get any closer.

The tone lightens as the poem ends, teasing us with just what is true in the farmer's words and with how we should take the mountain—as an ordinary, literal lump where the water is no different than elsewhere, or as an invitation to "fun." With Frost we're not always sure how seriously to take poetic license. The traveler asks again about the mythic spring, "Warm in December, cold in June, you say?" The local replies,

> "I don't suppose the water's changed at all.
> You and I know enough to know it's warm
> Compared with cold, and cold compared with warm.
> But all the fun's in how you say a thing."

That last line is frequently quoted out of context as characterizing Frost's poetics. Still the words belong to the farmer, a rustic too limited to climb the mountain, yet capable of imagining its sights and to find in them both similes and chiasmus ("warm / Compared with cold, and cold compared with warm"). Unlike Wordsworth's silent or profound rustics, he talks humorously, familiarly, and "equally" with the visitor, another hill dweller who finds time for a long walk. The farmer's "You and I know" anticipates Frost's invitations to his audience, supposedly on his level, in poems such as "The Pasture" and "Birches." Drawn from John Hall, this character implies that Frost learned how to be a poet from "below," picking up dialect and its suggestions of play from the tongues of neighbors.

This line from Frost's second book on "how you say a thing" poses several questions. What kind of poet has he learned to be? Will he be a postcard poet, clever at the dialect of an increasingly sentimentalized region? Or will the sounds he catches convey some abiding "sense"? Does Frost leave his readers as frustrated as this guide leaves the traveler? Have the speaker and audience learned to see and hear of the sublime (and its absence), or only to dismiss it in wordplay that gets nowhere? How we view the farmer and Frost's poetic endeavor depends in part on our attitudes toward the rural. "The Mountain" illustrates, as does most of *North of Boston,* how working out a new poetic language includes testing

relationships among the poet, the people who provide his subject matter, and his readers.

Frost surely realized as much. In a 1915 letter to William Braithwaite, he somewhat ashamedly traces his evolution from a "fugitive" from the world to a member of a rural community:

> It would seem absurd to say it (and you musn't quote me as saying it) but I suppose the fact is that my conscious interest in people was at first no more than an almost technical interest in their speech—in what I used to call their sentence sounds—the sound of sense. . . .
>
> . . . There came a day about ten years ago when I made the discovery that though sequestered I wasnt living without reference to other people. Right on top of that I made the discovery in doing The Death of the Hired Man that I was interested in neighbors for more than merely their tones of speech—and always had been.[22]

By now "the sound of sense" has a long history in Frost's poetics. His own "voice," especially for those who remember it in performance, has at times overwhelmed awareness of its dependence on others. As he wrote in 1915, "All I care a cent for is to catch sentence tones that havent [*sic*] been brought to book. I dont say to make them, mind you, but to catch them." His inscription three years later in a copy of *North of Boston* reasserted the value of "catching": "I am as sure that the colloquial is the root of every good poem as I am that the national is the root of all thought and art. . . . One half of individuality is locality: and I was about venturing to say the other half was colloquiality."[23] All this sounds well and good in its rootedness and independence, but as Frost knew its convincing achievement was difficult. His portrayal of New Englanders and his critical reception test the lines among caricature, sentimentality, deviant obsession, and authenticity.

"The Mountain" combines these matters with the value of landscape. Through conversational understatement typical of Frost, the poem remakes the unprofitable New England landscape into a moralized scene of limits that "transcends" (but not completely) social arrangements written upon it. The poet works to "catch" the sounds of others in a way that credits the rural with indications of the sublime without ever denying its compelling social strictures. A later poem, "New Hampshire," also refers to mountains; there talkative Frost plays the "rascal," the farmer who stands against being "soiled with trade" and having products to sell "in

commercial quantities." This sort of poem comes closer to popular philosophizing on rural virtue than a return to poetic tropes, and is more likely to offend "literate" critics. (Such critique of modern economy has not vanished, though it still struggles with formalist standards; Wendell Berry, for one, integrates the making of poetry with sustainable farming.) Despite possible complacency, "New Hampshire" makes pastoral and landscape significantly more than an aesthetic escape.

> *The treadmill routine of the week is: washing, baking, ironing, fixing dried fruit, airing clothes, sewing, cleaning, baking and cleaning again. So it goes week after week. Eating and drinking, cooking and cleaning, scrubbing and scouring we go through life; and only lay down our implements at the verge of the grave! . . . You bake, and boil, and fry, and stew; worry and toil, just as if people's principal business in this world was to learn how much they could eat—and eat it.*
>
> *Girls, do not scrub and scour until you have no time left to plant a tree, or vine, or flower.*
>
> —Jane G. Swisshelm, *Letters to Country Girls*, 1853[24]

Frost is not only the poet of the meditative walk through nature or the encounter between the local and the stranger. He is as well the poet of the interior (though his farmhouses are not always so cozy as the nineteenth-century hearth) and the poet of the boundary (enclosing, entrapping, mutable) between inside and outside. He often places characters inside a house and then has them crossing the threshold, or has the "outside"—storms, tree branches, the dark—trying the window. Inside is not always safer, even if its dangers are social and sexual. These dangers— of desertion, sexual infidelity, vengeance, and madness—undermine the domestic haven and result in a migration both social and spatial. What seems tamed crosses over into the natural, or more appropriately, the wild and lawless. In "The Hill Wife" from *Mountain Interval* of 1916, a wife who found her situation "too lonely" and "too wild" strays into the wood while her husband works and then on "impulse" she disappears into "the fern." "The Pauper Witch of Grafton" beguiles her husband "Off from the house as far as we could keep" to make him mysteriously serve her in the dark, "And he liked everything I made him do."[25]

Nonetheless, there is more to Frost's portrayal of women than identification with uncultivated subversive "nature." In several poems, women try to fathom their "place" by looking upon the landscape. As "The Mountain" illustrates, the solitary romantic freedom of the outdoor walk

or the inspiration of a fine prospect can be circumscribed by physical, cultural, and imaginative constraints. The men in Frost's poetry generally attain greater freedom to roam and reflect while the view accorded to women is literally bounded by a house. "Home Burial" and "A Servant to Servants" from *North of Boston* and "In the Home Stretch" from *Mountain Interval* present a woman in the archetypal pose of looking out of the farmhouse window. The view she observes disturbs rather than enlightens as it confirms the confinement of her domestic space.

The woman at the window conjures up a variety of mythic, romantic, and bourgeois images: Rapunzels and Juliets at casements, waiting for the beloved; wives faithfully and anxiously awaiting husbands' return; a mother framed by the window (as Mrs. Ramsay is in Virginia Woolf's *To the Lighthouse*) watching her brood. In the American tradition, an image fraught with unsatisfied desire is Whitman's lonely, "richly drest" woman from section 11 of "Song of Myself." From "the blinds of the window" she watches "Twenty-eight young men bathe by the shore." The poet— a voyeur like her, but like the bathers with greater physical and expressive freedom—imagines her dream: "Where are you off to, lady? for I see you, / You splash in the water there, yet stay stock still in your room."[26] And it is not surprising that in "I dwell in Possibility," reclusive Emily Dickinson imagines poetry as a domestic enclosure with a view and possible exits: "A fairer House than Prose— / More numerous of Windows— / Superior—for Doors."[27] In these scenarios, the woman may be at the "heart" of a scene as source of emotional, sexual, maternal fulfillment, or intense longing. Yet she is kept from the adventures and dangers of the world beyond while her happiness depends on the return of others, or on being discovered and led out into the world by men. The window is an "eye" that fosters hopes and worries; unlike Emerson's transparent "eyeball," however, it is a barrier, keeping spectator-women from life beyond the house, keeping them from seeing too much too far. The women of Frost's poetry see too little, as they view nothing to inspire dreams of romance and security, and too much as they see through the landscape a past haunting the present, foreshadowing a future.

It is the view from the window that sets off the infamous argument in "Home Burial": the gravesite that stirs irreconcilable responses from the husband and wife who have lost their first child. They may share a view, as they share a bedroom and a house, but this fact of their marriage is at odds with their emotional distance. The opening lines narrate how the

husband catches sight of his wife on the stairs, "Looking back over her shoulder at some fear." After she challenges him that he cannot know what upsets her, he realizes what she sees:

> "The wonder is I didn't see at once.
> I never noticed it from here before.
> I must be wonted to it—that's the reason.
> The little graveyard where my people are!
> So small the window frames the whole of it.
> Not so much larger than a bedroom, is it?
> There are three stones of slate and one of marble,
> Broad-shouldered little slabs there in the sunlight
> On the sidehill. We haven't to mind *those*.
> But I understand: it is not the stones,
> But the child's mound—"
>
> "Don't, don't, don't, don't," she cried.[28]

In this intimate New England setting, the gaze—who looks upon whom with what assumed right and knowledge—brings out marital discord and reveals the husband's contradictory desires for power and understanding. The husband seeks control through what he observes, while what she sees controls the wife as she surrenders herself to the scene. The "little graveyard" dominates her. She is compelled to look, and that glance undoes her and exposes her vulnerability. The man, seeing her while she does not see him, catches her off guard. He thus enters her privacy unasked, as her pose and what she looks upon unveil feelings she would keep hidden. But this seeing, whatever advantage it might grant him, does not guarantee emotional perceptiveness.

Baring grief in an enclosed tableau, the poem invokes archetypes beyond a particular mother's mourning: the window is filled by a minute example of earth as grave. In the words of William Cullen Bryant's nineteenth-century consolation, "Thanatopsis," "All that tread / The globe are but a handful to the tribes / That slumber in its bosom."[29] Whitman exchanged Bryant's somber majesty for a childlike tone and daring metaphors in the "*What is the grass?*" section of "Song of Myself": "And now it seems to me the beautiful uncut hair of graves. // Tenderly will I use you curling grass. . . . It may be you are from old people, or from offspring taken soon out of their mothers' laps."[30] Frost's poem does not strike the

conciliatory tone of these passages, though it too reminds the characters within the poem and the readers of the death that silently surrounds them, in the common New England graveyards. When "framed" by immediate loss this plot of ground, "The little graveyard where my people are," comes to the husband's attention. In his words, the scene does not evoke intense pain so much as family inheritance and belonging, albeit that inheritance includes the coming and passing of generations—a pattern disrupted by a child's premature death.

The woman of "Home Burial" resists directly her husband's speaking of loss, and indirectly a tradition of male poets taming death with magisterial distance and heightened diction. She will not be consoled. The husband is "wonted" to the scene of the graves, because the homestead was in his family and he has seen it from youth, and perhaps he is accustomed to death as part of an inherited routine. For him, the "family plot" domesticates death. His wife cannot or will not allow that acceptance. Her "glimpse" of death has overtaken her as she dwells on the sight of the grave from the stairway, a position suggesting that she has become unsettled in her domestic role. She is not in the bedroom, nursery, or kitchen, but uselessly, obsessively, between one place and another. What she sees in the landscape reminds her of roles she has lost within the house. She cannot return to the role of mother or of wife, and cannot stay peacefully in the house as long as she dwells on what lies in the earth. For her, the "prospect" offered by her marriage and husband's family farm has shrunk to the one framed by the stairway window.

In rejecting her husband, the wife also protests the earthiness of death. To borrow words from another, less soothing, poem by Whitman, "This Compost," the husband returns the child to "that calm and patient" earth that "grows such sweet things out of such corruptions."[31] The husband's digging of the grave to his wife's silent witness testifies to the emotional terror of their rural isolation. Rural life is idealized—and fled from— because the realities of survival are nakedly present. The father must bury his own child in the backyard, apparently without other mourners to ritualize and soften the moment, and the wife responds, "how could you? . . . Making the gravel leap and leap in air." She can bear neither the finality of individual death nor the cycles that subsume that death into ongoing process: she "won't have grief so." She is repelled by the physical facts of death and its connection to the landscape that surrounds her. The husband's act of returning his firstborn to gravel, and thus to dust, im-

plicates him in the decay. It is a callous act to the wife, a dismissal of the child and of her feelings, that leaves her husband "stained" with "fresh earth."

When "Amy" flees from her husband's protest that she let her grief go and allow him to approach her, she declares "I must go— / Somewhere out of this house." This "ending" to the poem does not offer a specific retreat. Her grief—fed by the landscape, by her husband's acceptance of the integration of death and place, and by his willfulness—can only escape into vagueness. That grief has everything to do with the farm setting: the isolation of the two, the necessity of burying the child nearby, that "family plot" within view of the house. The house, the window, the plot, and the marriage all create boundaries she would escape. The husband worries that she will take her woes to another, violating the privacy of the marriage. In terms of either a literal or figurative resting place beyond death and boundaries, though, she has nowhere to go.

It seems a truism to insist that Frost roots response in a defined setting and depicts in "Home Burial" emotional entrapment as inseparable from physical confinement. But the psychological component of his regionalism depends upon inseparability of feeling and place, even in poems dramatizing sexual, social tensions. The landscape is both source of distress and objective correlative for an interior state, as it elicits reflections on a woman's past and future. Whether she sees landscape as a foreboding other or as an extension of herself, it is where the woman finds herself with no other place or way to be. This reciprocity of scenery and feeling, of place and destiny, is evident in another poem of a woman's emotional malaise, "A Servant to Servants." The speaker's reaction to an ostensibly pleasant view marks her distance from the social "norm" of a contented wife. The overworked narrator, in describing her depression to a visitor camping on the land, has enough troubling self-awareness to believe she cannot voice her feelings: "I can't express my feelings any more / Than I can raise my voice or want to lift / My hand (oh, I can lift it when I have to)." Then she lets her history tumble out to a stranger, revealing the madness in her family as she tells of an uncle locked in a hickory pen in the attic who haunted the narrator's mother as a young bride: "She had to lie and hear love things made dreadful / By his shouts in the night." This background suggests exposure of rural degeneracy. The uncle in the attic, like the grave beyond the window, is a harsh fact that cannot be avoided: there is for him no institution or great house in which to hide his ravings. Interwoven in this distressful tale is the narrator's description

of current surroundings—a palliative, perhaps. Throughout the poem the lonely woman returns to the scene, as if it were a litmus test or as if she expects some relief from picturesque New England to find it fails her.

To illustrate that she is "all gone wrong," the woman dwells on her reaction to the lake:

> You take the lake. I look and look at it.
> I see it's a fair, pretty sheet of water.
> I stand and make myself repeat out loud
> The advantages it has, so long and narrow,
> Like a deep piece of some old running river
> Cut short off at both ends. It lies five miles
> Straight away through the mountain notch
> From the sink window where I wash the plates,
> And all our storms come up toward the house,
> Drawing the slow waves whiter and whiter and whiter.
> It took my mind off doughnuts and soda biscuit
> To step outdoors and take the water dazzle
> A sunny morning, or take the rising wind
> About my face and body and through my wrapper,
> When a storm threatened from the Dragon's Den,
> And a cold chill shivered across the lake.
> I see it's a fair, pretty sheet of water . . . [32]

Again a woman seems compelled to look yet must also make herself respond. The verbs of her account ("look and look," "see," "stand and make myself repeat") indicate a detached and forced activity. She only goes through the motions of appreciating nature. Her gaze does not immediately stir rapture, nor is she ennobled by simple tasks and close contact with nature. Her mood echoes the loss of faith and grace that haunts the romantic tradition. A dejection ode is not just the prerogative of a romantic poet whose uplifting imagination falters, but of a rural woman, constrained by a troubled family inheritance and economics. She too struggles, in the words of Samuel Taylor Coleridge's famous complaint, to "lift a smothering weight" from her breast: though she "should gaze for ever," she cannot "hope from outward forms to win / The passion and the life, whose fountains are within."[33] That Frost attributes to a household "servant" a bard's despair indicates how far he goes in his self-proclaimed attempt to take the passions of poetry down to "the talk of everyday life."[34]

Of course, this servant is fictional woman, and the distance between her "voice" and the poet-creator's complicates a reading of her description's import. The presence of a self-aware romantic is lacking in "A Servant to Servants," yet Frost is not one simply to toss out an insignificant literal description. If an "Oven Bird" can "say" something about landscape in the poem of that name, so can the outpourings of a distraught woman. What follows her forced looking is not a practical evaluation of the lake as source of fresh water or recreation, but rather a detailed account of its form as if that form itself were expressive. The lake's "advantages" are in the geological formation, a plausible rendering of a New England lake gouged by a glacier. It is long, narrow, deep, and old, cut short at the ends: in this, the lake could evoke old sources that instead of flowing freely are now enclosed. It is bounded, as the woman is between mountain and kitchen window, between family madness and demands of work. Also, water imagery (to be further considered in the poetry of Elizabeth Bishop) is frequently associated with the feminine. Men claim, or fail to claim, the mountain summit, while women are linked with fluid, mysterious sources.

As the woman describes the lake she observes while washing dishes, the poem offers intriguing alternation between sublimity and domesticity. The "slow waves whiter and whiter and whiter" hint of ominous powers (as in "Once by the Pacific") and of the terror of blank whiteness (as in "Design"). The waves and the "dazzle" of a sunny day are a distraction from "doughnuts and soda biscuit," and the narrator is temporarily relieved of her slavish social role in a brief surrender to "the rising wind / About my face and body and through my wrapper." Such sensations are connected with the wild, fantastical, and menacing: the storms from "Dragon's Den" and "a cold chill." That potential—for dangerously unsocialized sensuality and for exploring the depths—is controlled for the moment. The woman returns to detached understatement and local pride: "I see it's a fair, pretty sheet of water, / Our Willoughby!" The scene becomes a surface again, like her friendly manner that covers her desperation. The lake's appeal is then confined to that superficial prettiness as she declares it a shared public fact with a common name.

The narrator then turns to the "worth" of the area, a place not quite right for other people, just as she is not quite right for society. The wildness of the lake, despite its occasional power over her, has not saved her. She and her surroundings are not destined for sublime solitude or for material success. The scant development there has not proved prof-

itable, for the cottages her husband built are often empty and her dim hopes for the place match those for herself:

> We've a good piece of shore
> That ought to be worth something, and may yet.
> But I don't count on it as much as Len.
> He looks on the bright side of everything,
> Including me.

If commercialization can threaten romantic transcendence and New England virtue, Frost is well aware that poverty alone will not inspire delight and high-mindedness.

Inhabiting a setting in this poem means being exposed to the influence of "nature" yet limited by the social situation: in this case, neither is sufficient for relief. The narrator recounts how she and "Len" moved from a place "ten miles from anywhere" to improve her mental health, to get her away from her family's "old farm" with its madman in the attic and young bride just below, to get her beyond her own memories of "The State Asylum." However, the burden of her work and her leaning toward illness are too much to be arrested by new surroundings:

> Somehow the change wore out like a prescription.
> And there's more to it than just window-views
> And living by a lake.

The faith underlying nineteenth-century romanticism, that "Nature never did betray / The heart that loved her," is bankrupt here.[35] "Window-views" of a lake are not enough to heal one who believes in the inevitability of her own sickness.

To an extent, the woman's state exemplifies Thoreau's insight that the "mass of men" (and women) "lead lives of quiet desperation": "From the desperate city you go into the desperate country."[36] She also illustrates the difficulty of a woman attempting outdoorsy self-reliance, as she considers an alternative: that she live like the visitor. Not so blatant as those in "The Mountain," tensions nonetheless exist between the constrained local and the outsider—privileged with education, imagination, social class, and in this case, a male prerogative. The woman, who needs rest "from doing / Things over and over that just won't stay done," speculates

about the visitor's life in a tent. Although the brunt of this passage is the narrator's wishful thinking, it also critiques the "naturalist-poet" devoted to observing nature. She is struck hearing how her guest learned of "Willoughby":

> In a book about ferns? Listen to that!
> You let things more like feathers regulate
> Your going and coming.

The guest's botanical interest is an oddity to her, distant from her kitchen world of work. That eccentricity, something permitted an outsider, regulates his travels. She envies, though cannot quite imagine, such an elflike freedom for herself: instead of ferns and feathers, whimsy and curiosity, she has family secrets and chores, depression and duty. The visitor, a wayfarer who can "Drop everything and live out on the ground," is a version of Thoreau's man-in-nature. To the woman, he seems freed not only from enslaving mortgages but also from family obligation and a haunting past. On one hand, her history confirms Thoreau's insights into the burden of rural work. On the other, her suffering contrasts with the naturalist's interests as "light" as feathers, in her view detached from the web of family, marriage, and work.

This visitor does not appear to pursue the publication of life's "meanness," to paraphrase Thoreau, and his way of life represents escape through a curious combination of the frivolous and the daring. The "servant," however, has been too long domesticated. Even though that domestication undoes itself in causing the speaker's near-mad desperation, she lacks the spirit to undertake either more lightness in her life or the challenge of braving the elements: "The wonder was the tents weren't snatched away / From over you as you lay in your beds. / I haven't courage for a risk like that." The woman will sense the wind through her wrapper, but she fears exposing herself further to such forces. She believes she must be "kept" and dares not break the patterns she knows, wretched as they are. Just as the rustic on "The Mountain" does not hike just for the sake of hiking, she does not take leisure to contemplate the lake. She observes it from a wifely vantage point: "From the sink window where I wash the plates."

The visitor has been silent throughout this dramatic monologue; nonetheless, his presence comments on the relationship of poet to those he would poeticize. The woman's present misery makes his own life seem

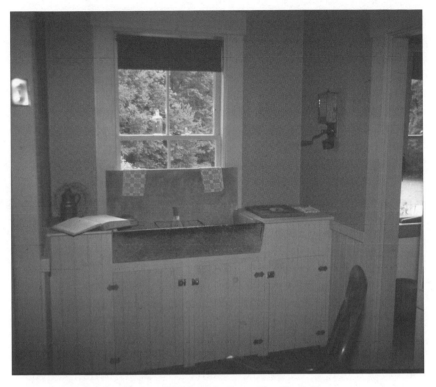

Fig. 21. Priscilla Paton, *The Frost Kitchen Sink, Derry, New Hampshire,* 1999.

the stuff of "feathers," and her words cannot be translated into the "tender melancholy" of a solitary reaper singing of "old, unhappy, far-off things."[37] At the poem's end, she does not peacefully recede into the landscape, but pathetically beseeches the visitor, "I'd *rather* you'd not go unless you must." She had said "there's more to it than just window views," but she is left with those views as her life remains framed by her family inheritance and the ubiquitous kitchen window.

"In the Home Stretch" from *Mountain Interval* of 1916 presents a woman whose voice resembles Frost's male speaker in the ability to speculate, imagine, and see through metaphor. The poem is uneven on several levels: it roughly juxtaposes lyrical, emotional, and blunt language; and the woman wavers in mood and outlook.[38] Her faith in her destiny is compromised by something in her marriage and situation, and a window view confirms that compromise as it shakes hope for the couple's chosen way of life (fig. 21). The wife's observations from an isolated New England

house also reveal how landscape bears the trace of human history: out the window she sees another woman's past that could predict her own future.

In the opening stanzas, the woman is preoccupied with looking out the window of a newly acquired farmhouse, while movers unload the couple's belongings:

> She stood against the kitchen sink, and looked
> Over the sink out through a dusty window
> At weeds the water from the sink made tall.
> She wore her cape; her hat was in her hand.[39]

This woman is drawn to the pose and view that will so often be hers: "sink" is repeated three times as if to stress its presence in her daily routine. The "dusty window" suggests a time of neglect, before which the view had belonged long enough to another that weeds flourish where dishwater had been tossed. Perhaps the weeds alone flourished. The former dishwasher behind that image is never directly mentioned—a telling absence. She has not left behind, as rural workers do in other poems, a tuft of flowers or rotting woodpile; the weeds are her sole trace upon the landscape.

Preoccupied by this discouraging prospect, the woman ignores the movers until one calls her "lady" and asks what she sees. She replies, "Never was I beladied so before." In part she mocks the coarse movers' strained formality, but what she looks upon reveals the future of a farm woman, not a pampered "lady":

> "What I'll be seeing more of in the years
> To come as here I stand and go the round
> Of many plates with towels many times."
> . . . [she turns to her husband]
> "Rank weeds that love the water from the dishpan
> More than some women like the dishpan, Joe;
> A little stretch of mowing-field for you;
> Not much of that until I come to woods
> That end all. And it's scarce enough to call
> A view."

The woman's first response emphasizes time and repetition, foreshadowing a mundane future of drying dishes. The husband, finding her enigmatic, then interrupts, and she provides detail: "Rank weeds that love the

water from the dishpan / More than some women like the dishpan." She envisions a fallen garden of weeds and labor, chores unlikely to inspire epiphanies. What she sees beyond the weeds—a bit of field, "not much"— is hardly more endearing, but is slight consolation given the delight of fieldwork in other Frost poems. The woods are not a place of wildness or further possibility, but simply an "end" to the view of work. There is "scarce enough" to evoke an ideal pastoral or to imagine a prosperous married future.

The woman's speculations and her husband's questions suggest this couple can converse seriously and intimately—a more companionable marriage than in preceding poems. However, the conversation remains strained. The husband is reluctant to realize the extent of his wife's doubts, she to reveal them. He gently presses for reassurance, "yet you think you like it, dear?" Then he presses her further:

> "I think you see
> More than you like to own to out that window."

> "No; for besides the things I tell you of,
> I only see the years. They come and go
> In alternation with the weeds, the field,
> The wood."

To the husband's concern that she sees "more," she replies "no" then contradicts herself by adding, "I only see the years," as if seeing the future were as ordinary as seeing weeds. She is hesitant to outline the confinement of years, her life measured out by dishes washed and dried, and lets herself be distracted again by the movers. Yet that distraction intensifies her mood. Speaking like a poet "in parables and in hints and in indirections," she imagines mortal loss in hearing furniture crash to the floor:[40]

> "It sounds as if it were the men went down,
> And every crash meant one less to return
> To lighted city streets we, too, have known,
> But now are giving up for country darkness."

That "darkness," besides characterizing the unillumined country night, hints of primitive impulses such as those of "Mending Wall" where the neighbor "moves in darkness . . . Not of woods only and the shade of trees." That poem suggests the archetypal aggression behind a neighborly

ritual and behind the farmer's saying, "Good fences make good neighbors." Here the woman's vision of drudgery and mortality upsets the husband so that he would not have her "go behind" her own saying: " 'Come from that window where you see too much, / And take a livelier view of things from here.' "

The darkness she sees "too much" becomes a metaphor for the silent fears underlying choice, marriage, and a deliberate retreat that throws the couple back on themselves alone. Instead of a life of profound simplicity replicated in a farmhouse's elegantly stark form and function, this woman, like the one in "A Servant to Servants," fears a darkness in her existence. "In the Home Stretch" also links that darkness to the perversity of choosing rural life in an era of urban "enlightenment." When the husband lightly suggests the movers try farming, awkwardness follows:

> "God!" one said wildly, and, when no one spoke:
> "Say that to Jimmy here. He needs a farm."
> But Jimmy only made his jaw recede
> Fool-like, and rolled his eyes as if to say
> He saw himself a farmer.

The husband, trying to regain the upper hand with optimism, turns to his wife with "We puzzle them." The sense of lovers contrary to the world recalls "In Neglect" from the earlier *A Boy's Will*, which romanticizes the lovers' flight from conventional expectations and asserts how they will prove doubters wrong: "They leave us so to the way we took, / As two in whom they were proved mistaken, / That we sit sometimes in the wayside nook, / With mischievous, vagrant, seraphic look, / And *try* if we cannot feel forsaken."[41] In these lines, the idyllic pastoral of lovers is realized. It is as if Christopher Marlowe's Shepherdess joined the Shepherd to "all the pleasures prove / That valleys, groves, hills, and fields, / Woods, or steepy mountain yields."

In the later view of New England "pastoral," neither husband nor wife is so young and enraptured. The two are not immune to doubt and feel abandoned in a far less wanton sense: instead of coming across a "wayside nook," they are left facing north and the "back" of a farm. The husband already grants the woman possession of this view; though his tone is half-unnerving, half-playful in imagining how "your woods" will "steal" up on the house. He reminds his wife of their "bargain," but her reply turns to the "fall" of her hopes:

> "It's all so much
> What we have always wanted, I confess
> It's seeming bad for a moment makes it seem
> Even worse still, and so on down, down, down."

She has experienced the sickening sensation of dying hope. To have doubt cast upon "What we have always wanted" by her vision of rank weeds and by the attitude of the movers threatens to take away "all" the two have based their lives upon. Dismissing this terror, she adds "It's nothing; it's their leaving us at dusk." That disclaimer barely offsets "worse still" and "down, down, down." Her "view" has deepened a mood she cannot quite shake, despite her own words that they are "Dumped down in paradise . . . and happy."

The couple attempt to become one again in aspirations, teasing over who first entertained the idea of their life together, the husband trying to ascertain if in a wifely sacrifice she went along for his sake. Her answer is ambivalent, and she chides her husband for wanting to know the "beginning": "There are only middles." These words, as they suggest the continuity of their marriage, also dull the joyous thrills of a new beginning:

> "This life?
> Our sitting here by lantern-light together
> Amid the wreckage of a former home?'
> .
> New is a word for fools in towns who think
> Style upon style in dress and thought at last
> Must get somewhere. I've heard you say as much.
> No, this is no beginning."
> "Then an end?"
> "End is a gloomy word."

As if to stop a conversation that, despite expressions of faith in a shared dream, keeps going "down, down, down" toward a gloomy end, the husband turns to thoughts of morning and chores. The final image of the poem is again ambivalent: depending on how the reader is influenced by the mood of the conversation, it could seem emblematic of an inhuman mystery in the house or of cozy domesticity:

> When there was no more lantern in the kitchen,
> The fire got out through crannies in the stove

And danced in yellow wrigglers on the ceiling,
As much at home as if they'd always danced there.

The fire may be at home, but it seems unlikely that the wife will find her spirits dancing in her setting; instead of Eden she has envisioned a garden of weeds.

"In the Home Stretch" presents a woman who is a match for her husband (and for the poet) in imagination and conversation. However, despite their mutual teasing and affection, she cannot will happiness into belief. The woman has imagined spiraling down, and neither her own dismissive explanations nor her husband's reassurances quell her fears. The figures of this poem do not achieve what Frost's lyric speaker does elsewhere: that is, in the words of Seamus Heaney, to approach the "bleakness in that last place" of oneself and be " 'genuinely rescued' from negative recognitions, squarely faced, and abidingly registered."[42]

In "Education by Poetry," Frost writes of belief that overcomes doubt and of disillusionment in that belief. He segues from the self-belief of a young man about to test himself against the world—confident, active, virile—to belief in love:

In his foreknowledge [a young man] has something that is going to believe itself into fulfillment, into acceptance.

There is another belief like that, the belief in someone else, a relationship of two that is going to be believed into fulfillment. That is what we are talking about in our novels, the belief of love. And the disillusionment that the novels are full of is simply the disillusionment from disappointment in that belief. That belief can fail, of course.[43]

In Frost's early poems about a woman's presence in the New England Pastoral, the belief reaches fulfillment when participation is shared. The poet-husband initiates a frolic in nature: the invitation in "The Pasture" that "You come too," and in "Putting in the Seed" that the "you" who "come to fetch me" will also yield to impulse and become "Slave to a springtime passion for the earth." In "Two Look at Two," a couple hiking a mountain trail see a deer and a buck, and all four are transfixed by the wonder of their togetherness. Such poems illustrate how Frost's small-farm pastoral becomes entwined with sociability and sexuality, with being two. But it is the male speaker who voices how "earth returned their love."

Even the dialogue of "West-Running Brook," in which the wife initiates the conversation and names the brook, grants the husband the longest, most philosophical say. The woman's query about the brook's direction inspires the poem, along with her thought that "It must be the brook / Can trust itself to go by contraries / The way I can with you—and you with me."[44] Like the male speaker of "Putting in the seed," she imagines the intimacies of marriage extending to the world about them: " 'As you and I are married to each other, / We'll both be married to the brook.' " The husband then reinterprets the woman's anthropomorphic fancy about the brook's "wave" at them. The husband, like the wife of "In the Home Stretch," recognizes the setting's potential for gloom, though his words reflect a general rather than an immediate circumstance: "It seriously, sadly, runs away / To fill the abyss' void with emptiness." Then against this "universal cataract of death" he imagines resistance in the brook's downward progress:

> "Not just a swerving, but a throwing back,
> As if regret were in it and were sacred.
> It has this throwing backward on itself
> So that the fall of most of it is always
> Raising a little, sending up a little."

In "Home Burial," "A Servant to Servants," and "In the Home Stretch," women falter at that resistance. Katherine Kearns contends that in Frost's poetry all becomes spent in the processes of nature and sexuality: "anything that expends itself in generation necessarily winds down acceleratively to death, but unlike nature and unlike women, men are possessed of the (potential) rationality by which they might imagine themselves to hold this process in abeyance."[45] I agree that fears of going "down, down, down" pervade much of the poetry, but not that women are always reduced to "natural" decline because of inherent irrationality. Resistance to disintegration implies power and control: if in Frost's work not only reason but also imagination and belief offer that power, that achievement of the spirit is undergirded by social prerogatives. Women can rarely exercise those prerogatives because of their "dependence" on families and husbands. It is moot, of course, to argue that Frost could or should have been more "feminist" in imagining a transcendence for women. Rather, I emphasize the range of his portrayal of women and that their connection with the land is integral with marriage. When the marriage loses empathy

and passion (sometimes men are faulted), the women are trapped within a landscape offering little recourse from death, madness, drudgery, and doubt.

Belief in fulfillment dissolves when the woman cannot perceive enough in her "place" to sustain her. That it is Frost's *women* who appear most fragile cuts several ways. The poetry sympathizes with the lonesome exhaustion of country wives: their narrow prospects are framed by sinks, windows, and relentless expectations of them, while their futures are determined by others who are themselves limited. The poems do not imagine a way out for such women: their domestic work is considered less rewarding than the fieldwork of men, and their moods incline toward desperation and depression. The women seem more in need of sociability yet more inclined to roam beyond the social if a bond is weakened. That reversion to "nature" occurs not so much because women are less rational, but because their situation leaves no room for reason to improve it. Then failure of love manifests itself through an agonized response to the landscape, seen through the window.

The landscapes above illustrate the symbiosis of place and character, the extent of poetic sympathies, and the integration—happy and otherwise—of the social and natural world. However, I suspect that in Frost's later poetry the landscape becomes contaminated by unfashionable politics. The stains on his reputation not only include the country sage and domineering husband, but also the conservative pundit. That label simplifies Frost's "ambivalent and complex" sense of politics; as Jay Parini explains, Frost "is an agrarian freethinker, a democrat with a small 'd,' with isolationist and libertarian tendencies."[46] Nonetheless, almost as infamous as Pound's remarks on *North of Boston* and Trilling's 1959 speech, is the attack on Frost as glib statesman. Malcolm Cowley's remarks of 1944 typify this criticism: "there is a case against Robert Frost as a social philosopher in verse and as a representative of the New England tradition. He is too much walled in by the past."[47] What a *Time* reviewer called "uninspired Tory social commentary" pervades selections from the postdepression, postwar collection of 1947, *Steeple Bush*.[48] The shrub of the title is "not good to eat" yet takes over the "meadow sweet" in "Something for Hope." But the speaker, in a casual yet "public" voice, assures his audience that its growth belongs to a beneficial cycle:

A cycle we'll say of a hundred years,
Thus foresight does it and laissez faire,
A virtue in which we all may share
Unless a government interferes.[49]

Although the 1930s and 1940s attacks on Frost as anti–New Deal seem stale now, such lines reveal not only a dated political problem but a poetical one as well. *Steeple Bush* often features the Frost too ready to make a pronouncement. Current modes of criticism (and I am under their influence) boldly make their own pronouncements while probing creative works for veiled ideology. In such a climate, direct statement in literature is suspect, though less distressing when concurring with a critic's views; Frost's faith in American self-reliance and suspicion of social action still seem naive. Another approach is to suggest that in Frost's outwardly conservative poems he violates his own poetics. Seamus Heaney defines the issue: "In that range [of "middle flight"], the poet draws *indirectly* upon a wisdom which in his greatest poems seems to be wrested *directly* from experience itself."[50] The poems of statement rarely offer the discovery Frost talks of in "The Figure a Poem Makes": "No tears in the writer, no tears in the reader. No surprise for the writer, no surprise for the reader."[51] Frost has proven how even in the twentieth century "nature" inspires profound metaphor, but poems that are, in his own phrase, "ready-made for you" undermine imaginative intensity and exploration with glibness. Then Frost himself forgets that "All metaphor breaks down somewhere," and nature reverts to a complacent pastoral, resistant to doubt and challenge.[52]

If Frost's "weak" poems offer smug rejections of innovation and urban life, those of probing observation and sympathy for the restrictions of the country challenge what we have become. Among other things, we've become envious of the rustic, as more Americans find themselves consumers and tourists in search of authenticity. A front page article in the *New York Times* of 2 November 1997 features "agritainment": people visiting farms to go through corn mazes, pick fruit, and eat homemade pie. (I doubt this is an option at hog confinement sites, the current Midwest concern, where owners live at a distance, leaving the "aura" and waste of thousands of hogs for the locals to enjoy.) The agritainment farmers miss their privacy

but, as one admitted, "It's more profitable than growing crops for whole-sale, that's for sure." In this era of pollution and rural life as theme park, Frost matters because he stirs us to reimagine our not easily understood relation to the natural world. As he continued with his defense of the region in "What Became of New England," Frost claimed, "I never gave up willingly any love I've had"; "I don't give up New England too easily. I don't give up these words that I've cared for, these phrases; I long to renew them; I seek to renew them." Frost bound together his love for New England with his love for the possibilities of language: "And the thing New England gave most to America was the thing I am talking about: a stubborn clinging to meaning; to purify words until they meant again what they should mean."[53] With our postmodern sense of things, we like to imagine ourselves as jaded, no longer believing in purity. But few of us suffer such personal and literary hardships as Frost endured. Reading this poet who, through those hardships, never ceased to find value in his surroundings, helps us renew our own words and experiences until pastoral, landscape, and nature resonate again.

Gothic Loneliness: The Different Cases of Edward Hopper and Andrew Wyeth

> The ruin or the blank that we see when we look at nature, is in our own eye.
> —EMERSON, "Nature"[1]

The landscape has all but disappeared in Edward Hopper's *House by the Railroad* (pl. 4). No clues help us situate the three-story monstrosity: no neighboring houses, no trees, no fields. It is surrounded by pale sky, cut off by the railroad track from connection with either a gracious avenue or sociable street. The brownish earth and grass by the track are the only suggestions of organic matter. By contrast, another twentieth-century icon of place is relatively humanized and pastoral: Andrew Wyeth's *Christina's World* at least offers a person in the foreground (pl. 7). However, the distant house, shrunken by perspective, seems as inaccessible as Hopper's; the meticulously rendered landscape does not embrace the reclining woman or the viewer. In the two paintings, "home" and landscape have become visually and emotionally distanced.

Though held in very different critical regard, both Hopper and Wyeth offer menacing landscapes haunted by the past of rural America. The grand, lush, idyllic quality of romantic landscapes and the vigor of Homer's seascapes have been replaced by spartan loneliness and spare composition. It would be easy to call up this familiar paradigm of change: America has deserted pastoralism for development and consumerism. That generalization is too blunt, however, to explore the "ruin or the blank" offered by the canvases of Hopper and Wyeth. Hopper's works, while reflecting the abstract, formalistic developments of modern art, have iconic

possibilities that contribute to, and eventually mute, the traditional dialectic between the country and city. Wyeth's paintings exemplify, through the popular approval and scholarly disdain they elicit, a paradoxical pattern of treating the rural with longing, sentimentality, simplification, seeming admiration, and latent condescension.

Edward Hopper's paintings bridge warring aesthetics of the early modernist era as they blend representation with an almost abstract compositional geometry to create an austere realism. In the famous *Nighthawks* of 1942, the suited men and garish woman are illuminated against the monumental and mundane backdrop of the night diner: these figures and the setting appear familiar and forever unknowable. Much of the acclaim for Hopper rests on such voyeuristic scenes of anonymous people in offices, apartments, restaurants, hotels, and trains. For viewers who witnessed America from the 1920s through the 1960s, his images take on a déjà-vu quality. As poet Mark Strand writes, "I often feel that the scenes in Edward Hopper paintings are scenes from my own past."[2] The cultural memory fostered by Hopper's paintings synthesizes high and low cultural trends because the imagery both reflects and influences advertising, theater, and film. For those of Hopper's era and of later generations who continue to see icons in gas stations, office buildings, city strangers, and empty roads, "real" places and individual recall become confused with the archetypal scenes of Hopper's art.

Hopper helped create a disquieting "norm" in freezing the isolated figure against the unyielding forms of the American city—a vision of a recognizable past that is dreamlike in its stasis and tangibly hard in its geometric outlines. If his works now seem an inevitable reflection of America's modernity, there has nonetheless been some strain in placing Hopper. More so than works of contemporary realists, Hopper's paintings defy a singular mode of interpretation, and he is often considered "essentially unclassifiable."[3] He has been identified with and yet distinguished from painters of "the American Scene," a label that can suggest a narrow and quickly dated regionalism. In general, the clarified form and light of Hopper's compositions render his places "modern" and set them apart from the detailed localities of predecessors such as John Sloan or contemporaries such as Charles Burchfield. If Hopper's simplified images seem more formally pure, they can also seem more directly iconic—a shorthand for the meaning (or meaninglessness) of modern life. As painterly conventions,

icons can render mystery accessible—vision and dogma made tangible with a numinous power. While Hopper's banal subjects are remote from traditional religious emblems, they share a paradox: they are explicit even as their aura resists explanation. Hopper's works thus lend themselves to a current aesthetic and interpretive debate in interarts scholarship. To what extent can a painting, apparently detached from the tradition of historical, religious, and mythic art, be read as a text or function as an icon? Does the visual successfully resist the verbal, leaving us with the pleasure of mere seeing?

Hopper's relatively neglected landscapes provide an unique angle on these issues because the artist's views of Cape Cod and the American road raise further questions. Do they belong to the current of American art, so dominant in the nineteenth century, that endows depictions of nature with powerful cultural meaning, or do they invert romantic, luminist, sentimental, and grandiose views, and thus mark the abrupt end of significant landscape? Hopper's landscapes, set against the context of his training and literary, artistic leanings, illuminate the particular case of his "nativism" and the various appeals of that famous cool light.

Hopper's early life was conventional enough. He was born 22 July 1882 in the Hudson River town of Nyack, New York. His parents ran a dry-goods store and attended a local Baptist church. Hopper's mother and her prosperous family dominated while his father, a reluctant salesman, preferred literature to aggressive advancement. The architecture, landscapes, materiality, and morality of the nineteenth-century shadowed Hopper's youth. The artist's upbringing, according to biographer Gail Levin, inculcated the strict values of the family's Dutch Protestant inheritance, "especially frugality and the willingness to postpone gratification, not to mention emotional reticence and sexual inhibition." As Edward (the only son) matured, his prodigious and isolating height, his shyness, and his talent became evident. His parents encouraged a career as an illustrator, rather than a riskier one as "artist": in Levin's judgment, "Virtues stamped with prudence and predicated on mediocrity prevailed."[4] So the young man's career began inauspiciously at the Correspondence School of Illustrating out of New York.

Hopper did go on to attend the New York School of Art, where he took classes with William Merritt Chase, Kenneth Hayes Miller, and Robert Henri; fellow students included George Bellows, Guy Pene du Bois,

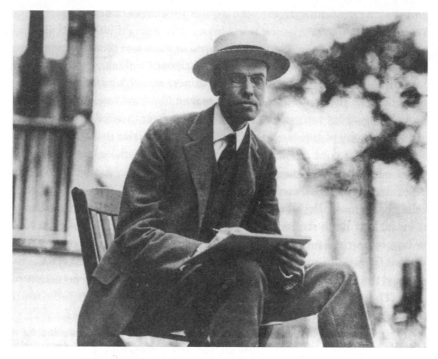

Fig. 22. Edward Hopper in Paris, 1907. Gail Levin, *Edward Hopper: An Intimate Biography*, 68.

and Rockwell Kent. Chase, not surprisingly given his elegant painting of leisure and social calls, represented gentility and appealed strongly, in Hopper's opinion, to the women students. Hopper, like many others, found Henri with his strong views on an independent national art inspiring and invigorating. Hopper wrote of his teacher in 1927, "No single figure in recent American art has been so instrumental in setting free the hidden forces that can make of the art of this country a living expression of its character and its people."[5] Also like his fellow students, Hopper read Continental literature and traveled to Paris, first in 1906 and again in 1909 and 1910 (fig. 22). Although Hopper had then and continued throughout his life great admiration for French culture, he did not mingle there with the bohemian and avant-garde. Years later, Hopper recalled, "Who did I meet? Nobody. I'd heard of Gertrude Stein, but I don't remember having heard of Picasso at all. I used to go to the cafes at night and sit and watch. I went to the theater a little. Paris had no great or immediate impact on me."[6] This statement, like those of Homer and Frost advertising their innocence of sophisticated traditions, is disingenuous. The "impact" of

Paris on Hopper is debatable: the sexual mores of street life apparently unsettled him, and upon his return to America he exhibited many French street scenes and landscapes, depicted in a soft palette. His most ambitious French-inspired work was harsher, *Soir Blue* of 1914. Its subject matter is reminiscent of Toulouse-Lautrec's demimonde as a voluptuous woman in heavy makeup scans the drinkers in a cafe, including a cigarette-smoking, white-faced clown. Hopper found little success with such scenes. At the Armory Show in 1913, he sold his first painting for $250: this work, *Sailing,* was based on a childhood love of boats and reflected his American roots. Hopper did not sell another painting until 1923. Meanwhile, he established himself in New York and at forty-two married another of Henri's students, Jo Nivison (as small and volatile as he was tall and reticent), and supported himself with commercial art until 1925.

Artistic development, sales, and recognition were slow in coming for Hopper. After spending summers in New England and witnessing the early success of George Bellows and Rockwell Kent, Hopper gradually produced his distinctive works, such as *House by the Railroad.* In the 1920s, he began to receive critical recognition, although he later remarked, "recognition never comes when you need it."[7] In 1930, he and Jo began to summer near Truro on Cape Cod, where they returned regularly. Also in the 1930s, the new Whitney Museum of American Art bought *Early Sunday Morning,* the Museum of Modern Art organized the first retrospective exhibition, and the Corcoran Gallery awarded a $2,000 prize for *Cape Cod Afternoon* (enthusiastically reported in *Life* magazine).[8] In the 1940s, Hopper continued to receive numerous awards and honors, and by the 1950s he was featured on the cover of *Time.* By then entering his seventies, Hopper had himself become an American icon, the "Silent Witness."[9] He continued to work slowly and deliberately, as if he conceived paintings almost out of a depression, finishing about two works a year until his death in 1967.

How and when Hopper found himself, his subject, and success is a narrative that can never be precisely reconstructed. I cannot explain by what internal developments Hopper's painterly imagination became "native." Apparently it took time to learn to become himself and American. His history again presents the paradox that one may be "born" to a place and destiny, yet achieve that destiny only after conscious deliberation and choice. American artists had to confront, at the risk of being overwhelmed, the foreign achievement of Old Masters and New Rebels. Art critic Brian O'Doherty speculates that American artists "can be divided into those

who have their crisis when they get to Europe and those who have it when they come back," and he quotes Hopper, "It seemed awfully crude and raw here when I got back. It took me ten years to get over Europe."[10] Hopper ponders the Continental influence in his 1927 essay on John Sloan. In writing on the older artist who had "a truer and fresher eye" for "not having been abroad," Hopper could be sorting out his own experiences:

> But what of the men of talent and originality who have until now dutifully spent their apprenticeships in Europe and returned with the persistent glamor of the European scene to confuse and retard their reabsorption into the American? The native qualities are elusive and not easily defined except in their superficial manifestations. Perhaps these are all that concern us. They are in part due to the artist's visual reaction to his land, directed and shaped by the more fundamental heritage of race. These national traits of ours may be so simple in their quality and narrow in their scope as to seem puerile to more subtle and sophisticated peoples.[11]

Hopper struggles to define the problems confronting an artist who would be notably "American." He does not offer a zealous, patriotic definition, but asserts that "native qualities are elusive" and may exhibit themselves only in "superficial manifestations." Perhaps Hopper is feeling his way toward a justification: these manifestations are all that is available to the artist's perception yet also sufficient, because the surfaces—apartment houses, gas stations, hotel lobbies, store fronts—are the contemporary matter to be witnessed. There is potential depth in the artist's vague consciousness of a "fundamental heritage of race," but it is a heritage that may spawn the "puerile." (Perhaps Hopper's reading of national character acknowledges its dedication to pop and consumer culture.) If Henri presented his students with an optimistic challenge to paint America, Hopper after Paris responded with a darkened confusion.

As Hopper emerged in the 1920s from years of painting without success, of illustrating, etching, and gradually finding the conventions and subjects that suited him, he was met with a critical climate still squaring off over foreign and native, avant-garde and realistic, effeminate and masculine. Critics of the 1920s and 1930s who espoused artistic nationalism praised Hopper in terms like those that lionized Eakins, Homer, and Frost. Hopper presented hard "manly" facts, valued the American setting in its commonness and degradation, reflected the outlook of an ordinary man,

and though "ordinary" was a quiet rebel who eschewed fashion. These assumptions buttress Lloyd Goodrich's 1927 article on this "vigorous and eminently native painter":

He has always been absolutely himself, going his own way and working out his own problems. Self-expression has not come easy to him; he has no taste for the facile depicting of superficialities, and he seems to be incapable of prettifying or compromising his own vision of the world. The same independence which kept him out of the Academy has also prevented him from riding in on the crest of the wave of fashionable modernism.

In all his work one feels the transparent brilliancy of our skies, our strong sunlight, the clearness of our atmosphere—natural qualities which find their echo in the stark angularity and hardness of American architecture.

Though it may have taken Hopper time to determine what sort of painter he was, for Goodrich the artistic vision seems inherent and inevitable: the American character will out. And when it does out, it will reinforce traits of integrity by being "absolutely" itself, unpretty and uncompromising. Not surprisingly, Goodrich places Hopper in the tradition of Winslow Homer and Thomas Eakins: "a realistic, spare, almost Puritanical strain . . . [Hopper's] work is akin to theirs in a fundamental quality which can only be described as austerity." Goodrich further praises Hopper's realism by distinguishing it from elitism and connecting it to common experience: "Hopper's painting is not 'modern' in the narrow sense in which that word is sometimes used to describe those artists who abjure the representational side of art. The vision expressed in his pictures is very much that of the average man, transformed into something more significant by the vision of the artist."[12]

Other early admirers of Hopper also emphasized his taciturn independence. In February 1929, Forbes Watson outlined the course of European modernism in America, noting both its early condemnation by conservative critics such as Royal Cortissoz and its eventual settling "into the calm of universal acceptance." Not just Hopper's painterly manner but his character set him apart: "Through that hysterical period of American art when the first rush to be modern took place (it had not then become a gold rush) Edward Hopper stalked, a quiet, slightly sneering, silently honest figure of obstinacy." Again there is the assertion on critic's and artist's part of virile autonomy and puritanical restraint rather than "hysterical" chasing of trends: "[Hopper] had once said that he was striving to achieve

'the greatest possible austerity without loss of emotion.' " Forbes admires the painter's "dry wit, his originality of invention, his depth of feeling for native material" and explains how Hopper's aesthetics ran counter to the preceding generation's pretensions: "This original recorder of the American scene often selects architectural subjects which disobey the criterions of taste that have been registered . . . by those American architects who have taken their Beaux Arts training too submissively."[13]

Hopper, with his city scenes and residency at New York's Washington Square, was clearly not a rustic. However, like Frost and Homer he was allied with the honest, authentic, and self-taught, with an integrity separate from an upper-class world of appearance, devious subtlety, and overwrought, feminized refinement. Hopper's statements about his work synthesize Freudian psychology and self-reliance as he acknowledges faith in an inherent character and predicts the consistency of his motifs: "In every artist's development, the germ of the later work is always found in the earlier. The nucleus around which the artist's intellect builds his work is himself, the central ego, personality, or whatever it may be called, and this changes little from birth to death. What he once, he always is, with slight modifications. Changing fashions in methods or subject matter alter him little or not at all." In a declaration resembling Homer's that if one were to paint, one should not look at pictures, Hopper claimed, "The only real influence I've ever had was myself."[14]

While it may be the case that many artists after years of effort develop a distinctive view, Hopper's self-explanations assured critics that his was a "genuinely American art." The drawback is that Hopper became linked with artists he did not much admire. The problem resides in the label, "American Scene." Though it can include nearly any realistic rendering of local settings, it became narrowly identified with regionalism (another limiting label) and painters like Grant Wood and Thomas Hart Benton. It becomes particularly associated with the Midwest, or with an image of the Midwest almost as earnest and corny as the musicals *Oklahoma* or *The Music Man*. One art-historical definition of "American Scene" is "that current in painting of the 1930s which concentrated on rural motifs and celebrated plain, down-home virtues to the point of ideological affirmation."[15] At its worst, the defense of the American Scene emerges as hick chauvinism: Thomas Hart Benton, a flagrant example in his xenophobia and homophobia, once declared, "I wallowed in every cockeyed ism that came along, and it took me ten years to get all that modernist dirt out of my system."[16]

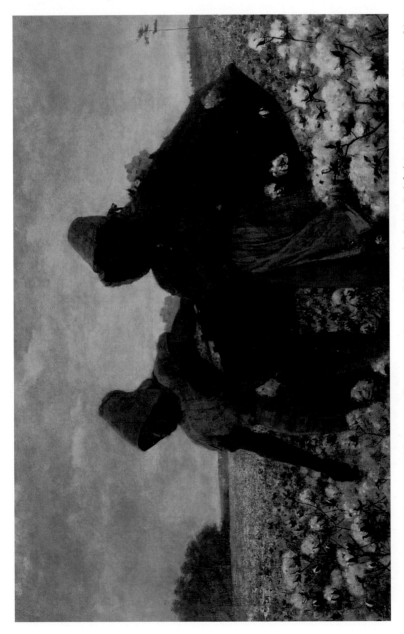

Pl. 1. Winslow Homer, *The Cotton Pickers*, 1876, oil on canvas, 61.12 × 96.84 cm (24¹/₁₆ × 38 ¹/₈ in.) Los Angeles County Museum of Art, Acquisition made possible through Museum Trustees: Robert O. Anderson, R. Stanton Avery, B. Gerard Cantor, Edward W. Carter, Justin Dart, Charles E. Ducommon, Camilla Chandler Frost, Julian Ganz, Dr. Armand Hammer, Harry Lenart, Dr. Franklin D. Murphy, Mrs. Joan Palevsky, Richard E. Sherwood, Maynard J. Toll, and Hal B. Wallis. Photograph © 2001 Museum Associates/LACMA

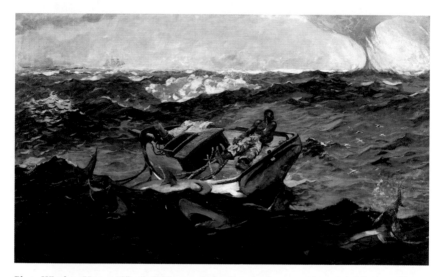

Pl. 2. Winslow Homer, *The Gulf Stream,* 1899, oil on canvas, 71.4 × 124.8 (28¹/₈ × 49¹/₈). The Metropolitan Museum of Art, Catherine Lorillard Wolfe Collection, Wolfe Fund, 1906. (06.1234) Photograph © 1995 The Metropolitan Museum of Art

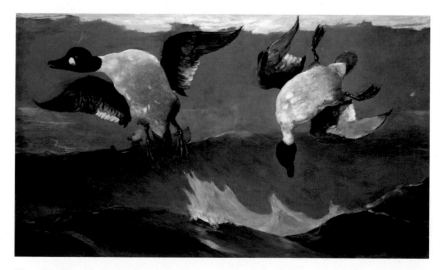

Pl. 3. Winslow Homer, *Right and Left*, 1909, oil on canvas, .718 × 1.229 (28¹/₄ × 48¹/₈). Gift of the Avalon Foundation, Photograph © 2002 Board of Trustees, National Gallery of Art, Washington

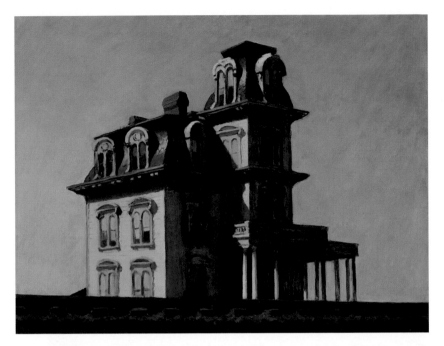

Pl. 4. Edward Hopper, *House by the Railroad* (1925). Oil on canvas, 24 × 29" (61 × 73.7 cm).
Museum of Modern Art, New York. Given anonymously. Photograph © 2003 The Museum of Modern Art,
New York.

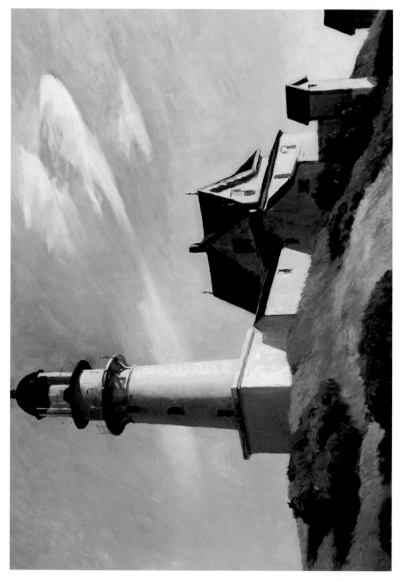

Pl. 5. Edward Hopper, *The Lighthouse at Two Lights*, 1929, oil on canvas, 74.9 × 109.9 (29¹/₂ × 43¹/₄). The Metropolitan Museum of Art, Hugo Kastor Fund, 1962. (62.95) Photograph © 1990 The Metropolitan Museum of Art

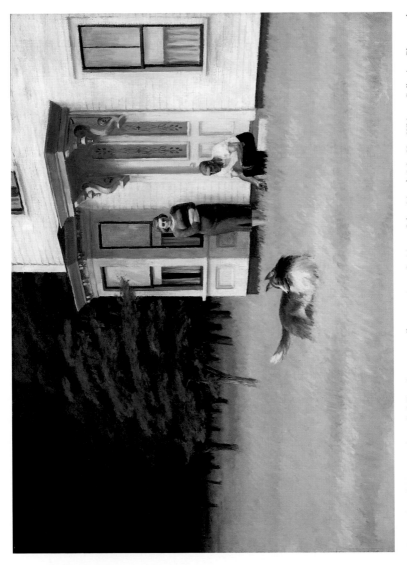

Pl. 6. Edward Hopper, *Cape Cod Evening*, 1939, oil on canvas, .762 × 1.016 (30 × 40). John Hay Whitney Collection, Photograph © 2002 Board of Trustees, National Gallery of Art, Washington

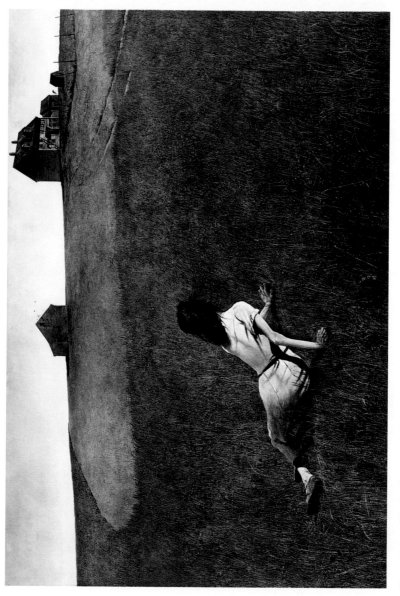

Pl. 7. Andrew Wyeth, *Christina's World* (1948). Tempera on gessoed panel, $32^1/_4 \times 47^3/_4$" (81.9×121.3 cm). The Museum of Modern Art, New York. Purchase. Photograph © 2003 The Museum of Modern Art, New York.

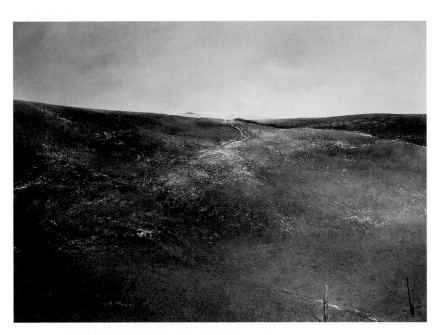

Pl. 8. Andrew Wyeth, *Snow Flurries,* 1953, tempera on panel, .945 × .122 (37¹/₄ × 48). Gift of Dr. Margaret I. Handy, Photograph © 2002 Board of Trustees, National Gallery of Art, Washington

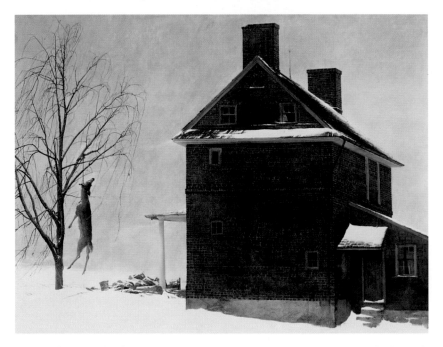

Pl. 9. Andrew Wyeth, *Tenant Farmer,* 1961. Tempera on masonite, 77.5 × 101.6 (30¹/₂ × 40). Gift of Mr. and Mrs. William E. Phelps, 1964. Delaware Art Museum.

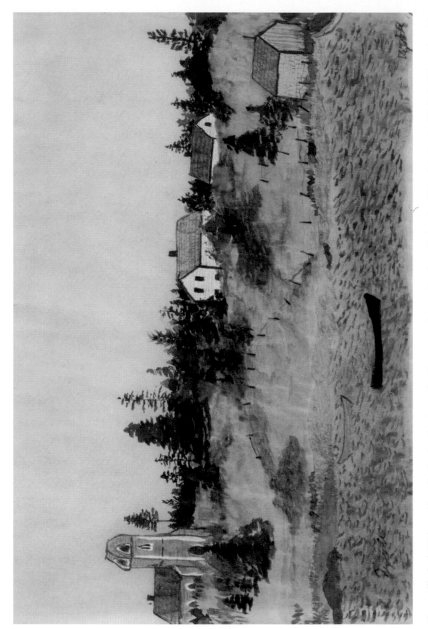

Pl. 10. Elizabeth Bishop, *Nova Scotia Landscape*, undated, water and gouache. From *Exchanging Hats: Paintings* by Elizabeth Bishop. Copyright © 1996 by Alice Helen Methfessel. Reprinted by permission of Farrar, Straus and Giroux, LLC.

Although Hopper in his quiet apolitical manner had little in common with Benton, his paintings fell under the same heading. As a critic wrote in 1937, "The name of Edward Hopper has come to be associated with the term 'American scene.' He has become its painter par excellence."[17] Though Hopper had used the phrase in admiring Burchfield's "intensely emotional and personal vision of the American scene," he was not keen on applying it to himself unless satisfactorily redefined. He wrote to George Stout at the Worcester Art Museum about a 1954 exhibition, "Five Painters of America":

I hope though that in the publicity to be given this show there will be no reference to the "American Scene." There is a stigma attached to this designation in the public's mind, that implies a rustic lack of sophistication on the part of the art so called that is far from the truth.

If one looks out of one's window in Ohio, Massachusetts, or California, and reports honestly what one sees and feels with one's personal vision of the world in command, that will be one's interpretation of the american scene. It is part of our daily existence. Even the mystics can not ignore it.[18]

Hopper's rejection of the phrase as a rustic stereotype also occurred in conversations with art critic Brian O'Doherty. Hopper admitted disliking sections of the *Time* cover story that had him, in the interviewer's words, "going around the country like some hick who happened to be a genius. The story even said he cracked his knuckles." After the knuckle-cracking rumor is laid to rest, Hopper responded testily to queries about being "a cracker-barrel All-American":

The thing that makes me so mad is the "American Scene" business. I never tried to do the American scene as Benton and Curry and the midwestern painters did. I think the American Scene painters caricatured America. I always wanted to do myself. The French painters didn't talk about the "French Scene," or the English painters about the "English Scene." It always gets a rise out of me. The American quality is *in* a painter. He doesn't have to strive for it.[19]

Consciously or not, Hopper may have striven for that "American quality" more than he acknowledges, and achieved it at a cost. O'Doherty, writing of the 1960s when regionalism was even less in favor than in the 1930s, summarizes the advantages and disadvantages of Hopper's nativism:

Hopper was physically and mentally eligible to tap a powerful American myth, that of an obstinate individualism, of a self-reliant and no-nonsense masculinity.

The history of this machismo in American art has (as in American Literature) distinct episodes—from the American Scene red-neck to the bullish Abstract-Expressionist. But Hopper suffered the ill-fortune of having American Scene isolationism projected on him; his myth was appropriated by the national iconography and connected with aspects of art he despised.[20]

As Hopper is defended against isolationism, emphasis is again directed toward his command of form and toward the belief that art emanates not from ideology or activist creeds but, in his words, from the "inner life of the artist." He is praised at the time for the *"presence"* of "a unique concentration of psychic energy animating and permeating the visual facade" and is shown not to be "so exclusively 'American' as he has been made out to be."[21] The critics' and Hopper's own attention to an inner expressiveness echoed romantic and modern conceptions of the artist who served the imagination rather than social mores or popular taste. Once again, an artist who had been hailed for his "Americanness" (which for some reduces a canvas from an energetic presence to a jingoistic cliché) must be rescued from the provincial curse.

Given the reluctance of modern critics to entrap Hopper in narrow nativism, can the iconic potential of his landscapes be recovered? If debates over the "American scene" seem dated, very current is discussion of how to interpret visual artifacts. Postmodern criticism has often argued for the "textuality" of signs and images from traditional painting, photo journalism, scientific figures, advertisements, fashion layouts, to computer pixels—the many forms of "visual culture."[22] Taking all the world as text, though, does not mean words will readily disclose everything there is to know about images. Challenges to the assumptions of traditional art history have probed an "inevitable" pairing of word and image in a sisterly tradition of "ut pictura poesis," and reconsidered "the fundamental incommensurability of structure between image and word."[23] In other words, our habits of mind—which synthesize the input of the senses into metaphorical language and representations immersed in cultural practices— invite pairing. Words create pictures, and pictures tell stories. Yet we hesitate to endorse an art lecture without full-color slides or a bedtime story without a voice; no description replaces the sight of a face and no picture conveys song. These examples, however, may be simplistic in comparison to confusion caused by new technologies for morphing sounds and sights.

The ancient word-image debate, heightened now by multimedia pro-

duction, is pertinent to "readings" or "viewings" of Hopper precisely because his images draw from conflicting aesthetic trends: the realist, the formalist, the nostalgic, the modern, the iconic. We rightly question how far words can go and how irrelevant they may be in response to form, line, shape, and color. Michael Ann Holly asserts, "visual objects, as most art historians would be the first to claim, demand that their formal specificity be appropriately acknowledged before any sort of ancillary investigation can begin."[24] This insistence itself recapitulates the dilemma of discussing art: bound by the nature of language, Holly employs metaphor and attributes to visual "objects" the ability to "demand"—as if they could speak. If words are inevitable in criticism, one must still beware of " 'the bias of privileging language' in accounts of visual culture."[25] Carol Armstrong fears that, "within the increasingly cyberspace model of visual studies," taking "text" as "the mother-model for utterances, performances, fashionings, and sign collocations of all kinds" leads to "disembodiment of the cultural object," to negation of its thingness: "I sometimes wonder if this [emphasis on textuality] is not simply a new face put on the old contempt for material crafting, the surface and the superficial, as well as the old privileging of the verbal register that went with traditional humanist notions of *idea* or *ut pictura poesis*, or with the iconographics of the old art history."[26]

While "the word" may be criticized for its assumed dominance, the ideal of formal purity is also dismissed. Interarts scholarship announces the complicity of the visual and verbal without dissolving difference. W. J. T. Mitchell makes the polemical claim that "all media are mixed media, and all representations are heterogeneous; there are no 'purely' visual or verbal arts, though the impulse to purify media is one of the central utopian gestures of modernism."[27] Martin Jay argues that we must "accept the irreducible linguistic moment in vision and the equally insistent visual moment in language."[28] Mieke Bal in *Reading Rembrandt* demonstrates this interplay with Rembrandt works that take a biblical tale as "pre-text": she aims to move beyond the "Word-Image Opposition" by showing "that *verbality* or 'wordness' is indispensable in visual art, just as *visuality* or 'imageness' is intrinsic to verbal art." [29] However, the concept of word and image as indispensable to each other must undergo additional testing with modern paintings. Though modernism's "utopian" impulse may not have achieved a "pure" aesthetic, it certainly resulted in radical change. The quest for what the influential Bloomsbury critic Clive Bell called "significant form" and freedom from the "nugatory" emotion

of sentimental illustration created those famous images of Braque, Picasso, or Klee that upset traditional representation and textual reference.[30] Even within the seemingly tame context of American Scene realism, Hopper participated in that quest for "significant form."

What is it then, that we see in a painting like *The Lighthouse at Two Lights* of 1929 (pl. 5)? The depiction of blue sky, rustic hill, and the distinct form of buildings in light and shadow evoke all the pleasure of a clear day. It is set in Cape Elizabeth, Maine, which matters less than the straightforward brilliance. Hopper's early landscapes were painted on summer trips with Robert Henri's circle of artists to Gloucester and Maine; several of these, such as *The Dories, Ogunquit* (1914), have a holiday feel about them. (Reproductions of Hopper's sailing works hang in a Burger King along the Maine turnpike near Kennebunkport, presumably to foster the sense that despite corporate fast food one is in an aesthetically pleasing Vacationland.) The fresh-air clarity of Hopper's early seascapes calls up a long-standing association of well-being with the outdoors. What more is there? Landscape and visual studies suggest a good deal more; however, cultural meanings more readily disclose themselves through the sunset of manifest destiny beaming from a Western panorama, and in general with works arising from strongly moralized and romantic traditions. Granted, outdoorsy vitality can be linked to complex ideas of manliness, power, social responsibility, protest, transcendence, practicality, and escapism in other literature and art that bridge the nineteenth and twentieth century: in the writings of Emerson, Thoreau, and Frost, and in the paintings of Winslow Homer, George Bellows, and Rockwell Kent, which illustrate manly labor and a wilderness ethos. But is it a stretch to say the same of a painting completed near the end of the Roaring Twenties that seems to be "about" light on curved and angular forms?

Placing Hopper in the context of landscape reveals an added dimension of his work and testifies to the shifting values of a pastoralism in American culture. A painting like *The Lighthouse at Two Lights* sustains the American vernacular—the lighthouse as emblem of fortitude, vision, and isolation—as it reveals Hopper's debt to and deviation from landscape and avant-garde conventions. To begin, the perspective of Hopper's urban and rural scenes recalls the stance of the nature poet and artist: a solitary figure views solitude, and in that private meditation captures a silence reaching beyond the human. The ghost of that romantic figure is conflated with the Baudelaire-like flâneur who detaches himself from the life of the city to observe it. (It is helpful to remember that Hopper's apprenticeship

included Homeresque seascapes and Parisian bar-scenes.) Baudelaire's urbane "painter of modern life" catches "the transitory, the fugitive, the contingent," and "incognito," "hidden from the world," provides glimpses of it.[31] But the flâneur is also a "passionate spectator" desiring "to become one flesh with the crowd."[32] There are no crowds in Hopper; there is no immersion, joyous or otherwise, in bustling street scenes. The press of flesh is controlled with form and light, a reflection perhaps of Hopper's personal reserve. The expansive silence manifests the quietude of landscape and the urban subject matter the focus of avant-garde art, while the detached perspective is Hopper's contribution to modernism. Its unnerving quality that seems both objective report and private dream recalls the surrealistic, hauntingly empty street scenes of the Italian modernist, Giorgio de Chirico. As Hopper's art developed through the 1930s and 1940s, his realistic perspective parallels other modern viewpoints: the spectator at a play or movie, the camera eye itself, or in a literary analogy the "fly-on-the-wall" narrative associated with the writing of Ernest Hemingway. (Hopper wrote a letter to *Scribner's* magazine after it published Hemingway's "The Killers" in March 1927, praising the story as "refreshing" and "honest" in comparison to "the vast sea of sugar coated mush that makes up the most of our fiction.")[33] Such perspective suspends judgment and understanding of the mundane, corrupt, and inexplicable.

To continue with literary analogies, I also find in Hopper's outdoor scenes a revision of an earlier outlook of another writer he admired: Ralph Waldo Emerson. It is a risk to connect a nineteenth-century essayist with a twentieth-century artist; nonetheless, the paintings' light and space recall for me the touchstone (or millstone) of American romanticism in "Nature": "Standing on the bare ground,—my head bathed by the blithe air, and uplifted into infinite space,—all mean egotism vanishes. I become a transparent eye-ball. I am nothing. I see all. The currents of the Universal Being circulate through me."[34] In Hopper's works there are often transparent skies, bare ground, infinite space, and a sense that the viewer's ego dissolves to become nothing more than a witnessing eye that sees all. This intuitive leap can only suggest general tendencies of Hopper's nativist outlook that parallel Emersonian observations—the focus on self-reliance, the attention to lowly and local subjects, or resentment at the emasculating stultification of conventional society.

Of course Hopper's scenes can deny Emerson's early optimism: the air is rarely blithe, the "Universal Being," if present at all, is in the pervasive light and apprehensive ambiance. The transparent eyeball becomes the

cold camera lens. We do not know exactly what sections of Emerson most appealed to Hopper, and he could well admire literary idealism without emulating it in art. He said once, "Emerson's a very shrewd New Englander, but he's no help."[35] The artist, like other readers, may have found more than joyous transcendence. Lines from the embittered writer of "Experience" could describe the unspoken mood of Hopper's scenarios:

Our life looks trivial, and we shun to record it. . . .

. . . Our relations to each other are oblique and casual. . . .

. . . Dream delivers us to dream, and there is no end to illusion. . . .

. . . There is an optical illusion about every person we meet. . . .

. . . It is very unhappy, but too late to be helped, the discovery we have made, that we exist. . . .

. . . And yet is the God the native of these bleak rocks. . . . The life of truth is cold, and so far mournful; but it is not the slave of tears, contritions, and perturbations. It does not attempt another's work, nor adopt another's facts.[36]

Hopper did not "shun" from recording "trivial," "oblique" relationships. In the art's attention to "bleak" facts, the vision resembles that of another modernist influenced by Emerson, the poet Wallace Stevens. His reinvention of the figure regarding "kindred" landscape is "The Snow Man," who "nothing himself, beholds / Nothing that is not there and the nothing that is." For the modern artist and writer, the "blank" is in nature, and "in our own eye."

Hopper's barren hills, angular houses, unsmiling figures, and empty roads negate an uplifting rapport between the human and the natural. They imply as well the end of a division between the serene landscape and the exciting, peopled, corrupt metropolis. Simply put, Hopper offers isolation everywhere. Yet I do not believe that Hopper's landscapes are merely extensions of his urban views. Subject matter never ceases to count, as photographer Edward Weston, famous for attention to light on form (often on the controversial nude female form) insists: "Subject matter is important and don't let anyone tell you it isn't."[37]

The importance of subject appears self-evident in the 1920 etching *American Landscape* (fig. 23). Hopper turned to etching as a respite from commercial art; at this point in his career and about thirty-eight years old, Hopper had not achieved success with either New England or French scenes. He claimed that when his income depended on illustrations for ad agencies, he wanted most "to paint sunlight on the side of a house."[38]

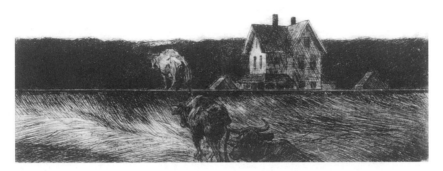

Fig. 23. Edward Hopper, *American Landscape*, 1920. Etching, 19.1 × 31.8 (7½ × 12½). Photograph Copyright © 1998: Whitney Museum of American Art, New York; Josephine N. Hopper Bequest 70.1005

This statement contains Hopper's mixed artistic background and desires by including the representational (illustration), the post-impressionistic impulse (capturing of light), and a tangible subject (the side of a house). However, there is nothing of Continental impressionism or coastal vigor in this scene. Saddled with the title "American Landscape" (anticipating Grant Wood's *American Gothic* of 1930), it begs interpretation, inviting or commanding viewers to consider what is American and representative here. The response, I suspect, is predictable: the bony cows convey a pastoral, no longer idealized, moving away from us. The triangular hip-bones of the animal awkwardly straddling the tracks echoes the triangular roof lines of the unadorned farmhouse. The setting, depicted only by cross-hatching, is hardly picturesque: its horizontal sameness is monotonous. The tracks of the infamous machine in the garden have slashed the landscape.[39] The cut-off house in the background looks more derelict than comforting, implying the debasement of the agrarian ideal and the virtue of the humble homestead. This etching indicates that at moments Hopper's work directly refers to the past, and to a past of didactic and visionary landscapes.

Whatever the influence of past renderings of nature, the painter's intentions and his achievement in "painting light on the side of a house"

warn against letting didactic interpretation override surface interest. Viewers acknowledge the fascinating narrative pull in many of Hopper's scenes: the suspended drama that suggests the painter's attraction to theater and film. The emotional tease of the paintings is not just in the hint of narrative, but also in the visual arrangements. Mark Strand acknowledges how Hopper's "largely aesthetic" approach through "pictoral strategies" creates paintings that "transcend the appearance of actuality and locate the viewer in a virtual space where the influence and availability of feeling predominate."[40] This "virtual space" beyond precise verbal definition sounds rather like Clive Bell's "significant form" and "pure aesthetics" in which "we have only to consider our emotion and its object" without prying "behind the object, into the state of mind [or state of culture] of him who made it."[41] Most concur that Hopper's works are compelling, pleasing, and even satisfying to look upon. The scenes may have a slightly sinister feel; however, the emotional restraint renders them intriguing rather than repulsively violent, and the composition has the balance of graphic design, recalling Hopper's early experience with posters and advertising. Friends and acquaintances tell me they "really like" Hopper. "Like" is a vague all-purpose verb, but it expresses the "virtual space" in which the intrigue of the blocks, trapezoids, triangles, horizontals, and light do their work.

Nonetheless, few viewers now would attribute their appreciation to a purely formalist response. Painting integrates the visual and the tactile; sensation and perception fuse with response to the subject matter. In viewing the paintings *Nighthawks* and *Early Sunday Morning* (but not the glossy reproductions), I find the rendering of bricks curiously rich and warm: is this the result of hue and color saturation only, or is the sense inextricable from the security (or entrapment) of painterly form, and by thematic association, of the form of looming buildings? The brightness on lighthouse towers has the eye-catching, nearly inexpressible appeal of whiteness. But again, the direct physical impact of color seeps into associations of light with conceptual, intellectual, and emotional clarity.

Of course, it is hardly a new realization that representational as well as abstract artists employ the power of composition: it is the relatively seamless synthesis of form and content that challenges interpretation. For all Hopper's desire to leave behind the world of illustration—drawing "people waving their arms" and "grimacing and posturing"—he never abandoned familiar subject matter.[42] He considered abstract art to be inventive decoration and remarked at a party in 1953, whose guests included Jackson Pollock and Andrew Wyeth, "People are starved for content today."[43] Also

in the 1950s, Hopper contributed to *Reality*, a publication supporting artistic realism: "One of the weaknesses of much abstract painting is the attempt to substitute the inventions of the intellect for a pristine imaginative conception. The inner life of a human being is a vast and varied realm and does not concern itself alone with stimulating arrangements of color, form, and design."[44] Much earlier in his career, Hopper seemed to outline his own aspirations in a 1928 essay on Charles Burchfield who also painted "everyday existence in a provincial community":

No mood has been so mean as to seem unworthy of interpretation . . . all the sweltering, tawdry life of the American small town, and behind all, the sad desolation of our suburban landscape. . . . Our native architecture with its hideous beauty, its fantastic roofs, pseudo-Gothic French, Mansard, Colonial, mongrel or what not, with eye-searing color or delicate harmonies of faded paint, shouldering one another along interminable streets that taper off into swamps or dump heaps—these appear again and again, as they should in any honest delineation of the American scene. . . . No time wasted on useless representation. No slavery to values, to color or to design as ends in themselves.[45]

This passage characterizes a variety of Hopper works with their spare representation and lack of painterly flourish, including *House by the Railroad*. Its strong horizontals and verticals command the viewer, but so does the alienation of the modern landscape as past grandeur declines to the grotesque.

This returns us to Hopper as painter of the American Scene, yet other considerations must be noted. Unlike many of his contemporaries, Hopper has been thought apolitical. While his isolated figures could indirectly reflect the distress of the Great Depression and war years, he did not pointedly represent social classes and problems, as did left-leaning realists Isabel Bishop, Reginald Marsh, or Moses Soyer. Hopper could be nativist with a reductive composition that appealed to formalist tastes and, in Andrew Hemingway's words, with "a rather nostalgic vision . . . which appealed to a particular bourgeois liberal faction" that wanted "an 'unproblematic' image of a 'changeless' America."[46]

Although populist and activist agendas are largely absent in Hopper's work and "nostalgia" by some definition is present, I do not find, however, "an 'unproblematic' image of a 'changeless' America." Hopper's urban and rural scenes appear "changeless" and archetypal in part because of their apparently neutral perspective. That perspective, in quietly reflecting the

circumstances of the artist's own life, no longer seems so "natural." It assumes a white, middle-class, middle-aged existence that does not extend into the extremes of the city or wilderness: the "eye," given the attention to female nudes, is male. The perspective seems objective because those circumstances have so long been taken as the norm. And while not witnessing active social upheaval, it implicitly contains historical reference. Cityscapes and landscapes are reminders that the past is always with us and always beyond retrieval.

Hopper's scenes initially seem unchanging because of their arrested quality and generally smooth geometric surfaces: he does not depict weathered facades as do Charles Burchfield and Andrew Wyeth. Still, Hopper's architectural interest illustrates that the buildings of the past, if not the values and way of life, remain for some time. The structures in rural, small-town, and city scenes frequently date from the nineteenth century. In depicting what Lewis Mumford called "the worst emblems of the period," Hopper includes a past of dubious achievement, pretension, and bad taste in its imitations of European grandeur. These structures, which intentionally or not reflect America's cultural confusion, are sometimes made stunning by light and sometimes made touching by their awkwardness: this is the American scene "with its hideous beauty." The rural scenes do not feature the details of a particular decade's architectural mistake; nonetheless, paintings like *Hills, South Truro* (1930) and *New York, New Haven and Hartford* (1931) are markers of change (fig. 24). The perspective of both and the title of the latter convey the dominance of car and train. The artist does not ascend a summit as a godlike conqueror or visionary poet who would possess material and spiritual values of the prospect. Rather, he is a transient who may not know the people of the place or return again.

In these two paintings, the sides and backs of the houses are presented. This may reflect "facts" of the railroad's placement, the attempt to cut up the landscape unobtrusively and avoid going through the front yard (as was the case with *House by the Railroad*). The railroad does obtrude, though. The tracks become prominent and the houses superfluous and displaced. Like Hopper's human figures, his houses often face away from the viewer and toward the sun—as if involved in a private existence, even transcendence, that can only be witnessed askance. Considered against past American landscapes, this side-view implies a way of life that no longer faces the viewer, who can be engaged in the past and present of the scene only tangentially, almost by accident. Perhaps the triangles and

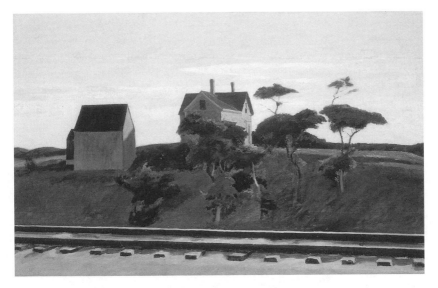

Fig. 24. Edward Hopper, *New York, New Haven and Hartford*, 1931, oil on canvas, 81.3 × 127 (32 × 50 inches). Indianapolis Museum of Art, Emma Harter Sweetser Fund.

rectangles of buildings set against the irregularity of hillsides attract the eye. There is no representation of practical or overtly moralistic engagement in the scene. Hopper's farms never seem farmed. Form triumphs, although in such Hopper paintings the form is not exclusively dependent on conceptual reconstruction, as in a cubist exercise. The perspective remains influenced by the position of artist as passenger in a car or train: it is not that of the flâneur lost in the crowd, a romantic seeing his own idealism returned, or the poetic farmer attuned to every nuance. It is the view of the traveler who seeks momentary relief from boredom and who finds the landscape familiar, rather like others seen, and impenetrable. Form may triumph in emptying the scene of sentiment and didacticism, but it also empties it of use-value and approachable humanity.

Cape Cod Evening (1939) further illustrates the elision for Hopper of city/country values—or lack of them (pl. 6). The drama is one rehearsed in several paintings: a couple is tensely together, physically close, emotionally at odds. In *Room in New York* (1932), a glimpse into an apartment reveals a man bent over his newspaper while a woman twists away from him to pick out a note on a piano. *Office at Night* shows a businessman again studiously reading, as if to avoid the glance of the curvaceous woman at the file cabinet. (A study for the painting had the two nearly facing

each other, as if about to speak).[47] *Hotel by the Railroad* (1952) depicts an older couple: the woman in her slip, seated, reading, the man smoking and looking out the window. This situation—a breakdown of intimacy and its remaking in a détente that keeps the couple together but not contented—is moved to a rural setting. As Hopper recounts the making of *Cape Cod Evening*, the aim was not to reproduce a specific incident or place; it is a very deliberate construction:

It is no exact transcription of a place, but pieced together from sketches and mental impressions of things in the vicinity. The grove of locust trees was done from sketches of trees nearby. The doorway of the house comes from Orleans about twenty miles from here. The figures were done almost entirely without models, and the dry, blowing grass can be seen from my studio window in the late summer or autumn. In the woman I attempted to get the broad, strong-jawed face and blond hair of a Finnish type of which there are many on the Cape. The man is a dark-haired Yankee. The dog is listening to something, probably a whippoorwill or some evening sound.[48]

Rare for Hopper, a third party is introduced, the collie that the man beckons. But the collie, like other Hopper figures, looks beyond the canvas and is drawn into the landscape as the people are not. The man looks as if he works outdoors: his lower face and arms are reddened, but his upper arms and forehead remain pale, suggesting he wears rolled-up sleeves and a hat to work. The woman, arms folded tight, hardly seems softened by the twilight time.

The outdoor setting is no more inviting than the couple. It does not connote pride in place and home. Nature encroaches, a claustrophobic rather than nurturing environment. The tall grasses come right up to the house: no lawn or landscaping. As often in Hopper, the border territory between elements, as it is between people, is effaced. There is no decorous or euphemistic easing into another mode, no coded paths that lead from distance and difference to closeness and intimacy—just stark confrontation. The grass and the house, despite the elaborate door, look undomesticated. The trees, very different from classical precedents framing a Claudian landscape, are according to Hopper "locusts." Yet botanical verisimilitude is less important than how they lean ominously toward the house. These woods may be "dark and deep" but not lovely, nor are they awesome enough to suggest primeval mystery. The house, though perpendicular and light in contrast to the shadowed woods, is not a welcoming cottage.

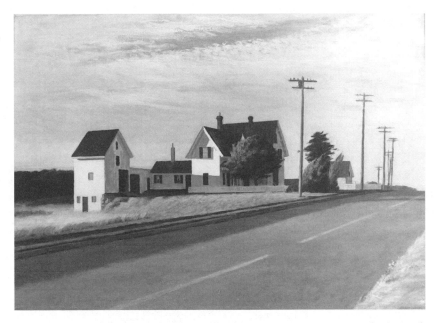

Fig. 25. Edward Hopper, *Route 6, Eastham*, 1941, oil on canvas, 68.6 × 96.5cm (27½ × 38¼).
Swope Art Museum Terre Haute, Indiana.

The window at the right edge of the painting is blank rectangles of frames
and drawn shades and curtains. The intimacy is ambiguous: a mood hov-
ers, but little of house, woods, or dramatic explanation is disclosed. Sur-
faces remain inaccessible. One cannot imagine entering the house or the
woods or desiring familiarity with this couple. Like the dog, we may wish
for something more vital to attract our attention.

In paintings like *Cape Cod Evening*, uncertainty of mood itself seems
iconic, contributing to the image of Hopper as the man who conveyed
the quiet desperation of modernism. The painter's scenes become icons
because he anticipates and reflects a general sense of culture and place in
the twentieth century. *Route 6, Eastham* offers the road, an American icon
from early exploration through Beat Generation wanderings, which takes
up nearly a third of the canvas (fig. 25). This positioning of the road
may not seem unusual to us: while the country lane has long been part
of pastoral scenes, Hopper was one of the first to attend to so much
asphalt. Technological changes are integrated into the composition: the
house, the road, the poles (the wires seem erased) inevitably belong to
the landscape now. The clash between old and new is not so strikingly

harsh as in *American Landscape;* rather, the road and poles, like Wallace Stevens's jar in Tennessee, have shifted our perspective to create a new whole. The painting shows how readily the eye accepts these shifts, even as taste may lag behind in declaring the scene beautiful or even worthy.

Here too, accounts of the painting's conception clarify Hopper's procedures and vision. According to Jo Hopper's diary, her husband, depressed by want of a subject, kept driving the Cape Cod roads: "Painted Cape so long now—it's increasingly difficult to dig up subjects." When he found a site, Jo had her doubts about the potential picture: "Eastham his happy hunting ground & it's the least attractive township on the Cape & could be Westchester or N.J. almost & to think he has all these marvelous Truro hills stretched out all around us. No—they are too unusual— too set off by themselves, of their own kind, unique. Most go to Eastham to get same old story. Can one beat that? And he hates Jersey & Westchester."[49] Though Jo found the completed painting to be "a scene relived & absolutely convincing," her comparison of the Cape Cod setting to the hated "Jersey & Westchester" remains pertinent. In this case, the artist did not seek out the distinctively picturesque and regional: the "marvelous Truro hills." Despite the given location in the title, *Route 6* could be nearly anywhere in eastern America. While many "American Scene" painters would dwell on local character to be called "regionalists," Hopper's simplified forms (a technique partly learned from advertising) take on a generic quality. The particularity of the Cape is only hinted at by the hills and trees. The yellows and reds of grass, bushes, and a tree may belong to late summer, but rural activity is again overridden by Hopper's architectural interest. The precise outlines of house, in the New England vernacular of white shuttered cape attached to ell and barn (perhaps now converted to garage), reveal nothing but themselves. Even so quiet a painting still raises questions. Who is tempted to take the road? What has it done to life here? Is there any difference between start and destination, or is all as transparent and opaque as this spot in the sunlight?

Hopper's landscapes continue to draw the eye with their distinctive light. Striking trees, roads, hills, and houses, the light haunts not just because of its cool tonal value, but because it illuminates ghostly references to past vistas. Hopper seems the opposite of Norman Rockwell or even Andrew Wyeth, charged with pursuing outdated realism contaminated by sentiment and nostalgia. That last word, however, has been applied to Hopper with his recurring interest in grotesque premodern architecture, lonely lighthouse beacons, bare hills, ominous trees, and empty roads.

When asked about "nostalgia," Hopper replied with characteristic direct-ness and reticence: "As for nostalgia, that isn't conscious. . . . But why shouldn't there be nostalgia in art? I have no conscious themes."[50] It is difficult to say from such a comment what nostalgia means to Hopper or to his audience, except that it reinforces that the artist accepts what comes forth in his paintings, even an unconscious nostalgia. Critics defend him against sentimental ideas of nostalgia by delineating responses toward the past. Brian O'Doherty disassociates Hopper from "a corruption of mem-ory. . . . Nostalgia is the result of a process by which the lazy mind stocks itself with cozy furniture."[51] Certainly Hopper's painterly temperament (he once declared of a "sweet and sugary" book of etchings, "God give us a little vinegar!") does not encourage cozy versions of the past.[52] In dis-cussing the "uncanny" character of Hopper's paintings, Margaret Iversen separates a comfortable longing for an innocent past from the haunting presence of a repressed past that returns "unbidden." She writes of *House by the Railroad* that it is an error to read it "as sentimentally nostalgic": the gothic house "looms up all too closely, too powerfully. The past here returns uncannily."[53] Whether he references the past through architectural and land forms or presents a contemporary situation, Hopper usually evokes vague uneasiness. That sensation derives from a variety of ele-ments: the cast of the light, the starkness of the forms, the truncation of borders, the unsmiling human figures, the darkened windows. Perhaps there is the suggestion that we as viewers live in that emptiness behind the window. Hopper's perspective implies that though we are the voyeurs, we are on a par with the subject observed: the view could be reversed to catch the observer in his own empty cubicle looking out a frame. The blankness is reflected.

This reflection becomes extremely subjective: how haunting we find scenes such as *Gas* of 1940 depends on how individual perceptions bal-ance the dark woods, which to me seem menacing in their solidity, with the red of the gas pumps and sign. Cheerful toylike presences or garish machines overwhelming the attendant? If Hopper inspires nostalgia for those looking back on the mid-twentieth century, its nuances vary. The scenes that are sinister to some are benign to viewers who stress that Hopper's paintings exclude harsh references to the Great Depression and World War II. His city scenes, like film noir of the 1930s and 1940s, yoke hard-edged cynicism with sentimentality. The hard-boiled conventions— the men's city suits, women's cheap glamor, the coffee and cigarettes at all-night diners—have a flip side: longings for success, a second chance,

a lost innocence, romance, and a past that seems a dream against a cold future.

A vague sense of yearning hovers about Hopper's barely expressive figures, and this indeterminate longing crosses over into the less peopled rural scenes. Their starkness can imply that something has been stripped away: stale painterly conventions, musty ideals of man and nature. It is both relief and loss to be rid of that "something," while traces linger. Charles Burchfield, in admiring his colleague's watercolors, connects them with an old regional ethos of discretion and asperity, as they exhibit "a clarity, or better, a chastity of outlook that seems to stem from the New England scene from which so many of them are taken."[54] There is an additional complication: what was "contemporary" for Hopper is dated now, so the nostalgia—or blankness—is in our eyes. His Cape Cod is hardly overtouristed, with bumper-to-bumper traffic on the roadways; *Route 6, Eastham* does not feature bed and breakfast signs. As the artist looked back to Victorian houses of his childhood, we look back to the solitude of his Cape.

Hopper's paintings contribute to the shifting meaning of place in American culture. If they often erase the dichotomy between the rural and the urban, that is not only a sign of modern advance but of cultural loss. Values are no longer inherent in either site. The argument between the pastoral and the urban has been muted, difference diminished. As conventional and biased as the country/city divide may have been, nevertheless it has provided a testing of social and aesthetic values over a long history. There is no vital dialectic between Hopper's settings; rather, the quiet revelation of what remains.

Hopper disliked writing, but in pondering Burchfield's representative art and implicitly his own, he takes us to the edge of verbal, and then visual, expressiveness:

> Is it not the province of [such work] to render to us the sensations that form, color, and design refuse to reveal when used too exclusively as an aim in themselves, and which words fail to encompass?
>
> A train rushes on straight and shining rails across our vision, past closed gates, raises clouds of suffocating dust, and rumbles into vague stretches that imagination tries to construct.
>
> Can words express this in full? We believe they cannot.[55]

In one photograph he is smiling and boyish, accompanied by a pretty wife and children in the fresh outdoors; a caption below adds, "Andy's

pictures make sense" (fig. 26).[56] The image hardly fits the stereotype of the modern artist. There is no sense of political exile from Europe; of displacements rooted in homosexuality, alcoholism, depression, of alienation from the subconscious; of an existentialist's ever uncertain quest. The cognomen, inherited from the famous illustrator of children's classics, does not sit well beside contemporaries Arshile Gorky, Willem de Kooning, or Jackson Pollock. He looks too happy to be subversive, and why should he be? Since his twenties, success has been continuous.

So Andrew Wyeth is to be mentioned cautiously in discussions of "serious" art. The condescension toward him began with the aesthetic partisanship of the 1940s and 1950s (are you with Abstract Expressionists or agin' 'em), and was fed by his popularity, his self-promotion, the ubiquity of *Christina's World*, the family handling of sales, and the "scandal" (or hoax) of the revelation of late nudes—the "Helga" paintings. As Brian O'Doherty sees it, Wyeth's "stardom has cannibalized his art to a degree unprecedented by any other artist with pretensions to seriousness."[57] Wyeth has been "excoriated for his sentimentality, his narrative approach, his rural subject matter, his purposeful naïveté, his commitment to realism, his appeal to the middle class."[58] Dismissal on one hand and incredible popularity on the other. What is unusual in this situation is not that hype overwhelms image—which has become expected with much experimental art—but that it occurs with paintings of once innocuous things. Leafless trees and dry fields, rural figures, berry baskets, become totems of all that is wrong with midcentury realism. Whatever one's assessment of his art, there is no denying that Wyeth's depictions of Chadd's Ford, Pennsylvania, and Cushing, Maine, have colored in subdued hues the vision of the rural in the twentieth century.

That vision may be distorted by Wyeth's limitations, but equally if not more so by prejudices about his popularity and subject matter. The "excoriation" of Wyeth, like responses to Homer and Frost, assumes a condescension toward the rural and fosters simplistic readings of country scenes. A glib critical habit that has warped views of Frost recurs with Wyeth. The character of the work, often bleak in content and unsparing in presentation, is forgotten and is replaced by the image of artist as popular toady. As Frost and Wyeth became icons of common humanity and the simple life, critics decried the appeal of their assumed sentimentality. Katherine Kuh wrote in 1971 that Wyeth, while a "competent" draftsman, offered "first-rate illustrations of 'the good life'" so that "the public has come to think of him as the American symbol par excellence of healthy

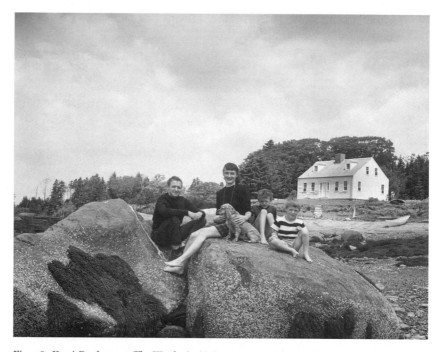

Fig. 26. Kosti Ruohomaa, *The Wyeths in Maine.* Courtesy of Kosti Ruohomaa, Stock Photo

self-reliance."[59] In 1996, another critic updated that condescension with the analogy of rusticated fashion fantasies: "Wyeth has produced a few memorable images, but essentially he is the Ralph Lauren of rural painting and illustrative at that—chic, class-bound and relying too much upon the seductions, the sheen and the blandishments of finely-wrought academic style."[60] To put aside for a moment the question of style, I wonder about the source of the "healthy," "chic, class-bound" type. The frequent models for Wyeth—husband and wife Karl and Anna Kuerner in Pennsylvania, brother and sister Alvaro and Christine Olson in Maine—do not cheerfully exemplify a prosperous "good life." They pursue labors that barely raise them above subsistence and give to their limbs arthritic grotesqueness; their clothes become cleaning rags that hang on nails. Anna Kuerner and Alvaro Olson may have been mentally ill; at the very least, they were not happily socialized into mainstream society. Assumptions about Wyeth's fans (are they the wearers of Ralph Lauren?), about his financial success, and about the simple goodness of the rural veil the paintings themselves. Another look at them and at Wyeth's personal and painterly relation to

his subjects clarifies what the twentieth century valued, sentimentalized, and mocked in the rural. Wyeth's accomplishments and limitations illustrate how provincial nativism can intensify the artist's vision and restrict it.

Wyeth never left home. In a century of expatriation and the mass physical and emotional uprooting of economic depression and world wars, he painted near his birthplace in Chadd's Ford, Pennsylvania, and the Cushing, Maine, summer home he had known since childhood. Perhaps he never quite escaped the looming bulk of his father, N. C. Wyeth, illustrator of such children's classics as *Treasure Island.* N. C. kept his children close to him in a world of fantasy realized (he would too convincingly and terrifyingly appear as Kris Kringle), idealism, and intense art training. One reading of the younger Wyeth's career is a love-hate rivalry with the father. There is the son's obedient tribute in the adherence to realism, the suggestion of narrative, the atmosphere of suspense, and at times a hint of the supernatural. Then there is divergence in the subdued palette rather than the romantic lushness of N. C.'s book work, the quiet rendering of the local rather than the dramatizing of exotic adventure, and success as a "real" artist rather than as an illustrator. Though biographies of both men disclose a more problematic relationship than their remarks in interviews suggest, Andrew repeatedly states that his work deepened emotionally after his father's death in 1945. While much contemporary art and literature struggled to respond to the failures of art, civilization, and the self, Wyeth was pursuing the nuances of the nearby.

The artist, in self-defense, does not present himself as a mere transcriber of topographical detail. He stresses artistic invention as "a strange, almost abstract excitement taking place in me, through tonality and shapes."[61] In explaining his allegiance to two regions, he suggests, as did Hopper, that the basis of his painting is not verisimilitude but an elusive private expression:

I am not a realist at all. This was brought to a focus for me by the death of my father. It was a tragic death; he was killed at a railroad crossing near his home. My difficulty—and my great urge—is that subject is unimportant. The less there is in the subject, the more I can pour myself into it. The familiar frees me. If I go to a place with marvelous settings, I am caught—caught by the object. I take pleasure in other landscapes, but I don't have any personal need to release it.[62]

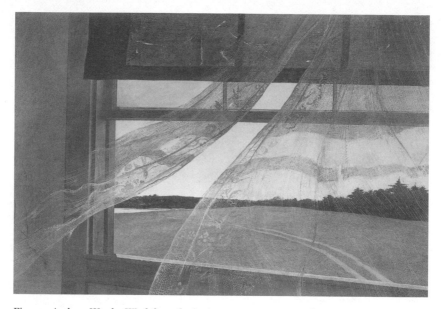

Fig. 27. Andrew Wyeth, *Wind from the Sea*, 1947, tempera on panel, 47 × 69.9 (18½ × 27½).
© Andrew Wyeth

But subjects there are in his work, and they imply much about the atti-
tudes of the artist and of his audience toward the rural. The question is,
do they free him or trap him more than he realizes in pastoral cliché?

Wind from the Sea, 1947, represents the setting so often associated with
Wyeth; it is presumably a view from the Olson house with its spartan
interior of walls, woodwork, and windowshade grayed and cracked with
age (fig. 27). The view looks out upon an equally minimal landscape: a
curved yellowed field and a strip of water to the left reflecting the bland
silver-gray of the sky. A few pines rise to distinguish themselves against
the mass of trees. A road or driveway cuts across the field. The worn ruts
signal long usage, while the grass between them indicates infrequent traffic.
The tracks do not have a clear destination, as they vanish near the water.
The boundaries established by the horizon of trees cut off any awareness
of other residences, other people, other places to go. What exists here
stays and does not leave. The scene is contained—except for the breeze
from the sea. The wind lifts the lace curtain, made more diaphanous by
disintegration, and sets the ghostly embroidered birds in flight to give
momentary life to the rags of past gentility. Like Frost, Wyeth uses win-
dows to convey the distinction between inside and outside, between hu-

man and natural, and the eerie crossover of boundaries. The sky and wall are different saturations of the same hue, while the greenish shade with its white splits parallels the mottled grass viewed through the white curtain threads. As in other paintings of the Olson house, the "invisible" air envelops the scene: Wyeth remembers "Everything was dry and hot—the shade curtains, the lace, the window frame."[63] The cropping of the scene enhances the ghostliness of this sere atmosphere. If someone were deliberately to look out, the window would be faced square on and the shade raised; here, however, the viewer seems caught by the unexpected breeze. Or the illusion is one of absence: no one is there, and this is the breathing inhuman quietness of an empty place.

A restrained sense of the genius loci also pervades *Snow Flurries* of 1953 (pl. 8). A hillside in winter is reduced to a nearly flat plane, the compositional devices simplified to a horizon line, with suggestions of a few diagonals and curves. The vertical fenceposts in the lower right are the only details that anchor the scene in a rural context—and even they are minimal representations. Rather like Winslow Homer, Wyeth balances between realism and abstraction. The artist's tempera technique, sometimes fussy and tight, here mimics the organicism of the landscape by imparting a subtle texture. As Wyeth explains tempera, "It's a dry pigment mixed with distilled water and yoke of the egg. I love the quality of the colors: the earths, the terra verde, the ochers, the Indian reds, and the blue-reds. They aren't artificial. . . . Tempera is something with which I build—like building in great layers the way the earth was itself built."[64] When Wyeth is at his best with tempera, the effect recalls luminism and its canvases made whole and transcendent by mystical light; the dryness of Wyeth's surfaces, however, like the skepticism of Frost's poetry, suggests an aura without the promise of divine grace. While this technique adds substance to the hill, it does not outweigh how space and light evoke feelings that cannot be verbalized as specific themes and reactions. Fastidious realism becomes the ultimate abstraction.

In this handling of light, Wyeth resembles Hopper, an affinity that writer and critic John Updike senses despite differences in the painters' reputations:

In the heyday of abstract expressionism, the scorn [of Wyeth] was simple gallery politics: but resistance to Wyeth remains curiously stiff in an art world that has no trouble making room for photorealists like Richard Estes and Phillip Pearlstein and graduates of commercial art like Wayne Thibault, Andy Warhol, and, for that

matter, Edward Hopper. We resent broody poses in Wyeth and accept them from Hopper, perhaps because there is a glamorizing touch in a Wyeth painting like *In the Orchard* and none in a Hopper like *Morning Sun*, or because broodiness feels more excusable in Hopper's urban than in Wyeth's rural settings. Nevertheless, the two men are close—close in their loyalty to American landscape and in their interest in the dramatics of light—and posterity may wonder how one could be so "in" and the other so "out."[65]

An occasional "glamorizing touch" and the rural subject matter again interfere. Did Wyeth succumb to cozy formulae? And how was the rusticity of his work received?

An astute critic on Wyeth's limitations and strengths is Brian O'Doherty, who anticipated Updike in outlining the rural problem:

Modernist art is urban art and it has incorporated the pastoral idea in various disguises, often hiding in its abstract facade a nostalgia for landscape. In modernism the landscape has been painted by urban creatures knowing nothing about it or the rural life. . . . That [urban] mind, however, while it accepts the urban view of the landscape (from Fairfield Porter's sunny idealizations to Hopper's bald realism), will not accept the rural view—nor is it equipped to read it, or perceive in it anything more than clichés identified with forms of nationalism troubling to the liberal spirit

Thus Wyeth, the only genuine *rural* artist of the slightest consequence, is attacked with a violence far beyond the usual etiquette of critical disagreement.[66]

If prejudice can be pushed aside, the issue then is what does this "*rural*" artist offer: sentimental tripe, an aesthetically compelling realism, or a melodrama of country degeneracy? The answer is probably all three. A large portion of Wyeth's oeuvre is dedicated to paintings of neighbors known since childhood or youth: the Kuerners on their farm in Pennsylvania, and the Olsons in their archetypal dilapidated house in Maine. If they and their homesteads are not exactly the found objects of radical art, they may be found "truths" as individuals in authentic, if not idyllic, connection with their surroundings. Or they may be rediscovered clichés of country hardship and character. Like Winslow Homer before him, Wyeth seemed to prefer local laborers to arty colleagues and urban sophisticates. However, Homer's relationship with his models remained distanced: they were paid. Wyeth spent long hours in the houses of his, observing and conversing, and gifts went back and forth. While Homer's models, like Hopper's, have their real-world identity submerged in the

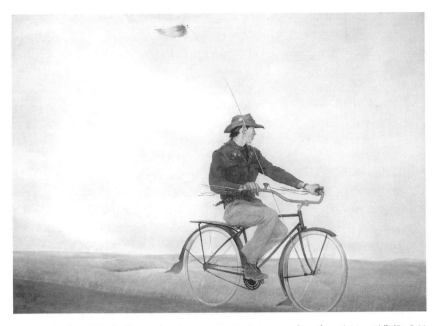

Fig. 28. Andrew Wyeth, *Young America,* 1950, egg tempera on board, 32½ × 45⁵⁄₁₆" (82.6 × 115.1 cm). Courtesy of the Pennsylvania Academy of the Fine Arts, Philadelphia. Joseph E. Temple Fund. © Andrew Wyeth

artist's renderings of them as types, Wyeth's paintings approach biography (authorized or not) so that people would seek out the "real" Christina to ask for her autograph. The rural realism of Homer and Frost often contains a subversive element: Homer's twist that makes a popular genre ambivalent, Frost's irony that challenges pastoral complacency. This doubleness has not been much sought in Wyeth's paintings, and I believe he has been less successful in sustaining subtle variations of tone over a long career and in appealing to vastly different audiences. However, doubleness is in many Wyeth images, intentionally or not.

For some viewers, *Young America* of 1950 is dangerously close to a Norman Rockwell illustration of national awkwardness made cloyingly endearing in a goofy ugliness (fig. 28). There is no cute smile or anecdotal context as in Rockwell, however, and the landscape does not promise reassuring domesticity, great bounty, or heroic destiny. Wyeth has painted the American lout. He is not the first, or last, to present him. He appears in Winslow Homer's Civil War painting, *Prisoners from the Front* (1866): a hunched uncouth figure among the captured Confederates, hands in

pocket, unable to grasp his place in the national moment. He reappears in Homer's Adirondack works such as *Huntsman and Dogs* with the affectless face of a predator who is part of brutal nature and who does not reflect poetically upon his place in the outdoors. That doltish sense of the American appears in the hyper-realistic sculptures of Duane Hanson: *Football Player* of 1981 is another Young America, the culture's hero and youthful hope in uniform and at rest with a styrofoam cup. Wyeth's boy on a bicycle is not exactly the machine in the garden, but he scarcely appears as an idealized kindred spirit in the landscape.

While discreditors of Wyeth slammed the assumed complacency and "healthiness" of his scenes, admirers often registered isolation or melancholy, the moods that might accompany *Wind from the Sea* and *Snow Flurries*. Other paintings take hints of bleakness further. If Hopper made the visual conventions of urban success and of advertising hollow, Wyeth upsets the kindly grandmother image of the rural homestead. Wyeth himself recognizes how his choice of subject and technique could create the saccharine: "I detest the sweetness I see in so much realistic painting. Awful. That's one of the great dangers of my technical accomplishment. I can get awfully nice in my lovely drifts of melted snow."[67] In the 1948 portrait *Karl*, a farmhouse interior is darkened so the only details are Karl Kuerner's stern features—those of an ex-German soldier—and a meat hook hanging behind his head. The perspective intimidates, as the hook and Karl loom over the viewer. The hook is for hanging sausages to cure, but nothing in the painting indicates that purpose. Even when that purpose is announced, as Wyeth did in interviews, it is still not reassuring because the painter emphasizes that "it's not a quaint farm . . . when they slaughter a pig it's brutal—and I was attracted by this."[68] The disconcerting intuition that rural self-sufficiency and determined practicality verge on brutality returns in *Tenant Farmer* of 1961 (pl. 9). This work does not glamorize country warmth as it offers the inverse: the winter starkness of a deer hanging from a barren tree next to a formidable brick farmhouse. The meticulous rendering of the discolored bricks, the prisonlike windows, and the fine snow blown off the left roof gable may alienate those favoring abstraction. That brick and snow can also seem unforgiving: no pity for the doe with splayed legs that hangs from a spidery willow. Like the wood and bucket below, the animal is part of the tenant's daily life— chilling in more ways than one. Selected paintings by Wyeth, like Frost's *North of Boston* monologues, upset the "given" that the countryside offers familiar aesthetic and emotional comfort with heartwarming stereotypes.

Of course, as also with Frost, images of rural hardness can become confined to the stereotype of the degenerate and backward hick, issues that will resurface in a later discussion of *Christina's World*.

Wyeth exemplifies the possibilities of nativism, but as did Thomas Hart Benton he defensively restricts it. Many of Wyeth's statements sound like variations on Emerson and Thoreau; while these transcendentalists never strayed far from Concord, however, their imaginations and sympathies roamed widely. Wyeth occasionally defended his provincialism with references to the poet who was by this time a revered elder, Robert Frost. In claiming a parallel between himself and Frost, Wyeth asks viewers to get beyond conventional responses to rural icons:

I have a very strong feeling . . . that the more objects you use, the less there is in the picture. Robert Frost is deeper than his New England subjects. I have painted old farm wagons and things like that, but I think this is the weakest part of my work. . . . Oh, I never doubt the object; I doubt the way I paint it."[69]

In articulating the feeling behind a painting, Wyeth echoes transcendental credos about becoming a transparent eyeball: "I wish I could paint without me existing—that just my hands were there. . . . When I'm alone in the woods, across these fields, I forget all about myself, I don't exist." Wyeth emphasizes that familiarity with place is crucial to attain this state:

Now, I couldn't get any of this feeling without a very strong connection for a place. Really, I don't paint these hills around Chadds Ford because they're better than the hills somewhere else. It's that I was born here, lived here—things have a meaning for me. I don't go to Maine particularly because of the salt air or the water. In fact, I like Maine in spite of the scenery. There's a lot of cornball in that state you have to go through—boats at docks, old fishermen, and shacks with swayback roofs. I hate all that.[70]

The saturation of place with significance is certainly important to twentieth-century figures of the traditional high-modernist canon: William Carlos Williams, Hart Crane, T. S. Eliot, Ernest Hemingway, William Faulkner, Georgia O'Keeffe, and Joseph Stella to name a few. But Wyeth's settings may be contaminated by the "cornball," a charge he anticipates and deflects by claiming he's after more than "shacks with swayback roofs." Such earnest intent, however, sounds naive and inadequate in a century of world wars, genocide, exile, and expatriation.

So does Wyeth provide the rootedness that renews as the mythical Antaeus was renewed by contact with earth, or does he retreat as a woodchuck goes into his burrow? As part of his self-defense in a 1965 *Life* magazine interview, Wyeth explains that he avoids the corny rustic with a portrait like *The Patriot* of Ralph Cline, an elderly neighbor in Maine who beams confidence and certainty as he poses in his World War I uniform. Though the background is merely a dark wall, Wyeth believes this depiction of Cline also expresses the locale, "an austere quality—very exciting—the quietness, the freedom." This is defense enough for the artist, though he provides ballast with reference to nativist artists who do receive critical respect:

All this is why I never go anywhere but Maine and Pennsylvania . . . everything we do is either going to take away or give. Robert Frost's life is a very good example. His later poems are not the important ones. He stopped living the thing that nourished him. That's the great danger of success and why I refuse to go places. . . .

You know, after you travel you're never the same—you get more erudite, you get more knowledge. I might lose something very important to my work—maybe innocence. And anyway, all those poops come back from Europe, I don't see where they're so damned deep in what they do. Seems to me they get thinner. . . . I actually like people such as Eakins and Homer. I admire Edward Hopper more than any painter living today—not only for his work but because he's the only man I know who actually feels that America can stand on its own. . . . I'm not talking about subject matter but a very American quality—an indigenous thing you're born with. . . . It's the quality of the early weather vanes, the hinges on the doors. It's very hard to pinpoint. *The Patriot*—there's a certain awkward, primitive quality in that portrait I feel could only have been done by an American. It's sort of dry, for one thing. Robert Frost's best poetry has a dry quality.

I've had people say, why paint American landscapes? There's no depth in it—you have got to go to Europe before you can get any depth. To me that's inane. If you want something profound, the American countryside is exactly the place.[71]

Like statements by Frost and Hopper, this smacks of xenophobia toward the "poops." Wyeth's counterprejudice aside, the value of his examples is both plausible and dubious. Frost wrote fine poems for years, but the late volumes do not match the overall quality and commanding tone of *North of Boston*. Is this because Frost "stopped living the thing that nourished him"? While after fame Frost's rural integrity, so to speak, was no longer protected from the urbane world by his hill-country farming, he remained

engaged in other arenas that nourished and plagued him: marriage, family, teaching, and conversation. Some late poems arise from his image more than his trials; nonetheless, Frost could not keep reliving and rewriting his early life. Wyeth is right in realizing that often American expatriates became addled by European trends, but this narrow view does not include the maturation of such a painter as Hopper who had to absorb and then move beyond Continental trends to his distinctive style.

Also, one might ask if Wyeth's dedication to the nearby was always enriching. After the death of the Olsons, Wyeth turned to other acquaintances: first the young Siri Erikson and then Helga Tesendorff. Some of the resulting nudes of virgin and woman reflect the artist's midlife crisis more than a life rooted in the local. Another work made problematic by social circumstances is the painting of Ralph Cline. The remarks of Wyeth and the Cline family reveal how the painter could be fascinated by this vital, intense character who would be at home in a stringent Frost poem. But there is a complicating context for the portrait. It was reproduced in a 1964 issue of *Life* magazine—the era of the Vietnam war, civil rights protests, and the assassination of Malcolm X. Is Cline then a neighbor exemplifying the enduring character of place, or a reassuring icon of conservative, simplistic values? If Edward Hopper's landscapes diminish city/country differences, Wyeth's paintings reassert them—but in a way that can be perceived as closed-minded and reactionary.

It is easy to line up the charges against Wyeth. He repeated and imitated himself—but so have lesser and greater artists including Edward Hopper and Georgia O'Keeffe. He has perhaps been living and painting too long to keep his reputation focused on a brief high point. (In contrast to Wyeth and Frost, painter Jackson Pollock and poet Sylvia Plath enjoy the dubious advantage of having tragically shortened lives reflected in a demonic creative phase.) Wyeth's wife promoted his work zealously with collections that increased the coffee-table-book appeal. While internationally known Wyeth admires his long-time rural neighbors, he is not "rural" in the way they were with their chores and limitations. In his fascination with the Olsons and the Kuerners, Wyeth may resemble writer James Agee writing of Southern tenant farmers in *Let Us Now Praise Famous Men*. Agee, in his "torrid idealizing of manual labor" can appear to be "cutting hay with peasants whom he will never resemble."[72] While it is not necessary to be poor to depict the poor (photographer Walker Evans was not), the relationship of artist to subject can cross over into a superficial sympathy and a nearly sordid fascination with an underclass.

When Wyeth dresses as a Mohawk or repeats his Halloween motifs of jack-o'-lanterns, cats, and crows in paintings, he seems less the prodigal son who returns home than the child who never had to leave. He is then the son playing with his illustrator father's props and indulging in fantasies of witchlike neighbors, frightening soldiers turned farmer, and fleshy naked women. This is a sequestered nativism. However, Wyeth's paintings can offer more (or less, in the minimalism of the landscapes). Then the native scene becomes a paradoxical presence—blank and layered—so that, in the artist's words, "Something waits beneath it."[73]

The Landscape of Desire: Elizabeth Bishop and the Feminine Earth

The fact is that we always tell the truth about ourselves despite ourselves.
—BISHOP, conversation with Wesley Wehr[1]

Landscape, observed and described, manifests some "truth" for and about Elizabeth Bishop. That truth may shift, turn, dissolve, and return with time and location—all the more reason for continued attentiveness. Evocations of place pervade her letters, prose, and poems, though often of places overlooked by others. An amateur artist, Bishop re-created interiors and landscapes familiar to her. The titles of her slim poetry collections convey the significance of "geography" for her, from her first book, *North & South* (1946), which opens with "The Map," through *A Cold Spring* (1955) to *Questions of Travel* (1965), and to *Geography III* (1976). Early critics found Bishop's descriptions—of Worcester, Massachusetts, her birthplace; rural Canada, home to her mother's family; and later residences, including depression-era Key West and exotic Brazil—remarkable in detail, but remote from literary experimentation and too self-effacing to stand among modernist exhortations, searing confessionalism, or militant feminism. Yet her readers have better learned to see beneath the surfaces and to recognize the poet's geography as central to an exploration of self and world. That geography is more than a metaphor for interiority and a singular relationship between the poet and the "other." Bishop's devotion to place sets her against several daunting traditions: the romantic and the transcendent, derelict in the modern era; and the colonial and imperial that map on the external terrain desire, knowledge, and power.

Within apparently modest descriptions, Bishop continues landscape traditions in a loaded way. As it was for romantics, explorers, and colonists, the land becomes for the poet an image of her own desire. Her observations involve a desire to know, to make contact, and to place herself, and the desire to challenge the imperial and find, cherish, and love the "feminine." Those intangibles—desire, knowledge, and power—intersect with haunting memory, loss, and doubt. So in observing the landscape, Bishop encounters traces of the past, sometimes to be obscured and at others to be exorcised or celebrated.

It has powerfully struck her readers that the settings of Bishop's prose, letters, and poetry are saturated with consoling and horrific memories, like the clang of the blacksmith's hammer and the scream of the lost mother hanging in the "pure blue skies" of her story, "In the Village."[2] Such memories are integral to readings of place and self: personal and poetic interpretations of the past shape identity. As we learn from literature and psychology, from history and our own experiences, such memories can be destructive, pulling the self into a past that can never be recovered and never resolved. As historian David Lowenthal writes of compelling reveries, "Total recall immerses us willy-nilly in the past; the present is hag-ridden by previous events so consequential or traumatic they are re-lived almost as though they were still occurring."[3] Bishop once explained, "Like most poets—I have a really morbid total recall of certain periods," and, I might add, of certain places.[4] Her works often return, implicitly and explicitly, to the terrors of her childhood isolation and their threats to selfhood, to the girl who at a mother's scream "vanishes." In doing so, they struggle with remaking the past and a poetic self that does not dissolve before ghosts but can endure and even affirm past and present.

Thus through the intersections of public and private history, Bishop employs landscape description to remake an imperial and androcentric tradition and to sustain a poetic identity. In her endeavor, she revalues, if obliquely, the perspective and imagination of the woman artist along with the love—familial, friendly, and erotic—of women for women.

The contexts of Bishop's dislocated life, her status as "unplaceable," and her uneasy response to an increasingly vocal feminism prepare for a discussion of poems that display a fraught and sensual feminization of landscape. To explore how desire surfaces, I trace the poetry's allusions to landscape conventions: these include the pastoral and the sublime; the perspective of the "eye" that may attain an empowering prospect or be denied entry; the attention to senses other than the visual; the relationship

of aesthetic and social issues; and the gendering of a scene. Bishop's variations on such practices provide further insight into her "feminism" and another significant avenue for valuing her seemingly idiosyncratic interests. Situating the poet in landscape traditions underscores further wide-ranging implications of her work, which contests exploitative, repressive paradigms and reinvents the value of the natural world for the postcolonial, postmodern era.

Elizabeth Bishop, who lived from 1911 to 1979, experienced a variety of landscapes, not always happily and not always by choice. Her father, son of a well-to-do builder in Worcester, died when Bishop was eight months old, and her mother returned with the child to her family home in rustic Great Village, Nova Scotia. Bishop's mother became increasingly unstable and was institutionalized for mental illness when Bishop was five years old: the child never saw her again. Bishop was then shuttled back and forth between her maternal grandparents' modest farm home, her prosperous paternal grandparents' house in Massachusetts (where she suffered from eczema, allergies, and asthma), and the residences of various aunts and uncles. Educated at a private Massachusetts school and Vassar (at both places she was known as solitary yet gifted), she seemed destined to be a poet, especially once she befriended Marianne Moore, known for her innovative poetics and Victorian manner; Bishop was initially compared to Moore as another selfless observer of the natural world. Throughout her life, Bishop's shyness masked her rootlessness and unconventionality; her travels and homes were shared with women, particularly with Lota de Macedo Soares in Brazil from 1952 through 1967 (fig. 29). As friend and poet James Merrill commented, "she impersonated an ordinary woman."[5]

That impersonation of "an ordinary woman" and the quiet, objective appearance of her poetry at times shadowed her reputation as a significant artist. While Bishop was respected for her craft and honored with fellowships and prizes, including the Pulitzer Prize, the National Book Award, the Neustadt International Prize, scholars have considered her "unplaceable" and admirers have lamented that during her life she was not better known. The peculiarities of her reputation result from a variety of circumstances.[6] She did not loudly announce herself a poet, à la Yeats or Eliot, who would boldly confront the history of Western Culture. Her first book of poetry was published when she was thirty-five, and others followed

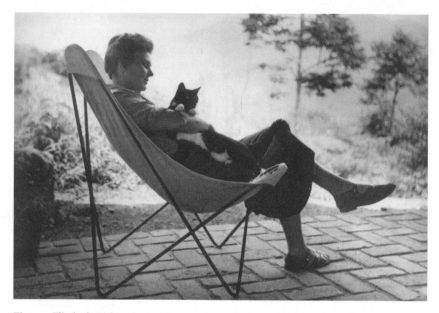

Fig. 29. Elizabeth Bishop in Brazil, 1954. Special Collections, Vassar College Libraries. Photograph by J. L. Castel.

about a decade apart. Not until late in her career did she join, reluctantly, the reading/teaching circuit. Despite connections with Marianne Moore, Robert Lowell, Randall Jarrell, and *New Yorker* editor Howard Moss, she was not part of a specific movement and felt alienated from the New York literary scene. So she was seldom before readers, and never in a confrontational manner that inspired heated debate. In fact, early commentary was often limited to reviews that struck a diminishing note. Such criticism was prevalent from Bishop's first book until the publication of *Geography III,* and, as Thomas Travisano explains, emphasized the "objective" character of her work and "visual accuracy and formal control" at the expense of passion, depth, and dreamlike imagination.[7] Bishop herself complained in a 1953 letter of the stereotyping of her style as one of " 'coldness and precision.' "[8] She was characterized as a "much-prized, plain-spoken, pleasantly idiosyncratic maiden aunt, one who has observed, considered, and savored the world, for the most part alone."[9] Her poetry, as did the very different works of Winslow Homer and Robert Frost, impressed these readers more as transcriptions of scenes than highly imagined works. David Kalstone defines this tendency: "Critics have praised [Bishop's] de-

scriptive powers and treated her as something of a miniaturist. As mistakenly as with the work of Marianne Moore, they have sometimes asked if Bishop's is poetry at all."[10]

The issue is not only Bishop's "manner" but her subjects. As American poetry moved toward demonic confessional modes during the 1950s and later toward feminist outcry, Bishop would elect to describe "a literal backwater" as she does in "Poem." She characterized her childhood in Great Village, a frequent backdrop for her writing, "like living in the nineteenth century" (fig. 30).[11] She mocked herself as a regressive romantic in a 1951 letter to Lowell: "I find I'm really a minor female Wordsworth—at least, I don't know anyone else who seems to be such a Nature Lover."[12] Though she appears politely restrained in the literary company of Robert Lowell (who became a close friend), Allen Ginsberg, Sylvia Plath, or Adrienne Rich, parallels do exist between Bishop and her contemporaries. She too felt ill at ease with mainstream American culture; an alcoholic and "closeted" lesbian, she failed to conform to the postwar feminine icon of the neatly coiffed housewife. However, her distinctiveness was not voiced through radical, blatant flaunting of poetic and social norms: her poems of place call attention to what others had overlooked or abandoned.

The intensely visual nature of Bishop's poetry has garnered praise but also complicated assessments of her range. By her own admission, Bishop considered herself "more visual than most poets." Her amateur paintings reveal her delight in form, her attraction to the direct and childlike character of the primitive style, and in her attention to objects a Cornell-like synthesis of whimsy and surrealism.[13] In her watercolor *Nova Scotia Landscape*, Bishop depicts rural buildings protectively settled into fields and woods and toy-like boats on an inlet; this scene demonstrates her fondness for the modest yet distinctive place (pl. 10). She recalls in an interview,

Many years ago, around 1942 or 1943, somebody mentioned to me something that Meyer Shapiro, the art critic, said about me: "She writes poems with a painter's eye." I was very flattered. All my life I've been interested in painting.[14]

This interest suggests that Bishop seeks value in the surfaces, the appearance of things, and that her poetic language may approximate painterly codes. However, this visuality fostered the poet's image as creator of "charming little stained-glass bits."[15] This attention to the visual alone, to what the eye coolly sees, detracts from a realization of how much Bishop's

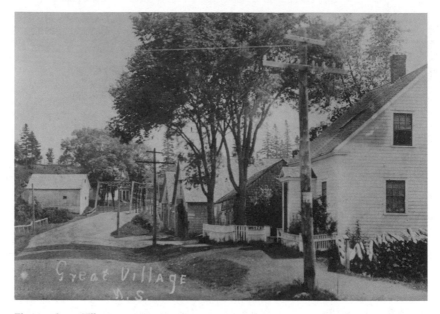

Fig. 30. *Great Village.* Special Collections, Vassar College Libraries. Photographer and date unknown.

poetry appeals to other senses. Vision is thought the most abstracted and detached of the senses, yet Bishop's poetry is also strongly tactile. The impression of breath, touch, and texture in "O Breath," "The Shampoo," "Brazil, January 1, 1502," and "Song for the Rainy Season" create a sensuous, sexual aura. Enhanced awareness of that appeal beyond the visual challenges a general perception of Bishop as a neutral scribe and suggests a sensual, if often discreet, woman.

With the overpowering view of Bishop as a visual writer, it has taken time to learn to read beyond what David Kalstone called "the deceptively simple surface" of her descriptions. Following the lead of such sympathetic readers as Kalstone, Moore, Lowell, and Jarrell, scholars since the late 1970s have probed the subjectivity of Bishop's work.[16] This trend to read for more than imagism was fostered as Bishop's poetry moved away from surrealistic accounts of shy, marvelous beings such as "The Man-Moth," "The Gentleman of Shalott," and the toy horse of "Cirque d'Hiver," to more conversational and situated poetry. Poems from *Geography III* (1979) and stories of childhood included in the posthumously published *Collected Prose* (1984) were openly autobiographical and allowed readers to decode the private elements of earlier works. This focus on the subjectivity of Bishop's writing coincided with developing feminist criticism. Certainly

the growth of interest in women artists has raised Bishop's stock, but the alliance between the poet and feminism is an uneasy one. Bishop did not want to be grouped with "women poets," was skeptical of the women's and gay rights movements, yet considered herself a feminist.[17] Over the past three decades, feminist critics have questioned how this reticent, singular writer nonetheless explored the restraints and potential of a woman's poetic voice and contributed to a tradition of women's literature.

Despite her connections with Moore and Lowell, Bishop's poetic heritage is difficult to map. Her eclectic interests include George Herbert, Walt Whitman, Charles Darwin, Joseph Cornell, and the natural history of *National Geographic*. Though she admired many of the same poets as male modernists, she does not display a "strong" relationship to a male figure; nor does she place herself in a specifically feminist tradition. Indeed, several studies have analyzed the complexity of Bishop's connections with literary mentors and traditions. Betsy Erkkila in *The Wicked Sisters* examines how Moore fostered the younger, "dutiful daughter" even as the older poet's strict maternal ethos became restrictive: "Bishop . . . was being at once 'hid' and 'crushed' by the 'Ionic chiton-folds' of Moore's art, even as she sought to free herself from Moore's potentially debilitating hold."[18] Joanne Feit Diehl in *Women Poets and the American Sublime* places Bishop in a countertradition formed by nineteenth- and twentieth-century women poets to the dominant romanticism that excluded woman from "the possibilities of the Emersonian imagination and the Whitmanian or American Sublime": "She is virginal, silent, an isolated object of observation, whereas a vast attractant power emanates from the male poet, and all life serves him as an 'exponent of his meaning.' "[19] However, Bishop's struggle against restrictions and silence imposed by sexist traditions, family decorum, or personal temperament rarely takes on overt expression.

Nor does Bishop readily embrace all that is feminine. Critics concur that Bishop is often uneasy with a female presence. The speakers of her early fiction, Brett Millier finds, "are always creative, imaginative, solitary little boys"; Lorrie Goldensohn notes that Bishop's female figures are often "subordinate and pitiable" and the "proto-selves" are frequently male; Diehl explains that as Bishop "identifies patently male images with aggression and violence, traditionally female images may be cast in an equally negative light."[20] As it has for many women artists, Bishop's internalization of negative response to the feminine impeded her development of a distinctly new and womanly voice.

Near the end of her life, Bishop addressed such barriers more openly. In a 1977 interview, looking back over the course of her career, she talked ambivalently about feminism. She recalled that in her college days she "never gave feminism much thought," concluding with an elliptical "until" that is not followed up. Instead, Bishop went on to observe that she "never [makes] any distinction" between men and women poets, and then admitted that "sometimes I think if I had been born a man I probably would have written more. Dared more, or been able to spend more time at it."[21] On the subject of "coming out," friends of Bishop record her as half-jokingly referring to a new home and to herself in saying that she believed "in closets, closets, and more closets," continuing to suspect that lesbianism was "unspeakable."[22] Adrienne Rich writes that as a young poet she did not find that Bishop's early "mannerisms" offered an accessible model "for a clear female tradition" and that she did not initially connect the work's "encoding and obscurities" with "a lesbian identity."[23] On her part, Bishop admired the younger Rich, although about *Diving Into the Wreck* she is recalled as saying, "*My God*, I've been a feminist since *way* back. I don't feel that you have to write about sex that way" and that "I could never use [sexuality] as a subject or write about things as baldly as Rich does."[24]

Instead of a bald exposé, Bishop offers sexuality, and much else, through scrutiny of landscape. Gender, power, identity, and desire converge there. In describing landscape, she absorbs then revises daunting, though perhaps moribund, traditions, and she finds means of expressing "unspeakable" desires. Bishop's poetic and personal search for a home returns her to the places of childhood and takes her to new sites of possibility. In her returns and travels, she traces, albeit indirectly or with disappointment, desire on a scene. Of course, postcolonial and ecological critiques warn that taking the external world as embodiment of desire often causes a destructive imposition. Therefore, the challenge before Bishop is not only to renew an "exhausted medium," but also to rewrite a tradition that frequently subjects the "other." As a conflicted woman drawing on conventions that have dehumanized the feminine and feminized an exploited nature, Bishop potentially places herself in both the roles of the violated and the violator as she seeks to be a "Nature Lover."

A Cold Spring (1955) and *Questions of Travel* (1965) depict places that challenge the poet with ordinariness and splendor, a challenge answered

in part by a gendering of the scene. The two volumes also bridge Bishop's extreme unhappiness at the end of the 1940s and her arrival in Brazil: her own encounter with a new exotic world and immersion in one of the most fulfilling relationships of her adult life. During the late 1940s, Bishop, having left Key West, moved from place to place; although she now had a book published, she still seemed personally and professionally unsettled. She had recurring problems with asthma, eczema, and alcoholism. She also seemed unresolved about her affections and sexuality: she and Robert Lowell developed an intense friendship with an undercurrent of attraction, and a relationship with Tom Wanning ("possibly her lover") came to an end.[25] At the writer's colony Yaddo in 1949, Bishop felt desperately out of place as she complained in a letter to Loren MacIver: "I can't seem to 'mix' any more here . . ."; "In fact I JUST DON'T KNOW anything except that I'd like to die quite quickly."[26] Lowell recommended her as poetry consultant for the Library of Congress, but after Lowell left for Europe with his new wife, Elizabeth Hardwick, Bishop's asthma flared up again and she "dragged herself through the summer in Washington, hating the climate, the job, the circumstances."[27] In October 1951, Bishop, perhaps fleeing this life, left for what was meant to be a solitary trip to South America and then on to Europe. The poems written before and after this voyage reveal a poet already on a journey to revalue her past. Her quest seeks out a creative perception that, however quiet its guise, could confront its powers and, in the words of "Questions of Travel," the "lack of imagination that makes us come / to imagined places."

"At the Fishhouses" and "Cape Breton," written before the trip to Brazil and included in *A Cold Spring,* return Bishop to the land of her troubled childhood and to pastoral traditions. While not explicit attacks on flawed paradigms of landscape, the poems play on one of the oldest tropes: water as feminine principle. The source of Bishop's attraction to water imagery is a matter of conjecture: that imagery may reflect the topography and climate of places she lived, as well as half-conscious absorption of artistic traditions that ally the fluid and the feminine. That affinity is probably as mysterious as some of the poetry's moments, but in some way it eventually empowers the woman poet.

The well-known epiphany of "At the Fishhouses" offers a twist on conventional icons derived from "nature" as the poet thinks of seeing "over and over, the same sea," "icily free." Like "The Fish," it is founded on a tradition of nature poetry in which detailed local observation gives rise to transcendent insight. In this poem, first published in the *New Yorker* issue of 9 August 1947, the speaker on "a cold evening" observes

an old man "netting" by archaic fishhouses, the "heavy surface" of the "silver" sea, and the "big fish tubs . . . completely lined / with layers of beautiful herring scales." She sings Baptist hymns to a seal, "like me a believer in total immersion." Her observations, balancing the casual and offhand with the intense and lyrical, yield to a contemplation of the sea: "Cold dark deep and absolutely clear, / element bearable to no mortal." She imagines how dipping "your hand in" is like a "transmutation of fire" and that "If you tasted it, it would first taste bitter, / then briny, then surely burn your tongue." This sensual experience of an eternal form of "transmutation" imparts "knowledge":

> It is like what we imagine knowledge to be:
> dark, salt, clear, moving, utterly free,
> drawn from the cold hard mouth
> of the world, derived from the rocky breasts
> forever, flowing and drawn, and since
> our knowledge is historical, flowing, and flown.[28]

The sublimation of elements is indebted to a visionary tradition; one only need think of the consuming fire of T. S. Eliot's *The Four Quartets*. There is, however, a shift away from divine fire to an emphasis on sensation, fluidity, and material or organic (as opposed to heavenly) origins. The water is "drawn" and "derived" from "the cold hard mouth" and "rocky breasts" of the world. Robert Lowell, inheritor of a troubled patriarchy, felt the "breasts" were "too much"; Bishop's biographer, Brett Millier, associates the "chill maternal image" with the poet's possible memories of her lost mother.[29] "Water, "mouth," and "breasts" may not be exclusively bodily "feminine" symbols, but they depart from conventional Western paradigms for knowledge: the "masculine" sun is the most prominent emblem of divinity and sovereignty, associated too with the singular gaze of a visionary figure. Notable in the American poetic tradition are the "tyrannous eye" that Emerson demands of the ideal poet, "a sovereign," who "stands on the centre," a genius whose "sunrise" would "put out all the stars," or Wallace Stevens's dedication to "The sun . . . gold flour-isher" in "Notes Toward a Supreme Fiction."[30]

Besides looking down to earth and water rather than up to the heavens for inspiration, Bishop, that most visual of poets, seems to abjure the gaze affiliated with the dominant imagination. That gaze, considered by post-modern critique as "predominantly phallic," connects to issues of power,

knowledge, and sexual relations. As Peter Brooks explains, "The drive for possession will be closely linked to the drive to know, itself most often imagined as the desire to see. For it is sight, with its accompanying imagery of light, unveiling, and fixation by the gaze, that traditionally represents knowing, and even rationality itself."[31] Even as it is highly pictorial, "At the Fishhouses" challenges such paradigms: the "as if" of this epiphany is set off by bodily sensations of touch and taste. The watery immersion, introduced in an offhand matter by the hymn-loving seal, may suggest baptism and purification; however, rather than ascendance to a heavenly father, there is continued immersion in a "flowing" that can never be arrested and possessed.

"Cape Breton" too offers mysterious waters and explores what can be seen and known from a landscape. It presents a misted, enfolded, fissured landscape, a place partly unveiled to the eye, partly hidden. This scene blends several possibilities. The enfolded interior evokes the geologic past of creation and also perhaps a bodily, feminine sexuality. As partly enclosed, the place echoes other physical and psychological enclosures in Bishop's poetry. Her work manifests a "yearning for enclosure" in ambivalent imagery of prison and solitude; it expresses a similar fascination with imagery of cages, ribs, and wires, as if the poet were seeking "sites of voluntary exile" or some "picture of order, even if order within ominous limits."[32] The landscape imagery is more expansive and permeable than that of prison or cage, perhaps uniting the internal and introspective with the external and responsive, a desire for safety with a desire for exposure and contact.

The opening lines of "Cape Breton" describe an island with unliterary birds that "all stand / with their backs to the mainland." Perhaps the oddity of the birds and their position reflect Bishop's self-consciousness about the "unlikeliness" of her settings and her own poetic posture that separates her from New York trends. Although the sheep may call up idealized pastorals of shepherd life, the poem presents a "machine in the garden," to borrow Leo Marx's phrase, to introduce even in this remote place the destruction of technology:

> Out on the high "bird islands," Ciboux and Hertford,
> the razorbill auks and the silly-looking puffins all stand
> with their backs to the mainland
> in solemn, uneven lines along the cliff's brown grass-frayed edge,
> while the few sheep pastured there go "Baaa, baaa."

> (Sometimes, frightened by aeroplanes, they stampede
> and fall over into the sea or onto the rocks.)

The machine's threat, however, remains an aside rather than a dominant force, and what follows is a soothing return to nature. As in "At the Fishhouses" with its "silver" sea, the poet's description of water inspires tranquility:

> The silken water is weaving and weaving,
> disappearing under the mist equally in all directions,
> lifted and penetrated now and then
> by one shag's dripping serpent-neck,
> and somewhere the mist incorporates the pulse,
> rapid but unurgent, of a motorboat.[33]

The hypnotic feel of these lines, enhanced by alliteration and rhythm, includes sexual overtones, with the interplay of penetration, pulses, and hiddenness. The mist blurs the distinction between the "silken" fluid element and "the mainland"; elements are not autonomous and discrete but mysteriously intermingled. The sensuous water is feminized, as if it were an elusive nymph "weaving" and "disappearing." There is occasional, perhaps masculine "penetration," but the sinister quality of the "serpent-neck" is moderated by the "mist." That mist also incorporates the machine, here a motorboat, whose "pulse" does not seem mechanistic but part of the scene's soothing, seductive rhythm.

Like "At the Fishhouses," therefore, "Cape Breton" suggests Bishop feminized the landscape with a difference: the imagination, rather than siding with the "masculine" sun, aligns itself with "feminine" water and mists. When the sun becomes more prominent it is in poems featuring lost and lonely male speakers: the earlier "The Prodigal" and the later "Crusoe in England." In "Cape Breton," the mist functions as the guiding light and quietly transforms the scene. Like the tonality of a painting, the island mist is a unifying element that draws the eye into the scene and creates an immanent presence:

> The same mist hangs in thin layers
> among the valleys and gorges of the mainland
> like rotting snow-ice sucked away
> almost to spirit; the ghosts of glaciers drift
> among those folds and folds of fir: spruce and hackmatack—

dull, dead, deep peacock-colors,
each riser distinguished from the next
by an irregular nervous saw-tooth edge,
alike, but certain as a stereoscopic view.

This scene could exemplify an Emersonian ideal: the material and spiritual of nature coincide in the specificity of "spruce and hackmatack" and the ghostliness of the "rotting snow-ice." The geologic past is contained and consumed in that mist. The layers of mist veil and reveal an interior landscape of "valleys and gorges," "folds and folds of fir," and "an irregular nervous saw-tooth edge"—a highly sensual, somewhat edgy description emphasizing the forms of the landscape and taking the viewer in and out of the scene. The illusion of three-dimensionality also suggests a perspective that goes beyond the surface of present moment, the foreground of mist, to something of depth in the interior, in the land's past.

Under the influence of the mist and "ghosts of glaciers," the island no longer represents the civilized pastoral middle ground of prosperous cultivated fields celebrated in English and American agrarianism. Rather, it reverts to the wildness prior to European settlement, as the Christian returns to the heathen:

The little white churches have been dropped into the matted hills
like lost quartz arrowheads.
The road appears to have been abandoned.
Whatever the landscape had of meaning appears to have been abandoned,
unless the road is holding it back, in the interior . . .

Such reversion might entail a personal element: the orphaned child of the provinces, Bishop is drawn to the neglected and abandoned. While one might need to know about her life, it is hard to resist connecting these lines with what for Bishop was the primal scene: the separation from her unstable mother. Earlier, she wrote explicitly about such memories in the short story "In the Village," dwelling on the mother's scream, which "hangs there forever" over the village.[34] Thus her own history contributes to the intrigue of what, or who, has been abandoned, and what is held back in some "interior."

The "interior" of a landscape often stirs conflicting responses: fear of entering the physical and emotional unknown is offset by desire for enclosure and belonging. As Annette Kolodny writes, the interior can rep-

resent a return "to the primal warmth of womb or breast in a feminine landscape."[35] Reflecting this dynamic, insofar as the poem encodes an allusion to Bishop's lost mother, the "holding . . . back" hints at secrets, vulnerability, and perhaps of something to be both recovered and discovered. Bishop, in her descriptions that initially seem objective yet allude to the personal, anticipates Simon Schama's insights in *Landscape and Memory:* "if a child's vision of nature can already be loaded with complicating memories, myths, and meanings, how much more elaborately wrought is the frame through which our adult eyes survey the landscape. . . . Before it can ever be a repose for the senses, landscape is the work of the mind. Its scenery is built up as much from strata of memory as from layers of rock."[36] The "strata" are not completely revealed in this poem; it seems haunted with past cultural and even personal meanings buried in the landscape.

Whether the road leads to memory and recovery, "Cape Breton" rejects romantic and pastoral tropes only to turn around and reinvent them. The landscape "appears to have abandoned" its moral, yet the abandonment re-naturalizes the scene as it regresses to provocative mystery. The road, marker of human travel and purpose, seems to have an intention of its own, drawing eye and imagination into the scene. Thus after the line, "Whatever the landscape had of meaning appears to have been abandoned," the sentence continues in a Whitmanesque breath, accumulating intriguing detail about the unknown "interior":

> where we cannot see,
> where deep lakes are reputed to be,
> and disused trails and mountains of rock
> and miles of burnt forests standing in gray scratches
> like the admirable scriptures made on stones by stones—
> and these regions now have little to say for themselves
> except in thousands of light song-sparrow songs floating upward
> freely, dispassionately, through the mist, and meshing
> in brown-wet, fine, torn fish-nets.

Where literal vision cannot penetrate, legend and imagination see and hear the interior of "deep lakes," an image evoking real and metaphorical repose, reflection and profundity, "feminine" fluidity and mystery. The lakes may then represent Kolodny's "female principle of gratification" as "enclosing the individual in an environment of receptivity, repose, and pain-

less and integral satisfaction."[37] However, this serenity is offset by nega-
tion—"we cannot see" the lakes—and by additional enigmatic signs of lost
meaning: the Scripture-like scratches evoke the archetypal trope of nature
as sacred text, here forgotten and neglected. Throughout the passage the
poet speaks as if the scene once communicated its inherent significance
(though she does not clarify what this might be), and her phrasing implies
that the landscape can no longer manifest such meaning: "these regions
now have little to say for themselves." The poet, and her readers, can
only speculate about what has been lost or abandoned: perhaps the reli-
gious, cultural, and artistic possibilities of the pastoral, or perhaps some
private connection? The poet does allow for the expressiveness of bird-
song (that most romantic of tropes) as conveying lightness and freedom
"dispassionately"; paradoxically the birds' disinterest in human concerns
creates an emotional release for the poet from memory of abandonment.
At the same time, these songs become enmeshed in the fish-nets, so that
the imagery in its contradictions and its synesthesia of the visual might
serve as an analogue for the poet's own expressiveness derived from a
forgotten place.

Such imagery makes the abandoned island at once ancient, fresh, and
domestic. Bishop, perhaps turning away from the "mainland," again re-
verses the modern tendency to see the machine overcome a demythified
land. From the "floating" sparrow songs, the poet turns to a bus that has
been absorbed into the quiet scene, moving with animal-like spontaneity
and cozy, houselike fullness; and it introduces a benign human presence:

A small bus comes along, in up-and-down rushes,
packed with people, even to its step.
(On weekdays with groceries, spare automobile parts, and pump parts,
but today only two preachers extra, one carrying his frock coat on a hanger.)
It passes the closed roadside stand, the closed schoolhouse,
where today no flag is flying
from the rough-adzed pole topped with a white china doorknob.
It stops, and a man carrying a baby gets off,
climbs over a stile, and goes down through a small steep meadow,
which establishes its poverty in a snowfall of daisies,
to his invisible house beside the water.

Though the straightforward description contains the possible sentimen-
tality of this country Sunday, it is an archaic idyll in which the past

becomes the present. Like Frost, Bishop honors a rural life that is past for others but a present reality for her. The pastoral is not rudely exposed but kept enclosed by the Sunday quiet. The man with the baby, like Marianne Moore's exotic bird in "He 'Digesteth Harde Yron'" who "watches his chicks with / a maternal concentration," represents a more intimate domestic ethos than that of a prominently visible and authoritarian patriarch. This ethos also rejects the land's "practical" economic worth for a "poverty" of aesthetic riches. Such gentle poverty idealizes country life as free of wealth's corruption and suggests that nature, at least the abandoned pastoral, resists being remade into a site of luxury or industry that would erase the past. For all the poet witnesses, too, there is much her eye does not possess, from the deep lakes" to the man's "invisible house beside the water."

With that unseen house, the poem returns to mystery, and the closing images suggest the landscape's life goes on peacefully, even as something remains portentous:

> The birds keep on singing, a calf bawls, the bus starts.
> The thin mist follows
> the white mutations of its dream;
> an ancient chill is rippling the dark brooks.

For all the empathy expressed toward this remote scene, the poem leaves us dangling. We leave without quite entering the interior, without learning what "meaning" has been abandoned or "held back." The final images suggest some ongoing presence: the mist, the most personified natural element, does not dominate so much as gently permeate the scene—it "follows" its dream, something so often bound to human imagination and desire. The "ancient chill . . . rippling the dark brooks" again recalls the imagery of "At the Fishhouses," with the icy water of "knowledge" "derived from the rocky breasts / forever." Expressive on its own of Bishop's attraction to pastoral and wild scenes, "Cape Breton" reveals more when linked to water imagery and interiors of later poems.

While "Cape Breton" remythifies the present by connecting the scene with the past, the poems of *Questions of Travel*, as that title itself affirms, foreground the quest for meaning in the "discovery" of a new land and people. These poems (as well as Bishop's letters) also foreground the impetus and desires motivating that discovery. In all this, her "personal" writings overlap with political and postcolonial concerns. Louis Montrose,

Tzevtan Todorov, Stephen Greenblatt, and others have delineated the confusion of desires behind New World exploration: the desire for paradise and religious ecstasy; the desire for land and wealth; the desire for political and sexual power, for autonomy and selfhood; the desire to know the other; and the desire to move on again.[38] In much psychoanalytic thought, from Freud to Lacan, "the desire to know—the epistemophilic urge—is ultimately linked to sexuality."[39] Whether or not one believes the link "ultimately" sexual, the commingling of selfless curiosity with the desires of the affections and body do seem to inform Bishop's "immodest demands" (a phrase from one of her Brazil poems entitled "Arrival at Santos"). Bishop thought her work composed since moving "to the other side of the Equator . . . a new departure." Written after a time of intense unhappiness for Bishop in America and during the period in which Bishop and Lota de Macedo Soares fell in love with each other, the poems may be emboldened by the poet's euphoria in feeling that she had "died and gone to heaven, completely undeservedly."[40] However, that bliss is not revealed at once.

Viewed in a postcolonial light, the poems written in Brazil seem a denial of the transcendent, the imperial, and the artist's "potency." In poems such as "Arrival at Santos," as in later works, Bishop frequently deflates male poses: the quester becomes the tourist, the exile becomes the vulnerable child, vision becomes what "Poem" calls "looks," symbols are replaced with hesitancies and questions. The opening stanzas of "Arrival at Santos," for example, undermine the sublimeness of exotic travel and the hope that such travel will fulfill the desire for a better life of meaning and connection. This traveler initially fails to discover the "*locus amoenus,* or pleasant place," desired by New World explorers:[41]

> Here is a coast; here is a harbor;
> here, after a meager diet of horizon, is some scenery:
> impractically shaped and—who knows?—self-pitying mountains,
> sad and harsh beneath their frivolous greenery,
>
> with a little church on top of one. And warehouses,
> some of them painted a feeble pink, or blue,
> and some tall, uncertain palms. Oh, tourist,
> is this how this country is going to answer you
>
> and your immodest demands for a different world,
> and a better life, and complete comprehension

of both at last, and immediately,
after eighteen days of suspension?[42]

The scenery has nothing suggesting spiritual or material prosperity: the adjectives deny any obvious positive value: "meager," "impractically shaped," "self-pitying," "sad," "harsh," "frivolous," "feeble pink, or blue," "tall, uncertain." Besides undermining male-dominated conventions, these descriptions raise other issues. Is this a clear-headed acknowledgment of the limitations of place, travel, and self? Or does Bishop feminize the scene, not as virgin land or voluptuous possibility, but as a spinster, "meager," "self-pitying," "sad," "frivolous," in "feeble pink, or blue"? Is the poet projecting the dismay and self-pity she carried with her? Bishop's "difference" from the sublime and from a vatic poetic voice is, as difference usually is, double-edged. On one hand, she avoids the implausible excesses of the sublime and the dominating ego of the explorer; she seems ready to see the port for what it is, a shabby city of commercial and political transitions. On the other hand, poet and place are diminished: the setting seems demeaningly feminized; and the poet is neither conqueror nor pilgrim but a tourist paying for a vacation with its passing experiences and souvenirs, whose connection with place is transient and unauthentic.

In any case, the poet's attitude toward another female presence—a character named "Miss Breen"—is clearly positive. Seemingly a descendent of the Victorian woman traveler who must balance curiosity and adventure with decency and propriety, she is first portrayed somewhat comically. Like the poet she must "gingerly" descend the ship, and her skirt is caught by the boat boy's hook. Yet this "feminine" hesitancy is balanced by her profession, her height, and her sympathetic appearance: "a retired police lieutenant, six feet tall, / with beautiful bright blue eyes and a kind expression." In a letter to Lowell about her voyage, Bishop notes how the "real" Miss Breen, the model for the poetic one, made her journey bearable: "[a] lady whom fortunately I like very much, otherwise these 17 days would have been a little too much—a 6 ft. ex-policewoman who has retired after being head of the Women's Jail in Detroit for 26 years."[43] In a travel notebook, Bishop expands on their possible empathy:

There is something very appealing about her, but I can't quite place it—something wistful, perhaps. She was "head of the Women's Jail" in Detroit for 26 years—

has been retired 4, I think & has obviously had the exact day-dream of travel
that I have had, down to the slightest detail of scenery . . .

. . . She speaks a lot to me of her "roommate," for many years, I gather—a
woman lawyer named Ida . . . [44]

The roommate, not mentioned in the letter to Lowell, may nonetheless
be significant: Millier proposes that Bishop found in Miss Breen "a vision
of an accomplished and successful lesbian life, not at all secretive or
ashamed."[45] While Bishop does not refer to this aspect of Miss Breen's
arrangements in the poem, it is clear that she functions as a source of
encouragement for the poet.

Despite the disappointing port and their oddity as questers, the two
women are not put off from their travels: "We leave Santos at once; / we
are driving to the interior." That last word, which provides a rhyme for
"inferior" (describing the glue on postage stamps) in an earlier line, is
poised to suggest much more than a felicitous pairing. George Monteiro
points out that Bishop's journey at the time from Santos to Rio, probably
by way of São Paulo, would follow the coast rather than an inland route.
He also remarks that while Brazilians use "interior" to refer to some prov-
inces, it is "less commonly used" than in English to suggest the interior
self.[46] Bishop's choice of the word to conclude the poem then is not a
literal reference to a journey but more likely a self-conscious reference to
symbolic "explorations."

Bishop did not originally intend a long stay in Brazil, and she went in
part to visit friends and acquaintances: Pearl Kazin and Mary Morse and
Lota de Macedo Soares, then a couple. However, while visiting Mary and
Lota in December, she had an extreme allergic reaction to the cashew
fruit. At the beginning of the new year, Bishop writes to Annie Baumann,
her New York doctor:

> I have a long tale of woe to tell you—about three weeks ago I suddenly started
> having a fantastic allergic reaction to something or other. The doctor thought it
> was to the fruit of the cashew . . . but I only ate two bites of one, two very sour
> bits. That night my eyes started stinging, and the next day I started to swell—
> and swell and swell: I didn't know one *could* swell so much. I couldn't *see*
> anything for over a week.[47]

At this moment of extreme pain and vulnerability, Bishop received won-
derful care and sympathy from Lota de Macedo Soares and her household,

so much so that she concludes the letter, "Aside from my swelled head and the asthma I feel fine & although it is tempting Providence to say so, I suppose, happier than I have felt in ten years."

Delighted by the "unbelievably impractical" scenery and Lota's solicitations, Bishop's letters express relief and ecstasy as she surrenders past problems and habits of being to a new "confusion": she writes to Ilse and Kit Barker in February 1952, "My troubles, or trouble, seems to have disappeared completely since leaving N.Y." Writing to Annie Baumann in July, the poet talks of altered life:

It has taken me a long time to get down to work . . . everything is so beautiful it is hard to stay indoors. . . . It seems to be mid-winter, and yet it is the time to plant things—but my Anglo-Saxon blood is gradually relinquishing its seasonal cycle and I'm quite content to live in complete confusion, about seasons, fruits, languages, geography, everything. . . . wishes seem to come true here at such a rate one is almost afraid to make them anymore.[48]

How tempting to mythologize Bishop's illness and its happy aftermath: she is nearly poisoned by the exotic other, but the entrapment of her illness in a fantastical landscape becomes beguilement. In a metamorphosis, the poison leads to love, and the traveler "arrives" at the place always imagined and desired (fig. 31). Such a testing and acceptance seem beyond superficial sight-seeing and shopping or exploitative domination. In *The Mind of the Traveler*, Eric Leed comments on the role of illness and of sexual intimacy in redefining "the social and even the biological self [to] make the traveler a 'native' "; he quotes a seventeenth-century French survivor of Maldive fever: "this malady, as it were, makes [the traveler] a new body, and he feels quite inured. And, indeed, if a stranger . . . recovers from it, they say that he is *diues*, as we should say, naturalized and is no longer a stranger." Leed further comments on the "erotics of arrival," which includes "uncertainty about what is being 'offered,' what gained, and what lost in the incorporation of a new member."[49] Bishop, a solitary woman without a strong sense of community, is indeed a variation on an ancient pattern of roaming men welcomed, or seduced, by rooted women. Her responses also reflect self-consciousness about the stereotypes of the Northerner who finds a less repressive, more sensual alter ego in a Latin culture. Her amazement that such change can really happen, while it may obliquely refer to the release of lesbian desire, testifies to the potency of place.

Fig. 31. Elizabeth Bishop, Brazil Landscape. Special Collections, Vassar College Libraries.

Bishop's welcome in Brazil evolved into the most stable relationship so far of her adult life. She writes to the Barkers in an "state of euphoria" induced by the cortisone she took for asthma and perhaps by love, still not quite sure what she has gained or lost: "I like it so much that I keep thinking I have died and gone to heaven, completely undeservedly. My New England blood tells me that no, it isn't true. Escape does not work; if you really are happy you should just naturally go to pieces and never write a line—but apparently that . . . is all wrong. And that in itself is a great help."[50] Bishop discovers she *can* be happy and write at the same time. Through travel she has found an enchanting setting, the security of an idealized and "chosen" family unburdened by past tragedies, and even an adopted culture unburdened by puritanical guilt. What she is able to write about from this perspective is not Brazil but her troubled childhood

in prose memoirs and stories. She writes in one letter, "It is funny to come to Brazil to experience total recall about Nova Scotia—geography must be more mysterious than we realize, even," and in another to Pearl Kazin, "This place is *wonderful.* . . . I just spend too much time in looking at it and not working enough. I only hope you don't have to get to be forty-two before you feel so at home."[51]

It is several years, not all so blissful as the first, before Bishop renders Brazil in poetry, and despite her early hopes she never quite writes lucrative travel pieces.[52] Her poems temper her euphoria with questioning of her own "immodest demands"; what she continues to share with the male explorer is that she too seeks to enter the "interior," which again has overtones of sexual conquest, the revelation of sacred cultural secrets, and self-exploration.

The poems "Brazil, January 1, 1502" and "Questions of Travel" test such myths and hopes as they make explicit latent issues in Bishop's treatment of landscape. The poet becomes highly conscious of a new terrain as the image of one's own desires, and equally aware that those desires, in their preconceptions, may be thwarted. In addition, these poems exemplify "the uneasy dialogue between the imperial eye that translates the foreign to the animal, and the one capable of establishing the foreign on an equal footing with the observer, or the Other on a par with the Self."[53]

The poem "Brazil, January 1, 1502," first published in the *New Yorker* (2 January 1960), sets the perspective of the contemporary woman against that of imperialistic conquistadors. It opens with an epigraph from Kenneth Clark's *Landscape into Art*, "embroidered nature . . . tapestried landscape," which conflates the natural with the artistic. In the poem, the new world transcends time and is represented as a visual and tactile artifact, a dense tapestry presenting the same details to the poet that it presented to sixteenth-century first Europeans:

> Januaries, Nature greets our eyes
> exactly as she must have greeted theirs:
> every square inch filling in with foliage—
> big leaves, little leaves, and giant leaves . . .
> .
> and flowers, too, like giant water lilies
> up in the air—up, rather, in the leaves—
> purple, yellow, two yellows, pink,

> rust red and greenish white;
> solid but airy; fresh as if just finished
> and taken off the frame.[54]

These lines have qualities of ekphrastic verse creating a scene in a "timeless" crafted form, the tapestry, and then animating that form. Bishop adapts the conventional gendered perspective of ekphrastic poetry: W. J. T. Mitchell explains, "female otherness is an overdetermined feature in [this] genre that tends to describe an object of visual pleasure and fascination from a masculine perspective, often to an audience understood to be masculine as well."[55] Here "Nature" is the traditional "she," but an artist herself, though "her" art is the feminine weaving of tapestries, webs, and "hanging fabric." (Such associations underscore the silken, weaving water of "Cape Breton" as feminine.) As this imagery suggests, the poet sees the landscape with a European eye, perceiving the new world as lush, sensual, exotic. In this poem, the eye does not merge with mist to permeate the landscape. Rather, it brings with it European judgments: "Still in the foreground there is Sin: / five sooty dragons near some massy rocks ... all eyes / are on the smaller, female one, back-to, / her wicked tail straight up and over, red as a red-hot wire."

That self-aware gendering of art and landscape is then set off by a distancing perspective as the poet drifts away from identification with the male explorers. She duly records the greed and lust behind a dream that is "out of style":

> Just so the Christians, hard as nails,
> tiny as nails, and glinting,
> in creaking armor, came and found it all,
> not unfamiliar:
> no lovers' walks, no bowers,
> no cherries to be picked, no lute music,
> but corresponding, nevertheless,
> to an old dream of wealth and luxury
> already out of style when they left home—
>
> they ripped away into the hanging fabric,
> each out to catch an Indian for himself—
> those maddening little women who kept calling,
> calling to each other (or had the birds waked up?)
> and retreating, always retreating, behind it.

The landscape is both foreign and "not unfamiliar," as if it were the realization of an image rooted in the past and the psyche. The Europeans' sexual pursuit of the "little women" recalls the common allegorical presentation of the New World as a native "female nude with feathered headdress."[56] Yet as much as these "Christians" are bent on rape, ripping into the feminine "fabric" of Nature, that fabric protects its own—the retreat of the desired "other," be it woman or bird. Bishop, a woman observing the tapestry centuries later, distances herself spatially and temporally: as if from a privileged perspective, she sees the armored soldiers "tiny as nails." However, there still remains the question of whether she will be like and unlike the explorers (or like and unlike poets who try to possess a feminized visual form): she finds the scene "exactly" as they did, and her descriptions frequently sexualize the landscape, with its fluidity, fecundity, and seductive interior that invites and resists exploration and conquest.

As a woman who has had difficulty asserting her voice and finding her place, as the traveler/colonist who desires the exotic other and to "capture" a foreign land in writing, Bishop is in the double position of being both object and subject, the violated and the violator. She pushes against rather than completely dispenses with traditional tropes for nature and landscape; for her too the New World is an image of her own desires, Nature is a "she," and water expresses a feminine sensibility. However, Bishop feminizes the landscape not so much as the body to be exploited but as an extension of womanly experience and sympathies.

Water permeates a poem unpublished in Bishop's lifetime, "It is marvellous to wake up together," probably dating from her Key West residence in the 1940s.[57] A storm inspires the lovers' transport: "marvellous to hear / The rain begin suddenly all over the roof, / To feel the air clear / As if electricity had passed through it / From a black mesh of wires in the sky. / All over the roof the rain hisses, / And below, the light falling of kisses." Lorrie Goldensohn, who discovered this poem, writes that it is "more joyful, erotic, and tender than anything Bishop allowed herself to publish in her lifetime."[58] In the published "Song for the Rainy Season," presumably set at Lota's house in the Brazilian mountains, ecstasy is not conveyed through an explicit accounting of kisses. Rather, mist and fog again create a magical "feminine" presence. Here the poet and lover *are* the interior, enclosed and protected by weather and setting:

> Hidden, oh hidden
> in the high fog

> the house we live in,
> beneath the magnetic rock,
> rain-, rainbow-ridden,
> where blood-black
> bromelias, lichens,
> owls, and the lint
> of the waterfalls cling,
> familiar, unbidden.[59]

The weather, which seems an "unbidden" grace from the natural world, has, like love, transformed the house into a hidden mystery of rainbows and bromeliads (which sustain themselves with water caught in cuplike leaves). The imagery is strongly visual and tactile: the dampness of the fog, the pull of the magnet, the bodily pulse and presence of "blood-black," the clinging of waterfalls—and of lovers. The "high fog" initiates the "vibration" between "the domestic and the strange" that for Helen Vendler sustains Bishop's poetry.[60] Immersed in that fog, the hominess that the women create becomes the erotic and the sublime.

While the Brazilian setting is exotic, the imagery like that of "At the Fishhouses" and "Cape Breton" links the sight, feel, and sound of water and mists with a private or mystical sensibility beyond a mundane present:

> In a dim age
> of water
> the brook sings loud
> from a rib cage
> of giant fern; vapor
> climbs up the thick growth
> effortlessly, turns back,
> holding them both,
> house and rock,
> in a private cloud.

The "vapor" that "effortlessly" enters the landscape embraces the human and the natural, "holding them both" as if an intimate lover in a sexual variation of Bishop's obsession with enclosure. The most inviting landscapes in Bishop's poetry share this quality of belonging to "a dim age" and of being a private, layered, enfolded place of domesticity, wildness, and intimacy—a veiled and vaporous idyll. The lines that follow temper that idyll by describing an "ordinary brown / owl" and "fat frogs," but even these creatures take on anthropomorphic qualities as in a fairy tale:

the owl counts, and the frogs "that, / shrilling for love, / clamber and mount" make blatant bodily desire.

This world seems closed to intruders that might break the spell, though open "to the white dew / and the milk-white sunrise / kind to the eyes." (In a 1952 letter to Pearl Kazin, Bishop describes how "every morning the valley is filled with mist just like a bowl of milk.")[61] Perhaps the weather, along with imagery of dew and milk, enables Bishop to accept in poetry lesbian desire, to place it "familiarly," safely, and amazingly in the natural, the maternal, and the domestic. This safety is not permanent, as the poet is aware that this "season" can pass:

> For a later
> era will differ.
> (O difference that kills,
> or intimidates, much
> of all our small shadowy
> life!) Without water
>
> the great rock will stare
> unmagnetized, bare,
> no longer wearing
> rainbows or rain,
> the forgiving air
> and the high fog gone;
> the owls will move on
> and the several
> waterfalls shrivel
> in the steady sun.

This may be an acknowledgement of loss in paradise: *et in arcadia ego*. That pastoral convention is rendered particular with the words "difference," "intimidates," and "forgiving." These words lack specific reference: *what* is different and intimidating, *what* must be forgiven? I do not insist these narrowly refer to a homosexual code, but in this poem of intimacy, lust, and hiddenness, they suggest the poet's uneasiness with a bare exposure of desire to the "steady sun" of public scrutiny.

"House in the Rainy Season" in its celebration of women's love in a womanly place breaks from the unease with the feminine found elsewhere in Bishop's work. The poet, particularly in this new setting, in a new relationship, can idealize water, which represents a gift from the external

world and also a feminine aura: this aura is at once protective, hiding the secrets of female sexuality and lesbian desire in the interior, and an emblem of an active imagination constructing meaning and emotion.

Bishop does not simplistically follow a tradition of feminizing the landscape or bluntly privilege the female over the male. "Crusoe in England," probably composed over several years between 1964 and 1971, complicates the paradigm offered above, with its male speaker and island of nasty, rather than delightful, hissing rain.[62] The loneliness of this poem may well have its source in Bishop's biography: her transience and shyness, the difficulties that eventually developed between herself and Lota, the poet's infidelity during a teaching stint in the United States, Lota's depression and death in 1967 (an apparent suicide on the night that she rejoined Bishop in New York). Bishop's friend, Frank Bidart, commenting on the confessional elements of her writings, believes

she was able to cut off certain parts of her mind in order to make the poem. For example, someone once said something to her about how "Crusoe in England" is a kind of autobiographical metaphor for Brazil and Lota. She was horrified by the suggestion. And obviously the poem is.[63]

However Bishop's life seeps into the poem, it presents a landscape of thwarted desire and in so doing also tests her romantic and modern poetic inheritance. Place remains important: even under blighted circumstances, authenticity and belonging, the realization of desire and of self, depend upon the interplay of gender and landscape.

"Crusoe in England" revises the archetypal European explorer, who when shipwrecked remains confident that providence has entrusted him with the ability and right to command the native to his own ends. Because of this archetype blended with a more modern one of the isolated figure stranded in a hellish place, I also sense in this poem a variety of allusions (whether intentional on the part of the poet I cannot say) to works by and about men. The poem depicts a wasteland, a phrase bound to suggest T. S. Eliot. The "ash-heaps" recall the valley of ashes in Fitzgerald's *The Great Gatsby;* the island as some "sort of cloud-dump" could suggest Wallace Stevens's "The Man on the Dump"; the "equivocal replies" of the gulls could "echo" the reply sought in nature by the solitary "he" of Frost's "The Most of It." And there is the explicit, anachronistic reference

to Wordsworth's "I Wandered Lonely as A Cloud," as Crusoe tries to remember what follows "bliss." Thus the speaker's "miserable philosophy" parodies and interrogates the poetic quest of seeking insight and identity in the encounter of the solitary poet's imagination with an external world of splendor, ruin, indifference, and diminishment.

If "Crusoe" is taking on such vast traditions, it is lightly done. Instead of making her poetic inquiries appear profound and herself larger-than-life with grandiloquent language and portentous tone and imagery, Bishop introduces "grand" questions as inevitably part of a local circumstance.[64] The poems of *Geography III* pose questions equaling those of the most philosophic poet, but in this "simple" manner: "In the Waiting Room" asks questions of identity, difference, and belonging; "Crusoe," of fate and choice; "The Moose," of affirmation; "Poem," of empathy and shared vision; "One Art," of loss and survival; "The End of March," of the deathlike dream of solitude; and "Five Flights Up," of the difficulty and wonder of persisting with an ordinary life that can yet be devastating.

To return to "Crusoe in England," Bishop's character is far less optimistic and opportunistic than Defoe's; the poem combines a tale of adventure and discovery, an example of failed colonialism (the island remains "lost" to civilization), a sense of self-pity and of the limits of human "philosophy, with disturbing images of birth. While "Cape Breton" interweaves pastoral serenity and the allure of mysterious secrets, a landscape of retreat and return, "Crusoe" depicts a metaphorical "island" of self-absorption and solipsism. Bishop's letter on Aruba contains one source for the poetic description; "[it] is a little hell-like island, very strange. It rarely if ever rains there and there's nothing but cactus hedges and prickly trees and goats and one broken-off miniature dead volcano."[65] The poem's awareness of limits, loss, and self-pity, while possibly reflecting Bishop's lingering pain after Lota's suicide, conveys too the unfertile island of the isolated self.

From the beginning, the emphasis is on singularity in several senses: the anomalous nature of Crusoe's lonely stay on the peculiar island with "one kind of everything." The poem opens with "an island being born": the geologic birth of a new volcano. This new exotic place, however, stirs a human possessiveness in others that Crusoe now seems beyond: "they," a label suggesting humanity as an alien force, quickly "capture" the island in their sights, "caught on the horizon like a fly," and claim it with a name. That birth and naming stir Crusoe's reminiscences of his "un-rediscovered, un-renamable" island, a place unmapped by others. (This

"place" may enhance Bishop's sense of her own singularity as person and poet, with a history and responses unmapped by others' approaches.) Crusoe's prosaic account of the island goes against the ideals of the pastoral literary tradition and dreams of explorers seeking new paradises:

> Well, I had fifty-two
> miserable, small volcanoes I could climb
> with a few slithery strides—
> volcanoes dead as ash heaps.
> I used to sit on the edge of the highest one
> and count the others standing up,
> naked and leaden, with their heads blown off.[66]

In this wasteland, relations and proportions that seem "natural" elsewhere are undone. If the imagery of the volcanoes can be construed as sexual, they are horrifyingly feminine with the volatile craters and impotently masculine "standing up, / naked and leaden, with their heads blown off." Distortion, so frequent in Bishop's work, suggests the discomfort felt in her life for a variety of reasons: the abandoned "country mouse" child too small to count; the sufferer of asthma and allergies with hideously swollen head and hands; the alcoholic poet who could not mingle in the New York literary scene; the lesbian lover who wanted to keep her closet and defenses. Here that distortion also rewrites landscape traditions. Instead of either a sublime grandeur of land or a sense of man's "proper" dominion over nature, the volcanoes are small and Crusoe dreads to think of himself as a "giant." Later in the poem he seems an absurd parody of a pastoral shepherd with no nymph to woo: he drinks his own brew of "fizzy, stinging stuff," plays his homemade flute, dances dizzily among the goats, and thinks "Home-made, home-made! But aren't we all?" This line suggests that like other figures, male and female in Bishop's poetry, Crusoe desires domesticity to ease the abandonment. He is neither the dominant heroic conqueror nor a simple shepherd in an arcadia of his own creation.

Nor does the poem clearly associate fluidity with a feminine landscape. One can speculate that the male presence does not wish to or cannot dissolve into the scene and remains conflicted, even in extreme loneliness, at passing some boundary of self to identify with such a miserable place. Tension resides in Crusoe's ambivalence about the island—which doubles ambivalence about himself. Does the place represent him? Do they become one? Can he resist how he's defined there—an unlikely, self-pitying, lonely

god? "Lost" on this island, he is never satisfactorily "found" in an ideal correspondence between self and world. Though he may command the summit of ridiculously small volcanoes and determine the color of a baby goat, neither he nor the scene offers emblems of generative sexuality or power. The volcanoes seem self-engendered. The island has "the same odd sun" that does not depict sovereignty as much as monotonous repetition of days and the singularity of its presence. To Crusoe, the "island seemed to be / a sort of cloud-dump," which scarcely pictures transformative rain but rather end-of-the-world exile for rejects. Instead of magical mists there is merely lousy weather that does not make the island fecund as it leaves the volcanoes parched and hissing.

In this inhospitable place, Crusoe is trapped in self-pity, but that mood's release eases the isolation to make Crusoe feel "at home," whatever that home may be like. "Crusoe in England" foregrounds questions of fate and self-determination:

> "Do I deserve this? I suppose I must.
> I wouldn't be here otherwise. Was there
> a moment when I actually chose this?
> I don't remember, but there could have been."
> What's wrong about self-pity, anyway?
> With my legs dangling down familiarly
> over a crater's edge, I told myself
> "Pity should begin at home." So the more
> pity I felt, the more I felt at home.

Heard out of context, volcano omitted, these words could be Bishop's— or anyone's—reflecting on responsibility and chance. Crusoe cannot resolve the issue of free will or determination, although allowing his self-pity helps him feel familiar, "at home" (Bishop well knew the most pitiable things could happen at home) on the edge of the abyss.

However, Crusoe is not always content in this home. Nature's response to his solitude does not restore Emersonian virility or answer his spiritual doubts, as Crusoe remembers, "The questioning shrieks [of gulls], the equivocal replies / over a ground of hissing rain / and hissing, ambulating turtles / got on my nerves." Just as the "replies" between the human and nonhuman are discordant, the propagation of human and natural distorts limits and proportions. Crusoe's worst dreams are of

> . . . slitting a baby's throat, mistaking it
> for a baby goat. I'd have
> nightmares of other islands
> stretching away from mine, infinities
> of islands, islands spawning islands,
> like frogs' eggs turning into polliwogs
> of islands, knowing that I had to live
> on each and every one, eventually,
> for ages, registering their flora,
> their fauna, their geography.

Crusoe's isolation has not led to tranquillity and romantic oneness with nature. Instead, it inspires murderous nightmares and confuses Crusoe's sense of roles and relationships (and his desires) as he confuses a kid with a child. Is it natural to slaughter one and nurture the other? His dream of the baby shocks him with its violence mingled with longing for something human. On his island, Crusoe exhibits misanthropy (hatred of the human also begins at home, with the self) and further self-loathing at discovering that possibility within his dreams. Crusoe's other nightmare of "spawning islands" replaces a fertile utopia with an endless repetition; discovering, naming, and claiming does not empower him, as Crusoe comes to dread the geographer's version of the myth of Sisyphus.

Relief from misanthropy and these infinities comes in companionship: "Just when I thought I couldn't stand it / another minute longer, Friday came. / (Accounts of that have everything all wrong.)" We cannot be sure what is wrong in traditional accounts of Crusoe and Friday: the European arrogance? the reading of sexuality? the assumption that anyone else can know the intimacy of others? Bishop, without being detailed, wants to rewrite the tale and perhaps her own history. If these lines are a defense of her own sexuality (was it fate or choice?), they are light rather than militant, admitting that "Friday was nice, and we were friends. . . . I wanted to propagate my kind, / and so did he, I think, poor boy." That collective, dreaded "they" returns to end this islanded intimacy: "And then one day they came and took us off."

Despite all the inversions of the poem—its antipastoral, anticolonial character, its births as doom rather than regeneration, and the implied sexual turns as a woman speaks through a man who desires another man/ woman—like other works in the pastoral tradition it still finds authenticity and identity in the relationship (however "singular") between a human

figure and his world. In England, Crusoe's brain no longer breeds islands: "I'm old. / I'm bored, too, drinking my real tea, / surrounded by uninteresting lumber." He looks on his belongings, now dead museum artifacts of a past Crusoe cannot revive, and his words evoke the aura of that past immersion in survival: "The knife there on the shelf— / It reeked of meaning, like a crucifix. / It lived." The knife, perhaps an emblem for poetry, once embodied real use-value and Crusoe's will to endure, his engagement with the landscape and another, however pitiable, and his individuality. In the museum, it becomes an institutionalized relic (how like poetry in a book?), a poor reminder of a passion that was. On the island, Crusoe lived. Now he has moved from active engagement to afterthought, from event to memory of what is lost.

Like other figures in Bishop's poetry, Crusoe is at once displaced and at home, powerless and inventive, abandoned and recovered. The value of his experience depends not on a sense of oneness with his surroundings, but on a keen sense of what is lacking. He is "at home" with self-pity and singularity, with the ugly reality of his islands, external and internal. With this poem, Bishop enables the pastoral to convey postmodern concerns—discomfort with sexual definition and desire, an awareness of detachment and lack—while not surrendering an intense experience of authenticity bound to place.

While "Crusoe in England" illustrates how Bishop invests a male speaker with sympathy and authenticity, "The Moose," which returns to Canadian provinces "of fish and bread and tea," again illustrates that stronger affirmation and pleasure stem from a landscape interweaving elements of the feminine, of the domestic and wild, and of isolation and family connection. Here memory does resurrect the sort of reflections that too often troubled Bishop, "a really morbid total recall": the poem offers, as Bonnie Costello explains, "a satisfying integration of imagination with experience" that is not blandly "optimistic" yet nevertheless offers "moments of completeness."[67] "The Moose" is dedicated to Grace Bulmer Bowers, Bishop's aunt, as if the "we" who share the bus ride through the provinces are the two women. This work had a lengthy gestation: inspired by a bus trip taken in 1946, Bishop did not complete it until faced with a deadline to present the Phi Beta Kappa poem at Harvard in 1972. Notes Bishop took during the summer of 1951, for an article that was never completed on Sable Island, Nova Scotia, provide one source for the poem:

Anyone familiar with the accent of Nova Scotia will know what I mean when I refer to the Indrawn Yes. . . . It consists of, when one is told a fact—anything, not necessarily tragic but not of a downright comical nature,—saying "yes," or a word halfway between "yes" and "yeah," while drawing in breath at just the same time. It expresses both commiseration and an acceptance of the Worst; and it occurred to me as I walked along over those fine, fatalistic sands, that Sable Island with its mysterious engulfing powers was a sort of large scale expression of the Indrawn Yes.[68]

This anticipates the moment of "commiseration" and "acceptance" in the poem and suggests that the island's tidal flow, "with its mysterious engulfing powers," becomes the apt metaphor for the corresponding sensibility of people and place. It is a "fine" and "fatalistic" landscape of paradox, in which outward communication becomes indrawn breath and the "Worst" elicits an affirmation.

Also, "The Moose" illustrates the pitfalls of assigning gender to words. The descriptions are not so explicitly sexualized as in poems previously discussed. While the presence of the female moose, the *genius loci*, leads some readers to acclaim the poem's "specifically feminine sensibility," at least one scholar disagrees. Mutlu Konuk Blasing argues that "far from showing a female sensibility, the poem situates itself firmly within the subgenre of Romantic and modern poetry narratives of personal encounters with nature, observing its gendering of nature as feminine vis-à-vis the masculine-gendered experiencing subject-poet"; Blasing also stresses that Bishop is "feminist" in exposing "how subject/object relationships are gendered" within that tradition and in resisting a stereotyped "organicism" that blends the feminine with the natural.[69] I agree with Blasing that Bishop adapts a "masculine-gendered" tradition in writing a romantic lyric and sexualizing landscape. But Bishop's absorption and resistance to the tradition fluctuates, and the tradition itself is not always one of sharp binary divisions. Blasing notes the possible influence of Whitman's "Out of the Cradle Endlessly Rocking" on the opening of "The Moose." That example raises as many issues as it settles, as Whitman's evocation in that poem of the ocean mother, a child that cannot be separated from that mother, and the mated birds could be perceived as "feminine" or "androgynous" in its rhythms and empathies. (One could further argue that Whitman assumes a "male" prerogative in giving language to the bird and ocean.) While I have asserted that the "masculine" or "patriarchal" imagination often identifies with the sun and the heavens, Whitman's poems

of the sea warn that this paradigm must be qualified. Bishop, like male poets before her, has absorbed widespread tendencies in the gendering of nature and of poetic activity, but does not follow and depart from them by any strict procedural code.

With "The Moose," the emblematic, ambient power of the landscape description and its creative empowerment of the female poet are enhanced by the implicit sense of a woman observing—or beholding—the feminine, sometimes with detachment, sometimes empathically entering into a scene. The dedication to Bishop's aunt, Grace Bulmer Bowers, the references to relatives and grandparents, the imagery evocative of the sublime but also the domestic garden, and the pervasiveness of the mist all suggest that any resistance to feminine "organicism" is porous. The "masculine" tradition, romanticism, and organicism—tempered as they usually are in Bishop's work by irony, discretion, and careful observation—are subsumed into the mood evoked by rhythm and atmosphere. The poet finds affirmation in relationship, in moonlit mist, and in the she-moose who is both autonomous and a revelation belonging to the primitive interior.

The rhapsodic rhythm of the opening beckons with the tidal pattern of departure and return, and mimics the "fluid" relationship between river and bay:

> From narrow provinces
> of fish and bread and tea,
> home of the long tides
> where the bay leaves the sea
> twice a day and takes
> the herrings long rides,
>
> where if the river
> enters or retreats
> in a wall of brown foam
> depends on if it meets
> the bay coming in,
> the bay not at home . . . [70]

This is a landscape of the give-and-take of fluidity, of openness and withdrawal in the entering and retreating, of the bay forever meeting the river. The sun does not rise in monotonous repetition as in the Crusoe poem; rather, the elements transform each other, as if in an echo of "At the Fishhouses," "the water were a transmutation of fire":

> where, silted red,
> sometimes the sun sets
> facing a red sea,
> and others, veins the flats'
> lavender, rich mud
> in burning rivulets . . .

The colors of this description seem volcanic, "burning rivulets," but the scene, also "rich" and "lavender," sounds far more fecund and sublime than the lava of Crusoe's island.

Against this scene of reciprocal reflection, "A lone traveller" (presumably the poet) catches the bus, but even this romantic solitary acknowledges family connections, kissing "seven relatives" good-bye. The traveler's ride is rendered almost magical with the return of fog at twilight: "The light / grows richer; the fog, / shifting, salty, thin, / comes closing in." That permeating mist gently enters a pastoral garden:

> Its cold, round crystals
> form and slide and settle
> in the white hens' feathers,
> in gray glazed cabbages,
> on the cabbage roses
> and lupins like apostles;
>
> the sweet peas cling
> to their wet white string
> on the whitewashed fences;
> bumblebees creep
> inside the foxgloves,
> and evening commences.

Again, I do not want to insist such description is "feminine" in an exclusive or clichéd manner. In describing watery elements Bishop blends vagueness and softness with sharp, clear sensations: as the "bitter," "briny" water in "At the Fishhouses" does not create the idealized liquid security of the womb, this wet, clinging mist also forms "cold, round crystals." Yet these crystals, evocative of beauty, worth, and clarity, are part of a pattern of departure (conscious or not) from the more sunstruck imagery of the Emersonian poetic sublime.

To the sunrise of Emerson's genius, Bishop in "The Moose" prefers

twilight and night. A hushed, expectant mood intensifies as the bus travels through the woods:

> Moonlight as we enter
> the New Brunswick woods,
> hairy, scratchy, splintery;
> moonlight and mist
> caught in them like lamb's wool
> on bushes in a pasture.

As in "Cape Breton," images associated with the feminine suggest an imaginative transformation, and a mysterious interior is entered. And as the mist in that earlier poem follows the "mutation of its dream," this mist too introduces "A dreamy divagation." The "we" on the bus overhear "Grandparents' voices // uninterruptedly / talking in Eternity," as if the travelers had entered some afterlife where they could hear their own grandparents (Bishop's Nova Scotia grandparents raised her after her mother's breakdown), settling and resolving family history. The talk is reassuring not because its content is pleasing (it includes "deaths, deaths and sicknesses") but because tragedy and disgrace are accepted in the rhythm of the voice and its now calm acknowledgment:

> "Yes . . ." that peculiar
> affirmative. "Yes . . ."
> A sharp, indrawn breath,
> half groan, half acceptance,
> that means "Life's like that.
> We know *it* (also death)."

The bus becomes the intimate domestic space where secrets and comfort are shared: "Talking the way they talked / in the old featherbed, / peacefully, on and on . . . down in the kitchen, the dog / tucked in her shawl." Perhaps this is a reassuring return to childhood for the poet, and reassuring not because it erases a painful past but because it acknowledges what Bishop in her Sable Island notes labeled "the Worst."

Now that it is safe to fall asleep, with the worries of life accepted and a sensation of being tucked in a comforting shawl, when one seems beyond desperation and need, a "miracle" occurs, a surprise that further moves travelers from self-pity. I sense a faint echo of Coleridge's "Rime of the Ancient Mariner": the wandering mariner, cursed by his lack of sympathy,

caught in a fantastical landscape, sees under the spell of a feminine moon the hideous water snakes transformed so that "A spring of love gushed" from his heart as he blesses them "unaware."[71] Bishop's bus passengers are certainly more benign and comfortable than Coleridge's haunted crew, but they too turn from contemplation of misery to spontaneous wonder at a creature under moonlight. A cow moose comes "out of the impenetrable wood":

> Towering, antlerless,
> high as a church,
> homely as a house
> (or, safe as houses).
> A man's voice assures us
> "Perfectly harmless. . . ."

This vision is sublime and safe, wild and domestic, a gift from the often hostile or indifferent nonhuman world, that augments the affirmative of the grandparents: "she looks the bus over, / grand, otherworldly. / Why, why do we feel / (we all feel) this sweet / sensation of joy?" Here the lack of proportion and the lack of beauty that haunts so many poems— evocative of Bishop's sense of difference as the abandoned child and lesbian poet—is redeemed as the "grand, otherworldly" moose that excites shared joy and thus a sense of community with its presence. In this, the poem commemorates a specific blessed moment. Yet the animal, as animals often are in the human imagination, is an avatar connecting past to present. The moose embodies vital, ongoing nature, as do Yeats's "Wild Swans at Coole," which year after year return "unwearied."[72] Bishop's poem may not be so idealizing; the moose sniffs the bus to test compatibility and attraction. Nonetheless, the creature belongs to the country's past as well as to the present. "The Moose" may even be an emblem of a feminine (awkwardly so) Canada, where the mother was lost but the girl was sustained by aunts and an adored grandmother. The moose is a sign, that for a moment, one can return home and find exotic wonders there.

Landscape in Bishop's writing is a repository and catalyst for personal and cultural memory. She may find what she wants or needs in landscape, yet as she sees through that inevitable subjective lens, she remains open to the variety a scene offers. Descriptions can swerve between demonizing

and redeeming the feminine, between losing oneself in the abandoned past of the mad mother and finding solace in the scenes from the world of the grandmother and the exotic terrain of the lover. Bishop does not merely offer stereotypical descriptions of place or develop a style exclusively for a "feminine sensibility." As one who disliked the category "woman poet" and who wanted privacy and "closets," she does not overtly seek a feminist or lesbian poetics. Nonetheless, her gendered scenes are revealing. When Bishop spoke to Wehr about always telling "the truth about ourselves despite ourselves," she added: "It's just that quite often we don't like how it comes out."[73] Whatever her conscious realizations, the poet's descriptions may render that feminine sensibility more available and attractive to herself and to men and women readers. Bishop's feminized descriptions of rural provinces and of Brazil create possibilities: they allow her to revalue her childhood and adult desires, her own sense of difference, and the place itself. Attention to her gendered scenes suggests further how she both absorbs and revises traditional attitudes and imagery for her own ends. Her revisions of the tropes of landscape description, while not militantly dismantling sexual politics, enable her to empower the love and imagination of women.

As Bishop's work illustrates, poets in the twentieth century can still "discover" meaning in abandoned landscape, and for her that meaning includes recovering the feminine. W. J. T. Mitchell posits that "Landscape is a medium of exchange between the human and the natural, the self and the other. As such, it is like money: good for nothing in itself, but expressive of a potentially limitless reserve of value."[74] Landscapes, especially the "backwaters" remote from imperialist and masculine enterprises, provide "space" for Bishop to renegotiate the value of her past and reconcile herself with the emotional and physical terrain of her childhood.

What Bishop's poetry also does, however, is question the validity of applying a strict Marxist economy to landscape description, and especially the notion that landscape "is good for nothing in itself." Like Moore, for example, Bishop has devoted much effort to recording scenes and creatures considered "Useless and free" by others ("Poem"). In this she shares concerns with nature writing, which decenters the significance of the human subject and which in offering "a deliberate dislocation of ordinary perception deserves to be taken quite seriously."[75] In "Renegotiating the Contracts," nature writer Barry Lopez insists that setting aside "our relationships with wild animals" (or the natural world in general) "as inconsequential is to undermine our regard for the other sex, other cultures,

other universes."[76] Bishop's poetry implicitly understands that arrogantly misperceiving the "poverty" of Cape Breton or the "impracticality" of Brazilian scenery undermines a regard for existence at large. She foreshadows many contemporary essayists' and artists' discomfort with "the traditional Western view" that "landscape has always been an *other*, an entity apart from humankind" and that dominance is the immediate response to that otherness.[77] In its attention to otherness and its sense that we cannot completely possess what we see, Bishop's poetry also connects ongoing aesthetic and philosophic debates about the meaning of natural beauty to those on emotional and sexual knowledge. We still question the boundaries between self and desired other, whether that other be part of nature or a person; we wonder about the pleasures, misreadings, and dangers involved in pursuing that desire.

While Bishop alerts us to the possibilities of landscape, she warns us of problems as well. If nature is detached from a metaphysical foundation (a reflection of ideal truth, the sign of divinity) or from the political agendas of imperialism and manifest destiny, it is perhaps freed from distorting ideologies.[78] Yet this "freedom" raises question. Does the natural world then have no "objective" value for the mind that must construct meaning, or only a multiplicity of private associations projected upon it? How much respect do we grant to pragmatic and provisional readings of landscape, particularly when haunted by the grandeur, resonance, and even error of past associations? It will take far more than a review of Bishop's work to answer such issues: it is worth emphasizing, however, that her landscapes foster meaning by diffusing boundaries between the conventional and the innovative, the interior and the exterior, the private and public. Similarly, although Bishop's feminized landscapes do not offer *the* model for all negotiations with nature, she does provide an instructive alternative in the face of a dominating tradition. Instead of a "tyrannous" eye that commands the scene, Bishop integrates the landscape and female desire in these poems that offer weaving waters, green tapestries, hidden houses, and mists of imagination that follow their dreams. Most important, Bishop's work reveals what remains alive in landscape—a fascination with the external world and a need to feel "placed." Construction of place is, as geographer Yi-Fu Tuan believes, a necessary "creative adaptation to the myriad human experiences of fragility . . . aloneness and indifference."[79] Besides fragility, aloneness, and indifference, Elizabeth Bishop's landscapes offer moments of strength, connection, and love as she searches out "imagined places" that become home.

The Vernacular Ruin and the Ghost of Self-Reliance

All my life I have been drawn to deserted houses. They were far more
numerous when I was a boy. They stood forlorn and open besides country
roads, their clapboard weathered grey, their porches sagging. Each presented
a teasing detail from an old forgotten story . . .

—DALE MACKENZIE BROWN, *House Beautiful*

The Olson house, made famous by Andrew Wyeth's *Christina's
World,* is a museum now, preserved in its formidable, dilapidated grandeur
(pl. 7).[1] Would we even want to imagine it restored and painted, with
computerized heating and plumbing? The same could be said of Edward
Hopper's *House by the Railroad:* updating it with dot.com furniture for a
life of forward-looking activity would destroy its compelling essence, even
if that essence is one of haunted abandonment (pl. 4). While poverty
remains a disturbing social issue, no one would suggest colorizing Walker
Evans's images of tenant-farmer dwellings. These shacks, substandard
housing by almost any measure, appear beautiful in the eye of such be-
holders as James Agee, who worked with Evans and wrote to accompany
the gray photographic images: "Upon these structures, light . . . such an
intensity and splendor of silver in the silver light, it seems to burn."[2]
Perhaps Americans honor such images because they assume that Art and
Truth must reside somewhere other than in the "McMansions" of sub-
urban sprawl. Or perhaps there is a sense that as American character
evolves, its DNA retains the configuration of founding principles: e-trading
is just another phase of self-reliance and manifest destiny that forges ahead
into a new frontier. If Old World cultures have colossal monuments tes-
tifying to the course of development and ruin of empires, the nativist
tradition offers weathered houses, collapsing sheds, empty barns, and cel-

lar holes "closing like a dent in dough" as vestiges of history and moral emblems.

Remnants of the past impressed upon the present stir more than simplistic nostalgia. In recording them, artists and writers engage in what poet Robert Pinksy calls the "destiny" of the American people: "the difficult action of historical recovery" and finding a "source of wholeness" in memory.[3] Of course memory can deceive. It can become clouded with sentiment, misguided by complacency, warped by hypocrisy, or trapped by failure. There is the promise of recovery, but to paraphrase Frost's "Directive," the guides who return you to the ruin may only have at heart your getting lost.

The vernacular ruin, particularly when it was once the house of a farmer or laborer, resonates with cultural nostalgia for a spartan existence of virtuous work and the pleasure of small things. This longing for the simple life manifests itself in the popularity of Wyeth's paintings and Robert Frost's poetry, and appears in other modes as well. *Time in New England* of 1950, a collaboration between photographer Paul Strand and editor Nancy Newhall, paired images of clapboard, shed, and lined faces with writings of earlier New Englanders.[4] Eliot Porter offers similar color photographic images, accompanied by editorial emphasis on conservation, in a Sierra Club book of 1966, *Summer Island: Penobscot Country.*[5] If such commemorations of the past seem sanctified as Art and History or serve an admired principle, other versions appear dominantly commercial: picturesque layouts of once-grand mansions and forgotten farms in magazines such as Maine's *Down East;* the flocking of tourists to Amish farms; or the appeal of up-scale "country stores" selling old-fashioned candies, knit throws to adorn a checkered couch, and faux primitive wooden figurines of scarecrows. During the 1990s, "shabby chic" was the antique collector's rage, with peeling paint signifying a piece's authenticity and market value; if real wear-and-tear could not be found, then new furniture could be distressed at an extra cost. As nineteenth-century structures continue to disappear from the landscape, gorgeously illustrated coffee-table books called *Farm* and *Barn* are published as if in memoriam. The authors of another barn book propose that interest in rural artifacts offsets the stresses of a contemporary society governed by excessive materialistic consumption and relentless social, professional activity. Against this view of a driven (but financially pros-

perous) existence, images of rural life "may be just the antidote we need to soothe our urban malaise."[6]

The vernacular ruin as an "antidote," a moral paradigm, a picturesque commodity, or merely an eyesore again reflects ambivalent attitudes toward the rural, the regional, and the imagined yesteryear of pastoral purity. Those attitudes can lean toward the ideal: a time is envisioned when the community is nurturing, the self virtuous, and the land edenic. Such is the case with David Brower's introduction to Porter's photographs of coastal habitats and people:

> There was world enough then, and more time than there is now. Neither had to go and both can return. Not the times and the people whom Eliot Porter remembers here, for their time was a special one, a golden time, and they had room to live in it, room that let human spirit grow—the wide green land, the untroubled shore, a little alabaster here and there, and places no one thought to pave yet that are almost all slipping away now.[7]

Brower, then executive director of the Sierra Club, idealizes rare examples of antiquated labor to promote a current agenda of conservation. Of course, it is ancient to lament the loss of green and golden worlds, to elegize Arcadia when there was world enough and time. Those elegies can be atavistic in content, traditional in form, sincere in tone—and out-of-temper with progressiveness, postmodern skepticism, and mass communication. But they do express the discontents, hopes, and modes of their own time in imagining a past that can reform the present—even as that present results from the discontents, hopes, and modes of the past. The twentieth and twenty-first centuries heighten this irony, in that artists can employ the technology of cameras and computers to document and revere what technology has destroyed.

One poet who returned to the past but did not revive all its practices is Donald Hall. In the 1970s, he left behind the urban and suburban professor's life (and as he admits the 1950s–style writer's life of drinking and divorcing) for freelancing in rural New England. With his wife Jane Kenyon, Hall returned to the New Hampshire farmhouse that had been purchased by his great-grandparents in 1865. There he experienced the resurgence of some old-fashioned habits and values; he began to attend church because "*they*"—neighbors who were mostly cousins—expected it. To his surprise, he found the minister thought-provoking, and he discov-

ered "there was something else, something that endures—a community radiating the willingness or even the desire to be careful and loving."[8]

One of Hall's poetic tributes to past ways is "The Ox-cart Man," a poem rewritten as a children's book about a nineteenth-century farmer and his family. The family's varied work follows the seasons so that in autumn the man sells his "left over" produce in the village, purchases a few supplies and the luxury of candy, and returns to begin again the homey cycle of work. In the children's version, the primitive folk style of Barbara Cooney's illustrations enhance the quaint simplicity of Hall's cumulative sentences:

> Then he walked home, with the needle and the knife
> and the wintergreen peppermint candies tucked into the kettle,
> and a stick over his shoulder, stuck through the kettle's handle,
> and coins still in his pockets,
> past farms and villages,
> over hills, through valleys, by streams,
> until he came to his farm,
> and his son, his daughter, and his wife were waiting for him,
> and his daughter took her needle and began stitching,
> and his son took his Barlow knife and started whittling,
> and they cooked dinner in their new kettle,
> and afterward everyone ate a wintergreen peppermint candy,
> and that night the ox-cart man sat in front of his fire stitching new harness
> for the young ox in the barn . . . [9]

It would be difficult not to be enchanted by this tale. However, Hall for all his admiration of the "ox-cart man" had no intention of replicating the self-sufficiency of physical labor. Although Hall had done farmwork as a boy (or *because* he had done such work), he never intended to farm and never put in a single acre. Nonetheless, he believes that his approach to writing shares the ethos:

> It is the family farm—which historians of work's structure derive from utter antiquity—that provides a model for my own work; one task after another, all day all year, and every task different. Of course: It was precisely the Connecticut family business of the Brock-Hill Dairy—milk pasteurizing and bottling and delivering; every-day-the-same, temporarily efficient subdivision of the industrial

world; my father's curse—that I grew up determined to avoid or evade. And did.[10]

Hall begins to sound like a Luddite or Marxist: the modern "curse" is capitalistic with its subdivision of labor that separates one's avocation from vocation and that ignores the connectedness of seasonal variation. The implied moral too is that the family farm is founded on principles other than the profit motive, a point not only emphasized in artistic expressions but in sociological studies of agricultural patterns.[11] Hall writes of his extended family in *Life Work,* "The people who stayed home in the countryside—while others left . . . for the cities and the suburbs, for better-paying work—were not merely the feckless ones, the lazy or stupid. They were the people for whom place and family came before everything else, not as ideas or ethics but as necessities of feeling."[12] The icons of tumbledown barns and peely-paint rocking chairs may appeal particularly to the transitional generation who witnessed the increased urbanization before and after World War II, and who remember farms of parents and grandparents. Those white-bread school readers of the 1950s with Dick, Jane, and Sally assumed a suburban existence enlivened by a trip to the grandparents' farm—a wholesome vacation to keep children from becoming too thoroughly brats of middle-class privilege.

So how does the longing for a rural past and the impulse to leave it account for the ubiquity of *Christina's World?* Why is it so compelling (at least to those who don't despise Wyeth's meticulous realism)? The easy answer would be that realism is generally regarded as the most accessible art form, drawing in the aesthetically naive, and that the painting's sentiment reassures rather than threatens. However, while the painting's elements of figure, field, and buildings seem straightforward, the response is potentially complex. More than bland illustration, the composition offers the sere quality of the tempera, the flattening of the field, the odd perspective of a remote house nearly cropped from the picture. The painting is familiar in its realistic rendering of landscape, but unnerving in its barren distances. The woman's dark hair, turned face, and pose that leans toward the house evoke isolation and yearning, as well as feminine fragility and strength flowering against the drabness.

That famous figure is a composite: the thin, large-jointed arms and hands indicating a life of hardship and disability are drawn from Christina

Olson's features, but the artist's wife Betsy also posed and the resulting image looks more graceful and youthful than other portraits of Christina. The dress, which Christina made for a nephew's wedding and eventually became a cleaning rag depicted in other paintings, captured Wyeth. From an upstairs room in the Olson house, he had seen her crawl across the grass and began to dwell on the image:

My memory can be more of a reality than the thing itself . . . I kept thinking about the day I would paint Christina in her pink dress, like a faded lobster shell I might find on the beach, crumpled. I kept building her in my mind—a living being there on a hill whose grass was really growing. Someday she was going to be buried under it.[13]

The pink, feminine and delicate as it may be, resembles debris—the crumpled shell. Not just the house is in decline; so are the people and their way of life. While Wyeth asserts that he "honestly did *not* pick her out to do because she was a cripple" and insists on the "dignity of this lady," he does conceive of Christina, her brother Alvaro, and the house as decaying monuments to the past: "The world of New England is in that house—spidery, like crackling skeletons rotting in the attic—dry bones."[14]

This emblem of an individual's and a culture's mortality struck many personally: viewers sought their own past in the image. Like Frost in his poem "On the Sale of My Farm," they hope it is "no trespassing" to return to a place they feel was once theirs, "seeking ache of memory" there.[15] However, this response became rather messy when some were not content with metaphors and paint but pursued the "real" Christina. People wrote to Wyeth wanting to know all about her, and others spoke of their own prewar memories of rural life.[16] Unexpected visitors would arrive in Cushing, intending to pose in the field and to meet Christina. The icon became a celebrity. The Wyeths, while protectively close to the Olsons (whom Betsy had known since her childhood), fed this tendency. Husband and wife collaborated on a 1982 commemorative volume detailing the creation of *Christina's World* with studies, companion paintings and photographs of the Olson farm, and biographical commentary. The volume can be considered a tribute to friends and a record of Wyeth's technical development, but its emphasis on the history of the "real" Christina (who died in 1968) keeps alive the idea of her as a genuine presence. And that presence becomes inseparable from the theme of loss. The book opens: "In Cushing, Maine, the expression 'it daughtered out' means that no

male heirs were born or survived to carry on a family name.' "[17] This is a half truth: neither Christine nor Alvaro married, and they remained in the house without the means of maintaining its once-prosperous facade. There were, however, other siblings and nieces and nephews whose lives followed a more ordinary course. Yet it is the homestead that becomes a shrine where pilgrims seek the aura that moved the woman in pale pink to reach toward the house of her family's past. When she was older and unable to move on her own much beyond a few downstairs rooms, Christina Olson offered her own reading on the painting to Betsy Wyeth: "You know pink is my favorite color. . . . Andy put me where he knew I wanted to be [in the field]. Now that I can't be there anymore, all I do is think of that picture and I'm there." The letters Wyeth received thanking him for "sharing Christina's world" suggest that others were like Christina herself and wanted, in imagination at least, to be transported to that field.[18]

While *Christina's World* kindles a longing for simplicity and intimacy with nature, it also stirs up less benign responses to country life. On one hand, the rural is linked with the wholesome; on the other, with the degenerate. Nineteenth-century images of farms provided assurances of potential prosperity and orderliness; the twentieth and twenty-first prefer for art not the sites of agribusiness but bittersweet confirmations that small-farm life is indeed in its last autumn. Also, historians of agrarian America point out that in the early twentieth century the rural became increasingly identified with squalor, inbreeding, and backwardness: we might think of the connotations of "hick" and of Frost himself being teased as the "hen-man."[19] Such assumptions complicate the obsession of Wyeth and his audience with Christina Olson. She lived with a brother whose hold on reality became increasingly slight; she suffered from a degenerative disease that crippled her and left her incontinent—if one could get past the smell of urine in the house, one could appreciate her excellent pies.[20] For most of her life, she refused pity, help, and a wheelchair. As the model for many Wyeth works, she is an extreme, even grotesque, form of self-reliance (fig. 32). Her lined, wall-eyed face seems a ruin itself that testifies to the trial of existence. It is as if in looking upon her image, we can admire her endurance and the unsparing "honesty" of the painter's depiction. There is in ravaged faces, worn wood, and overgrown fields the lure of loss, poverty, age, failure, and stoicism as authentic: these images provide antidotes to the assumed artificiality of American success, even as that success generally remains preferred. We want to admire such scenes but do not wish to enter into them too completely. The gaunt figure, browned

Fig. 32. Andrew Wyeth, American, born 1917, *Anna Christina*, 1967. Egg tempera on masonite. 53.97 × 59.05cm (21¼in. × 23½). Partial gift and private collection. Courtesy, Museum of Fine Arts, Boston. Reproduced with permission. © 2000 Museum of Fine Arts, Boston. All Rights Reserved.

landscape, and dilapidated house evoke spartan perseverance. Such a decayed way of life, however, is no longer healthy nor part of mainstream aspirations. That crawling woman could not sell country artifacts to aging yuppies. It is as if in looking on thin, dignified Christina, I can complacently indulge in nostalgic admiration while taking comfort in the fact that this life of hers, this road not taken by most Americans, has come down to images confirming that it does, and in many ways should, belong to an irretrievable past. There may be relief that our culture has turned from this life to one surrounded by middle-class comforts, in which age is virtually erased from the scene by updated landscaping and renovation, and from the human face by laser resurfacing.

To take a milder view of the vernacular ruin, it is worth considering

the explanations and assumptions connected to decline and abandonment. Of course, in New England's case we could reductively cite the rocky soil and out-migration during the eras of Western expansion and industrialization. Whatever the ecological and economic factors behind change, painting and poetry invite us to think morally and mythically. Decline and Fall are often represented as an epic pattern of extremes. The fall of Rome is in decadence; excessive human appetite spends itself in corrupt luxury. Painter Thomas Cole, famous for ideal American landscapes, employed such a paradigm in an allegorical series of paintings inspired by his study in Italy, *The Course of Empire* of 1836. This series, heavily traditional in conventions, offered a warning to a young republic that it should attend to higher principles in the face of rapid development. Five paintings trace the "progression" of a classical site from wilderness to ruin through "The Savage State," "The Pastoral State," "The Consummation of Empire," "The Destruction of Empire," and "The Desolation of Empire." The "consummation" is the fantastic glittering city of luxury and pomp, but the sequence implies that this epitome of civilization contains the impulse for conflict; "The Destruction" portrays human brutality, and that violence seems to collude with devastating storms to spawn a cataclysm. The last of the series, "The Desolation of Empire," portrays the return of peace, but not of civilization: nature with its invasive growth claims the ruins, and a pillar that once represented the ideal of human order becomes a base for vines and birds (fig. 33).

However, less extravagant societies also fail, not because of decadent indulgence but because human appetite is restricted. In the nineteenth century, Thoreau's Walden, Alcott's Fruitlands, or Shaker communities experimented with alternatives to the risk and corruption of empire building. However, utopian plans may expect too much of flawed participants: one would need to be too good (or too foolish) to choose subsistence farming over urban progress. Nonetheless, the ideal of material restraint and transcendent wealth lingers: as Frost asserted in "New Hampshire": "The having anything to sell is what / Is the disgrace in man or state or nation."

So, in encountering the vernacular ruin, is there regret (to quote "New Hampshire" again) that we are "soiled with trade"? Does it recall principles we wish to lean toward, but forgivingly tell ourselves we cannot be expected to realize? Is it both frightening and reassuring that weathering reclaims and renders picturesque the handiwork of common folk? Wooden structures bear the marks of human self-reliance working with and against nature's cycles; what metaphors can vinyl siding yield? How the past

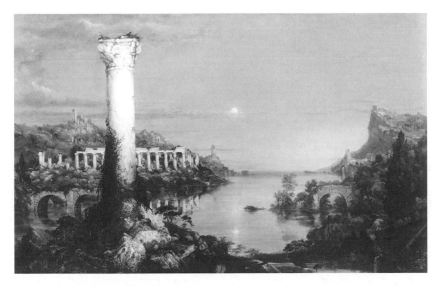

Fig. 33. Thomas Cole, *The Course of Empire, Desolation,* 1836, oil on canvas, 100.3 × 155 (39½ × 61). Collection of the New-York Historical Society, accession number 1858.5, negative number 6049

reassures and haunts us involves a vague sense of lost possibilities and, as Dale Brown wrote, of lost stories. In an essay for *House Beautiful,* a magazine devoted to the pursuit of elegant (and expensive) decor, Brown writes of abandoned houses in upstate New York as "victims of the Depression": "Their debt-ridden owners departed in the thirties, giving up farming, the only way of life they had ever known." He remembers a "broad-eaved, gracious type portrayed in Currier and Ives home-for-the holidays scenes" that was recently destroyed as a fire hazard, and he regrets more than the loss of an interesting structure:

I wondered what clues to the owners' lives might have lain hidden in there— perhaps letters and diaries in a trunk left behind in the attic. I derived a certain amount of comfort from the thought of the flames lighting up the rooms, warming them, licking away the mold. But that is not what happened, I later learned. Instead, a bulldozer came and broke the building's bones, crushed its walls, knocked it into a heap of splinters and dust. Only after enduring this ignominy was it burned, its wreckage constituting its own pyre. Then earth was shoved into its grave.[21]

The house became like a human being to Brown, deserving some dignity in its death. In part, the vernacular ruin offers a fragment of a narrative,

and recovering that narrative includes recovering past lives and even the ideals that guided them. The dead, though, can never really be brought back in their original form. If the attempt includes heartwarming sentiment about old-fashioned ways, it can also include fear of ghosts. If the past contains the origin of security and virtue, it can also be a misleading maze back to folly and grief.

Frost's poetry often seeks a way through the past and finds itself in deserted places. Early poems mildly echo late nineteenth-century conventions in depicting ruins. "A Ghost House" from *A Boy's Will* conveys pleasing melancholy for what has vanished to all but the Poet: "I dwell with a strangely aching heart / In that vanished abode there far apart / On that disused and forgotten road."[22] "The Black Cottage" from *North of Boston* opens picturesquely: two walkers—the poet and a minister— glimpse a "cottage" (a word more Old English than New) as "a sort of special picture" which is "Fresh painted" by rain and "framed by leaves." It is quaint, not junky or dirty as abandoned houses can be then and now. The minister also speaks with gentle regret, but his reflections uneasily probe the meaning of such a place. His explanation of its disuse after a pious widow's death encapsulates one archetypal view of the past: children—new generations—want something that does not change, an emblem rendering the world of their childhood eternal, even as they themselves have changed. In the poem, the sons, sustaining the illusion that they can, and really want to, revive the past, have created an empty memorial:

> "Everything's as she left it when she died.
> Her sons won't sell the house or the things in it.
> They say they mean to come and summer here
> Where they were boys. They haven't come this year."[23]

The minister's recollections imagine the past as having its painful sacrifices—the death of the husband in the Civil War—yet also imply that the pain is transcended in unshakable high-mindedness, such as the widow's "innocent," "serene" belief "that all men are created free and equal." In telling how he would not liberalize the church's creed because of her, the minister offers an odd insight that seems to undermine sincerity and faith: "For, dear me, why abandon a belief / Merely because it ceases to be true." Then he adds, "Cling to it long enough, and not a doubt / It will

turn true again, for so it goes." The presence of New England ruins suggests that an ideal, like nature, does not follow a linear "progressive" path but a cyclical pattern: if past ideals are kept before us enough they will "turn true again." The minister takes his conceit further, with a scene similar to that of Shelley's "Ozymandias" and offering revelation in the ancient, abandoned, and barren. The minister envisions "a desert land" dedicated "To the truths we keep coming back and back to." This recalls another archetype that humanity needs a hallowed place apart from the dailiness of existence. Like the desert of prophets, that place and the virtues it shelters are protected from temporal change (what we might call "development") by inaccessibility and material uselessness:

> "So desert it would have to be, so walled
> By mountain ranges half in summer snow,
> No one would covet it or think it worth
> The pains of conquering to force change on."

Like ancient relics, the vernacular ruin and simple life are protected from greed: where capitalism fails, transcendence returns. Marianne Moore expresses as much in her poem of a seaside town, "The Steeple-Jack": "yet there is nothing that / ambition can buy or take away / It could not be dangerous to be living / in a town like this, of simple people."[24] Elizabeth Bishop also finds an idyllic poverty in such poems as "At the Fishhouses," with its "principal beauty" created by iridescent fishscales, and "Cape Breton" where the soil's "poverty" is announced "in a snowfall of daisies."[25] When an area is highly marketable, as Wyeth's neighborhood in Chadd's Ford, Pennsylvania, has become, new suburban mansions loom in exclusively priced developments with historical names: Century Farm, The Reserve at Chadd's Ford, Ravenswood, Sentinel Way.

Contemporary painters following the popular tradition of Currier and Ives make explicit, perhaps trite, the aura of the rural past and small village. Wisconsin artist Charles L. Peterson says, "I hope I'm reminding people of values worth keeping—family, work, friendship, community, religious values—of the validity of those things as a way of life"; "My painting speaks on behalf of the simple pleasures, that having more is not always better."[26] Peterson's speciality is 1940s-style scenes that are probably idealized versions of his own childhood. The artist imposes transparent figures on the scenery, so ghost farmers ride Farmall tractors, ghost grandmothers knit on the porch, ghost mothers read to children in a

rocking chair. These spectral images, however, appear neat and content: all is cozy and middle-class rather than sparse or chilling.

A persistent myth, which most adults indulge in at some time, is that the past evokes the lost happiness and innocence of childhood. Time (along with progress and wealth) changes all, as it did for Orson Welles's Citizen Kane: the boy playing outdoors receives unexpected riches, leaves his modest home to be educated, grows into a young idealist, a man of power, and then the self-indulgent tyrant whose too-famous dying word is "Rosebud." With this death, the past is lost in several ways. The body dies, and with it an unshared memory that had resisted biological aging: no one (except the viewer) knew the meaning of the last word. Because that meaning is unknown, the icon of wood with rusted runners seems worthless: the sled Rosebud is tossed upon the fire.

Of course, not all childhoods are either simple or happy. To return to Elizabeth Bishop, her scenes of her early childhood home, Great Village— a name that belies the reality of its few, closely clustered houses—are haunted by the terrifying scream of her emotionally disintegrating mother, who would disappear from Bishop's life. Remnants of such a past testify to devastation. As a child walking by everyone she knew to take a package to the post office (the "secret" gift for her mother in the sanatorium), Bishop would cross a bridge and see beneath the water and swimming trout, "the old sunken fender of Malcolm McNeil's Ford": "It has lain there for ages and is supposed to be a disgrace to us all. So are the tin cans that glint there, brown and gold."[27] But the supposed disgraces from the past, whether material or psychological, are not easily pushed into oblivion; they have a "glint" that captures attention. As child and adult, Bishop wishes to escape the scream ("surely it has gone away, forever") but if that memory should be suppressed or silenced, it takes too much with it. The story ends with Bishop listing the attic ruins of family memorabilia and calling upon the village blacksmith to strike his anvil again:

All those other things—clothes, crumbling postcards, broken china; things damaged and lost, sickened or destroyed; even the frail almost-lost scream—are they too frail for us to hear their voices long, too mortal?
Nate!
Oh, beautiful sound, strike again!

Bishop's reflections on "too frail" mortality reveal that for her pain cannot be distilled away to leave a pure elixir of sweet memory. Her poetic

visions of isolation arise from an ambivalence toward recovering or sup-
pressing the past, and thus toward confronting possibly devastating emo-
tion or avoiding it. While she does not always return to the homestead
of "In the Village," she frequently imagines a form of isolation. In "The
End of March," she dreams of retreat as she walks with friends along a
Duxbury, Massachusetts, beach on a "cold and windy" day of "steely
mist." The dreary weather and the appearance of the ocean "withdrawn
as far as possible, / indrawn," elicit an introspective mood despite the
company:

> I wanted to get as far as my proto-dream-house,
> my crypto-dream-house, that crooked box
> set up on pilings, shingled green,
> a sort of artichoke of a house, but greener
> (boiled with bicarbonate of soda?),
> protected from spring tides by a palisade
> of—are they railroad ties?
> (Many things about this place are dubious.)
> I'd like to retire there and do *nothing,*
> or nothing much, forever, in two bare rooms:
> look through binoculars, read boring books,
> old, long, long books, and write down useless notes,
> talk to myself, and, foggy days,
> watch the droplets slipping, heavy with light.[28]

This deserted box makes a peculiar "forever," a writer-scholar's heaven
of endless activity that achieves nothing. Here the only change is the
occasional foggy day. The "droplets slipping, heavy with light" distantly
echo William Butler Yeats's "The Lake Isle of Innisfree" with its archaic
seclusion in "a small cabin . . . of clay and wattles made" where "peace
comes dropping slow."[29] However, Bishop's house—a surrealistic boiled
and "dubious" green—sounds less like a serene fairy tale, and her en-
gagement in "boring books" and "useless notes" sounds whimsically self-
effacing but also futile and escapist. The poet deserts all but the dustiest
relics of humanity in a retreat from direction and purpose, a retreat from
memories that might stir desire and regret, and a retreat from the self that
must acknowledge responsibility and vulnerability in its relations to others.

Virtuous isolation offering spiritual renewal and misanthropic with-
drawal tinged by self-hatred are not so far from each other. In an early
Bishop piece, "Chemin de Fer," the poet wandering through "impover-

ished" scenery along a railroad track witnesses the confusion of love and hate in the person of a "dirty hermit" who fires a "shot-gun" and then screams, "Love should be put into action!" As in "Crusoe in England," choice and fate also become confused. Does anyone "deserve" to be so isolated? Was there a moment in a lonely childhood or transient adulthood when the poet "actually chose this" to avoid the pain of flawed relationships? Or did she by chance find herself abandoned?[30] Perhaps because Bishop realizes in "The End of March" that her fantasy constructs a coffin, she does not, or cannot, pursue this "dream-house" even if it seems "perfect": "But—impossible. / And that day the wind was much too cold / even to get that far, / and of course the house was boarded up."

Hopper's houses are not generally "boarded up," but they might as well be. The windows and doors do not open into domestic warmth as they present either an uninvited voyeuristic glance or the blankness of blinds and shadows. If the past is evoked in his architectural presences, it is not a pleasing confrontation. The enigmatic starkness denies the possibility that one would encounter benign, Casper-like ghosts resembling the figures of Charles L. Peterson's work. Some paintings of Cape Cod farms, such as the watercolor *House on Pamet River* of 1934, approach charming images of rural ruins with attention to sheds, gray roofs, and ramshackle shutters. They hardly re-create, however, a charming homestead with its warm hearth: that sort of image is offered by the contemporary popular painters Thomas Kinkade and Terry Redlin. Their works, like Charles Peterson's, are not the stuff of shocking postmodern installments; instead, prints are available at Internet sites and occasionally featured on television shopping networks. The images have the look of painstaking craft adapted to the mass market. (Wyeth seems innovative and shockingly harsh in comparison.) Claimed by gallery websites to be the most popular contemporary painter, Redlin is famous for his light—the opposite of Hopper's. A comparison of these two sets a cozy sentiment against an unnerving chill. At the "heart" of a Redlin scene is a warm, candlelike glow. This often illumines a cottagelike dwelling settled within foreground and background dense with saturated colors and detail: it seems the archetypal welcoming home, full of good smells and companionship. Hopper denies this sort of bosomy embrace in a painting, with his fluorescent coolness and ambivalent geometry that obscures, reveals, and transposes public and

private space so that the composition dominates human response without revealing precisely what that response could be.

This comparison underscores viewers' intuitions about Hopper: his paintings elicit not the cozy but the uncanny. In his classic essay on the uncanny, Sigmund Freud emphasizes the relationship, sometimes oppositional and sometimes fluid, between the *heimlich* (homely) and the *unheimlich* (unhomely). While the English word lacks a direct reference to domestic intimacy or its lack, it still suggests "that class of the frightening which leads back to what is known of old and long familiar."[31] Adapting Freud's conception of the uncanny, Margaret Iversen finds in the ghost houses of art (including Hopper's), something "ambivalently familiar and unfamiliar, intimate and strange" and "a space that is filled, negated, and to which we cannot return." These spaces also reproduce "a sensation in the viewer of what it is like for . . . memories to return unbidden."[32] There is a doubleness to the uncanny, because it evokes absence and presence, fear and desire. The antiquated architecture of such buildings as the one in *House by the Railroad* prefigures the mortality of an individual or culture. The looming house's awkward existence past the moment of its fashion makes it out of sync: the painting undercuts the possible consolation that for everything there is a season, the right time to begin and the right time to end. Hopper acknowledged a similar disjunction in the making of paintings as he commented on a Burchfield scene: "*March* is an attempt to reconstruct the intimate sensations of childhood, an effort to make concrete those intense, formless, inconsistent souvenirs of early youth whose memory has long since faded by the time the power to express them has arrived, so close to dreams that they disappear when the hand tries to fix their changing forms."[33] Rather than sealing in paint a securely defined and possessed knowledge, the artist finds that he can only summon up ineffable dreams that continually resurface and disappear. In this, Hopper modernizes William Wordsworth's romantic lament, "Whither is fled the visionary gleam"? Part of the eeriness of his paintings is that they will not offer a tangible and satisfying epiphany, a fulfilled image in Wordsworth's phrase of "the glory and the dream."[34]

While "early youth" suggests a time of pleasure, Hopper does not work from a consistent paradigm that the past meant happiness and the present means alienation. Just as there is no clear divide in his landscapes between country and city values, there is no sharp demarcation between the worth of the past and the hollowness of the present. The sense of suspension

in many works, particularly those in which the light falls upon empty spaces, does not so much suggest a historical loss as a chronic detachment: nothing ever converges in a warm flood of emotional ties. Or, the lighted emptiness stirs a perverse delight in the purity of isolation. Hopper critiques modernism, with its anxieties, consumerism, and transience manifested in its "Ex-Lax" signs, disaffected figures, and anonymous hotel rooms. However, the artist is also fascinated by the city, electric lighting, and travel: the bleakness of *Nighthawks* is offset by the wash of light—bold, if garish—in the night diner. And the suggestions of the past in Hopper's landscapes and old-style houses are not necessarily "antidotes" to urban malaise. As with Bishop's poetry, the return of the repressed brings back a range of moods and insights. To rephrase this as a question, can we imagine a happy childhood in Hopper's *House by the Railroad?* Others have imagined otherwise: if this house did inspire the image of the Bates hotel in Alfred Hitchcock's *Psycho,* then the past was one of a mother's ruinous domination that gave birth to a murderer. A less horrific, more ordinary, story is suggested by Hopper's childhood, in which he was isolated in adolescence by his extreme height and shyness and also absorbed his father's emasculated apathy toward business and marriage. It is not that Hopper's paintings require the completion of narrative (which would erase the ominous vagueness of the uncanny). Rather, his scenes suggest that brilliant light does not by itself dispel a sinister history.

It is important to avoid the conclusion that popular artists like Kinkade, Redlin, and Peterson create a false past while Hopper depicts a "real" one: history is a reconstruction, a dream with evidence. It is the directions in which the dreams lead us and their shaping of the present that matters. If poets and painters can indulge in the fictiveness of the past, they nonetheless find their imaginations constrained by historical circumstance and are judged by how their illusions perpetuate and rewrite cultural memory. Joseph Cornell (1903–72) with his famous boxes pigeonholed discarded fragments: compasses, marbles, bits of maps, hotel names. The detritus of others' pasts is reassembled into the artist's own fantasy as a miniature decaying museum, surrealistic, whimsical, and sad. The melancholy these bits evoke lies in the partial connections, in the blend of wishful dream and tattered artifact: the box implies but does not complete a story, and the icons elicit emotion with little context other than that they have been preserved and framed. It is the mystery of visualizing memory, which will not be ordered and will not be complete, of reading fragments when the key has been lost.

Nostalgia and sentiment can be contrived, but contrived out of need; as with Cornell's boxes the artist can become carried away by his own magic. Contemporary photographer Sally Mann, best known for controversial images of adolescent girls in *At Twelve* and of her own children, recently created deliberately nostalgic pictures of Georgia and Virginia. Mann was inspired by a sort of attic find, the discovery of a Civil War veteran's glass negatives depicting familiar places. She reprinted many of these images and began taking her own of similar sites, "slipping indistinguishably between the centuries." In so doing, Mann not only self-consciously succumbs to myths of the South as a "lost paradise" with "distinctive light" in a photographic collection called *Mother Land*, but also disturbs concepts of technology and spiritual aura.[35] Instead of mundane mechanical reproduction, Mann's images illustrate that through age and abandonment technology regresses from an exemplar of inhuman progressive efficiency to an anthropomorphic totem of past spirits.[36] Mann employed out-of-date equipment and individualized developing strategies to produce a ghostly ruin of a photograph. The "Mother land" scenes include avenues arched by moss-laden branches and defined by old walls, misty pastures of broken trees, and fading leaves in silvery rivers, while the photographic surfaces are blurred, warped, and crossed by uneven light. So both place and its representation seem the genteel ruins of once serene beauty. A *New York Times* writer summarizes Mann's technique for creating mock-aged, damaged, and therefore idiosyncratic images: "she used a view camera and lenses that were old and flawed, then soaked the prints in tea to give them a lovely, warm tone akin to that of 19th-century photographs."[37] Mann's own explanation, however, is far less technical as she talks of being drawn into a mystical sense of her homeland:

In the Miley prints [of the Civil War era], it was the suspension of time that led me into the light, but when I am in the pastures making my own images it is the light that leads me into suspended time. The photographs created there in that oneiric warp embrace time and memory and become the still point at which they intersect.[38]

That "oneiric warp" harkens back to the uncanny as Mann goes on to write, "that stillness brings longing and a dizzying, time-unraveling spiral into the radical light of the American South." Mann's talk of the "history of defeat and loss" does not probe the right and wrong of plantation life and the Civil War, but intensifies the yearning for whatever fullness and

possession the "memory [that] becomes art" can provide. If for Mann the "warp" and "spiral" of that light are integral to her sensibility and connection with the South, she does not see the synthesis of time and place as simply benign, or as a Disneyland version of history as an uplifting robotic spectacle: "To identify a person as a Southerner is always to suggest not only that her history is inescapable and profoundly formative but that it is also paralyzingly present."[39]

The past—or rather an idea of the past—can be a fascinating (if murky and distorted) lens that transports the viewer beyond a mundane sense of the present moment. That vision can also arrest the present in a limbo and frame the viewer in a "formative" yet "paralyzing" identity. In contrast to Mann's defeated South, New England's history, as popularized in calendar art and tourism, seems more happily reminiscent of its founding principles with Pilgrim settlements and Revolutionary War sites. Such a "living history" vision, challenged in the bleaker works of Andrew Wyeth and Robert Frost, is debunked as well in several poems by Robert Lowell (1917–77) as he critiques the moral paralysis of his post–World War II generation.

Known for his fusion of the "raw" and the "cooked" in poetry (the uninhibited spontaneity of the Beats with the intellectual rigor of formalism), for the confessionalism of *Life Studies* of 1959, for his political statements against saturation bombing in World War II and against the Vietnam War, for association with diverse poets including John Berryman, Sylvia Plath, and Elizabeth Bishop, and for his struggles with alcoholism and manic-depression, Lowell is in some ways as much a New England poet as Frost. Family names—Winslow, Hubbard, Lowell—could be found in old New England cemeteries; James Russell Lowell, genteel nineteenth-century writer and professor at Harvard, was one of his ancestors. Robert Lowell often disclosed the less admirable side of his regional and family inheritance in early poems such as "At the Indian Killer's Grave" and "Mr. Edwards and the Spider"; like Nathaniel Hawthorne, he was obsessed with the bloodshed, fear, hypocrisy, and guilt that accompanied puritanical self-righteousness. If the sins of the past haunt, so do its ideals. Lowell does not exactly imagine a lost paradise; like the minister of Frost's "Black Cottage," however, he longs for faith in principles of an earlier age. In "For the Union Dead" of 1964, Lowell reflects upon Augustus Saint-Gaudens's Boston monument to Colonel Robert Gould Shaw, white leader of an African-American regiment who, along with most of his soldiers, died in battle. The poet contrasts contemporary scenes of parking-

garage construction, commercial photographs, and television coverage of civil rights with nineteenth-century emblems of idealism:

> On a thousand small town New England greens,
> the old white churches hold their air
> of sparse, sincere rebellion; frayed flags
> quilt the graveyards of the Grand Army of the Republic.
>
> The stone statues of the abstract Union Soldier
> grow slimmer and younger each year—
> wasp-waisted, they doze over muskets
> and muse through their sideburns . . . [40]

Lowell struggles with a longing for the past and its icons of sincerity, even as he realizes the cost of often misguided self-sacrifice. Rather than finding reason for complacency in the heroism of forbears, Lowell pictures an embittering decline: the Shaw monument "sticks like a fishbone / in the city's throat." For him the present is entrapped by a "servility" to commercialism, conformity, and prejudice. As one who can witness but not adequately redress the failings of his time, the poet displaces his own sense of decline: he sees the increasingly ideal—and unapproachable—image of "abstract" soldiers who "grow slimmer and younger each year." The model for heroism, even a heroism complicated by narrowness and foolish sacrifice, recedes further.

It is no surprise that past and present can distort each other. History becomes aggrandized as impossibly virtuous, branded as savagely destructive, or collected as quaintly valuable; The present appears paralyzed by old wounds, self-deluded in its faith that it is rooted in past principle, or shallow in its ignorance of how it came to be. In writing of the importance of "the project of American memory," Robert Pinsky singles out one of Frost's most enigmatic poems:

Perhaps the most profound poetic contribution to that project is Robert Frost's poem "Directive," which presents the undertaking of American memory as dire and frightening as well as arduous. . . . In this poem Frost suggests that our destiny as a people may lie in the difficult action of historical recovery—and that the source of wholeness is in memory. Here the past is presented as a mysterious spiritual reality: attainable not through the spectacle of re-creation but through a

journey. History is a quest, not a diorama. His challenge here should be inspiring. The project of shaping ourselves as a people, his poem implies, has only begun. "Beyond confusion," our cultural work still lies ahead of us.[41]

Frost's challenge in "Directive" may be "inspiring," but it can thwart as much as guide in the quest for "wholeness." This poem has haunted readers with its supposedly regenerative pilgrimage back to an abandoned village. The poem may exemplify Frost's sly designing, because the advice can be read as straight and sincere or as ironic and duplicitous. Can we trust all or nothing in the poet's promise that we can be delivered "beyond confusion"? Within the 1947 volume *Steeple Bush,* it subverts for me surrounding poems that offer more complacent responses to stepping back and saving oneself. The tone of several, such as "Something for Hope," is difficult to determine: the poet may be genuinely trying himself, or he may be slipping into a conservative complacency: in talking of cyclical growth patterns, he opines, "Thus foresight does it and laissez faire, / A virtue in which we all may share / Unless a government interferes."[42]

The mood of "Directive," however, is both soothing and tense, while the images are more mythical and ambiguous. The return is to a specific place—and an archetypal one. In hiding a "goblet like the Grail," Frost likely alludes to T. S. Eliot's *Waste Land* and its quest for the fragments that might preserve the spirit from the collapse of modern culture's "Unreal" cities. Perhaps also in mind were Eliot's returns in "Burnt Norton" of 1935 to the "rose-garden" of childhood and in "East Coker" of 1940 to ancestral houses that "rise and fall." Journey and return are persistent motifs of Eliot's poetic quest, which would culminate in "Little Gidding" of 1942 with its epiphanic glimpses of time redeemed:

> If you came this way,
> Taking the route you would be likely to take
> From the place you would be likely to come from,
> If you came this way in may time, you would find the hedges
> White again, in May, with voluptuary sweetness.[43]

While Eliot and Frost were often placed in opposition as the Great Sophisticated Modernist versus the Authentic, Home-Grown American, certainly both poets, whose writings span the progress and devastation of the first half of the twentieth century, test the mysteries of ends and beginnings and the powerful, if often vague, desire to return to innocence.[44] Both

question if the imagination can find redemption in the wreck of personal and cultural histories. However, the ardent spirituality with which Eliot confronts the quest is challenged in "Directive" by something illusory, even sinister.

The opening riddles with contraries, as the rhythm seduces one into the haunted landscape:

> Back out of all this now too much for us,
> Back in a time made simple by the loss
> Of detail, burned, dissolved, and broken off
> Like graveyard marble sculpture in the weather,
> There is a house that is no more a house
> Upon a farm that is no more a farm
> And in a town that is no more a town.
> The road there, if you'll let a guide direct you
> Who only has at heart your getting lost,
> May seem as if it should have been a quarry—[45]

As in Frost's much earlier "Birches," one dreams "of going back" when the details of present life "burn and sting." In that poem, the image of the boy swinging birches offered to the adult poet who was "weary of considerations" a sustaining metaphor of control and belonging. However in "Directive," as in "Once by the Pacific" and "Design," natural forces elide into malicious, almost supernatural powers. Though New England towns may have been abandoned for specific reasons, the poem mystifies the change. It is difficult to say exactly what the traveler sees. The awareness of ruin and death asserts itself not in exact details (these are exactly what has dissolved) but in the imagination's simile: "Like graveyard marble sculpture in the weather." Objects, places, and the words naming them appear to undo themselves, so there can be no sorting out of the "real" and the ghostly: "a house that is no more a house / Upon a farm that is no more a farm." Is it no more a house because it is an abandoned ruin, or does the poet understand the riddle of the landscape by remembering where a house once was? With the fading or complete disappearance of human traces, pastoral settlement reverts to geologic, glacial origins. As in Elizabeth Bishop's "Cape Breton," the prehuman past lingers, overwhelming a quotidian perspective with "Great monolithic knees the former town / Long since gave up pretense of keeping covered."

Frost's poem goes further in animating the landscape, as if the return were to a time of anonymous legend and Titans:

And there's a story in a book about it:
Besides the wear of iron wagon wheels
The ledges show lines ruled southeast northwest,
The chisel work of an enormous Glacier
That braced his feet against the Arctic Pole.
You must not mind a certain coolness from him
Still said to haunt this side of Panther Mountain.

Against this background of cool, monolithic presences that force their will on the earth, the idea of ordinariness (presumably what one initially sought to escape in this return) is now offered as reassurance against the surrounding loneliness. Yet the thought of a comforting routine becomes eerie:

Nor need you mind the serial ordeal
Of being watched from forty cellar holes
As if by eye pairs out of forty firkins.
As for the woods' excitement over you
That sends light rustle rushes to their leaves,
Charge that to upstart inexperience.
Where were they all not twenty years ago?
They think too much of having shaded out
A few old pecker-fretted apple trees.
Make yourself up a cheering song of how
Someone's road home from work this once was,
Who may be just ahead of you on foot
Or creaking with a buggy load of grain.

The period of settlement seems a brief aberration sandwiched between the era of the Glacier and Mountain and the "upstart" growth of woods. The cyclical changes in vegetation that seemed a benevolent order in "Something for Hope" become in "Directive" a threat. One must reimagine human activity and assert a voice over the rustling with a "cheering song" to contain the fear that the pilgrim too will be "shaded out" by this landscape.

Yet this quest remains an "adventure," a rather archaeological one that requires foreknowledge and speculation to unbury a treasure covered by years of growth and change. Just as Crusaders could name themselves agents of salvation and explorers could claim the title of heroes to establish an honorable identity, the pilgrims of this poem may find themselves and find "home":

> The height of the adventure is the height
> Of country where two village cultures faded
> Into each other. Both of them are lost.
> And if you're lost enough to find yourself
> By now, pull in your ladder road behind you
> And put a sign up CLOSED to all but me.
> Then make yourself at home. The only field
> Now left's no bigger than a harness gall.

The "height" of this adventure, however, is a mirage: instead of a grand prospect, there is the dissolved boundary, perhaps visible in some vestige of crossroads or only in the guide's memory, of two lost village cultures. Security may be established by withdrawing into this place and closing it off to intruders, who might disturb the illusion that "you" are distinguished in the solitary privilege of being lost and found. However, it is undercut by the observation that the human trace has shrunken to a space no bigger than a sore, "a harness gall." This gall suggests the pains of the repetitious tasks that once made this place, and like Frost's "The Wood-Pile" in *North of Boston* seeing such labor undone reveals human intent as futile: the accomplishment of the villagers has been erased.

Then conjuring up more ghostly residents, the poet suspends time— as if they were just snatched away. If references to childhood most powerfully evoke the past for us, Frost exposes that vulnerability:

> First there's the children's house of make believe,
> Some shattered dishes underneath a pine,
> The playthings in the playhouse of the children.
> Weep for what little things could make them glad.

Besides hinting that all our lives are brief "make believe," the passage denies the consolation of family and community continuity. The poem may reflect the disruption of New England's out-migration; more figuratively, it implies that continuity is a delusion—the past is always lost. Rather than tracing known generations, these lines present the children as if they had been untimely bewitched away, by the glacier or some pied piper. The speaker himself seems another pied piper, manipulating us where he knows we are soft with his directives: "Weep for what little things could make them glad." The past never seems more desirable, and more irretrievable, than in thoughts of childhood security vanished.

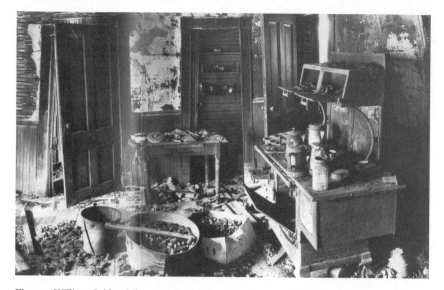

Fig. 34. William Gabler, Minnesota Farm House Interior, 1997, © W. G. Gabler.

That sentiment also introduces a recent photo-essay on Midwest ruins, *Death of the Dream: Classic Minnesota Farmhouses* by William Gabler (fig. 34). In recording "dismal" abandoned farm buildings that nonetheless have an "air of mystery and threat," Gabler, like Frost, returns to what others left behind, seeking intimations of past hopes and contentments. He finds this in a child's script:[46]

> *Then give me but my homestead*
> *I'll ask no palace dome*
> *For I can live a happy life*
> *With those I love at home*

This rhyme becomes the book's epigraph—and elegy for the "happy life" as this biting detail is added, "from a child's composition book lying in the refuse."

It is not enough for the guide of "Directive" to point out the loss of childhood: he mentions again a homestead that has become less visible than the country ruins Gabler photographed. The only domestic traces left are the lilacs and the poet's image of the earth as rising dough:

> Then for the house that is no more a house,
> But only a belilaced cellar hole,

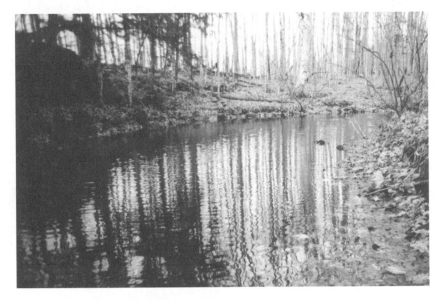

Fig. 35. Priscilla Paton, "Black Brook," 1996.

> Now slowly closing like a dent in dough.
> This was no playhouse but a house in earnest.

If our guide manipulates us, he too may be under a spell he can only half control. Why else would he act like the superstitious child, or trickster who had himself once been tricked? As in "The Mountain," a brook seems to be an origin, something loftier than streams that destructively leave "tatters" along their banks; it is difficult to say, however, what that source offers now that it no longer is a practical water-supply for a house (fig. 35):

> Your destination and your destiny's
> A brook that was the water of the house,
> Cold as a spring as yet so near its source,
> Too lofty and original to rage.
> (We know the valley streams that when aroused
> Will leave their tatters hung on barb and thorn.)
> I have kept hidden in the instep arch
> Of an old cedar at the waterside
> A broken drinking goblet like the Grail
> Under a spell so the wrong ones can't find it,

So can't get saved, as Saint Mark says they mustn't.
(I stole the goblet from the children's playhouse.)
Here are your waters and your watering place.
Drink and be whole again beyond confusion.

To drink is our "destiny," but to drink of what? The fountain of knowledge, youth, bliss, forgetfulness? Is this drink a clarifying tonic, another "dull opiate," the waters of "Lethe" as Randall Jarrell suggests, or an inebriant as in the "Tale of Rip Van Winkle" that keeps one in the past by erasing the present?[47] The poet and we may be among the elect who are saved, but the question now is, saved from *what*? The current life of some settled place that is left behind as "too much for us? The past that is "no more" in these abandoned villages? Or the present of the rustling woods with its "eye pairs" that ominously reclaims once domesticated space? The poet seems petulant in hiding the broken goblet, as if he suspected that he could be revealed as a false prophet or that he has no particular right to claim the past as his clear entitlement. He must steal the emblems and hope that his directives endow him with authority and certainty: "Drink and be whole again beyond confusion." But what is made whole? The spirit of the traveler redeemed by a sight that compresses history, the image of origin and ruin together? It does not seem that the villages will arise again full-fleshed in a second coming. Can there be life "beyond confusion," or does that serene destiny only come with complete loss, with death? If that is so, then in drinking we become "whole" by being absorbed into the woods like the lost workers and children. The landscape is left once again to ghostly traces.

The haunted quality of "Directive," like that of *Christina's World* and *House by the Railroad,* is evoked by the paradox that the place feels both immediate and distant: we return to the site, but do not truly reenter it.[48] The "moral" of many ghost stories is that the living and the dead should not come together: one realm must exclude the other or be undone itself. The hope stirred by the ruin is that a life of value will be restored; the fear is that the living will be lost to the world of the ghosts, if not through literal death then through a denial of the present. A related fear is that we cease being the observers to become the observed, watched "by eye pairs out of forty firkins." Where the uncanny or a spiritual aura is present, the seemingly dead and material become animated, so that a deserted house has mysterious movement or a religious icon looks down on the pilgrim; the imagined gaze can be spooky or holy.[49] In broad terms, en-

dowing the past with eyes means it can see, or see through, the present. The monument of Robert Lowell's poem can look down upon the moral cowardice of the speaker; the blank windows of Hopper's houses mirror the viewers' loneliness; the eyes of "Directive" reveal that the "you" is no longer the native but the intruder. If this sensation can also transport one out of the quotidian, there is also the possibility that one is stranded in limbo, between past and present. If returning to the ruin means discovering a source that clarifies identity and purpose, is there also a map to find the way back?

Epilogue

My grandparents had to live their way out of one world and into another, or into several others, making new out of old the way corals live their reef upward. . . . I believe in Time, as they did, and in the life chronological rather than in the life existential. We live in time and through it, we build our huts in its ruins, or used to, and we cannot afford all these abandonings.

—WALLACE STEGNER, *Angle of Repose*[1]

If as individuals and as a culture, we look to the past inscribed upon the landscape to assure us that we have lived, we also find evidence that we die and are dying. That death takes with it certain principles and failings. In this the vernacular ruin is a humble, local variation on the classical themes of transience and permanence: monuments outlast honored faiths and heroes only eventually to crumble into dust. The modest houses of the pastoral dream also outlast their inhabitants, but then—unless preserved by deliberate effort that more often makes them an artifact than a dwelling—are claimed by natural processes of decay and regeneration. It is the human body that disappears most quickly from the scene. Because human desires advance, or are simply fickle, once vital places are abandoned; the flesh of those who stay to die is outlasted by the slow, deceptively picturesque decline of buildings, monuments, roads or pastures.

Each generation of Americans has its version of ruin to contemplate: a bankrupt downtown, a depreciating ranch house, a vacant strip mall. If the image of the decaying country homestead is rooted in pre-modern agricultural history, it is updated by the sight of equipment rusting in a field (fig. 36). While farm trucks and tractors stir boyish nostalgia—the big new toy recovered at last, but transformed by neglect—the obsolete machine can be separated from a rural context to become an icon on its own. A recent collection of photography by William Eggleston displays

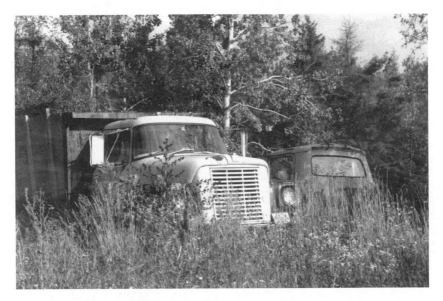

Fig. 36. Priscilla Paton, "Maine Farm Truck," 1997.

cars tipped over, wheels gone, fenders eaten away, on abandoned roads. The totems and trademarks of modern prosperity become quaint to such a camera eye, as "Ice Cold Coca Cola" signs lose legibility and gain a patina like that of the weathered wood facade of a store that now stocks nothing. A Texaco sign lies fallen in the weeds, a forgotten warrior that the earth half entombs.[2] These scenes imply that deterioration reverses an object's significance so it becomes something other than blight and non-biodegradable waste. A battered car in the landscape suggests a crack in technology's prosperous dominance; it becomes a type as ruin and an individual in its irregular surface, with a story to keep secret.[3] Is it fair to conclude, however, that age and the end of utility are enough to redeem any object from the status of material excess and render it a melancholy emblem?

That belief would further erase the differences between pastoral and urban. The poets and artists of this study would preserve many distinctions, even if in ruined form. Images of abandoned places evoke an imagined chronology. The past is always lost, but fascination with its traces reveal that the sensory and cognitive life of moment-to-moment presentness is shallow and ephemeral. An origin implies a character and destiny, a meaning and shape to life's course (though as in "Directive" the outlines

and values of that plot can be obscure and misleading). The image of a ruin or the traces on the landscape compress history. Instead of the exact fiction of a timeline, abstract and bloodless, an image of a place can contain past and present together without equating them: dying maples surrounding a collapsing barn can be seen from a new interstate highway. That compression of history, appalling and alluring in its different moods, can reveal connections but also cast a spell that clouds perception of past and present.

In the confusion of pleasure and despair that results from the return to the country of the past, it may seem these poets and painters only have at heart our getting lost. At times they may indulge a dream, as Cornell does with his boxes or Mann with her soft pictorial images. The traces upon the landscape invite the artist's divination, and it is tempting to fall under that spell cast by desire and loss. We may think these figures self-deluded in trying to make "true again" the romantic, ethical, or emotional values of out-of-date places. Nevertheless, they are wary of losing the details, of living by what either could not be reclaimed or could be honored only through lip service; their works hint at the selectivity of their own passions. Contemplation of abandoned landscapes approaches sentimental indulgence, but these writers and artists also unleash the fear that the past will lose its innocence if examined too closely. Yesteryear might not stand as a better world if the details are recovered: the alienation of Homer's fieldworkers, the depression of Frost's farmwomen, the unwelcoming pretension of Hopper's gothic houses, the trauma of Bishop's childhood, the swollen joints of Christina Olson's hands, the violent deaths of Union and Confederate soldiers, or the "gall" that was once a pasture. These artists continually weigh self-conscious wariness against the persistent hope of finding in a once-loved place some emblem that renders it more than the future site for a mall. With real and imagined vernacular ruins, effort—physical, economic, emotional, and imaginative—is required to make the return valid and to realize when it is impossible.

Although it sounds naive to speak of the book of nature or a moralized landscape, only the jargon has changed, not the underlying impulse. Shared beliefs in cyclical fertility rites, in divine decrees of dominion over the earth, or in imperial destinies to explore and conquer may no longer broadcast themselves. But in the Internet era, the natural and social worlds are more intertwined than we tend to admit. The formation and integrity

of relationships with each other and the external world remain elusive, desirable ideals; for this, images inspired by landscape continue to matter. As Wendell Berry writes, "To preserve our places and to be at home in them, it is necessary to fill them with imagination. . . . To imagine the place as it is, and was, and—*only then*—as it will or may be."[4] The landscape is always moralized because our perceptions of it, our daily habits, the actions (and inactions) of government and business always have upon it an undeniable impact, and that impact returns to us. It is habitual to eulogize Nature and Landscape. The challenge is determining how the elegies foreshadow the future.

Notes

1. Introduction (pp. 1–27)

1. *Poems*, 67.

2. John Brinckerhoff Jackson, *Discovering the Vernacular Landscape* (New Haven: Yale University Press, 1984), 6–7. Also see Gina Crandall, *Nature Pictorialized: "The View" in Landscape History* (Baltimore: Johns Hopkins University Press, 1993), 5.

3. John Stilgoe, *Common Landscape of America, 1580 to 1845* (New Haven: Yale University Press, 1982), 3.

4. Salim Kemal and Ivan Gaskell, "Nature, Fine Arts, and Aesthetics," in *Landscape, Natural Beauty and the Arts*, ed. Kemal and Gaskell (Cambridge: Cambridge University Press, 1993), 2.

5. Vitaly Komar, *Painting by Numbers: Komar and Melamid's Scientific Guide to Art* (New York: Farrar, Straus, and Giroux, 1997).

6. See Anne Whiston Spirn, *The Language of Landscape* (New Haven: Yale University Press, 1998), 32.

7. See Sally Schauman on the cultural construction of the countryside, "The Garden and the Red Barn: The Pervasive Pastoral and Its Environmental Consequences," *Journal of Aesthetics and Art Criticism* 56, no. 2 (Spring 1998): 181. Schauman concludes, "Basically, most Americans do not value the countryside landscape for the intrinsic worth of its soil and water resources but they cherish its mythical images, its iconography, wherever they can be found or imagined" (188).

8. Sebastian Junger, *The Perfect Storm: A True Story of Men Against the Sea* (New York: Norton, 1997); Linda Greenlaw, *The Hungry Ocean: A Swordboat Captain's Journey* (New York: Little, Brown, 1999); Jon Krakauer, *Into the Wild* (New York: Doubleday, 1997); Jon Krakauer, *Into Thin Air: A Personal Account of the Mount Everest Disaster* (New York: Villard, 1997).

9. Junger, *Perfect Storm*, 223.

10. Bill Bryson, *A Walk in the Woods: Rediscovering America on the Appalachian Trail* (New York: Broadway Books, 1998), 3–4.

11. Ibid., 272.

12. Quoted in David Seideman, "Editor's Note," *Audubon* (January 2002): 6.

13. W. J. T. Mitchell, "Imperial Landscape," *Landscape and Power*, ed. W. J. T. Mitchell (Chicago: University of Chicago Press, 1994), 5.

14. Fredric Jameson, *Postmodernism; Or, The Cultural Logic of Late Capitalism* (Durham: Duke University Press, 1991), ix.

15. William Cronon makes a similar observation in *Uncommon Ground: Rethinking the Human Place in Nature*, ed. Cronon (New York: Norton, 1996). In discussing the ecological manipulations and development of southern California, he stresses how frequently after earthquakes and mudslides, houses with a prospect are rebuilt: "Since World War II, roughly 75,000 upper-income homes have been built on hillside lots by people seeking a room with a view" (32).

16. Jennifer Price, *Flight Maps: Adventures with Nature in Modern America* (New York: Basic Books, 1999), 168.

17. Ralph Waldo Emerson, "The Poet," *The Complete Works of Ralph Waldo Emerson*, (Boston: Houghton Mifflin, 1903), 3:37.

18. See Leo Marx, *The Machine in the Garden: Technology and the Pastoral Ideal in America* (New York: Oxford University Press, 1964), 1–8.

19. I am indebted to Raymond Williams's discussion of residual and emergent cultural values in *Marxism and Literature* (New York: Oxford University Press, 1977), 121–27, and to Leo Marx for applying Williams's distinction to the American version of pastoralism, "Pastoralism in America," in *Ideology and Classic American Literature*, ed. Sacvan Bercovitch and Myra Jehlen (New York: Cambridge University Press, 1986), 66.

20. See Paul Alpers, *What is Pastoral?* (Chicago: University of Chicago Press, 1996), x; and Leo Marx, "Pastoralism in America," 42.

21. Spirn, *Language of Landscape*, 17–18.

22. Mitchell, "Imperial Landscape," 6.

23. David C. Miller, *American Iconology: New Approaches to Nineteenth-Century Art and Literature* (New Haven: Yale University Press, 1993), 2.

24. Michael Ann Holly, "Past Looking," *Critical Inquiry* 16 (Winter 1990): 372.

25. See Simon Schama, *Landscape and Memory* (New York: Knopf, 1995), 7–10; and William Cronon, *Uncommon Ground*, 24–25. Both emphasize that intense alteration of landscape is not a modern phenomenon and that what is considered natural often looks so because of past cultivation.

26. A partial list includes John Barrell's influential work on British painting, *The Dark Side of Landscape* (Cambridge: Cambridge University Press, 1980), exposing the workings of social class underlying depictions of the English pastoral. Other works on British landscape include David Solkin, *Richard Wilson: The Landscape of Reaction* (London: Tate Gallery, 1982); Simon Pugh, ed., *Reading Landscape: Country-City-Capital* (Manchester: Manchester University Press, 1990); Ann Bermingham, *Landscape and Ideology: The English Rustic Tradition, 1740–1860* (Berkeley and Los Angeles: University of California Press, 1986); Andrew Hemingway, *Landscape Imagery and Urban Culture in Early Nineteenth-Century Britain* (Cambridge: Cambridge University Press, 1992). The following on American landscape have also linked myths, spirituality, and aesthetics with

political and economic developments: Barbara Novak, *Nature and Culture: American Landscape and Painting* (New York: Oxford University Press, 1980, 1995); Albert Boime, *The Magisterial Gaze: Manifest Destiny and American Landscape Painting* (Washington, D.C.: Smithsonian Institution Press, 1991); Thomas Gaehtgens and Heinz Ickstadt, eds., *American Icons: Transatlantic Perspectives on Eighteenth- and Nineteenth-Century American Art* (Santa Monica, Calif.: Getty Center for the History of Art and the Humanities, 1992); Angela Miller, *The Empire of the Eye: Landscape Representation and American Cultural Politics, 1825–1875* (Ithaca: Cornell University Press, 1993); David C. Miller, ed., *American Iconology: New Approaches to Nineteenth-Century Art and Literature* (New Haven: Yale University Press, 1993). Other studies have mingled past and present landscapes, and cultural and personal histories: Kent Ryden, *Mapping the Invisible Landscape: Folklore, Writing, and the Sense of Place* (Iowa City: University of Iowa Press, 1993); Simon Schama, *Landscape and Memory* (New York: Knopf, 1995).

27. Jackson, *Discovering the Vernacular Landscape*, xii.

28. Ibid., 142.

29. Spirn, *Language of Landscape*, 15, 19, 27.

30. Ralph Waldo Emerson, "Nature," *Complete Works of Ralph Waldo Emerson* (Boston: Houghton Mifflin, 1903), 1:26; "The Poet," *Complete Works of Ralph Waldo Emerson* 3:13.

31. Spirn, *Language of Landscape*, 32.

32. Henry David Thoreau, *Walden*, introd. and annotations by Bill McKibben (Boston: Beacon, 1997), 148.

33. Spirn, *Language of Landscape*, 23.

34. Mitchell, "Imperial Landscape," 2.

35. Cronon, *Uncommon Ground*, 46.

36. Carolyn Merchant, *The Death of Nature: Women, Ecology and the Scientific Revolution* (San Francisco: Harper, 1989), xv.

37. Jocelyn Bartkevicius and Mary Hussmann, "A Conversation with Terry Tempest Williams," *Iowa Review* 27, no. 1 (Spring 1997): 7.

38. Williams with Bartkevicius and Hussmann, 12. Also see Williams, *Refuge: An Unnatural History of Family and Place* (New York: Vintage, 1992) and *Desert Quartet* (New York: Pantheon, 1995).

39. Lorraine Anderson, Preface, to *Sisters of the Earth*, ed. Lorraine Anderson (New York: Vintage, 1991), xvii.

40. Merchant, *Death of Nature*, xix.

41. Annette Kolodny, *The Lay of the Land: Metaphor as Experience and History in American Life and Letters* (Chapel Hill: University of North Carolina Press, 1975).

42. Carolyn Merchant, "Reinventing Eden," in *Uncommon Ground*, ed. Cronon, 145.

43. Thoreau, *Walden*, 85.

44. Stephen Crane, "The Open Boat," in *Tales of Adventure*, ed. Fredson Bowers (Charlottesville: University Press of Virginia, 1970), 73.

45. Paul Shepard, "Virtually Hunting Reality in the Forests of Simulacra," in *Reinventing Nature? Responses to Postmodern Deconstruction*, ed. Michael E. Soulé and Gary Lease (Washington, D.C.: Island Press, 1995), 20.

46. Kemal and Gaskell, "Nature, Fine Arts, and Aesthetics," 3.

47. John Hay, "The Nature Writer's Dilemma," in *On Nature: Nature, Landscape, and Natural History*, ed. David Halpern (San Francisco: North Point, 1987), 7.

48. Kemal and Gaskell, "Nature, Fine Arts, and Aesthetics," 4.

49. Steven Vogel, *Against Nature: The Concept of Nature in Critical Theory* (Albany: State University of New York Press, 1996), 1, 7, 5–6.

50. Eric Katz, *Nature as Subject: Human Obligation and Natural Community* (Lanham, Md.: Rowman and Littlefield, 1997), 67, 72. Katz makes these statements in response to Anthony Weston's "Beyond Intrinsic Value: Pragmatism in Environmental Ethics," *Environmental Ethics* 7 (1985): 321–39. For further discussion of philosophical approaches to the environment, see the other essays in Katz's *Nature as Subject,* as well as *Landscape, Natural Beauty, and the Arts*, ed. Salim Kemal and Ivan Gaskell (1995), and *Journal of Aesthetics and Art Criticism* 56, no. 2 (Spring 1998).

51. Jhan Hochman, "Green Cultural Studies: An Introductory Critique of an Emerging Discipline," *Mosaic* 30, no. 1 (March 1997), 84, 85.

52. Cronon, *Uncommon Ground*, 20, 21.

53. Ibid., 87.

54. Don Scheese, *Nature Writing: The Pastoral Impulse in America* (New York: Twayne, 1996), 55.

55. Barry Lopez, "Renegotiating the Contracts," in *This Incomperable Lande: A Book of American Nature Writing*, ed. Thomas J. Lyon (New York: Penguin, 1989), 383.

56. Yi-fu Tuan, *Topophilia: A Study of Environmental Perception, Attitudes, and Values* (New York: Columbia University Press, 1990), xi.

57. Henry David Thoreau, *The Maine Woods*, ed. Joseph J. Moldenhauer (Princeton: Princeton University Press, 1972), 71. See Cronon, "The Trouble with Wilderness," on Thoreau's affinity with European literary sublimity (*Uncommon Ground*, 74–75); see Scheese on Thoreau's revisions of the Katahdin passage, possibly to broaden his audience with a "potboiler passage" (*Nature Writing*, 54).

58. Lawrence Buell, *The Environmental Imagination: Thoreau, Nature Writing, and the Formation of American Culture* (Cambridge: Harvard University Press, 1995), 2.

59. Jack Turner, "The Abstract Wild," in *On Nature's Terms*, ed. Thomas Lyon and Peter Stine (College Station: Texas A&M University Press, 1992), 89.

60. Rebecca Solnit, *As Eve Said To The Serpent: On Landscape, Gender, and Art* (Athens: University of Georgia Press, 2001), 2.

61. Carolyn Merchant, "Reinventing Eden," in *Uncommon Ground*, ed. Cronon, 133.

62. See Merchant, *Death of Nature*, 152–55.

63. Thomas Lyon, *On Nature's Terms*, 3. Also see Merchant, "Reinventing Eden," on the "disenchantment of the world" and on the environmental crisis that leads to "endism" (154–55).

64. Merchant, *Death of Nature*, 154.

65. Ibid., 156, 158.

66. *FCP*, 116.

2. Rustic Sophistication: Lionizing Winslow Homer, Defending Robert Frost (pp. 28–57)

1. Jay Parini, *Robert Frost: A Life* (New York: Holt, 1999), 434–35.

2. For examples, see the covers of Suzanne Juhasz, *Reading From the Heart: Women Readers, Women Writers, and the Story of True Love* (New York: Viking, 1995) with a section of Homer's *The New Novel* (1877), which depicts a girl lying on her side reading, and Marcia Jacobson, *Being a Boy Again: Autobiography and the American Boy Book* (Tuskaloosa: University of Alabama Press, 1995), based on *Raid on a Sand Swallow Colony* (1874) showing young boys on a seaside cliff.

3. "For Once, Then, Something," *FCP*, 208.

4. William Howe Downes, *The Life and Works of Winslow Homer* (1911; New York: Dover, 1989), 3.

5. Samuel Isham, *The History of American Painting* (New York: MacMillan, 1905; new ed., 1927), 3.

6. S. G. W. Benjamin, *Art in America*, ed. H. Barbara Weinberg (1880; New York: Garland, 1976), 117.

7. Examples of such paintings are *The Noon Recess* (1873), *Backgammon Game* (1877), and *A Visit from the Old Mistress* (1876).

8. Downes, *Life and Works of Winslow Homer*, 11.

9. Quoted from New York *Art Journal* 4 (August 1878), 226, in Natalie Spassky, *American Paintings in the Metropolitan Museum of Art* (Princeton: The Metropolitan Museum of Art, with Princeton University Press, 1985), 2:430.

10. Lecture citations from my notes, 14 October 1995.

11. *Four American Painters: George Caleb Bingham, Winslow Homer, Albert P. Ryder, Thomas Eakins* (1935; New York: Museum of Modern Art, 1969), 6, 7. Commentary on Homer was written by Alfred H. Barr, Jr., director of trustees, and Frank Jewett Mather, Jr.

12. Robert Crunden, *American Salons: Encounters with European Modernism, 1885–1917* (New York: Oxford University Press, 1993), xi–xii, xiii.

13. See Edward Lucie-Smith: "realism was increasingly forced to the margin during the 1940s and 1950s, and has not been fully rehabilitated today," *American Realism* (New York: Abrams, 1994), 16.

14. Clement Greenberg, *Art and Culture: Critical Essays* (Boston: Beacon, 1961), 184–85.

15. Sarah Burns, *Inventing the Modern Artist: Art and Culture in Gilded Age America* (New Haven: Yale University Press, 1996), 44.

16. Quoted in Bruce Robertson, *Reckoning with Winslow Homer: His Late Paintings and Their Influence* (Bloomington: Cleveland Museum of Art, with Indiana University Press, 1990), 77.

17. Burns, *Inventing the Modern Artist*, 189; Robertson, *Reckoning with Winslow Homer*, 77.

18. Homer's 1901–3 letters to galleries about *High Cliff, Coast of Maine* indicate the difficulty of sorting out the painter's motives. His focus and tone could suggest practicality, desire for financial success and reputation, and disappointment that work he values in unknown ways is not well received. He wrote to Knoedler's in New York, "I think if it will not sell there is little use in my putting out any more things." When the painting was displayed at O'Brien's in Chicago, he commented, "Why do you not sell that 'High Cliff' picture? I cannot do better than that. Why should I paint?" Quoted in Nicolai Cikovsky, Jr., and Franklin Kelly, *Winslow Homer* (Washington, D.C., and New Haven: National Gallery and Yale University Press, 1995), 327.

19. Bruce Robertson, *Reckoning with Winslow Homer: His Late Paintings and Their Influence* (Bloomington: Cleveland Museum of Art with Indiana University Press, 1990), 1.

20. Nicolai Cikovsky, Jr., *Winslow Homer* (New York: Abrams, 1990), 7–8.

21. Lawrence Levine, *Highbrow/Lowbrow: The Emergence of Cultural Hierarchy in America* (Cambridge: Harvard University Press, 1988), 233–35.

22. Quoted in Sarah Burns, *Pastoral Inventions: Rural Life in Nineteenth-Century American Art and Culture* (Philadelphia: Temple University Press, 1989), 218–19.

23. Henry James, *Roderick Hudson* (New York: Harper, 1960), 24.

24. Ibid., 31, 39.

25. Kenyon Cox, *What is Painting? "Winslow Homer" and Other Essays* (New York: Norton, 1988), 22.

26. Ibid., 21.

27. Burns, *Pastoral Inventions*, 219–20.

28. See Peter J. Schmitt, *Back to Nature: The Arcadian Myth in Urban America* (1969; Baltimore: Johns Hopkins University Press, 1990), xvii–xxiii.

29. Robertson, *Reckoning with Winslow Homer*, 11.

30. John Wilmerding suggests that Homer's English figures may reflect the unacknowledged influence of Pre-Raphaelite art and possibly of the Elgin Marbles in the British Museum. Wilmerding, *Winslow Homer* (New York: Praeger, 1972), 132–33.

31. See Philip Beam, *Winslow Homer at Prout's Neck* (Boston: Little, Brown, 1966), 19; Cikovsky, *Winslow Homer* (New York: Abrams, 1990), 58; Robertson, *Reckoning with Winslow Homer*, 11 12.

32. Robertson, *Reckoning with Winslow Homer*, 12.

33. To Leon Kroll, quoted in ibid., 173 n. 26.

34. Quoted in Wilmerding, *Winslow Homer*, 135.

35. Quoted in Burns, *Inventing the Modern Artist*, 187. Also see Ann Douglas, *The Feminization of American Culture* (New York: Knopf, 1977) on the definition and fear of the "feminine."

36. William A. Coffin, "A Painter of the Sea," *Century Magazine* 58, no. 5 (September 1899): 653.

37. Homer Saint-Gaudens, *Critic* 46, no. 4 (April 1905): 323.

38. Milton W. Brown, *American Painting From the Armory Show to the Depression* (Princeton: Princeton University Press, 1972), 83.

39. Quoted in Robertson, *Reckoning with Winslow Homer*, 177 n. 14.

40. Lloyd Goodrich, *Winslow Homer* (New York: Whitney Museum of American Art, 1973), 39.

41. H. Barbara Weinberg, "Thomas B. Clarke: Foremost Patron of American Art from 1872 to 1899," *American Art Journal* 8, no. 1 (May 1976): 52, 54.

42. Lois Marie Fink notes that "virility" in nineteenth-century art criticism is matched with an artistic "approach based on the exterior, material world, on 'realist' art rather than on subjective expressions of form and feeling"; this "chauvinistic criticism" is most pronounced with reactions to Homer as "an artist whose works were entirely native products." Lois Marie Fink, *American Art at the Nineteenth-Century Paris Salons* (Cambridge: Cambridge University Press, 1990), 287.

43. See Burns on the professionalism of the era and on the atavistic faith in the artist's independence (*Inventing the Modern Artist*, 42, 1–7).

44. See Cikovsky and Kelly, *Winslow Homer*, 329.

45. Bruce Robertson writes that in the painting Homer "de-humanized" his home and offered a vision of human correspondence to nature that was "an uncomfortable one" compared with that offered by Transcendentalists (*Reckoning with Winslow Homer*, 133).

46. Quoted in Cikovsky and Kelly, *Winslow Homer*, 329.

47. Quoted in Parini, *Robert Frost*, 7.

48. Quoted in ibid., 20.

49. William H. Pritchard, *Frost: A Literary Life Reconsidered,* 2d ed. (Amherst: University of Massachusetts Press, 1993), unpaginated preface.

50. Seamus Heaney, "Above the Brim: On Robert Frost," *Salmagundi* 88–89 (Fall 1990–Winter 1991): 275.

51. The volumes are *Robert Frost: The Early Years, 1874–1915* (1966); *Robert Frost: The Years of Triumph, 1915–1938* (1970); and with R. H. Winnick, *Robert Frost: The Later Years, 1938–1963* (1976).

52. Joseph Brodsky, "On Grief and Reason," *New Yorker*, 27 September 1994, 70.

53. Derek Walcott, "The Road Taken," *New Republic*, 27 November 1995, 30.

54. Thinking of Frost as divided or as employing several personas has become commonplace in criticism since Randall Jarrell's essay "The Other Frost" (included in *Poetry and the Age* [New York: Octagon, 1972], 28–36). Also see William Logan on the dual characterization of the poet, "The other other Frost," *New Criterion*, June 1995, 21–34.

55. Lionel Trilling, "A Speech on Robert Frost: A Cultural Episode," in *Robert Frost: A Collection of Critical Essays*, ed. James M. Cox (Englewood Cliffs, N.J.: Prentice-Hall, 1962), 156–57.

56. Frank Lentricchia, *Robert Frost: Modern Poetics and the Landscapes of Self* (Durham: Duke University Press, 1975), 3; Lentricchia, *Modernist Quartet* (New York: Cambridge University Press, 1994), 76. Robert Kern, "Frost and Modernism," in *On Frost: The Best from* American Literature, ed. Edwin H. Cady and Louis J. Budd (Durham: Duke University Press, 1991), 195. John Hollander, foreword to *Robert Frost: The Work of Knowing*, by Richard Poirier (Stanford: Stanford University Press, 1990), xi, xii. Richard Poirier, *Poetry and Pragmatism* (Cambridge: Harvard University Press, 1992), 167. William Pritchard, *Frost: A Literary Life Reconsidered* (Amherst: University of Massachusetts Press, 1993), unpaginated preface.

57. Sidney Cox, *Robert Frost: Original "Ordinary Man"* (New York: Holt, 1923), 5.

58. Louis Untermeyer, *American Poetry Since 1900* (New York: Holt, 1923), 7–8.

59. Mark Richardson, *The Ordeal of Robert Frost: The Poet and His Poetics* (Urbana: University of Illinois Press, 1997), 4.

60. Royal Cortissoz, *American Artists* (1923; reprint, Freeport, N.Y.: Books for Libraries Press, 1970), 119.

61. H. Wayne Morgan, *New Muses: Art in American Culture, 1865–1920* (Norman: University of Oklahoma Press, 1978), 158.

62. I am indebted here to Frank Lentricchia's discussion of the anthology in "The Resentments of Robert Frost," in *On Frost*, ed. Cady and Budd, 225.

63. See Katherine Kearns, *Robert Frost and a Poetics of Appetite*, for a discussion, informed by postmodern readings of language and sexuality, of "masculine" control but also "feminine" impulses and a "feminized" poetics in Frost's

poetry. Still, unlike much modern poetry, Frost's did not graphically assault middle-class sexual mores.

64. Cox, *Robert Frost*, 6, 8.

65. Frost's remark to his son is in Lawrence Thompson, ed., *Selected Letters of Robert Frost* (New York: Holt, 1964), 390. For further discussion of gender issues, see Mark Richardson's discussion of "Muscular Poetics," *Ordeal of Robert Frost*, 29–55. Also see Frank Lentricchia, "The Resentments of Frost": Lentricchia views Frost as turning away from a genteel feminized tradition and seeking "a skeptical and even scoffing masculinized audience" (232). And see James R. Dawes, "Masculinity and Transgression in Robert Frost," for an examination of homosocial relations in the poetry and responses to "threats to sexual masculinity" in "Masculinity and Transgression in Robert Frost," *American Literature* 65 (June 1993): 297–312.

66. Amy Lowell, *Tendencies in Modern American Poetry* (1917; New York: Octagon, 1971), 85.

67. Cox, *Robert Frost*, 8.

68. Lowell, *Tendencies in Modern American Poetry*, 135.

69. Quoted in Linda Wagner, ed., *Robert Frost: The Critical Reception* (New York: Burt Franklin, 1977), 17.

70. Lentricchia, *Modernist Quartet*, 71.

71. See Tyler Hoffman on "the close connections between Frost and the London literary avant-garde during his residency in England," *Robert Frost and the Politics of Poetry* (Hanover, N.H.: Middlebury College / University Press of New England, 2001), 6.

72. Sarah Burns, "Revitalizing the 'Painted-Out' North: Winslow Homer, Manly Health, and New England Regionalism in Turn-of-the-Century America" *American Art* 9, no. 2 (Summer 1995): 22–23, 35.

73. I am indebted here to Karen Kilcup's discussion of Frost in context of "the tradition of woman-authored New England regionalist fiction." Kilcup traces similarities in the techniques and thematic sympathies of the women writers and Frost; she also notes how critics sought to elevate Frost by distancing him from regionalist "limitations" in *Robert Frost and Feminine Literary Tradition* (Ann Arbor: University of Michigan Press, 1998), 61–64.

74. Paul Alpers, *What is Pastoral?* (Chicago: University of Chicago Press, 1996), ix, 317.

75. Leo Marx, "Pastoralism in America," in *Ideology and Classic American Literature*, ed. Sacvan Bercovitch and Myra Jehlen (New York: Cambridge University Press, 1986), 38, 44, 66.

76. Joseph Brodsky, Seamus Heaney, and Derek Walcott, *Homage to Robert Frost* (New York: Farrar, Straus, and Giroux, 1996).

77. Pritchard, *Frost*, 201–2.

78. Hollander, foreword to Poirier, *Robert Frost*, xii.

79. Jonathan Barron at the 1999 Middlebury Frost Conference noted these references to Frost; similar examples were provided by other Frost scholars during a panel on his celebrity.

80. Quoted in Poirier, *Robert Frost*, 228.

81. Quoted in Lentricchia, *Modernist Quartet*, 68. I am indebted to Lentricchia's discussion of the economic climate for poetry in the chapter, "Lyric in the Culture of Capital" (47–76).

82. Pritchard (*Frost*, 70) and Lentricchia (*Modernist Quartet*, 70–71) both propose that Frost's subtleties and indirectness partly result from his attempt to reach casual readers of poetry and intellectuals (the latter usually decided the canon).

83. Some of the most recent include Pritchard's *Frost* (1984, 1993), emphasizing Frost's guardedness and the pain he endured because of his family's suffering. Frost's granddaughter, Lesley Lee Francis, claims she had resolved "not to write about someone, anyone, in the immediate family," but was compelled to respond to Thompson's "single-minded interpretation." *The Frost Family's Adventure in Poetry: Sheer Morning Gladness at the Brim* (Columbia: University Press of Missouri, 1994) is her sympathetic reconstruction of her grandparents' early years at Derry, portraying the imaginative vitality of the family. Jeffrey Meyers, *Robert Frost: A Biography* (Boston: Houghton Mifflin, 1996) spices up the debate with the assertion that Thompson's work was compromised because biographer and poet were simultaneously having affairs with Kathleen Morrison. Jay Parini, in *Robert Frost*, hopes to set "the record straight here and there" and strives to balance Frost's difficulties with his humor, attentiveness to family, and "immense fortitude."

84. *FCP*, 753–54.

3. Power and Impotence: The Black Figure and the Prey in Winslow Homer's Outdoors (pp. 58–95)

1. *FCP*, 274.

2. See David Tatham, *Winslow Homer in the Adirondacks* (Syracuse: Syracuse University Press, 1996), on Homer's participation in the North Woods Club and on the typical clientele of the club (102–7).

3. William Howe Downes, *The Life and Works of Winslow Homer* (1911; New York: Dover, 1989), 5–6.

4. Quoted in Sarah Burns, *Inventing the Modern Artist: Art and Culture in Gilded Age America* (New Haven: Yale University Press, 1996), 188.

5. See Burns, *Inventing the Modern Artist*, 187–217, and Bruce Robertson, *Reckoning with Winslow Homer: His Late Paintings and Their Influence* (Bloomington: Cleveland Museum of Art with Indiana University Press, 1990), 63–80.

6. Burns, *Inventing the Modern Artist*, 199, 217.

7. Carol Vogel, "Sale of Homer Seascape Sets Record,"*New York Times*, 5 May 1998, A14.

8. Quoted in Nicolai Cikovsky, Jr., and Franklin Kelly, *Winslow Homer* (New Haven: Yale University Press, 1995), 230.

9. See Lynda Roscoe Hartigan, *Sharing Traditions: Five Black Artists in Nineteenth-Century America* (Washington, D.C.: Smithsonian, 1985), on the status of Tanner's biblical paintings, 106.

10. Quoted in Frances K. Pohl, "Black and White in America," in *Nineteenth Century American Art: A Critical History*, ed. Stephen F. Eisenman (London: Thames and Hudson, 1994), 186.

11. See Pohl for further discussion of these artists in Europe and America (ibid., 180–87).

12. Ann du Cille further adds that "it often seems to take the interest and intervention of white scholars to legitimize and institutionalize African American history and literature: "The Occult of True Black Womanhood: Critical Demeanor and Black Feminist Studies," *Signs: Journal of Women in Culture and Society* 19, no. 3 (Spring 1994): 598.

13. See Mary Ann Calo on the conventionality of Homer's early black figures and also on his departure from convention in what Calo labels a "pivotal work," *At the Cabin Door* (1865–66), in which a black woman is central as she anxiously watches Union prisoners being led away, "Winslow Homer's Visits to Virginia During Reconstruction" *American Art Journal* 12 (Winter 1980): 5–9.

14. Guy C. McElroy, *Facing History: The Black Image in American Art, 1710–1949* (San Francisco: Bedford Arts in association with Corcoran Gallery of Art, 1990), xix.

15. See Steven Adams, *The Barbizon School and The Origins of Impressionism* (London: Phaidon, 1994), 142–54; and Peter Bermingham, *American Art in the Barbizon Mood* (Washington, D.C.: Smithsonian Institution, 1975), 14.

16. Bermingham, *American Art in the Barbizon Mood*, 13.

17. Downes, *Life and Works of Winslow Homer*, 12–13.

18. Adams, *The Barbizon School*, 174.

19. Ibid.

20. Bermingham, *American Art in the Barbizon Mood*, 80, 78.

21. Isham quoted in Bermingham, *American Art in the Barbizon Mood*, 78. Kenyon Cox, *What is Painting? "Winslow Homer" and Other Essays* (1914; New York: Norton, 1988), 21.

22. Michael Quick, "Homer in Virginia," *Los Angeles County Museum Art Bulletin* 24 (1978): 61, 69, 71, 66, 62.

23. Frances Pohl, "Putting a Face on Difference," *Art Bulletin* 28, no. 4 (December 1996): 621.

24. Pohl, "Black and White in America," 174–75.

25. Downes, *Life and Works of Winslow Homer*, 86–87.

26. Pohl, "Putting a Face on Difference," 621.

27. Quick, "Homer in Virginia," 74.

28. Again, see Calo for an account of alterations and restoration of *Upland Cotton* and of the negative reception ("Winslow Homer's Visits," 22–24).

29. Quoted in ibid., 24.

30. *New York Times,* 30 March 1879, 6.

31. *New York Times*, 12 March 1880, 5.

32. For a similar reading of the expressions, see Peter Wood and Karen Dalton, *Winslow Homer's Images of Blacks: The Civil War and Reconstruction Years* (Austin: University of Texas Press, 1988), 97.

33. The book by Pat McKissack, *A Picture of Freedom: The Diary of Clotee, a Slave Girl* (New York: Scholastic, 1997), is part of a fictionalized historical series, "Dear America," featuring adolescent girls as protagonists.

34. bell hooks, *Art on My Mind: Visual Politics* (New York: New Press, 1995), 203–5.

35. See Cikovsky and Kelly on the "disruption of narrative" in this painting and on the differences from the engraving *Watermelon-Eaters* (*Winslow Homer*, 249–50).

36. Quoted in *Collected Black Women's Narratives*, introd. by Anthony G. Barthelemy; foreword by Henry Louis Gates, Jr. (New York: Oxford University Press, 1988), vii, xiv.

37. W. E. B. Du Bois, *The Souls of Black Folk* in *The Oxford W. E. B. Du Bois Reader*, ed. Eric J. Sundquist (New York: Oxford University Press, 1996), 164.

38. Henry Louis Gates, Jr., "The Face and Voices of Blackness," in McElroy, *Facing History*, 18.

39. Lawrence's panels and texts are reproduced in *Jacob Lawrence: The Migration Series*, ed. Elizabeth Hutton Turner (Washington, D.C.: Rappahannock, 1993).

40. See Cikovsky and Kelly on the painting's purchase (*Winslow Homer*, 150).

41. See Lloyd Goodrich, *Winslow Homer* (New York: Braziller, 1944), 30; and Peter Wood and Karen Dalton, *Winslow Homer's Images of Blacks: The Civil War and Reconstruction Years*, 13.

42. John Wilmerding, "Winslow Homer's Maine," *Winslow Homer in the 1890s: Prout's Neck Observed* (New York: Hudson Hills, 1990), 92–93.

43. William Howe Downes applied this phrase to *The Gulf Stream* (*Life and Works of Winslow Homer*, 133).

44. See Bruce Robertson on Homer's increasingly abstract composition (*Reckoning with Winslow Homer*, 25).

45. Toni Morrison, *Playing in the Dark: Whiteness and the Literary Imagination* (Cambridge: Harvard University Press, 1992), 37, 13.

46. Downes, *Life and Works of Winslow Homer*, 9–10, 97.

47. Wilmerding, "Winslow Homer's Maine," 86.

48. Homer Saint-Gaudens, "Winslow Homer," *The Critic* (April 1905): 322–23.

49. Jules Prown, *American Painting: From Its Beginnings to the Armory Show* (1969; New York: Rizzoli, 1980), 310.

50. Quoted in Natalie Spassky, *American Paintings in the Metropolitan Museum of Art* (Princeton: The Metropolitan Museum of Art with Princeton University Press, 1985), 2:485.

51. Wilmerding, "Winslow Homer's Maine," 92–93.

52. Jules Prown, "Winslow Homer in His Art," *Smithsonian Studies in American Art* 1 (Spring 1987): 31.

53. Nicolai Cikovsky, Jr., "Homer Around 1900," *Studies in the History of Art* 26 (1990): 133.

54. Cikovsky and Kelly, *Winslow Homer*, 370. The exhibition, which garnered much attention for Homer, was held at the National Gallery of Art, Washington, D.C. (15 October 1995–28 January 1996); Museum of Fine Arts, Boston (21 February–26 May 1996); and The Metropolitan Museum of Art, New York (20 June–22 September 1996).

55. Cikovsky, "Homer Around 1900," 137, 140, 152; Cikovsky and Kelly, *Winslow Homer*, 369–71.

56. Morrison, *Playing in the Dark*, 6, 68, 66.

57. Cikovsky also suggests a "close resemblance" between *The Gulf Stream*, Delacroix's *Barque of Dante* (1822) and Thomas Cole's *Voyage of Life* (1840), enhancing allegorical readings of the voyage through life to death (Cikovsky and Kelly, *Winslow Homer*, 369–70).

58. Hugh Honour, "Slaves and Liberators," in *The Image of the Black in Western Art: From the American Revolution to World War I*, (Cambridge: Menil Foundation with Harvard University Press, 1989), 4: pt. 1, 120.

59. Ibid., 39. Also see Albert Boime, *The Art of Exclusion: Representing Blacks in the Nineteenth Century* (Washington, D.C.: Smithsonian Institution, 1990), for a discussion of the political views of Copley and Watson and the eighteenth-century debate on the rights of blacks (15–46).

60. Of the fifteen that were rescued, five died soon after. For an account of the incident and of the painting's evolution, see Lorenze E. A. Eitner, *Géricault: His Life and Work* (London: Orbis, 1983), 158–201.

61. Honour, "Slaves and Liberators," 120, 119.

62. Ibid., 164.

63. Quoted in McElroy, *Facing History*, xxix.

64. Alain Locke, *Negro Art: Past and Present* (1936; New York: Arno, 1969), 46.

65. Barbara Novak, *American Painting of the Nineteenth Century: Realism, Idealism, and the American Experience* (New York: Praeger, 1969), 187.

66. Roger B. Stein, *Seascape and the American Imagination* (New York: C. N.

Potter, 1975), 112. Stein has moved away from formalism in evaluating Homer: in a 1990 review of exhibitions, he called for recontexualization of Homer with greater awareness of "the production of art as a signifying practice"; "Winslow Homer in Context," *American Quarterly* 42, no. 1 (March 1990): 76.

67. Spassky, *American Paintings*, 486; Mary Judge, *Winslow Homer* (New York: Crown, 1986), 82.

68. Cikovsky and Kelly point out the "tomb-like" character of the hatch (*Winslow Homer*, 383).

69. Spassky, *American Paintings*, 483.

70. Cikovsky and Kelly, *Winslow Homer*, 301. Also see Cikovsky, "Winslow Homer's Unfinished Business," *Studies in the History of Art* 37 (1990). Cikovsky argues that the heroic works of the 1880s are "traditionalist art," "the most conventionally invented and executed, and finds other paintings with ambiguous narratives and moods more intriguing (93–117).

71. Peter Wood, "Waiting in Limbo: A Reconsideration of Winslow Homer's *The Gulf Stream*," in *The Southern Enigma: Essays on Race, Class, and Folk Culture*, ed. Walter J. Fraser, Jr., and Winfred B. Moore, Jr. (Westport, Conn.: Greenwood, 1983), 78, 81.

72. Boime, *Art of Exclusion*, 38.

73. Du Bois, *The Souls of Black Folk*, 100, 206, 106. Boime provides further examples of the "association of blacks and 'shipwreck' " (40–41).

74. Quoted in Spassky, *American Paintings*, 482–83.

75. Wood and Dalton, *Winslow Homer's Images of Blacks*, 16–22.

76. William C. Church, "A Midwinter Resort," *Century Magazine* 33, no. 4 (February 1887), 500.

77. Ibid., 506.

78. William Henn, "Caught on a Lee Shore," *Century Magazine* (June 1893); reprinted in *Tales of Old Florida*, ed. Frank Oppel and Tony Meisel (Secaucus, N.J.: Castle, 1987), 200.

79. Cikovsky, "Homer Around 1900," 35.

80. Quoted in Spassky, *American Paintings*, 484.

81. From a letter to M. O'Brien & Son, picture dealers in Chicago, in which Homer suggests selling *The Gulf Stream* to a "public gallery"; quoted in Downes, *Life and Works of Winslow Homer*, 149.

82. For income estimates, see Nell Painter, *Standing at Armageddon: The United States, 1877–1919*, xxiii. For accounts of the painting's exhibitions and purchase, see Spassky, *American Paintings*, 483–5; Patti Hannaway, *Winslow Homer in the Tropics* (Richmond, Va.: Westover, 1973), 169; Downes, *Life and Works of Winslow Homer*, 134–35.

83. Quoted in Spassky, *American Paintings*, 485.

84. Downes, *Life and Works of Winslow Homer*, 134–35. Also see Hannaway, *Winslow Homer in the Tropics*, 169; and Philip Beam, *Winslow Homer at Prout's Neck* (Boston: Little, Brown, 1966), 170.

85. Helen A. Cooper, *Winslow Homer Watercolors* (New Haven: Yale University Press, 1986), 215.

86. Stephen Crane, *Tales of Adventure*, ed. Fredson Bowers (Charlottesville: University Press of Virginia, 1970), 70.

87. Morrison, *Playing in the Dark*, 39.

88. Painter, *Standing at Armageddon*, 139.

89. Henry Adams, *The Education of Henry Adams*, ed. Ernest Samuels (Boston: Houghton Mifflin, 1973), 3.

90. Morrison, *Playing in the Dark*, 15.

91. My comments here are influenced by Morrison's *Playing in the Dark* and by Shelley Fisher Fishkin, "Interrogating 'Whiteness,' Complicating 'Blackness': Remapping American Culture," *American Quarterly* 47, no. 3 (September 1995): 482–66. In that essay, Fishkin reviews the influence of Morrison's book and the pertinence of Ralph Ellison's emphasis on "the true interrelatedness of blackness and whiteness" in academic discourse on race.

92. Peter J. Schmitt, *Back to Nature: The Arcadian Myth in Urban America* (1969: Baltimore: Johns Hopkins University Press, 1990), 10.

93. David Tatham, *Winslow Homer in the Adirondacks* (Syracuse: Syracuse University Press, 1996), 117, 128.

94. Quoted in Stephen Deuchar, *Sporting Art in Eighteenth-Century England: A Social and Political History* (New Haven: Yale University Press, 1988), 19.

95. Cikovsky and Kelly pair *A Good Shot* with the Currier and Ives lithograph *The Death Shot*, which also has gunsmoke in the background but carries further the romantic convention of a noble animal shot down in his glory (*Winslow Homer*, 263).

96. Tatham, *Winslow Homer in the Adirondacks*, 117.

97. Downes, *Life and Works of Winslow Homer*, 245.

98. Cikovsky and Kelly, *Winslow Homer*, 374.

99. John Berger, *About Looking* (New York: Pantheon, 1980), 2, 4.

100. Ibid., 14, 15.

101. Schmitt, *Back to Nature*, 13.

102. Christopher Reed, "The Artist and the Other: The Work of Winslow Homer," *Yale University Art Gallery Bulletin* 40, no. 3 (Spring 1989): 69.

4. The Hick on the Hillside, The Woman at the Window: Frost's Rustics (pp. 96–132).

1. *FCP*, 111.

2. *FCP*, 668, 678, 684, 888.

3. Edward Lathem, ed., *Interviews with Robert Frost* (New York: Holt, 1966), 9–10, 15.

4. *FCP*, 756–57.

5. The first two phrases, previously quoted, are Brodsky's and Derek Walcott's. The third is William Logan's in "The other other Frost," *New Criterion*, June 1995: 21.

6. Seamus Heaney, "Above the Brim: On Robert Frost," *Salmagundi* 88–89 (Fall 1990–Winter 1991): 88–89.

7. Quoted in Hal S. Barron, *Those Who Stayed Behind: Rural Society in Nineteenth-Century New England* (New York: Cambridge University Press, 1984), 33.

8. David Danbom, *Born in the Country: A History of Rural America* (Baltimore: Johns Hopkins University Press, 1995), 151.

9. David Danbom, *Resisted Revolution: Urban America and the Industrialization of Agriculture, 1900–1930* (Ames: Iowa State University Press, 1979) 24; *Born in the Country*, 175.

10. Joe Klein, "The Campaign: Barnyard Platitudes," *New Yorker* 24 January 2000, 30.

11. I am indebted here to the argument throughout Sarah Burns, *Pastoral Inventions: Rural Life in Nineteenth-Century American Art and Culture* (Philadelphia: Temple University Press, 1989), 7, 216.

12. Quoted in Jayne Kribbs, *Critical Essays on John Greenleaf Whittier* (Boston: G. K. Hall, 1980), 41–42.

13. See Karen Kilcup, *Robert Frost and Feminine Literary Tradition* (Ann Arbor: University of Michigan Press, 1998), 80–101.

14. Barron, *Those Who Stayed Behind*, 30.

15. *FCP*, 755.

16. David Bromwich, *A Choice of Inheritance: Self and Community from Edmund Burke to Robert Frost* (Cambridge: Harvard University Press, 1989), 221.

17. *FCP*, 45–49.

18. See Laurence Perrine, "Frost's 'The Mountain,' " *Concerning Poetry* 4 (Spring 1971): 9.

19. *FCP*, 633–35.

20. Henry David Thoreau, *Walden* (Boston: Beacon, 1997), 77.

21. Perrine, "Frost's 'The Mountain,' " 5.

22. *FCP*, 684–85.

23. *FCP*, 690–91, 693.

24. Quoted in Helen Nearing, *Wise Words on the Good Life* (New York: Shocken, 1980), 48.

25. See Katherine Kearns, who emphasizes the identification of women with irrational, impulsive "nature" and men with control and rationality, *Robert Frost and a Poetics of Appetite* (New York: Cambridge University Press, 1995). She presents a convincing case with several poems. However, I find the portrayal of "female" nature more diversified. Also see Robert Faggen on women "exercising control," *Robert Frost and the Challenge of Darwin* (Ann Arbor: University of Michigan Press, 1997), 188.

26. Justin Kaplan, ed., *Walt Whitman: Complete Poetry and Collected Prose* (New York: Library of America, 1982), 197.

27. R. W. Franklin, ed., *The Poems of Emily Dickinson*, reading ed. (Cambridge: Harvard University Press, 1999), 215.

28. *FCP*, 55–58.

29. William Cullen Bryant, "Thanatopsis," in *Norton Anthology of American Literature*, ed. Nina Baym et al., 4th ed. (New York: Norton, 1994), 1:974–75.

30. Kaplan, *Walt Whitman*, 193.

31. Ibid., 496.

32. *FCP*, 65–69.

33. Samuel Taylor Coleridge, "Dejection: An Ode," in *English Romantic Writers*, ed. David Perkins (New York: Harcourt Brace Jovanovich, 1967), 433.

34. *FCP*, 694.

35. William Wordsworth, "Lines: Composed a Few Miles Above Tintern Abbey," in *English Romantic Writers*, ed. Perkins, 211.

36. Thoreau, *Walden*, 6.

37. Wordsworth, "The Solitary Reaper," in *English Romantic Writers*, ed. Perkins, 296.

38. See Karen Kilcup for a discussion of the pressures behind the publication of *Mountain Interval*, which may have weakened the poetry of the volume. Also, Kilcup discusses the transition in the volume from "the prosaic, realistic dramatic poems" typical of *North of Boston* to the "canonical, masculine lyric" (*Robert Frost and Feminine Literary Tradition*, 91).

39. *FCP*, 108–114.

40. The phrase is from Frost's comments on poets in "Education by Poetry," *FCP*, 720.

41. *FCP*, 25.

42. Joseph Brodsky, Seamus Heaney, and Derek Walcott, *Homage to Robert Frost* (New York: Farrar, Straus, and Giroux, 1996), 62–63.

43. *FCP*, 726.

44. *FCP*, 236–38.

45. Katherine Kearns, *Robert Frost and a Poetics of Appetite* (New York: Cambridge University Press, 1994), 2.

46. Tyler Hoffman, *Robert Frost and the Politics of Poetry* (Hanover, N.H.: Middlebury College University Press of New England, 2001), 221; Jay Parini, *Robert Frost: A Life* (New York: Holt, 1999), 280.

47. Malcolm Cowley, "The Case Against Mr. Frost," *Robert Frost: A Collection of Critical Essays*, ed. James M. Cox (Englewood Cliffs, N.J.: Prentice-Hall, 1962), 39.

48. "Hardy Perennial," *Time*, 16 June 1947, 102–4.

49. *FCP*, 339–40.

50. Heaney, *Homage to Robert Frost*, 77.

51. *FCP*, 777.

52. *FCP*, 725, 723.

53. *FCP*, 755–57.

5. Gothic Loneliness: The Different Cases of Edward Hopper and Andrew Wyeth (pp. 133–68)

1. Ralph Waldo Emerson, *The Complete Works of Ralph Waldo Emerson: Nature, Addresses and Lectures* (Boston: Houghton Mifflin, 1903), 1:73.

2. Mark Strand, *Hopper* (New York: Ecco, 1994), 3.

3. Edward Lucie-Smith, *Visual Arts in the Twentieth Century* (New York: Abrams, 1997), 162.

4. Gail Levin, *Edward Hopper: An Intimate Biography* (New York: Knopf, 1995), 12, 26.

5. Edward Hopper, "John Sloan and the Philadelphians," *The Arts* 11 (March 1927): 175.

6. Brian O'Doherty, "Portrait: Edward Hopper," *Art in America* 52 (1964): 73.

7. Ibid., 74.

8. "Edward Hopper's Cape Cod Wins A $2,000 Prize," *Life*, 3 May 1937, 44–45.

9. "The Silent Witness," *Time*, 24 December 1956, 28–39.

10. O'Doherty, "Portrait: Edward Hopper," 73.

11. Hopper, "John Sloan and the Philadelphians," 171, 170.

12. Lloyd Goodrich, "The Paintings of Edward Hopper," *The Arts* 12 (March 1927): 135–37.

13. Forbes Watson, "A Note on Edward Hopper," *Vanity Fair*, February 1929, 64, 106–7.

14. Quoted in Lloyd Goodrich, *Edward Hopper* (1976; New York: Abrams, 1993), 27.

15. Wieland Schmied, *Edward Hopper: Portraits of America* (Munich: Prestel, 1995), 8.

16. Quoted in H. H. Arnason, *History of Modern Art: Painting, Sculpture, Architecture, Photography* (New York: Abrams, 1986), 373.

17. John O'Connor, Jr., "Edward Hopper, American Artist." *Carnegie Magazine* 10 (1937): 305.

18. Quoted in Levin, *Edward Hopper*, 480.

19. Brian O'Doherty, *The Voice and the Myth: American Masters* (New York: Universe, 1988), 15. The commentary on Hopper in this book is a revision with slightly different material of O'Doherty's 1964 "Portrait: Edward Hopper."

20. O'Doherty, *The Voice and the Myth*, 42–43.

21. Sidney Tillim, "Edward Hopper and the Provincial Principle," *Arts Magazine* 39 (November 1964): 25.

22. See the responses to a "Visual Culture Questionnaire" sent to "a range of art and architecture historians, film theorists, literary critics, and artists" in *October* 77 (Summer 1996): 25–70.

23. Michael Ann Holly, "Past Looking," *Critical Inquiry* 16 (Winter 1990): 372.

24. Ibid., 372.

25. Mieke Bal and Norman Bryson, "Semiotics and Art History," *Art Bulletin* 73, no. 2 (June 1991): 175.

26. Carol Armstrong, response to "Visual Culture Questionnaire," *October* 77 (Winter 1996): 27.

27. W. J. T. Mitchell, *Picture Theory* (Chicago: University of Chicago Press, 1994), 5.

28. Martin Jay, "Scopic Regimes of Modernity," in *Vision and Visuality*, ed. Hal Foster (Seattle: Bay Press, 1988), 19.

29. Mieke Bal, *Reading Rembrandt: Beyond the Word-Image Opposition: The Northrup Frye Lectures in Literary Theory* (Cambridge: Cambridge University Press, 1991), 27–28.

30. Clive Bell, "The Aesthetic Hypothesis," in *Modern Art and Modernism: A Critical Anthology*, ed. Francis Frascina and Charles Harrison (New York: Harper and Row, 1982), 68–69.

31. Lucie-Smith, *Visual Arts*, 18; Charles Baudelaire, *The Painter of Modern Life and Other Essays,* trans. and ed. Jonathan Mayne (Greenwich, Conn.: Phaidon, 1964), 9.

32. Lucie-Smith, *Visual Arts*, 18; Baudelaire, *Painter of Modern Life*, 9.

33. Quoted in Levin, *Edward Hopper*, 350.

34. Emerson, *Complete Works*, 1: 10.

35. Quoted in O'Doherty, *The Voice and the Myth*, 15.

36. Emerson, *The Complete Works of Ralph Waldo Emerson: Essays, Second Series* (Boston: Houghton Mifflin, 1903), 3:46, 50, 50, 52, 75, 81.

37. Quoted in Ben Maddow, *Edward Weston: His Life and Photographs* (New York: Aperture, 1979), 144.

38. Quoted in Levin, *Edward Hopper*, 139.

39. The cultural resonance of this image, which in the nineteenth century evoked the railroad, is explored in Leo Marx, *The Machine in the Garden: Technology and the Pastoral Ideal in America* (New York: Oxford University Press, 1964).

40. Strand, *Hopper*, 3, xiii, xiv.

41. Bell, "The Aesthetic Hypothesis," 69.

42. Quoted in Levin, *Edward Hopper,* 139.

43. See O'Doherty, *The Voice and the Myth,* 22, and Levin, *Edward Hopper,* 472.

44. Quoted in Levin, *Edward Hopper*, 460.

45. Edward Hopper, "Charles Burchfield: American," *The Arts* 14 (July 1928): 5–12; quotation is from page 7.

46. Andrew Hemingway, "To 'Personalize the Rainpipe': The Critical Mythology of Edward Hopper," *Prospects* 17 (1992): 388, 399–400.

47. Levin, *Edward Hopper*, 323.

48. Hopper quoted in Goodrich, *Edward Hopper*, 129.

49. Quoted in Levin, *Edward Hopper*, 342, 344.

50. Quoted in ibid., 131.

51. O'Doherty, *The Voice and the Myth*, 21.

52. Edward Hopper, review of "Five Prints of the Year, 1925," *The Arts* 9 (March 1926): 172–174; quote is from page 173.

53. Margaret Iversen, "In the Blind Field: Hopper and the Uncanny," *Art History* 21, no. 3 (September 1998): 410–411.

54. Charles Burchfield, "Portrait of a Realist: Edward Hopper at Sixty-seven," *ARTNews* 49 (March 1950): 14–17, 62–64; quotation is from page 16.

55. Edward Hopper, "Charles Burchfield: American," 7.

56. "American Realist," *Time*, 16 July 1951, 72.

57. O'Doherty, *The Voice and the Myth*, 229.

58. Beth Venn and Adam D. Weinberg, *Unknown Terrain: The Landscapes of Andrew Wyeth* (New York: Abrams, 1998), 15.

59. Katherine Kuh, *The Open Eye: In Pursuit of Art* (New York: Harper and Row, 1971), 11–12.

60. Bryan Robertson, "Edward Hopper: Reality and Artifice" *Modern Painters* 9, no. 1 (Spring 1996): 40–45; quotation is from page 41.

61. Interview with George Plimpton and Donald Stewart, *Horizon* 4, no. 1 (September 1961): 88.

62. Interview with E. P. Richardson, *Atlantic* 213 (June 1964): 64.

63. *Andrew Wyeth: An Exhibition Organized by Pennsylvania Academy of the Fine Arts* (New York: Pennsylvania Academy of the Fine Arts with Abercrombie and Fitch, 1966), 26.

64. Andrew Wyeth and Thomas Hoving, *Andrew Wyeth: Autobiography* (Boston: Little, Brown, 1995), 11.

65. John Updike, "Heavily Hyped Helga," *New Republic*, 7 December 1987, 28.

66. O'Doherty, *The Voice and the Myth*, 230.

67. Richard Meryman, "Andrew Wyeth: An Interview," *Life*, 14 May 1965: 114.

68. *The Real World of Andrew Wyeth*, video, director Andrew Shell, London Weekend Television / RM Co. Production, 1980.

69. Interview with E. P. Richardson, 64.

70. Meryman, "Andrew Wyeth," 114, 116.

71. Ibid., 116.

72. Anthony Lane, "The Eye of the Land: How Walker Evans Reinvented American Photography," *New Yorker,* 13 March 2000, 88.

73. Meryman, "Andrew Wyeth," 110.

6. The Landscape of Desire: Elizabeth Bishop and the Feminine Earth (pp. 169–207)

1. Wesley Wehr, "Elizabeth Bishop: Conversations and Class Notes," in *Conversations with Elizabeth Bishop,* ed. George Monteiro (Jackson: University Press of Mississippi, 1996), 38.

2. *Prose,* 251.

3. David Lowenthal, *The Past is a Foreign Country* (Cambridge: Cambridge University Press, 1990), 204.

4. Quoted in Bonnie Costello, *Elizabeth Bishop: Questions of Mastery* (Cambridge: Harvard University Press, 1991), 187. Costello comments on the complexities of memory for Bishop and notes that she "tried to imagine some control over the stream of consciousness," even dreaming up "mechanical devices it would be useful for the mind to possess." Costello adds, "But the mind possesses no such exact device. Memory is, rather, involuntary, transforming and disruptive" (176).

5. Quoted in Marilyn May Lombardi, "Prologue: 'Another Way of Seeing,' " in *Elizabeth Bishop: The Geography of Gender,* ed. Lombardi (Charlottesville: University Press of Virginia, 1993), 2.

6. Critics who have discussed Bishop's reputation in some detail and whose insights influenced my comments include David Kalstone, *Five Temperaments* (New York: Oxford University Press, 1977), 12–13; Lorrie Goldensohn, *Elizabeth Bishop: The Biography of a Poetry* (New York: Columbia University Press, 1992), 130; Lombardi, "Prologue," 1–4; Lee Edelman, "The Geography of Gender: Elizabeth Bishop's 'In the Waiting Room,' " also in *Elizabeth Bishop: The Geography of Gender,* ed. Lombardi, 91–94; Thomas Travisano, *Elizabeth Bishop: Her Artistic Development* (Charlottesville: University Press of Virginia, 1988), 5–14; and Victoria Harrison, *Elizabeth Bishop's Poetics of Intimacy* (Cambridge: Cambridge University Press, 1993).

7. Travisano, *Elizabeth Bishop,* 9.

8. *One Art,* 262.

9. Quoted in Lombardi, "Prologue," 2.

10. Kalstone, *Five Temperaments,* 13.

11. Quoted in Gary Fountain and Peter Brazeau, *Remembering Elizabeth Bishop: An Oral Biography* (Amherst: University of Mass Press, 1994), 9.

12. *One Art*, 222.

13. Bishop's forty-two known paintings, which she kept or presented to friends as gifts, are reproduced in *Exchanging Hats: Paintings/Elizabeth Bishop*, ed. William Benton (New York: Farrar, Straus, and Giroux, 1996).

14. Ashley Brown, "An Interview with Elizabeth Bishop," in *Conversations with Elizabeth Bishop*, ed. Monteiro, 24.

15. Quoted in Lombardi, "Prologue," 2.

16. Travisano discusses this phase of criticism in greater detail (*Elizabeth Bishop*, 10–14).

17. Fountain and Brazeau, *Remembering Elizabeth Bishop*, 327–30.

18. Betsy Erkkila, *The Wicked Sisters: Women Poets, Literary History, and Discord* (New York: Oxford University Press, 1993), 124.

19. Joanne Feit Diehl, *Women Poets and the American Sublime* (Bloomington: Indiana University Press, 1990), 9.

20. Brett C. Millier, *Elizabeth Bishop: Life and the Memory of It* (Berkeley and Los Angeles: University of California Press, 1993), 37; Goldensohn, *Elizabeth Bishop*, 46; Diehl, *Women Poets*, 101.

21. George Starbuck, " 'The Work!': A Conversation with Elizabeth Bishop," in *Elizabeth Bishop and Her Art*, ed. Lloyd Schwartz and Sybil P. Estess (Ann Arbor: University of Michigan Press, 1983), 321, 322, 329.

22. Fountain and Brazeau, *Remembering Elizabeth Bishop*, 327, 330. See Bonnie Zimmerman on attitudes toward "unspeakable" lesbianism, "What has Never Been: An Overview of Lesbian Feminist Literary Criticism," in *The New Feminist Criticism: Essays on Women, Literature, and Theory*, ed. Elaine Showalter (New York: Pantheon, 1985), 200.

23. Adrienne Rich, *Blood, Bread, and Poetry: Selected Prose, 1979–1985* (New York: Norton, 1986), 125.

24. Fountain and Brazeau, *Remembering Elizabeth Bishop*, 329.

25. Millier, *Elizabeth Bishop*, 186–214.

26. *One Art*, 187.

27. Millier, *Elizabeth Bishop*, 226.

28. *Poems*, 66.

29. Millier, *Elizabeth Bishop*, 192, 194.

30. Ralph Waldo Emerson, "The Poet," in *Essays*, 2d ser. (Boston: Houghton Mifflin, 1903), 37, 7, 10; Wallace Stevens, *Collected Poetry and Prose*, ed. Frank Kermode and Joan Richardson (New York: Library of America, 1997), 329.

31. Peter Brooks, *Body Work: Objects of Desire in Modern Narrative* (Cambridge: Harvard University Press, 1993), 9.

32. See Travisano (*Elizabeth Bishop*, 26–31) on Bishop's prison imagery and Goldensohn on cages (*Elizabeth Bishop*, 85).

33. *Poems*, 67–68.

34. *Prose*, 251.

35. Annette Kolodny, *The Lay of the Land: Metaphor as Experience and History in American Life and Letters* (Chapel Hill: University of North Carolina Press, 1975), 6.

36. Simon Schama, *Landscape and Memory* (New York: Knopf, 1995), 6–7.

37. Kolodny, *Lay of the Land*, 4.

38. See Louise Montrose, "The Work of Gender in the Discourse of Discovery," *Representations* 33 (Winter 1991): 1–41; Tzvetan Todorov, *The Conquest of America: The Question of the Other*, trans. Richard Howard (New York: HarperPerennial, 1992); Stephen Greenblatt, *Marvelous Possessions: The Wonder of the New World* (Chicago: University of Chicago Press, 1992).

39. Brooks, *Body Work*, 9.

40. *One Art*, 253, 249.

41. See Kenneth John Myers for the use of this phrase, "On the Cultural Construction of Landscape Experience: Contact to 1830," in *American Iconology: New Approaches to Nineteenth-Century Art and Literature*, ed. David C. Miller (New Haven: Yale University Press, 1993), 63.

42. *Poems*, 89–90.

43. *One Art*, 225.

44. Quoted in Millier, *Elizabeth Bishop*, 238–39.

45. Ibid., 238–39.

46. George Monteiro, personal correspondence, 11 November 1997.

47. *One Art*, 231.

48. *One Art*, 235, 243–44.

49. Eric J. Leed, *The Mind of the Traveler* (New York: Basic Books, 1991), 111–13.

50. *One Art*, 248–49.

51. Ibid., 249, 262.

52. Millier, *Elizabeth Bishop*, 287.

53. Goldensohn, *Elizabeth Bishop*, 6.

54. *Poems*, 91–92.

55. W. J. T. Mitchell, *Picture Theory* (Chicago: University of Chicago Press, 1994), 168. Bishop, consciously or not, challenges the conventions of ekphrastic verse in other ways. Instead of reifying the silent greatness of a known masterpiece, she commemorates the remote landscapes of her forgotten artist uncle in "Large Bad Picture" and "Poem."

56. Montrose, "The Work of Gender," 3.

57. This poem was discovered by Lorrie Goldensohn, who offers the dating; the poem is included in *Elizabeth Bishop: The Biography of a Poetry* (27–28).

58. Ibid., 28.

59. *Poems*, 101–2.

60. Helen Vendler, *Part of Nature, Part of Us: Modern American Poets* (Cambridge: Harvard University Press, 1980), 97.

61. *One Art*, 239.

62. See Millier on the dating of "Crusoe in England" (*Elizabeth Bishop*, 446–47).

63. Quoted in Fountain and Brazeau, *Remembering Elizabeth Bishop*, 333.

64. Victoria Harrison, in *Elizabeth Bishop's Poetics of Intimacy* (Cambridge: Cambridge University Press, 1993), reads Bishop's attention to the local through the approach of American pragmatism, which, as she quotes Richard Rorty, finds "a vocabulary of practise rather than of theory, of action rather than contemplation, in which one can say something useful about the truth" (4). Harrison stresses the immediacy and specificity of Bishop's responses and her focus on "subject-subject relationships" (6).

65. *One Art*, 349.

66. *Poems*, 162–66.

67. Costello, *Elizabeth Bishop*, 160.

68. Quoted in Millier, *Elizabeth Bishop*, 234–35.

69. Mutlu Konuk Blasing, "From Gender to Genre and Back: Elizabeth Bishop and 'The Moose,' " *American Literary History* 6, no. 2 (Summer 1994): 269, 273.

70. *Poems*, 169–73.

71. Samuel Taylor Coleridge, "The Rime of the Ancient Mariner," *English Romantic Writers*, ed. David Perkins (New York: Harcourt Brace Jovanovich, 1967), 409.

72. William Butler Yeats, *The Collected Poems of W. B. Yeats* (New York: Macmillan, 1974), 129.

73. Wehr, "Elizabeth Bishop," 38.

74. W. J. T. Mitchell, "Imperial Landscape," *Landscape and Power*, ed. W. J. T. Mitchell (Chicago: University of Chicago Press, 1994), 5.

75. Lawrence Buell, *The Environmental Imagination: Thoreau, Nature Writing, and the Formation of American Culture* (Cambridge: Harvard University Press, 1995), 104.

76. Barry Lopez, "Renegotiating the Contracts," in *This Incomperable Lande: A Book of American Nature Writing*, ed. Thomas J. Lyon (New York: Penguin, 1989), 383.

77. Martin Friedman, et al., *Visions of America: Landscape as Metaphor in the late 20th Century* (New York: Abrams, 1994), 16.

78. Salim Kemal and Ivan Gaskell, "Nature, Fine Arts, and Aesthetics," in *Landscape, Natural Beauty and the Arts*, ed. Kemal and Gaskell (Cambridge: Cambridge University Press, 1993), 4.

79. Yi-Fu Tuan, "Place and Culture: Analeptic for Individuality and the World's Indifference," in *Mapping American Culture*, ed. Wayne Franklin and Michael Steiner (Iowa City: University of Iowa Press, 1992), 44.

7. The Vernacular Ruin and the Ghost of Self-Reliance (pp. 208–35)

1. The Olson House is part of the Farnsworth Museum, Rockland, Maine.

2. James Agee, *Let Us Now Praise Famous Men* (Boston: Houghton Mifflin, 1988), 142.

3. Robert Pinsky, "Poetry and American Memory," *Atlantic Monthly* (October 1999): 70.

4. *Time in New England*, photographs by Paul Strand with text edited by Nancy Newhall (New York: Aperture, 1950, 1977).

5. Eliot Porter, *Summer Island: Penobscot Country*, ed. David Brower (San Francisco: Sierra Club, 1966).

6. See *Time in New England*, (1977). Also see *Down East* November 1993, 60–65; Elric Endersby, Alexander Greenwood, and David Larkin, *Barn: The Art of a Working Building* (Boston: Houghton Mifflin, 1992); David Larkin, *Farm: The Vernacular Tradition of Working Buildings* (New York: Monacelli, 1995); and Eric Arthur and Dudley Witney, *The Barn: A Vanishing Landmark of North America* (Norwalk, Conn.: New York Graphic Society, 1972; quotation from un-paginated introduction).

7. Eliot Porter, *Summer Island, Penobscot Country*, ed. David Brower (1966; New York: Ballantine Books, 1976), 12.

8. Donald Hall, *Life Work* (Boston: Beacon, 1993), 6.

9. Donald Hall, *Ox-Cart Man*, illus. Barbara Cooney (New York: Penguin, 1983), unpaginated.

10. Hall, *Life Work*, 11.

11. See Cynthia M. Duncan, *Worlds Apart: Why Poverty Persists in Rural America* (New Haven: Yale University Press, 1999), 157.

12. Hall, *Life Work*, 30.

13. For an account of Christina Olson making the dress, see Jean Olson Brooks and Deborah Dalfonso, *Christina Olson: Her World Beyond the Canvas* (Camden, Maine: Down East Books, 1998), 76. For Wyeth's account of the painting's conception and execution, see Richard Meryman, *Andrew Wyeth: A Secret Life* (New York: HarperCollins, 1996), 5–19.

14. Meryman, *Andrew Wyeth: A Secret Life*, 12–13.

15. *FCP*, 519.

16. E. P. Richardson, "Andrew Wyeth," *Atlantic*, June 1964, 63. Also see Richard Meryman, *Andrew Wyeth: A Secret Life*, 7.

17. Andrew Wyeth and Betsy James Wyeth, *Christina's World* (Boston: Houghton Mifflin, 1982), 1.

18. Ibid., 272.

19. See David Danbom on condescension toward farmers, *Born in the Country: A History of Rural America* (Baltimore: Johns Hopkins University Press, 1995), 151. Also, see Jay Parini on Pinkerton students mocking their unconven-

tional teacher as the "hen-man," *Robert Frost: A Life* (New York: Holt, 1999), 97, 101.

20. See Richard Meryman on Christina Olson's situation, *Andrew Wyeth: A Secret Life*, 8–13.

21. Dale MacKenzie Brown, "Forgotten Houses," *House Beautiful*, January 2000, 14, 16.

22. *FCP*, 15.

23. *FCP*, 59–62.,

24. Marianne Moore, *The Complete Poems of Marianne Moore* (New York: Macmillan / Viking, 1981), 5–7.

25. *Poems*, 67–68.

26. Charles L. Peterson, *Of Time and Place* (New London, Minn.: White Door, 1998), 74, 73.

27. *Prose*, 273.

28. *Poems*, 179–80.

29. William Butler Yeats, *The Collected Poems of W. B. Yeats* (New York: Macmillan, 1974), 39.

30. *Poems*, 8, 163.

31. Sigmund Freud, "The 'Uncanny,'" *Psychological Writings and Letters*, ed. Sander L. Gilman, trans. Alix Strachey (New York: Continuum, 1995), 121.

32. Margaret Iversen, "In the Blind Field: Hopper and the Uncanny," *Art History* 21, no. 3 (September 1998): 409.

33. Edward Hopper, "Charles Burchfield: American," *The Arts* 14 (July 1928): 7.

34. William Wordsworth, "Ode: Intimations of Immortality From Recollections of Early Childhood," in *English Romantic Writers*, ed. David Perkins (New York: Harcourt Brace Jovanovich, 1967), 280.

35. Sally Mann, *Mother Land: Recent Landscapes of Georgia and Virginia* (New York: Edwynn Houk Gallery, 1997), 5–6.

36. My argument here is influenced by Walter Benjamin's "The Work of Art in the Age of Mechanical Reproduction," in *Illuminations*, ed. Hannah Arendt, trans. Harry Zohn (New York: Harcourt, Brace and World, 1968), 219–253. However, the aging of technological processes complicates Benjamin's distinction between the auratic "presence" of an original artwork and the lifeless stasis of a reproduction.

37. Vicki Goldberg, "Landscapes That Are Steeped in Time," *New York Times*, Oct. 17, 1997, B31.

38. Mann, *Mother Land*, 6.

39. Ibid., 6.

40. Robert Lowell, *Selected Poems* (New York: Farrar, Straus, and Giroux, 1977), 136.

41. Pinsky, "Poetry and American Memory," 70.

42. *FCP*, 339–40.

43. T. S. Eliot, *The Complete Poems and Plays, 1909–1950* (New York: Harcourt, Brace and World, 1971), 138.

44. See Robert Faggen for further discussion of the poem's comment on a modernist "search" for "archaic ideals of primitive order" and "religious symbols," *Robert Frost and the Challenge of Darwin* (Ann Arbor: University of Michigan Press, 1997), 274.

45. *FCP*, 341–42.

46. William G. Gabler, *Death of the Dream: Classic Minnesota Farmhouses* (Afton, Minn: Afton Historical Society Press, 1997), 24.

47. Randall Jarrell, "To the Laodiceans," in *Robert Frost: A Collection of Critical Essays*, ed. James M. Cox (Englewood Cliffs, N.J.: Prentice-Hall, 1962), 93.

48. I am indebted here to Andrew Lakritz's discussion of Frost's poetry and Walter Benjamin's concept of the aura as "the phenomenon of distance no matter how close a thing appears," in *Modernism and the Other in Stevens, Frost, and Moore* (Gainesville: University Press of Florida, 1996), 14.

49. See Freud, "The 'Uncanny,' " and Lakritz's discussion of Benjamin's comment, "to perceive the aura of an object we look at means to invest it with the ability to look at us in return" (*Modernism and the Other*, 77).

8. Epilogue (pp. 236–39)

1. Wallace Stegner quoted in Maxwell MacKenzie, *Abandonings: Photographs of Otter Tail County, Minnesota* (Washington, D.C.: Elliot and Clark, 1995), unpaginated.

2. William Eggleston, *2¼* (Santa Fe N. Mex.: Twin Palms, 1999), untitled, unpaginated plates.

3. Robert Adams makes this point about the character of individuation and generalization in Paul Strand's New England photographs, *Why People Photograph: Selected Essays and Reviews* (New York: Aperture, 1994), 78–79.

4. Wendell Berry, *Standing By Words* (San Francisco: North Point, 1983), 90–91.

Index

Page numbers in *italics* represent illustrations.